PAINTING
in
ACRYLICS

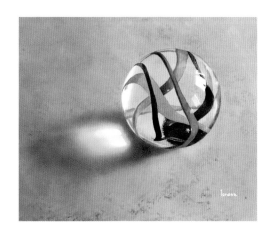

Japanese Blue
by Lorena Kloosterboer
12 x 12 inch (30 x 30 cm)

PAINTING
in
ACRYLICS

The Indispensable Guide

Lorena Kloosterboer

FIREFLY BOOKS

A Firefly Book

Published by Firefly Books Ltd. 2014

Sixth printing, 2023

Publisher Cataloging-in-Publication Data (U.S.)

CIP data for this title is available from the Library of Congress

Library and Archives Canada Cataloguing in Publication

Kloosterboer, Lorena, author
 Painting in acrylics : the indispensable guide / Lorena Kloosterboer.
Includes index.
ISBN 978-1-77085-408-6 (bound)
 1. Acrylic painting--Technique. I. Title.
ND1535.K66 2014 751.4'26 C2014-903803-8

Published in the United States by
Firefly Books (U.S.) Inc.
P.O. Box 1338, Ellicott Station
Buffalo, New York 14205

Published in Canada by
Firefly Books Ltd.
50 Staples Avenue, Unit 1
Richmond Hill, Ontario L4B 0A7

Color separation in Singapore by Pica Digital Pte Ltd
Printed in China

Conceived, designed and produced by
Quarto Publishing plc, The Old Brewery,
6 Blundell Street, London N7 9BH

FOR QUARTO:
Senior editor: Victoria Lyle; Designer: John Grain; Design assistant: Martina Calvio; Picture researcher: Sarah Bell; Copy editor: Sarah Hoggett; Proofreader: Claire Waite Brown; Indexer: Helen Snaith; Art director: Caroline Guest; Creative director: Moira Clinch; Publisher: Paul Carslake

Contents

Contents continues over the page ⟶

Contents continued

Technique files

Throughout the book various techniques are shown and described. For easy reference these are listed below with the technique file number on the left and the relevant page on the right.

Introduction

Beautiful art has always inspired me. Being infinitely curious, great paintings draw me closer to investigate brush strokes and colors and make me wonder about methods and techniques used. Well yes, I admit that I'm one of those inquisitive people who actually reads labels, instruction manuals and encyclopedias—because I want to know everything!

Starting out as an oil painter when I was in my teens, I switched to using acrylics in 2004 and haven't looked back since. Of course, building a successful relationship with acrylics took time and energy, but just as with true friendship, my interest and devotion harvested fruits. I came to know and accept its little idiosyncrasies and weaknesses, as well as its strengths and pleasures. Acrylic paint has become a trusted and dearly beloved friend that still surprises me regularly.

I believe that each artist grows and develops along a very personal path, learning through observation, practice and especially by making mistakes. Looking at other artists' paintings and work methods is always useful in order to learn, gain insights and sometimes find solutions for our own artwork.

The suggestions and demonstrations in this book merely present a few possibilities of expression among numerous equally valid approaches. It is impossible to touch upon all artistic subject matter in these pages, let alone show all conceivable forms and methods of expressing them.

This book offers you practical guidelines and useful facts, but the tools and methods shown are mere suggestions—certainly not rigid instructions. Apart from a few technical dos and don'ts, as far as I'm concerned there are no rules in making art. I believe we all need to follow our hearts and intuition and dance to our own tune. Use whatever method you like to achieve the best end result; don't ever let any dogma dictate you!

Sometimes a simple sentence or image sparks an "aha" moment that stimulates you to create new artwork that suddenly propels you to reach a new level. I sincerely hope this book will inspire you to experiment, practice and find your own artistic voice, to ultimately become the very best artist that's inside of you.

Lorena Kloosterboer

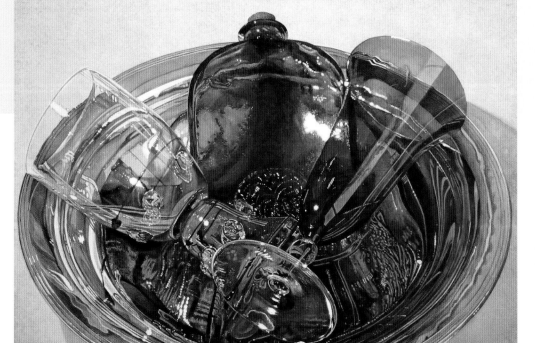

Over the next few pages and throughout this book a selection of paintings illustrate the fabulous possibilities that can be achieved by painting in acrylics.

Sapphire Blue
by Lorena Kloosterboer
22 x 28 inch (56 x 71 cm)
This graceful photorealistic painting of glass and silver objects presents a theatrical impression of abstract reflections dancing on gleaming surfaces.

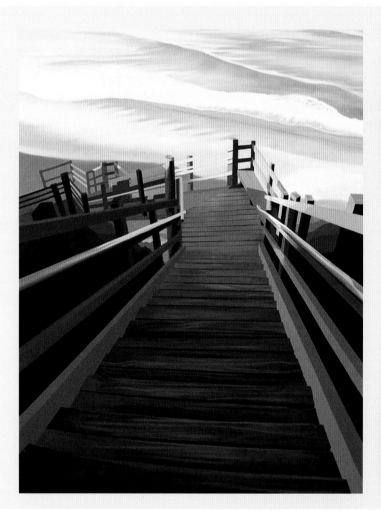

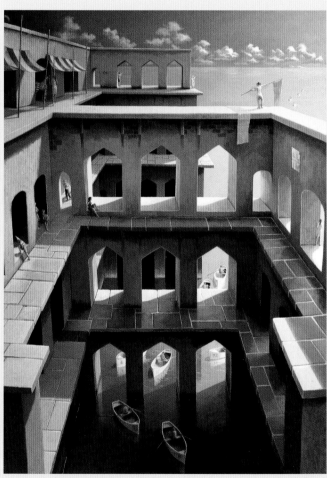

El Capitan
BY NANCY YAKI
60 x 48 inch (152 x 122 cm)
Giving a wonderful sense of height and perspective,
the weathered wooden steps meander toward the
gentle lapping waves, moving the viewer from
the shadows into the light through skillful use
of subtle colors.

While the Sun is Rising
BY MICHIEL SCHRIJVER
59 x 43¼ inch (150 x 110 cm)
The brilliant depiction of depth in this imaginary
landscape gives a sense of great height, inviting us
to catch glimpses through windows and to follow
the incoming boats approaching from where clouds
meet the horizon.

MEMPHIS BLUES
BY DAN FENELON
24 x 70 inch (61 x 178 cm)
Delightful, whimsical figures and bizarre structures
in a complex mosaic of vibrant, well-balanced colors
come together in this playful and exuberant painting.

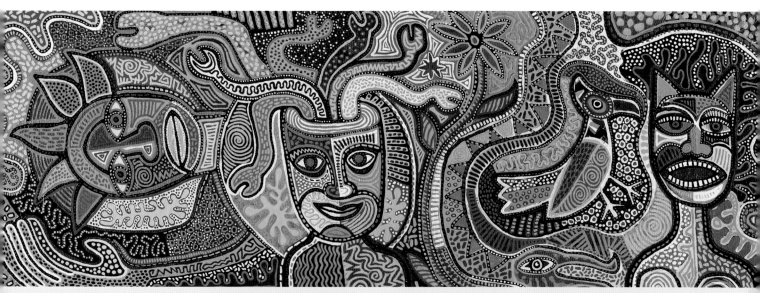

SEED
BY RALPH WHITE
24 x 30 inch (61 x 76 cm)
This intense abstract seems to invite
the viewer to discover the hazy and
mysterious atmosphere veiled behind
the curtain of poured rivulets of
wonderfully fluctuating cool and
warm colors.

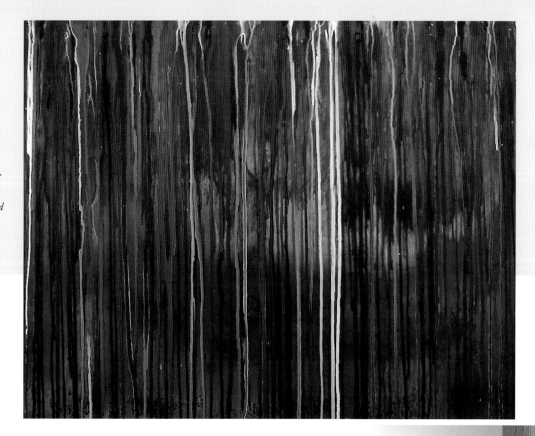

Introduction continues over the page ⟶

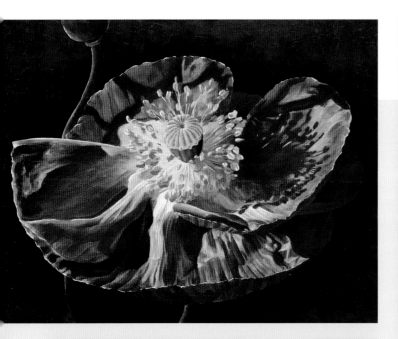

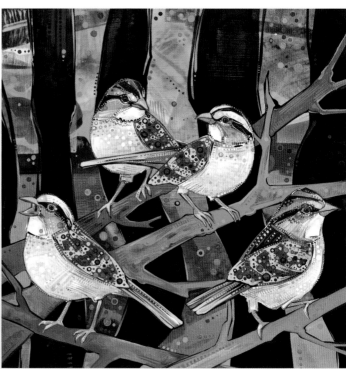

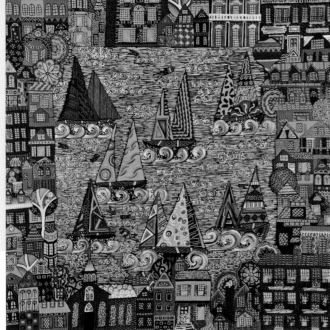

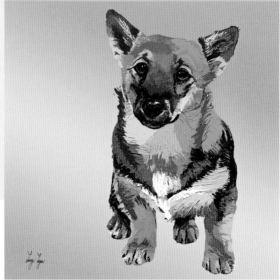

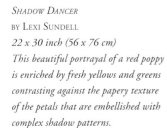

Shadow Dancer
BY LEXI SUNDELL
22 x 30 inch (56 x 76 cm)
This beautiful portrayal of a red poppy is enriched by fresh yellows and greens contrasting against the papery texture of the petals that are embellished with complex shadow patterns.

White-throated Sparrows
BY GWENN SEEMEL
10 x 10 inch (25 x 25 cm)
This delightful painting features beautiful color shifts and strong shapes enhanced by quirky marks delicately suggesting the birds' feathers and volume, making it a joy to the eye.

Regatta Town
BY DEBRA PURCELL
36 x 36 inch (91 x 91 cm)
This enchanting naïve landscape shows a skewed perspective, framing the movement of waves with colorful houses. The abundance of details invites the viewer for a closer look.

George
BY LINZI LYNN
12 x 12 inch (30 x 30 cm)
The range of vivid hues on a gold background of this dog portrait attests that art need not be slave to conventional color use in order to achieve realism and emotion.

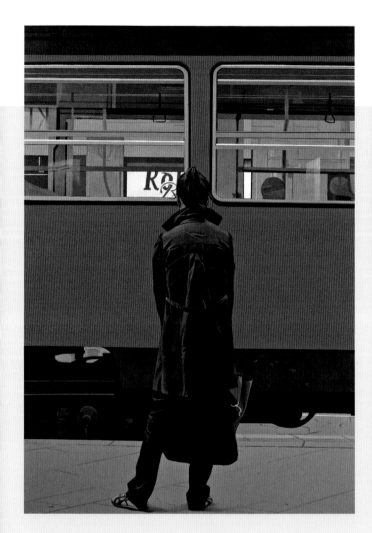

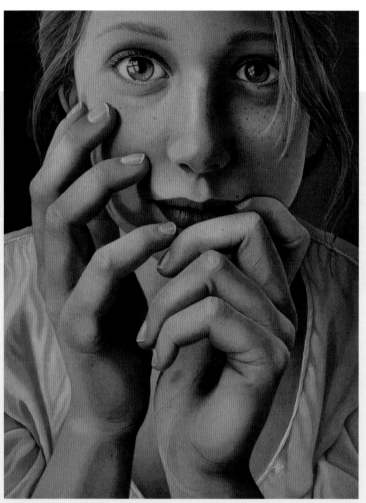

Waiting in Milan
BY Neil Douglas
47 x 36 inch (120 x 33 cm)
*The powerful composition—juxtaposing textures
and stark color contrasts—of this superb
contemporary portrait create an intense emotional
framework embracing the solitary figure.*

Sigrid
BY Jantina Peperkamp
9½ x 7 inch (24 x 18 cm)
*The superb rendering of delicate soft skin, silky
hair, expressive eyes and graceful hands skillfully
enhance the noteworthy gestural pose in this
remarkable portrait.*

Introduction continues over the page ⟶

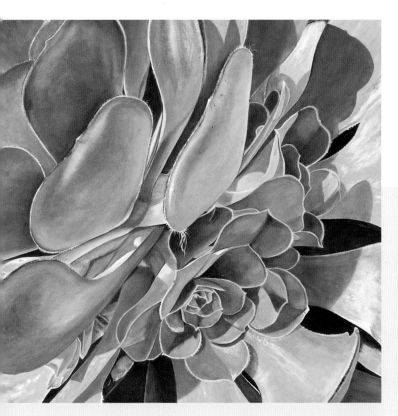

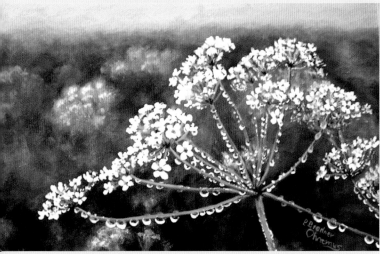

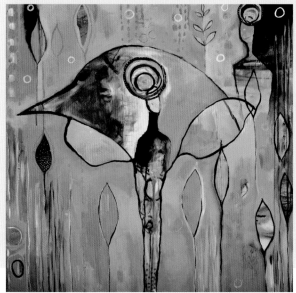

Sunbather II
BY Reenie Kennedy
24 x 24 inch (61 x 61 cm)
The marvelous rendering of this sunlit succulent, with its vibrant juicy greens skillfully modulating volume and texture, is greatly enhanced by its distinctive angle and intimate close-up view.

River Turning One
BY John Groves
12 x 12 inch (30 x 30 cm)
This conceptualized landscape displays irregular abstract lines enhanced by an array of muted colors that suggest directional movement of flowing water.

Morning Dew
BY Pamela Ohnemus
8 x 12 inch (20 x 30 cm)
This close-up of sparkling dew drops clinging to a flower is enhanced by the delicately blurred background, creating perspective and distance using rich colors and darker values.

Newfound Wings
BY Flora Bowley
36 x 36 inch (91 x 91 cm)
The fresh hues complement the warm earth tones and hint at recognizable organic shapes, created through spontaneous layering of flowing colors and thoughtful mark making.

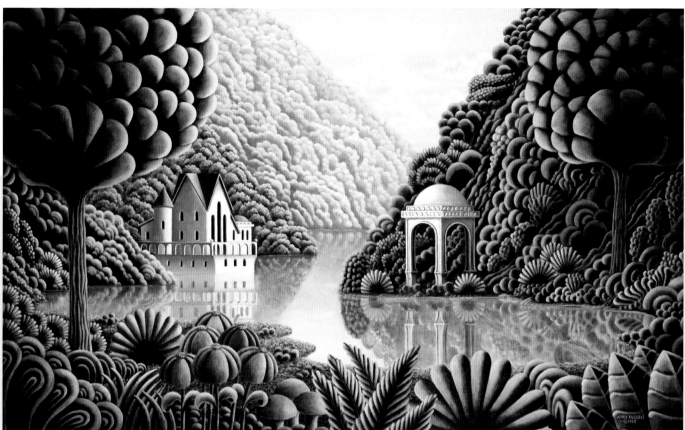

TEAL LAKE
BY ANDY RUSSELL
30 x 50 inch (76 x 127 cm)
Smooth, flowing, rounded shapes in vivid colors and exaggerated values depict a compelling fantasy landscape in which warm colors fade into misty cool colors, suggesting perspective and distance.

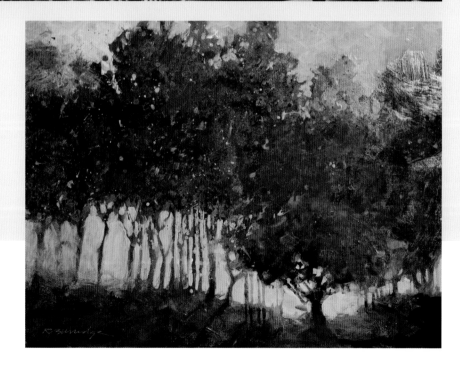

DREAM CAY
BY ROBERT BURRIDGE
20 x 24 inch (51 x 61 cm)
This stunning landscape, depicted in quick intuitive brush strokes, skillfully juxtaposes multiple layers of cool blues with warm reds and greens, creating lost and found edges of the silhouetted trees.

This book is organized into six chapters, covering all you need to know about painting in acrylics.

ABOUT THIS BOOK

Navigator

This device provides an at-a-glance listing of all the chapters in the book as well as the articles in that particular chapter.

Arrow indicator
The arrow points to the article on the page you are viewing.

Technique number
Each step-by-step technique is numbered and can be found by using the technique file listing on page 7.

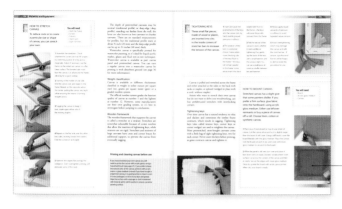

Step-by-steps
Clear step-by-step photographs are accompanied by concise instructions to help you understand each technique. Techniques are numbered and a full listing can be found on page 7.

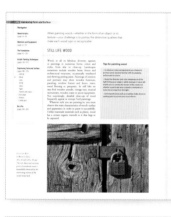

Gallery paintings
Stunning finished artworks by professional artists have been selected to exemplify and illuminate the wide range of techniques covered.

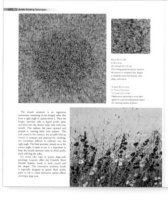
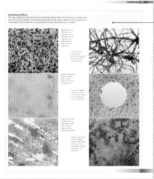

Swatches
Swatches show the different effects that can be achieved using the technique.

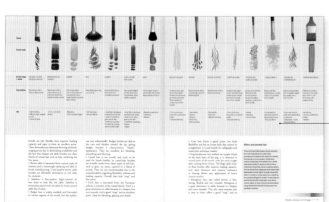

Tables and charts
Tables and charts present information that can easily be compared in order for you to make informed decisions.

CHAPTER FOUR
Acrylic Painting Techniques
(pages 130–197)

The versatility of acrylics means that they lend themselves to a wide range of techniques, which are explained in this chapter with gallery art, swatches and step-by-step demonstrations.

CHAPTER FIVE
Expressing Form & Surface
(pages 198–279)

Divided into four painting categories—still life, portrait, animals and landscape—this chapter looks at a selection of textures and surfaces you may wish to paint and presents approaches for painting them.

CHAPTER SIX
Be a Pro
(pages 280–307)

This chapter discusses the practical, noncreative issues that affect your life and work as an artist—including photographing, framing and packaging your artworks, as well as critique versus criticism, ethics and copyright.

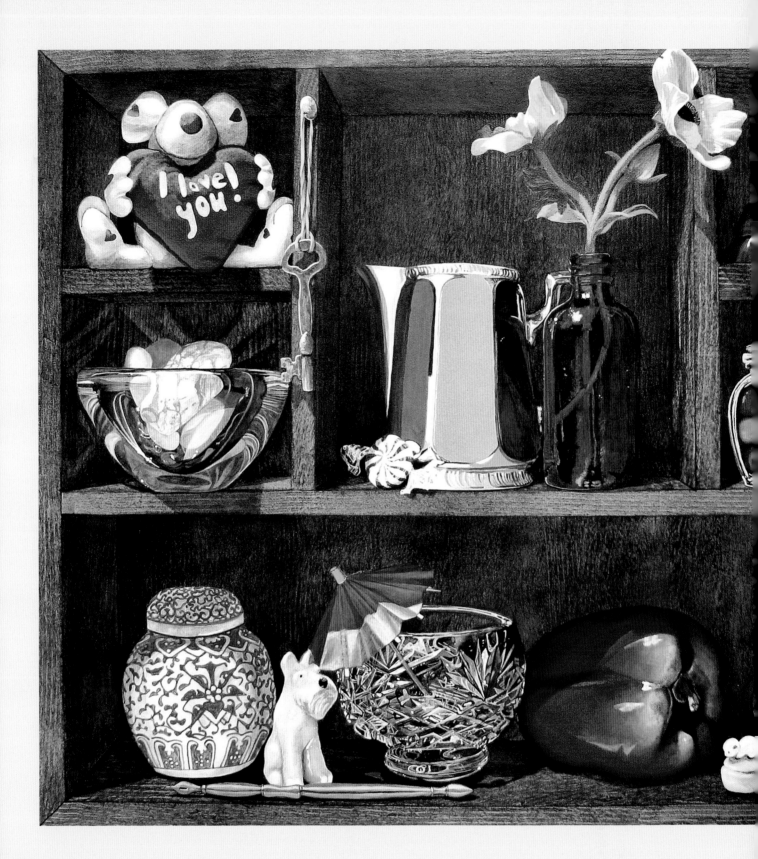

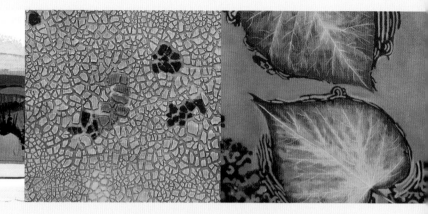

ABOUT ACRYLICS

The more you know about the properties and applications of the acrylic paints and mediums you use, the more you will get out of them. Whenever a work of art sparks your interest, it will lead you to investigate how and with what products it was created, thus encouraging you to try out new techniques and new products in order to develop and grow in your own artistic expression. This chapter examines the pros and cons of different types of acrylic paints, mediums and additives so that you can make an informed choice about what to buy. It also describes how to prepare the support before you begin to paint and explains how to varnish your paintings to give them extra protection and longevity.

Bric-a-Brac (main picture)
by Lorena Kloosterboer
12 x 15¾ inch (30 x 40 cm)
Acrylics allow such an enormous diversity of techniques and effects that artists use them to paint all genres. This trompe l'oeil painting effectively captures a range of recognizable textures and surfaces.

Above from left to right
January, Rio Grande River Basin (detail)
by Stephen Quiller
see page 21

Diversity (detail)
by Becky Bening
see page 30

Fallen Leaves (detail)
by Lorena Kloosterboer
see page 261

Acrylic paint comes in an increasingly extensive range of colors, qualities and consistencies, offering you virtually infinite ways of expressing your personal creativity.

ACRYLIC PAINT

Acrylic paint—a water-based acrylic polymer emulsion containing pigments—dries fast into a waterproof, flexible and permanent surface. Due to their versatility, acrylics allow a staggering array of techniques in all painting genres.

Compared to other more traditional paints such as oils, egg tempera and watercolors, the widespread use of acrylics is relatively recent. Acrylic paint not only encourages modern experimental expression but also can mimic the look of any traditional paint. Not surprisingly, today it ranks number one in popularity among all other artists' paints.

Ever since acrylic paint became commercially available in the mid-20th century, research and development have continued, contributing to enormous advances and improvements in the paints' properties and quality. Acrylic paint comes

Artists' quality	Student quality
Greater color saturation	Less color coverage
Highest pigment levels	Lower pigment levels
Limited color shift	Greater color shift
Varied price range	More affordable price range
Widest color choice using finest pigments	More hues using cheaper pigments
Ideal for fine art	Useful for large-scale paintings and underpainting
Best possible performance	Good-to-average performance
Precise label information on pigments, lightfastness, properties	Reduced label information

Forms of acrylics

Acrylic paint comes in a wide range of different consistencies—from liquid inks all the way to heavy body acrylics. These different consistencies dictate packaging, from tubes and squirt bottles to spray cans and pots. Manufacturers offer a choice between higher priced artists' acrylics and economical students' acrylics. Newly formulated acrylics offer extended open time for blending and transitions.

Acrylic inks come in jars or bottles. Some have eye-droppers in the cap.

Flip-top squirt bottles containing soft or fluid body acrylics stay upright, therefore avoiding spills.

Tubes are the most common packaging for virtually all types of acrylic paint consistencies.

Acrylic paint markers (left) are the latest addition to the way acrylics are packaged.

Spray cans containing artists' acrylics should be shaken vigorously before use.

Advantage of acrylics

- Available in different consistencies: Inks, soft or fluid body, heavy body and super- or extra-heavy body.

- Wide range of single and mixed color pigments as well as hues.

- Exceptional adhesion to nearly all painting surfaces.

- Flexible paint film when dry—doesn't become brittle or crack except when exposed to temperatures below 40°F (4.5°C).

- Independent of viscosity, good-quality acrylics contain the same high pigment strength.

- Most acrylics remain workable for between 10 and 30 minutes, making them ideal for successive layering, masking, textural, impasto, glazing and watercolor techniques.

- Odorless, fumeless, nonflammable.

- Waterproof, flexible, nonyellowing and permanent when dry.

- Suitable for indoor and outdoor artwork.

- Thin layers dry within 10 to 20 minutes. Thicker paint layers may take between an hour and several days.

- Viscosity can be reduced (diluted) or enhanced (thickened) by adding mediums.

- No delay for varnishing after drying.

Viscosity

Unlike any other single kind of paint on the market today, acrylics come in a wide range of consistencies to suit any artist's preferences and needs. Acrylic paint appears in the following viscosities:

- Ink and soft (or fluid) body for liquid or thin applications, including airbrush.

- Heavy body and super- (or extra-) heavy body for thick applications, including impasto.

Ultramarine Blue

| Acrylic ink | Fluid or soft body acrylic | Heavy body acrylic | Extra-heavy body acrylic |

Combining viscosities

Acrylics in different consistencies can be used simultaneously in one painting to create a surface with different textural effects.

Thin fluid layer of Primary Cyan—no visible brush strokes.

Thick layer of soft body Metallic Silver—visible brush strokes.

Impasto layer of heavy body Chromium Oxide Green—visible palette knife marks holding soft peaks.

Wet-to-dry color shift

The binder in acrylic paint—acrylic polymer—is milky white. It clarifies as the paint dries, resulting in a slight darkening of colors. Color shift is especially noticeable among dark colors and when adding mediums. Acrylic manufacturers strive to create increasingly clearer acrylic polymers to eliminate color shift.

Brilliant Blue Permanent

Left: wet Right: dry

Acrylic Paint continues over the page ⟶

not only in an impressive selection of colors, but also in a number of different consistencies, ranging from liquid ink to buttery heavy body, to suit any artistic endeavor and artist's preference. Prominent paint manufacturers are vying to win our hearts by offering us ever-better acrylic paints and a vast array of mediums and additives that modify the paint's workability and appearance— a direct benefit for artists worldwide.

There are relatively few restrictions to using acrylic paint. Never thin acrylics with more than 25% water; instead, add acrylic medium to ensure color intensity and stability. Never expose acrylics to temperatures below 40ºF (4.5ºC) to avoid brittleness and cracking. Never mix acrylics with oils or solvents, since these will destroy the integrity and permanence of the acrylic polymers.

These swatches show a transparent hue next to an opaque hue over a black-and-white background.

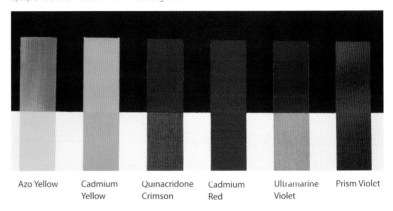

Azo Yellow | Cadmium Yellow | Quinacridone Crimson | Cadmium Red | Ultramarine Violet | Prism Violet

Opacity

The covering power of acrylics varies depending on the color pigments used. Opaque acrylics offer excellent coverage of the underground. Transparent acrylics allow the underground to show through with minimum coverage. Semi-opaque or semi-transparent acrylics are moderately opaque, somewhat allowing the underground to show through.

Interference or opalescent acrylics

Interference or opalescent acrylics are colorless, transparent paints that shift color depending on the angle from which they are viewed. They are translucent when applied over a light underground and appear as shimmering pastel colors when applied over a dark underground. The number of colors available depends on the brand; there are even some that "flip" between two color points on the spectrum, and these are indicated by two color names (for example, Interference Green Orange).

To increase visual interference effects:
• Use thin applications (wash or glaze).
• Add a tiny bit of black to the interference color.
• Add more black for iridescent grays.

Interference colors shown in a thin layer and impasto over a black-and-white background.

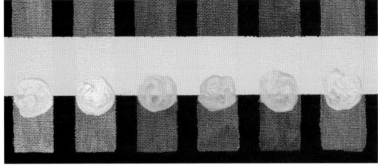

Interference Green | Interference Gold | Interference Orange | Interference Red | Interference Violet | Interference Blue

Metallic and iridescent acrylics; there are many more colors available depending on brand.

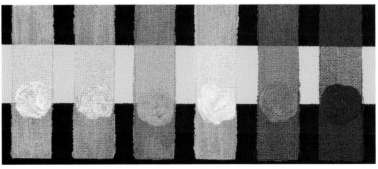

Metallic Silver | Metallic Pale Gold | Metallic Rich Gold | Iridescent White | Metallic Copper | Micaceous Iron Oxide

Iridescent or metallic acrylics

Iridescent or metallic acrylics are reflective, opaque paints that mimic metal sheens. Their metallic appearance is produced by mica flakes reflecting light.

To create various metallic and iridescent effects:
• Blend Iridescent White with regular colors to create pearlescent colors.
• Blend with acrylic mediums for metallic glazes or textures.
• Blend with transparent colors for different iridescent effects.
• Iridescent White added to regular colors creates shimmering pastels.

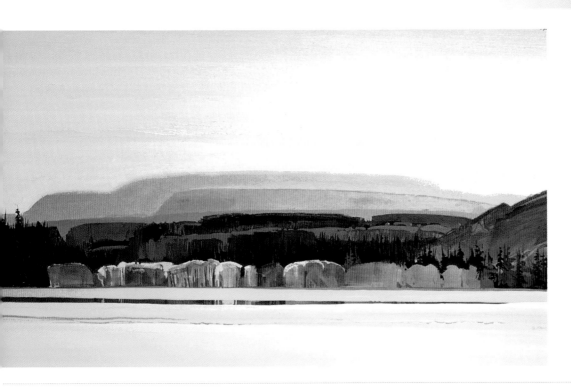

January, Rio Grande River Basin
by Stephen Quiller
25 x 34 inch (64 x 86 cm)
This serene landscape was superbly
painted bringing the transparent,
translucent and opaque qualities
of different acrylic colors into play,
bestowing the surface with rich, intense
hues and an ethereal luminosity.

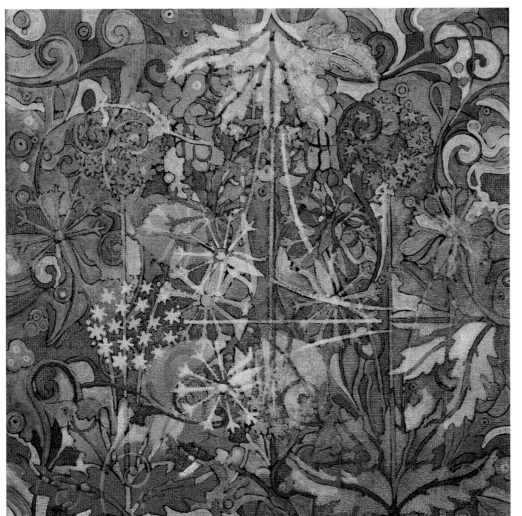

Metallic Garden
by Lorena Kloosterboer
11½ x 11½ inch (30 x 30 cm)
The shimmering, changing
effects of metallic, iridescent and
interference colors are best seen
in person when light enhances
reflectivity and shifts colors.
Due to the dark underground
these opalescent and interference
colors look a lot stronger than
if they had been painted over
a light underground.

Colors used:
· Interference Blue
· Interference Gold
· Interference Green
· Interference Orange
· Interference Red
· Iridescent White
· Metallic Copper
· Metallic Rich Gold
· Metallic Silver

Compared to other paints, acrylics are relative newcomers in the world of fine art. Their acceptance among artists, collectors and curators has gradually increased due to their versatility as well as their excellent archival qualities.

COMPARISON TO OTHER PAINTS

When they first appeared, acrylics were viewed with suspicion, and during many decades the established art world dismissed them. Over time, however, acrylics have proven they can compete with traditional paints, including oils. Acceleration tests, although still unreliable, suggest that acrylic paintings can survive just as long as oil paintings—and probably outlive them without the typical discoloration and cracking expected in aged oil paintings. Although it will take several centuries to factually demonstrate acrylics' longevity and endurance, fine artists around the world have embraced and accepted the paints.

Oil paint, the medium of the Old Masters, is still considered the standard and enjoys a perception of greater value, which affects status and prices. While many renowned artists proudly work in acrylics and achieve high sums for their acrylic paintings, less self-assured artists sometimes buckle under the pressure exerted by the views of conservative collectors, galleries and museums. Consequently, some artists label their acrylic paintings as "mixed media" or "synthetic polymer." And since it's virtually impossible to tell whether a painting is created in oils or acrylics, some simply resort to presenting their acrylic paintings as oils.

This begs the question whether there is a factual basis for the discrepancy regarding the higher prestige, respect and monetary value of oil paintings versus acrylic paintings. Since similarly painted artwork in oils and acrylics cannot be told apart, the discrimination boils

Acrylics

Advantages	Disadvantages	Advantages and disadvantages
+ Acrylic polymers are virtually colorless, and yellowing is not a significant problem.	**−** Acrylic paint films are soft and porous, attracting dust and pollutants.	**+/−** Needs varnish protection. Varnish can be applied immediately once dry.
+ Acrylics are odorless and nontoxic (except for those containing toxic pigments, such as cadmium and cobalt).	**−** Acrylics are too young to prove longevity, although educated expectations on durability and permanence are high.	**+/−** Fast drying time. Both a strength and a weakness.
+ Acrylics dry through evaporation and coalesce to form a soft, flexible, yet tough film that is not prone to cracking even in very thick applications.	**−** Acrylics become brittle at cold temperatures below 40°F (4.5°C), which is problematic for unheated storage and shipping.	**+/−** Mistakes can be corrected by overpainting.
+ Acrylics dry to a shiny finish (less shiny than oils), unless matte medium is added. Good control over finish sheen.	**−** Because of the fast drying time, you cannot pre-mix many colors on the palette.	**+/−** Wide array of mediums and additives offer incredible versatility.
+ Handling: Forgiving except for techniques requiring open time, such as gradations.	**−** The color shift from wet to dry makes it difficult to accurately blend and match colors.	
+ Supports need no undercoat or ground, unless surfaces are sleek and need tooth. Acrylics adhere to virtually any support.	**−** Brushes need to be protected from drying out during the painting session.	
+ Techniques: All techniques possible to mimic all other wet media. Open to innovative new methods and special effects.		
+ Can be applied thinly or thickly.		
+ Can be thinned and cleaned up with water.		
+ Wide range in consistencies and viscosities.		
+ Archival cleaning process is easy when removable varnish and isolation coat are used.		

Comparison of acrylic viscosities

Versatile acrylic paints and mediums are able to mimic all other paints.

Category	Viscosity	Suggested tools	Offers	Compares to
Acrylic ink	Liquid	Airbrush Brush Refillable markers Pen/Calligraphy pen	Flat, thin coating Watercolor effects Washes Airbrush effects Glazes	Gouache Watercolors Water-soluble inks
Soft body Fluid body	Heavy liquid cream	Airbrush Brush Sponge	Fine details Little or no brush strokes Glazes	Casein Diluted oils Egg tempera Gouache Watercolors
Heavy body	Soft butter	Brush Painting knife Sponge	Retains brush strokes Retains painting knife marks Impasto	Alkyd Casein Gouache Oils
Super-heavy body Extra-heavy body	Thick soft butter	Brush Palette knife	Retains brush strokes Retains painting knife marks Impasto Sculptural textures	Alkyd Casein Oils

down to the perception of long-term durability. This certainly is the case for watercolor paintings, which, despite requiring considerable expertise, command lower prices due to their fragility. Luckily, current prognostics suggest that acrylics will likely far outlast oils.

All paints have pros and cons. It is up to each artist to decide whether acrylics are their preferred medium of expression, based on handling properties and desired results. If you work in acrylics it is imperative to be honest about it, to support its reputation and to endorse its standing and value in order to eradicate the last traces of bias against it.

Currently, the most popular, best known and widely used commercially produced paints are acrylics, oils and watercolors. Oils and watercolors have a long history, while acrylics are relative newcomers. Let's assess the pros and cons of each.

Comparison to Other Paints continues over the page ⟶

Oils

Advantages

+ Oil paint films are resistant to picking up dust and pollutants.

+ Oils withstand low temperatures slightly better than acrylics, becoming brittle below 32°F (0°C).

+ Proven longevity of 500+ years.

+ Rich, buttery consistency.

+ Thin and thick applications.

+ Finish: Dries shiny.

+ Handling: Forgiving, easy to correct mistakes by scraping and overpainting.

+ No color shift from wet to dry. Allows accurate color blending.

+ Techniques: Oil painting methods including wet-in-wet, impasto, glazing, easy gradations and transitions.

Disadvantages

− Hazardous to health due to toxic solvents and thinners (turpentine, turpenoid or mineral spirits).

− Oils dry in a complex chemical process that slows down as the film hardens, resulting in brittleness over time.

− Oils tend to yellow over time.

− Need varnish protection. Varnish can only be applied after a minimum of six months.

− Archival cleaning process is complicated.

− Finish: Tends to result in an uneven surface finish depending on pigments and medium.

− Supports need a sealing undercoat or ground to accept oils.

Advantages and disadvantages

+/− Limited array of mediums and additives.

+/− Slow drying time. Long open time to build up the painting.

Watercolors

Advantages

+ Techniques: Wet-in-wet, glazing, washes, staining, accidental bleeding, special effects.

+ Can be thinned and cleaned up with water.

+ Viscosities available: Creamy in tubes and hard pans.

+ Watercolors are odorless and nontoxic (except for those containing toxic pigments, such as cadmium and cobalt).

Disadvantages

− Handling: Requires high level of skill to avoid muddy colors and maintain vivid luminosity.

− Offers minimal control, especially during wet-in-wet applications. Hard to layer.

− Can be hard or even impossible to correct mistakes.

− Need matting and framing and UV protection. High maintenance due to fragility of support (usually paper).

− Paint film microscopically thin. No dimensional build-up possible.

− Watercolor paper is expensive and not re-paintable.

− Very slight color shift, sometimes loss of chroma upon drying.

Advantages and disadvantages

+/− Dries flat and matte, without sheen.

+/− Fast drying time. Both a strength and a weakness.

+/− Limited array of mediums and additives.

+/− Thin, transparent applications.

Comparison of popular paints

Type of paint	In widespread use since	Binder/vehicle (without pigment)	Dilution
Acrylics	Approx. 1950s	Acrylic polymer emulsion	Water
Acrylic gouache (designer gouache)	Approx. 1950s	Acrylic polymer emulsion with matting agent	Water
Alkyd (so-called fast-drying oils)	Approx. 1950s	Oil-modified alkyd resin	Solvents and thinners
Casein	Approx. 3000 BC	Milk casein (milk protein) in water-soluble medium	Water
Egg tempera	Approx. 3000 BC	Oil in water-soluble emulsion (egg yolk)	Water
Gouache	16th century	Gum arabic with additives such as glycerin, honey, ox gall	Water
Oils	15th century combining oils with tempera 16th century onward, pure oils	Drying oils, usually linseed, sunflower or poppy oil Sometimes with natural resins such as damar and mastic	Solvents and thinners
Watercolor	Paleolithic times Resurgence in the Renaissance	Gum arabic or synthetic glycol	Water
Water-soluble oils (also called water-miscible oils) **Water-mixable oils**	Mid-1990s	Modified linseed and safflower oils that accept water with or without a detergent	Water

COMPARISON OF PAINTS SWATCHES

These examples clearly show that acrylics can mimic other paints quite efficiently. The coverage and textures are highly similar when used in the same method, although depending on the brands used, the properties of paints may vary.

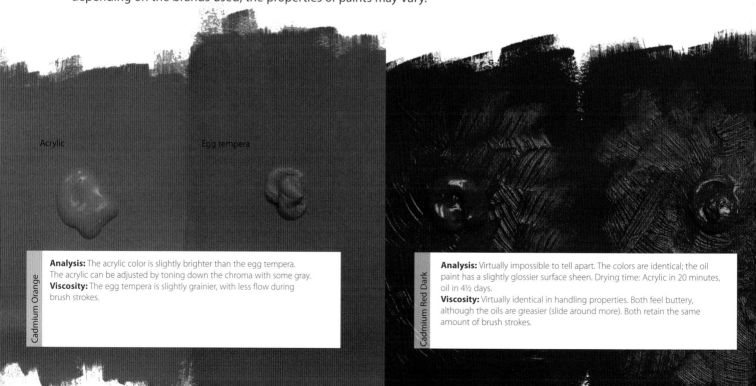

Acrylic Egg tempera

Oil

Analysis: The acrylic color is slightly brighter than the egg tempera. The acrylic can be adjusted by toning down the chroma with some gray.
Viscosity: The egg tempera is slightly grainier, with less flow during brush strokes.

Cadmium Orange

Analysis: Virtually impossible to tell apart. The colors are identical; the oil paint has a slightly glossier surface sheen. Drying time: Acrylic in 20 minutes, oil in 4½ days.
Viscosity: Virtually identical in handling properties. Both feel buttery, although the oils are greasier (slide around more). Both retain the same amount of brush strokes.

Cadmium Red Dark

Drying time	Opacity	Color shift	Waterproof when dry	Film strength	Health risks (short of toxic pigments)
Fast	Transparent to opaque	Yes, sometimes dries darker	Yes	Strong and flexible, except below 40°F (4.5°C)	Low
Fast	Opaque	Yes, lighter colors dry darker	No	Strong, somewhat flexible, except below 40°F (4.5°C)	Low
Moderate	Transparent to opaque	No	Yes	Strong, less brittle than oil	High
Fast	Opaque	Yes, slightly	No	Brittle	Low
Fast	Translucent	No	No	Strong, brittle	Low
Fast	Opaque	Yes: Lighter colors dry darker, darker colors dry lighter	No	Brittle	Low
Slow	Transparent to opaque	No	Yes	Strong, brittle	High
Fast	Transparent	Yes, slightly lighter or less vivid when dry	No	Lacks substantial film	Low
Moderate	Transparent to opaque	No	Yes	Strong, brittle	Low

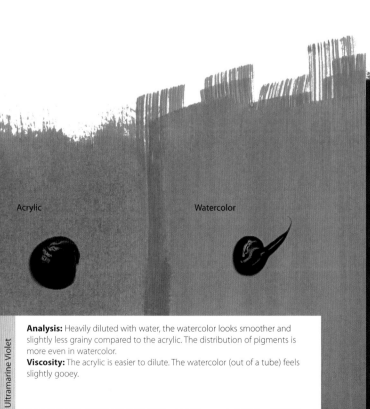

Acrylic Watercolor

Ultramarine Violet

Analysis: Heavily diluted with water, the watercolor looks smoother and slightly less grainy compared to the acrylic. The distribution of pigments is more even in watercolor.
Viscosity: The acrylic is easier to dilute. The watercolor (out of a tube) feels slightly gooey.

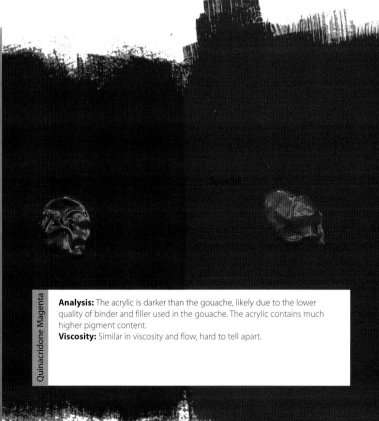

Gouache

Quinacridone Magenta

Analysis: The acrylic is darker than the gouache, likely due to the lower quality of binder and filler used in the gouache. The acrylic contains much higher pigment content.
Viscosity: Similar in viscosity and flow, hard to tell apart.

At first glance, the label on a pot or tube of paint tells us about the brand, color and viscosity. Additional label information about pigments, series number, coverage, lightfastness rating, binder used and health information can prove invaluable.

Tube and tub
Whether the paint is in a tube or tub, the same information is included in the labeling.

READING THE PAINT LABEL

Basic label information, such as brand, viscosity and color, are usually enough for us to decide whether to buy or not. But there's so much more an artist can learn from reading a label.

KEY:
1. Brand name
2. Color
3. C.I. code
4. Quality
5. Series
6. Lightfastness rating
7. Permanence rating
8. ATSM
9. Opacity rating
10. Health information

Brand name (1) All acrylic paints display their brand name. Examples of internationally renowned brands are Winsor & Newton, Liquitex and Golden.

Color names (2) and pigments (3) In addition to the color name the label indicates the single or multiple pigments used, designated by pigment name and/or color index (C.I.) code. The first letter (P)

C.I. pigment code example

Full name
Pigment Blue

Abbreviation
PB

Color and C.I. code
Ultramarine/PB 29

A complete list of C.I. pigment codes can be found on pages 312–315.

stands for pigment. The next letter(s) stand for the color family it belongs to, while the number identifies the chemical pigment.

Sometimes color names indicate precise color and pigment content, such as Cadmium Orange. Other names do not state the pigment, such as Ivory Black, which is derived not from ivory but from carbon produced by burned animal bones. Some colors, such as Sap Green or Portrait Pink, are blends, and it's useful to know their pigment composition for further blending. Color names followed by the word "hue" mimic the referenced color but are not composed by its traditional

pigments. Hues closely match appearance and working properties, but are less expensive. For example, Cobalt Blue is a single expensive pigment, while Cobalt Blue Hue is a blend of lower-priced blue pigments and white. Hues are great alternatives if you're on a restricted budget.

Quality (4) Artists' versus student grade quality and performance are indicated by the class of acrylic paint. All acrylic paint is composed of color pigments suspended in an acrylic polymer vehicle or binder (the "glue" holding together the pigment molecules). Artist grade acrylics have the highest and purest

pigment content and the clearest-drying polymer binders. Student or regular grade acrylics have lower pigment content and added fillers to increase the volume of the acrylic polymer binder.

Series (5) The series indicates the relative value of the raw material, the pigment. The lower the series (e.g., Series 1, I or A), the lower the price. And vice versa: the higher the series (e.g., Series 4, IV or D), the higher the price. Series and related pigment costs are not an indication of quality. Some pigments are simply more expensive due to their scarcity or production method.

Opacity (9) Opacity is identified with a pictogram or letter. Some labels display a hand-painted color swatch over a black-and-white design to show the degree of coverage and finish.

□ ○ T — Transparent paint does not cover the underlying surface.

◩ ⦸ ST
◪ ◕ SO — Semi-transparent and semi-opaque paint extend partial coverage, allowing some of underlying surface to show through in different degrees.

■ ● O — Opaque paint offers excellent coverage, preventing the surface underneath from showing through.

Health information (10) Even though there's no standard international regulation on health warnings (each label being subject to the laws and standards of the manufacturer's geographical location), all good-quality artists' acrylic labels show health information.

 The Art & Creative Materials Institute (ACMI) is an international organization promoting safety in art products. All U.S.-made acrylics show an AP pictogram when the product is considered nontoxic. Many non-U.S. brands use the ACMI standard as well. Some non-U.S. labels without the AP seal will include a notice indicating that the paint is safe.

 All U.S. acrylic brands show a written warning and/or a caution label (CL) pictogram if there's a possible health risk. The CL indicates the product is potentially hazardous, accompanied by an additional notice—for example, "Warning: Contains cobalt. Avoid skin contact. Wash hands after use. Keep out of reach of children." Hazardous products without the CL seal carry a written warning.

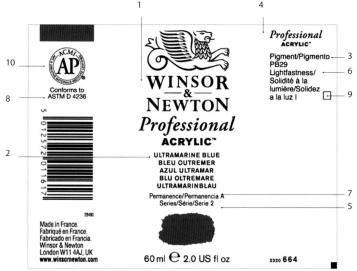

Lightfastness (6) and permanence (7) Although permanence and lightfastness are terms that are often used interchangeably, they are different evaluations of paint and pigments. The permanence rating refers to longevity. There are no reliable methods to test permanence in the strictest meaning of the word, because ultimately nothing is. Some brands use this term to indicate lightfastness.

Lightfastness indicates the color's resistance to change on exposure to light, and is important because it indicates the life expectancy of color strength in a painting.

ASTM (8) A worldwide standard set by ASTM International (formerly known as the American Society for Testing and Materials) rates lightfastness, quality and health guidelines in artists' materials. ASTM International rates lightfastness from one to five,

but only the first two grades are considered suitable for artists' acrylic paint. ASTM I stands for excellent lightfastness and ASTM II for very good lightfastness.

When the rating on the label shows ASTM D, the paint has been subjected to the most demanding test an artists' acrylic can undergo.

Brands not using ASTM ratings show internal company evaluations of lightfastness, indicated by letters, stars or plus signs. These ratings are as valid as the overall respectability and distinction of the brand name.

The Blue Wool Scale, used in the United Kingdom, rates pigments' lightfastness from one to eight.

Comparison of ASTM and Blue Wool Scale

ASTM Scale	Blue Wool Scale	Lightfastness
ASTM I	Blue Wool Scale 7 & 8	Excellent
ASTM II	Blue Wool Scale 6	Very good
ASTM III	Blue Wool Scale 4 & 5	Fair, non-permanent
ASTM IV	Blue Wool Scale 2 & 3	Poor
ASTM V	Blue Wool Scale 1	Very poor, fugitive

Acrylics can be enhanced, modified and customized by adding any of dozens of acrylic mediums and additives. The wealth of effects these formulas offer make acrylic paint the most versatile paint ever.

MEDIUMS AND ADDITIVES

The number of mediums and additives on the market continues to grow as manufacturers develop new products to enhance acrylic paints. This makes it impossible to buy and try them all out. Posters showing swatches found in art-supply stores are both tactile and visually helpful. Manufacturer's websites offer information with explanatory images and sometimes videos that are good starting points for creative applications. Schedule some studio time to familiarize yourself and experiment with the products you buy.

The difference between mediums and additives

A medium is an ingredient added to acrylic paint in order to change its physical properties and appearance. Mediums contain acrylic polymer emulsion—essentially colorless paint—whose binding qualities assure stability, flexibility and

GIA

BY THANEEYA McARDLE

18 x 24 inch (46 x 61 cm)
Acrylic mediums—usually
associated with non-figurative
painting styles—can be
successfully combined with
realism and other traditional
styles to create exciting abstracted
backgrounds and to add
appealing, innovative textures.

Choosing a medium

Objective	Medium	Effects	Objective	Medium	Effects
To thin the paint	Airbrush extender; Airbrushing medium	Breaks surface tension of water for better dispersal; Dilutes paint color without losing stability; Useful for spray applications; Avoids airbrush tip dry		Molding paste	Holds peaks; Firm, strong, yet flexible; Semi-gloss to opaque film; Can be sculpted; Can be stenciled; Adds layers underneath sculptural impasto; Does not add weight
	All liquid and fluid mediums; Glazing medium; Gloss, satin or matte medium	Dilutes paint color; Enhances sheen Extends colors; Glazing—creates transparent glazes; Maintains film integrity (avoids instability of paint due to thinning with water); Increases working time for blending; Pouring—creates fluidity so paint becomes pourable		Pumice (volcanic lava) gel; Mineral texture gel; Graphite paste; Granite paste; Corundum gel	Gray opaque grit; Blends with acrylic colors; Comes in various granularities; Dries to a hard surface; Flexibility can be increased by mixing with other gels or mediums
To thicken the paint	Any of the texture mediums (see To add texture, below)	Increases viscosity; Creates innovative surfaces containing glass beads, sand, lava, etc.		Garnet gel; Quartz paste	Semi-precious stones in different colors; Blends with acrylic colors; Comes in various granularities; Dries to a hard surface; Increase flexibility by mixing with other gels or mediums
	Heavy gel; Heavy medium; Impasto medium	Increases viscosity; Impasto—enables impasto applications; Oil-painting techniques—enables the use of oil-painting techniques		Sand medium	Blends with acrylic colors; Comes in various granularities; Is an excellent ground for acrylic paint; Finish is similar to that of glossy beach sand
	Molding paste	Allows the build-up of thick films without adding weight; Can be sculpted; Can be stenciled; Can be sanded and carved; Creates textured surfaces; Creates a firm, strong, yet flexible paint layer; Holds peaks; Gives an opaque finish	To create special effects	Crackling medium	Creates a crackled surface; Separates top layers for aged effect
				Fabric medium	Allows painting on fabric; Keeps painted fabric supple
	Thickening medium	Thickens acrylic paints and mediums without adding transparency; Gives handling characteristics similar to those of oils and encaustic paint		Iridescent medium; Mother-of-pearl gel	Blends with acrylic colors; Allows control of opalescent strength
				Marbling medium	For marbleizing effects; Stops paint colors from mixing
To increase transparency	All gloss and clear mediums—except opaque mediums	Transparency is gained by thinning or by adding body with a clear-drying binding agent	To use paint as glue	All acrylic polymer binders	For collage; Gloss binder offers greatest transparency
To increase opacity	Molding paste; Pumice paste	Increases opacity; Extends paint without increasing transparency; Possible color shift	For cost effectiveness	All polymer gels and thick (viscous) mediums	Extends paint without loss of consistency
To control finish sheen	Gloss medium; Satin or semi-gloss medium; Matte medium	Choice of surface sheen—gloss medium is most transparent while matte medium is slightly opaque; Blends offer a variety of sheens	To make your own acrylic paint	All acrylic polymer binders	Blend with powdered pigments to create inexpensive student grade acrylic paint; Gloss binders have the highest binding power
To change rheology*	Pouring medium; String medium; Tar gel	Dripping; Pouring; Reduced crazing; Controlled spreading; Self-leveling	To prime the support	Soft gel; Gloss medium	To seal absorbent support without tooth; To avoid SID (Substrate Induced Discoloration—impurities of the support that result in discoloration)
To add texture	Texture medium; Structure medium	Builds relief or three-dimensionality; Creates innovative surfaces; Increases viscosity			
				Digital ground	Prepares any flat surface for ink-jet printing
	Clear granular gel	Adds texture without altering color; Creates textural glazes; Do not add color for transparent texture	As an isolation coat	Soft gel; Gloss medium	As isolation coat to separate the paint layer from the varnish (see Varnish on pages 38–41)
	Fiber paste	Rough yet flexible; Creates a paper-like surface	To increase film integrity	Any acrylic polymer medium	To avoid cracking or chalky finish due to excess of dry pigment; To avoid instability of paint diluted with too much water
	Glass beads medium	Creates an innovative visual texture; Effective as one single layer; Described as condensation on cold glass			

* Rheology refers to the character of flow and elasticity of acrylic paint and mediums.
• Short rheology indicates a buttery, semi-solid consistency. This paint retains brush strokes and holds peaks.
• Long rheology indicates a "syrupy" quality of acrylic paint and mediums. This paint pours and spreads well, and has a self-leveling quality.

Mediums and Additives continues over the page ⟶

DIVERSITY
BY BECKY BENING
8 x 10 inch (20 x 25 cm)
Crackle paste applied over
a teal colored base layer
formed, once dry, beautiful
random patterns that were
meticulously colored in using
a small brush creating a
delightful organic abstract.

NERUDA'S ALMOND
BY RHÉNI TAUCHID
16 x 16 inch (41 x 41 cm)
Rich transparent substrates
overlaid with attractive
flowing designs were skillfully
implemented through the
artist's innovative exploration
and experimentation with
acrylic mediums.

are waterproof once dry. Many mediums can be used on their own, without adding acrylic color. Examples are gloss medium, texture gel and modeling paste.

An additive refers to an ingredient that is added to acrylic paint and/or acrylic medium in order to support a painting method or technique. The additive evaporates during the drying process and does not influence the final look of the paint. Additives can only be added in limited quantities. Writing the ratio down on the lid with a waterproof marker helps as a reminder for future use. Examples are retarder fluid and flow improver.

The beauty of acrylic mediums and additives is that virtually all products are compatible with one another. They can be intermixed, expanding the number of effects into near infinity.

Acrylic additives

There are basically only two kinds of acrylic additives—those that improve flow and those that delay the drying process.

Flow improver is a dispersant that breaks the surface tension of water to help spread paint more easily. It's especially useful for staining, glazing and watercolor techniques.

Retarder mediums and gels come in different viscosities to achieve the desired consistency of paint while increasing the working time. Viscous retarders retain brush strokes (think oil-painting effects), while the liquid retarders allow fluid applications (think wet-in-wet).

Acrylic mediums

There are dozens of acrylic mediums. Blended with acrylic paint or used by themselves, they yield an infinite variety of effects. The consistency of each medium dictates its purpose and result.

• Liquid mediums are pourable and self-leveling.
• Gels are creamy, spreadable and hold soft peaks.
• Pastes are moldable and hold stiff peaks.

The name of the medium usually describes the consistency and finish, and suggests the application. Note that words such as "light" and "heavy" denote viscosity, not weight. It pays to do some online research, as manufacturers' websites offer detailed information on their mediums' applications and effects. Page 29 shows a generic list of popular acrylic mediums, with key wording to help you find your mediums of choice among many different brands. Please note that this list is destined to be incomplete, as the range of acrylic mediums continues to grow. Discover new mediums by visiting art-supply stores and manufacturers' websites regularly.

Foam control

Fluid acrylic mediums have a tendency to foam and bubble when shaken or stirred vigorously. This can affect translucency. Mediums and additives demand delicate blending, slow pouring and gentle handling. If bubbles do occur, let the product rest (covered) for 24 hours.

Textural effects

The swatches over the next three pages show the array of effects you can achieve with different mediums and additives.

Garnet gel blended with Zinc White and Ultramarine Blue, applied with a soft bristle brush over a Cadmium Orange background with metallic colors blended in fine sand medium.

Glass beads gel medium applied with a painting knife in a single packed layer over a Phthalo Turquoise underground.

Fine pumice gel blended with Cobalt Blue, Metallic Silver and Iridescent White, applied with a hard bristle brush over an Indian Yellow and Cadmium Orange underground.

Mediums and Additives continues over the page ⟶

Textural effects continued

Heavy gel blended with Quinacridone Blue Violet and Cadmium Yellow Dark. Color blended gels applied separately with a painting knife over a Light Blue Permanent underground.

Heavy gel gloss blended with Cadmium Red, applied with a painting knife and scraped with a rubber wood-graining comb.

Light molding paste loosely blended with Cadmium Yellow and Quinacridone Burnt Orange, applied with a painting knife over a scraped blend of interference colors.

Pouring medium blended with Primary Cyan, Cadmium Yellow and Titanium White.

String gel drizzled clear and in separate blends using Cadmium Yellow, Cadmium Yellow Dark, Cadmium Red, Cobalt Blue, Viridian Green and Burnt Sienna.

Soft gel loosely blended with Cobalt Teal, applied by painting knife over an underground of Sap Green blended with Naples Yellow.

Solid gel (gloss finish) blended with Ultramarine Blue, applied with a little plastic spoon over a white canvas.

Self-leveling gel blended with Metallic Gold, Metallic Bronze and Iridescent White, drizzled over a Metallic Silver underground.

Heavy molding paste blended with Viridian Green and applied by painting knife over white canvas.

Coarse pumice gel blended with Burnt Sienna, applied and evenly packed with a large painting knife.

Extra-heavy gel blended with Sap Green and Quinacridone Magenta, applied with a painting knife on an Indian Yellow underground and scraped with a shaper.

Clear granular gel blended with Metallic Gold, Metallic Silver, Cadmium Yellow, Vivid Lime Green and Light Blue Permanent, applied by brush over a Cadmium Red Dark underground.

Acrylics are celebrated for their fast drying time—thin applications dry within minutes. This is usually an advantage, yet it can pose quite a challenge as well.

KEEPING ACRYLICS WORKABLE

The so-called "open time" of acrylics refers to the interval of time that the paint stays wet and workable. As soon as acrylic paint starts drying it creates a "skin" that, when disturbed, can ruin a painting and the colors on the palette by gumming up.

There are several excellent ways to extend the open time of acrylics to allow more working time for gradations and blends. This is especially important for artists who are accustomed to painting in oils.

Spray bottle or diffuser with purified water
During work, regularly spritz a fine mist of water over your palette and painting surface to extend the open time of acrylic paint. Avoid spraying too heavily, as this may cause the paint to run. Avoid using a spray atomizer or a diffuser that spatters droplets.

Palette wetting spray
Use Liquitex Palette Wetting Spray to slow the drying process and improve color blending. Alternatively, make your own formula by blending purified water with a bit of retarder fluid and use it to repeatedly spritz your palette and painting.

Moisture-retaining or stay-wet palette
An acrylics palette is lined with a moisture-retaining membrane and has an airtight lid. As long as the membrane is kept moist and the palette is sealed after use, the acrylics remain workable for days. Buy extra disposable refill inserts to avoid running out. Alternatively, make your own moisture-retaining palette.

Magnet Time
by Raoof Haghighi
12 x 15¾ inch (30 x 40 cm)
Extending the open time of acrylic paint is especially important in order to allow sufficient time to skillfully blend subtle gradated backgrounds, delicate shadows and understated shifting values.

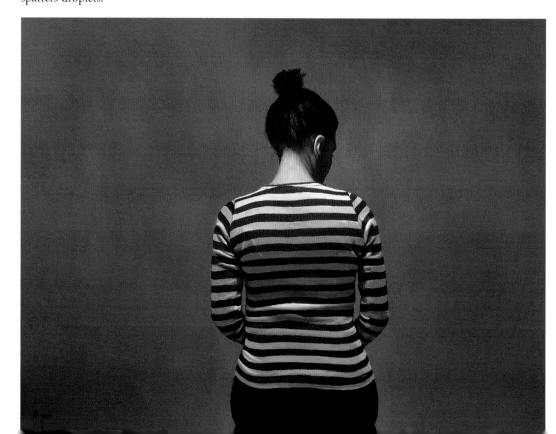

Tips for maintaining open time

- Close the lid of your paint tube or pot immediately after use.
- Close the lid of your moisture-retaining palette immediately after use.
- Mold can form inside the moisture-retaining palette—if this happens, throw out the contents immediately, wash the palette and start fresh.
- Seal absorbent supports (e.g., canvas, paper) with medium or gesso.

- Apply paint generously—the thicker the layer, the slower it dries.
- Maintain cool temperatures and high humidity in the studio.
- Never intermix fast-drying with slow-drying products.
- To avoid air currents that encourage drying, close windows and turn off fans and air-conditioning.

Retarder mediums and gels

There are many different specialized retarder gels and mediums that increase open time by slowing the drying process of acrylics. Always use them as directed on the label. Fluid retarders reduce the paint to a more fluid consistency, while gel retarders maintain the paint's viscosity.

Acrylics with extended open time

Depending on brand and working conditions, these newly formulated acrylic paints offer improved open times of anywhere from hours up to a week. We can expect more of these breakthroughs to become available in the future.

- Winsor & Newton Artists' Acrylics give an increased open time of 20% as compared to regular acrylic paint.
- Chroma Atelier Interactive Acrylics are specially formulated acrylics and mediums that allow control over the drying process—fast drying, controlled drying and slow drying.
- Golden Open Acrylics are specially formulated acrylics and mediums with increased open time—up to several hours for thicker applications. Tacked-up paint allows additional layering and blending.

TECHNIQUE FILE 01

MAKING YOUR OWN MOISTURE-RETAINING PALETTE

Moisture-retaining or stay-wet palettes are expensive, but you can easily make your own and save on costs.

You will need

- A shallow container made of plastic, metal or glass—with a lid that seals well. Alternatively use plastic wrap to cover your palette.
- Paper towels or a large flat sponge (to line the container).
- Spray bottle with distilled water.
- Wax paper or parchment paper.

Above
A ready-made moisture-retaining palette with packets of replaceable inserts.

1 Fold several layers of paper towel to line the bottom of the container. Alternatively, cut the sponge to line the container.

2 Spray the paper or sponge to moisten it.

3 Cut or fold the parchment paper to fit on top of the moistened paper or sponge.

Now the moisture-retaining palette is ready for use. Be sure to seal your palette properly after working to keep the paint moist, fresh and open for days.

Colors of gesso
Gessoes come in different colors; the most popular ones are white, gray and black. Transparent gesso is a relative newcomer. All gessoes shown here have been applied on raw linen and loosely painted with Cadmium Yellow.

Most painting supports need a primer—a base that seals the painting surface and prepares it for effective paint adhesion. Acrylic gesso is specifically tailored to handle this job.

GESSO

Traditionally, gesso (from the Latin *gypsum*) is a blend of rabbit-skin glue (binder) with chalk (calcium carbonate) and white pigment. Especially formulated for acrylic painting, modern acrylic gesso is a preparation of acrylic polymer medium (binder), chalk and pigment. Most supports, whether rigid or flexible, benefit from a few layers of gesso as a primer. It offers excellent coverage with an opaque, flat coloring, and provides "tooth" for good paint adhesion, yet it remains relatively flexible, allowing canvas and linen to be loosely rolled up without cracking. You will need to apply at least two coats, especially on absorbent supports such as canvas.

Gesso is available in both artists' and student grades. The pricier artist-quality gesso contains more pigment, offering better coverage and higher opacity, and requires fewer layers. The economical students' grade gesso contains more filler, and is slightly more susceptible to cracking due to water contents. Always buy the best quality you can afford.

Gesso comes in two viscosities—fluid and heavy. Heavier, thicker gesso is sold in tubs and pots, while fluid gesso is sold in bottles and spray cans. Fluid gesso can be applied by spray, airbrush, soft bristle brush or roller brush. Heavy gesso can be applied by hard bristle brush, roller brush, painting knife or trowel.

A relatively recent arrival among primers is absorbent ground—a thick, white, gesso-like primer that imitates paper and allows you to produce watercolor effects on supports other than paper. It is applied like a gesso primer and is ideal for stains, washes and watercolor effects on canvas, panel or wood. Once the finished artwork is sealed, there's no need to frame it behind glass.

Thinning gesso

Diluting ready-to-use gesso is not necessary unless it's for spray application or to build up many thin layers. If you do want to thin it, however, use no more than 25% water (10% water for transparent gesso) and use distilled water instead of tap water to avoid contaminants.

Bear in mind that gesso that is diluted with too much water may crack and become brittle.

For airbrush application, dilute gesso with acrylic airbrush medium to improve flow, reduce viscosity and avoid tip dry. Blend equal parts of gesso and airbrush medium, increasing the ratio of airbrush medium if necessary.

White gesso is an indispensable staple in the artist's studio. It is opaque and luminous. Blend in acrylic color for pastel grounds.

Transparent gesso seals the support and adds excellent tooth while allowing the underground to remain visible. Apply transparent gesso over ultra-smooth layers of paint to improve tooth for adding additional layers.

Gray gesso is an excellent color to give your support a mid-tone value. Blended with acrylic color, it can provide the perfect toned starting point.

Black gesso is extremely opaque and matte, offering excellent coverage. It is very useful to cover up failed paintings in order to reuse the canvas and start afresh.

Modifying gesso

Gesso can be blended with any acrylic medium or additive to create a tailored primer. To lower absorbency and tooth, add gloss gel or gloss medium to gesso. To thicken, alter texture and/or increase tooth, add any medium that contains coarse solids, such as molding paste or pumice gel and apply with a painting knife. To achieve a unique surface add textural mediums or pastes. Always test custom blends for desired results.

Sanding gesso

To obtain a polished, flat surface the gesso needs to be sanded. The gesso should be completely dry before sanding. Both wet and dry sandpapers may be used. Wet-sanding avoids dust and offers a smoother, marble-like surface; however, sanding to a super-smooth surface eliminates tooth, so expect acrylic paint to slide around.

Begin sanding with a coarse-grit sandpaper and progress to a finer grit. Use a sanding sponge for a better grip to sand around edges. Be careful not to sand all the way through the gesso and damage the support! After sanding, wipe your surface with a soft damp cloth and assess whether it needs additional sanding.

APPLYING GESSO

TECHNIQUE FILE 02

Gesso can be applied by spray, airbrush, brush, roller brush, painting knife or trowel. Depending on the choice of application tool, the surface texture will differ from flat and smooth (roller brush) to rough and irregular (trowel).

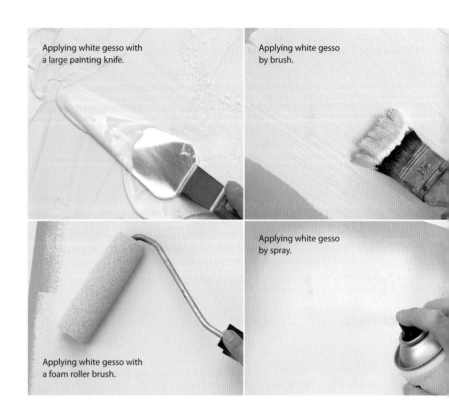

Applying white gesso with a large painting knife.

Applying white gesso by brush.

Applying white gesso with a foam roller brush.

Applying white gesso by spray.

WET-SANDING GESSO

TECHNIQUE FILE 03

Wet-sanding eliminates airborne dust and the process redistributes loosened wet gesso particles into the surface's unevenness. You can wet-sand until you reach the surface texture you seek—from relatively level with tooth all the way to ultra-flat, marble-like smoothness.

1 Loosely apply several thick layers of gesso on a canvas by brush and allow to dry thoroughly. In this case, a loose blend of gray and white gesso is used for visual clarity.

2 Soak the sanding sponge underneath the faucet and slowly sand the gesso in circular motions, applying a light, even touch. The gesso absorbs moisture, so you may need to re-wet the sanding sponge if the surface gets too dry.

Varnish is a transparent, colorless coating that protects the finished painting surface from damage and adverse environmental conditions. Its aesthetic function is to increase color saturation and unify surface sheen.

VARNISH

Acrylic paint is a porous, thermoplastic polymer that becomes pliable under higher temperatures and high humidity, making it vulnerable to contaminants such as dust and dirt particles. Art conservators recommend a final application of removable varnish to protect your paintings from dust and pollutants, as well as from fading due to ultraviolet light. A coat of varnish also unifies surface sheen and increases color saturation. Always buy the best-quality varnish you can afford, follow the manufacturer's instructions faithfully and devote as much care in applying the varnish as you did to painting your artwork.

Sign your painting before you apply varnish. Photograph your painting before applying gloss varnish. A less reflective surface is easier to photograph.

Always add an isolation coat before applying removable varnish.

Isolation coat
An isolation coat is a layer of transparent acrylic medium applied to separate the painting surface and the removable varnish. When the varnish is removed, the isolation layer prevents solvents from damaging the paint layer.

Mix an isolation coat using three parts gloss gel or gloss medium and two parts distilled water and apply like a varnish.

Allow the isolation coat to dry for at least 24 hours before varnishing.

Thinning varnish
Most varnishes are rather viscous and need to be thinned.

Dilute solvent-based varnish with full-strength mineral or white spirits. Never thin with low-strength "odorless" mineral spirits. Dilute water-based varnish with distilled water instead of tap water to avoid impurities.

The extent of thinning depends on the application method. Always follow the instructions on the product label, but as a guide, for brushing, use a ratio of three parts varnish to one part diluent and for spraying, use a ratio of one or two parts varnish to one part diluent.

Epoxy resin
Recently it has become fashionable to coat paintings in epoxy resins, giving the artwork a fabulous, thick, transparent, high-gloss, glass-like layer. However, epoxy resins are not durable and hence not recommended for fine art. Over time they develop yellow or brown discoloration, become opaque and brittle and lose adhesion. For a thick, shiny, high-gloss finish, build up dozens of thin layers of gloss varnish instead.

Varnish sheens
Glossy varnish is the clearest, most transparent varnish. It allows multiple layers. Glossy varnish reflects its surroundings. Matte and satin varnish can cause a milky finish and lighten dark colors when not mixed adequately.

From left to right: matte, satin and glossy.

Choosing a varnish

Although there are a great variety of varnishes for oil paintings on the market that can be used for acrylics, these pages will focus on varnishes specifically formulated for acrylics.

Permanent or removable?	With or without UVLS (ultraviolet light stabilizers)?	Solvent-based or water-based?	Finish
Permanent (irremovable) varnish is not recommended: if it is not applied perfectly, it can ruin your painting permanently. Always use removable varnish. All information below focuses exclusively on removable varnish.	UVLS varnish slows the effects of ultraviolet light on color lightfastness. While it is not essential for paintings created with high-quality artists' acrylics, it is indispensable in delaying UV damage on fugitive pigments and dye-based paints.	Solvent-based varnish, also called MSA (mineral spirit acrylic) varnish, is recommended over water-based varnish due to its durability and lightfastness. Water-based varnish, also called polymer varnish, prevents contact with harmful solvents.	Varnishes come in three finishes: glossy, satin and matte. These varnishes can be intermixed (using the same type and brand to ensure compatibility) to obtain any desired level of sheen. Avoid using more than one final top coat of matte or satin varnish. If multiple layers of varnish are desired, apply a matte or satin top coat over previous layers of glossy varnish.

Varnishes can be bought in bottles for brushing on and aerosols for spraying—the latter is useful for imapsto techniques.

Ambient conditions for varnishing

The work area where varnishing takes place should be:

• Well lit—you need to use the reflection to check the varnish application against the light.

• At room temperature—65–75°F (18–24°C).

• At a humidity level of between 50 and 75%.

• Dust free—if you don't like dusting, spritz the room with water. Keep pets away.

• Without air currents—close doors and windows, and turn off fans and air conditioning.

Dos and don'ts of varnishing

• If multiple coats are desired with a matte or satin finish, always apply under-layers of gloss varnish or an isolation coat, and finish with one top coat of matte or satin varnish.

• Lay your painting flat to apply the vanish evenly.

• To avoid bubbles, don't shake or stir varnish vigorously—unless it's in a spray can. If bubbles form while thinning and blending, let the varnish rest (covered) for 24 hours.

• To avoid dragging, never brush over varnish that has started to dry.

• Apply thin coats of varnish to avoid dripping, ripples and cloudiness.

• To avoid foaming and loss of transparency, never use a roller brush or sponge to apply varnish.

• To avoid pooling on an impasto painting, apply varnish by spray rather than with a brush.

• To avoid running out of varnish during the application process, prepare more than you anticipate needing.

• To correct bubbles and irregularities, continuously inspect your wet surface against the light during the varnishing process.

• Once the varnish is dry to the touch, prop the painting against a wall facing inward or place in a sealed cupboard or plan chest and leave to dry. Most varnishes dry overnight.

• Allow varnish to dry and cure for at least 48 hours before packing and shipping.

Varnish continues over the page ⟶

APPLYING VARNISH

There are basically only two reliable methods for applying varnish—by brush or by spray. Whichever method you choose, begin by wiping the painting surface with a lint-free cloth so that it's dry and clean.

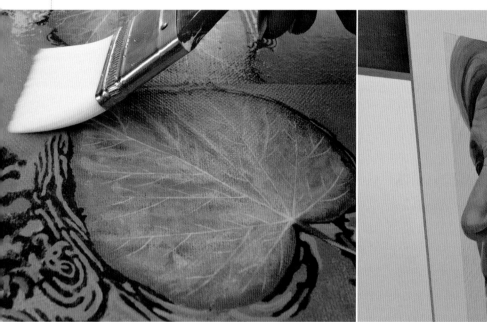

With a brush

• Use a 2-inch (5 cm) wide flat synthetic brush. Dip one-quarter to one-third of the bristles into the varnish.

• Apply the varnish in long, even strokes from side to side, each one slightly overlapping the previous stroke.

• Avoid going back into previously varnished areas to avoid disturbing partially dried varnish. Wait until the varnish has dried before touching up or applying another coat.

• Allow three to six hours between coats.

• Rotate the painting 90° for subsequent layers.

To varnish paintings with a flat finish by brush, place the painting in a horizontal, flat position. Protect the floor or underground from drips. When varnishing the sides, elevate the painting by propping up each corner.

With a spray

• Shake the can of varnish vigorously for at least two minutes. Set an egg timer if necessary. Alternatively, fill the cup of your airbrush with diluted varnish.

• Spray in uninterrupted horizontal strokes, overspraying beyond the edges.

• Spray parallel to the surface from a distance of about 10–14 inches (25–35 cm).

• Regularly clean the nozzle to avoid blockage.

• Allow three to six hours between coats.

• Rotate the painting 90° for subsequent layers.

To varnish very large paintings and impasto paintings by spray, place the painting in a vertical, upright position. Protect the background and surroundings from overspray.

REMOVING VARNISH

Some acrylic brands offer specially formulated varnish removers, which can be used to cleanse removable varnish off a painting.

Solvent-based MSA varnish can be removed with mineral spirits, rectified (highly distilled) white turpentine or the brand's associated varnish remover.

Water-based polymer varnish can be removed with ammonia or the brand's associated varnish remover.

Never use acetones, "odorless" mineral spirits, paint strippers or anything stronger than recommended.

Always remove varnish in a well-ventilated area and, if possible, wear gloves and a dual filter respirator. Meticulously follow the instructions of the varnish remover.

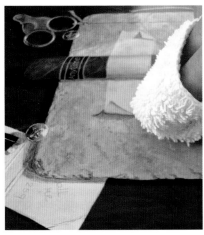

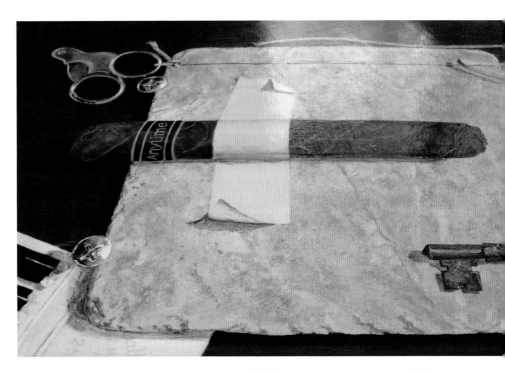

1 Moisten a piece of lint-free white cloth with varnish remover or solvent. Generously apply the solvent to the painting's surface. Leave it to work for 15–30 minutes while the varnish softens.

2 Gently rub a clean, lint-free cloth with solvent in circular motions on a small area (about 2 square inches/5 square cm) removing the dissolving varnish. Continue this process on the entire painting.

3 Thanks to the isolation coat, the old varnish and accumulated dirt stain the white cloth without traces of color coming off. If color stains the cloth, stop immediately and let the surface dry.

4 Once the varnish has been removed, allow the surface to dry thoroughly before recoating it with fresh varnish.

MATERIALS & EQUIPMENT

When you think of painting tools, you typically envision a painter's palette and a jar filled with brushes next to a canvas on an easel. Knowing the characteristics and possibilities of these and many other tools is of great importance since it will help you decide which ones are right for you. This chapter explores an array of useful tools and equipment for the acrylic painter's studio, while respecting the budgetary and space restrictions that many of us have. Explore how to optimally set up your studio regardless of location, and discover which tools will enhance your creative experience.

Java Jing-A-Ling (main picture)
by Michael Mewborn
28 x 22 inch (71 x 56 cm)
Improving your skills using
tools and hand-eye coordination
will enhance your end results.
This vivid geometric abstract
pulls the viewer in to examine
the delightful organic nature
of its illusory symmetry.

Above from left to right
Mountain Aspens (detail)
by Lena Karpinsky
see page 69

Water Hazard 2 (detail)
by Gregory Simmons
see page 258

Dried Sunflowers (detail)
by Morten E. Solberg
see page 226

Once you decide to paint in acrylics, the next step is to get a number of basic art supplies to get started. Choosing from the huge array of art materials doesn't need to be either daunting or excessively expensive.

BEGINNER'S GUIDE TO ART SUPPLY SHOPPING

This basic list of art materials will be your guide through the maze of art supply shopping. Since many choices depend on the kind of artwork you make and the size of your workspace, adapt it to suit your personal preferences, creative needs and budget.

The studio
The area or room you intend to paint in—let's just call it the studio, regardless of the setting—can be the kitchen counter, the dining table, a corner in the living room, a spare bedroom or the garage. Whether your studio is confined or spacious, you'll need a work surface that's adapted to your circumstances. Consider using a work surface that's already available, such as a table or kitchen counter—it doesn't need to be complicated. For small work, especially if it's on paper, you can opt for a drawing board with bulldog or binder clips. For upright painting there are table easels, paintboxes and other portable and foldable solutions. For shared spaces

such as a living room or guest room, consider an all-in-one painting station. See all the options on pages 52–55.

Illumination
You will need a suitable and reliable light source. A daylight lamp with a full-spectrum bulb mimics natural light, so it allows you to work at any hour of the day or night, maintaining true color while reducing eye strain and glare. Daylight-simulation lamps can be used in a variety of light fixtures. Depending on your studio set-up, consider a small portable table lamp, a clip-on lamp that mounts onto the table or easel, or a floor lamp—some floor lamps have casters for easy moving and some are equipped with a magnifying glass. Many fixtures have a flexible arm to aim the light where needed. For larger studios, ceiling-mounted fluorescent fixtures can be a good solution. See pages 89–90 for more information.

Personal preferences

First, consider your painting style, as this will influence your choice of paint viscosity, tools and useful mediums.

Technique	Paint viscosity	Suggested tools	Suggested mediums
Fine detail, miniature	Soft body or fluid acrylics	Fine brushes Pointed brushes	Flow improver Gloss medium
Impasto	Heavy body acrylics	Painting knives	Thickening medium or impasto gels
Oil color, traditional	Regular or heavy body acrylics, or acrylics with extended open time	Bristle brushes Soft brushes for blending transitions	Retarder medium or gel
Watercolor	Acrylic inks or soft body or fluid acrylics	Watercolor brushes	Flow improver Absorbent ground (if support is canvas or panel)

Tips for art supplies on a budget

Texture mediums

Good-quality brushes

Titanium White paint

Given free rein, any artist could easily spend a fortune on art supplies. The reality is that the majority of us are on a budget, so we need to be pragmatic and smart about buying art materials.

• Buy smaller sizes of artists' quality acrylics for better coverage. Extend acrylic colors by adding mediums.

• Buy a large tube or pot of Titanium White, the most frequently used color.

• Buy colors followed by the word "hue", which mimic the referenced color but contain lower-priced pigments.

• Use a minimum of colors for a restricted or monochromatic palette. You will learn a lot about color mixing and values as an added benefit.

• Paint on smaller-sized supports. They are more cost effective and also demand less paint.

• Use texture mediums, impasto gel and/or thickening medium to increase paint volume and viscosity for impasto or sculptural textures.

• Buy two to four good-quality brushes and care for them well.

• Recycle unfinished or unsatisfactory paintings on canvas or panel instead of holding on to them. Be brave: sand and cover them in gesso to start fresh.

• Stretch your own canvas or prepare your own panels.

• Allocate a set amount for art supplies in your monthly budget.

• Only buy what's on your shopping list. Buy yourself a gift once in a while.

• Save up for the really expensive items—don't settle for less. Durable items, such as easels and lamps, can be bought secondhand.

• Suggest a wish list of art supplies or ask for gift cards for birthdays and other gift-giving occasions.

• Use (online) store coupons and discount customer cards whenever possible. Watch for sales and brand-name promotions. Subscribe to art supply store newsletters.

• Buy ready-made, standard-sized frames or avoid them altogether by painting on canvas with staple-free edges or cradled panels.

• Don't be tempted to buy cheap, low-quality materials, as they will ultimately fail and you will be disappointed.

Good brushes are expensive, so it pays to take care of them, see pages 66–67.

Must-have basics

Regardless of studio set-up and favored technique, you will need some must-have basics.

• Paper towels or rags to wipe your brushes.

• At least one glass jar or plastic container to hold water for rinsing brushes.

• If you're the messy type, an apron to protect your clothes.

• A palette: A mixing tray for liquid colors or a flat palette for viscous acrylics. See pages 50–51 for more information.

• A painting support: Your choice of canvas, panel or paper, in a format and size adapted to your studio space. See pages 76–87 for more information.

• A pad of medium-weight white paper (not the expensive kind) to practice brush marks, make color swatches and test wet-to-dry color bias.

Treasure trove

An art store is an exciting place to spend time. Your local store is a great resource not only for inspiring materials but also for expertise, advice, contacts and news.

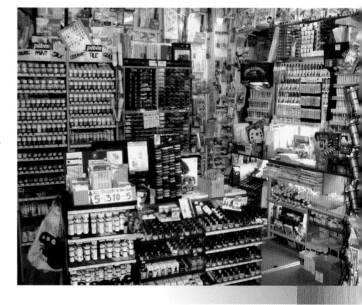

Beginner's Guide to Art Supply Shopping continues over the page ⟶

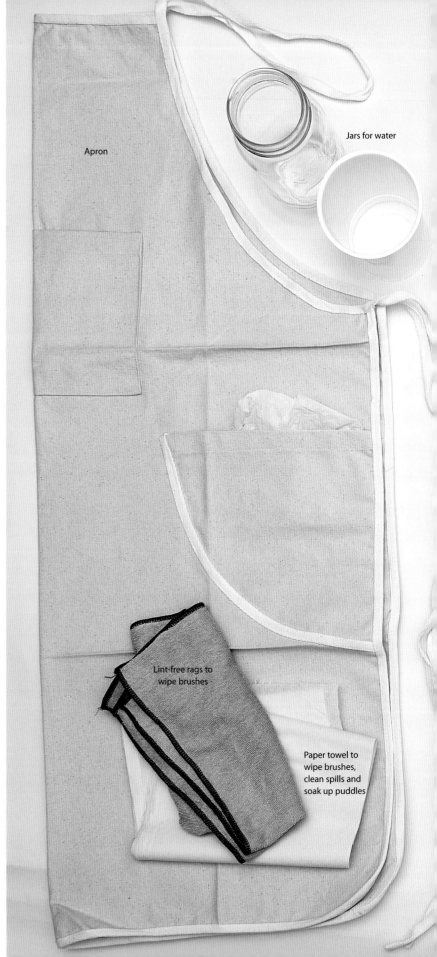

Apron

Jars for water

Lint-free rags to wipe brushes

Paper towel to wipe brushes, clean spills and soak up puddles

Studio essentials

To paint in acrylics you just need a few basics to get off to a good start.

• A foam roller brush or house painting brush for applying gesso as a base for painting on canvas or panel.

Brushes Unless you exclusively use the painting knife for impasto painting, you need between two and four brushes in different sizes and shapes. I recommend buying at least one or two filbert brushes; these are versatile and allow a variety of different brush strokes. Their sizes depend on the dimensions of your painting support and technique—smaller brushes for small detailed work or small-format painting, larger brushes for broad strokes or large-format painting. See pages 62–66 for more information on bristles and shapes.

Painting knives Buy one painting knife to blend viscous colors, although acrylics can be easily blended using a firm brush. To paint impasto using the painting knife exclusively, consider buying two or three different knives in appealing shapes. Affordable sets of molded plastic painting knives allow you to experiment with different shapes without overspending.

Basic medium and ground Gloss medium is the most versatile acrylic polymer suited for multiple uses and applications. See pages 28–33 for more information.

If you paint on canvas or panel, you will need gesso. Don't forget to buy sandpaper if you prefer smooth surfaces. See pages 36–37 for more information.

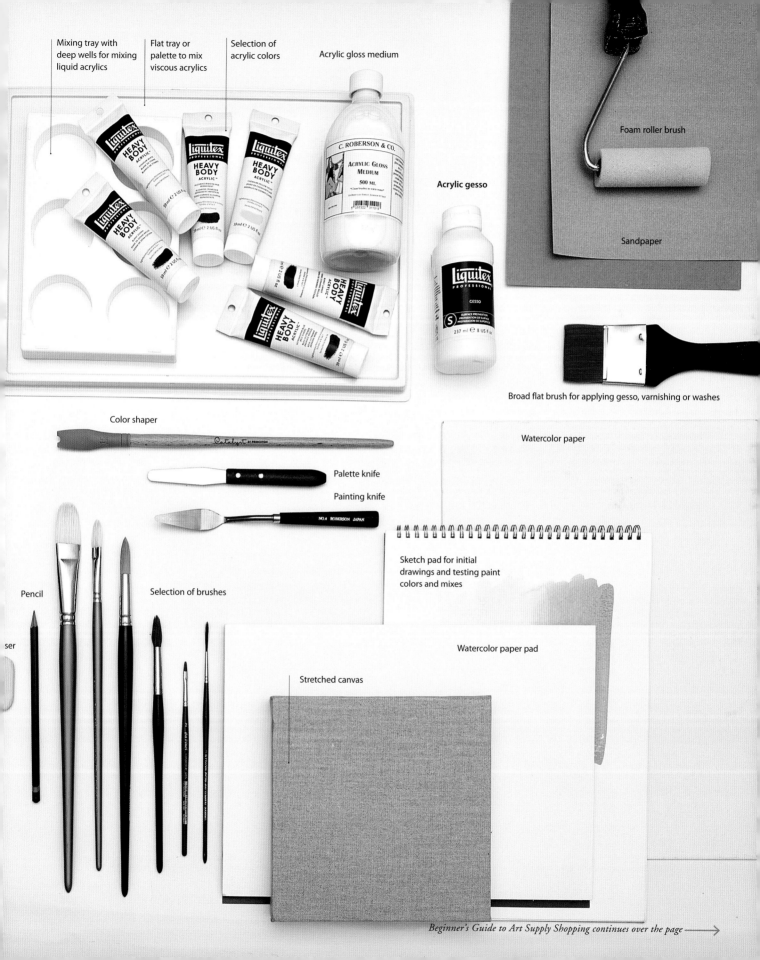

Mixing tray with deep wells for mixing liquid acrylics

Flat tray or palette to mix viscous acrylics

Selection of acrylic colors

Acrylic gloss medium

Foam roller brush

Sandpaper

Acrylic gesso

Broad flat brush for applying gesso, varnishing or washes

Color shaper

Watercolor paper

Palette knife

Painting knife

Sketch pad for initial drawings and testing paint colors and mixes

Pencil

Selection of brushes

Watercolor paper pad

ser

Stretched canvas

Beginner's Guide to Art Supply Shopping continues over the page ⟶

Basic range of paint colors

The huge variety of acrylic colors is both irresistible and confusing. Buying all colors would cost a fortune and a large part would probably never be used. Avoid guesswork and overspending by starting out with one of these palettes, or start with the most basic one and slowly add more colors over time. Limiting yourself can be extremely educational.

Titanium White

By far the most used acrylic color is Titanium White. Buy a large tube or pot to save on costs and to avoid running out.

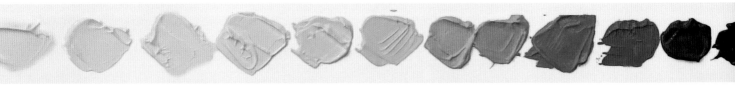

OPTION 1: ONE DARK COLOR + TITANIUM WHITE

Select one dark single pigment color, such as Phthalo Blue, Burnt Umber or Carbon Black to blend a grisaille palette.

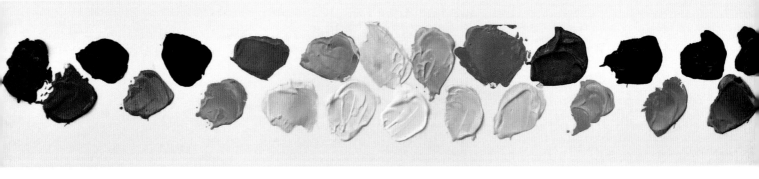

OPTION 2: TWO COLORS + TITANIUM WHITE

• Burnt Sienna
• Ultramarine Blue

This two-color palette makes a wonderful range of neutrals, appropriate for all subject matter including near-monochromatic portraiture.

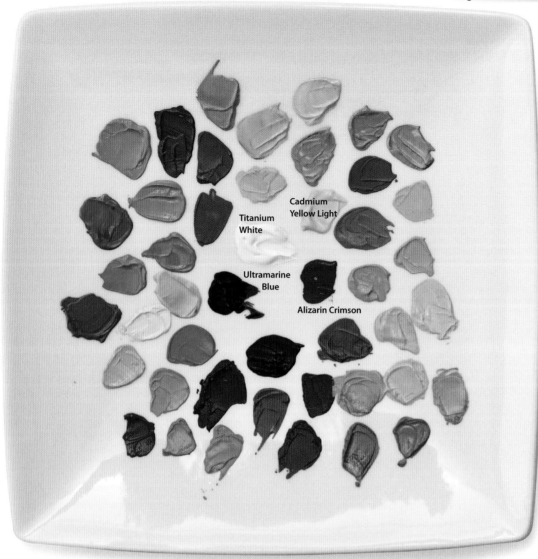

Titanium White

Cadmium Yellow Light

Ultramarine Blue

Alizarin Crimson

OPTION 3: THREE OR FOUR COLORS + TITANIUM WHITE

- Alizarin Crimson
- Cadmium Yellow Light
- Ultramarine Blue
- Burnt Umber (optional)

This limited palette of three cool primaries generates a very good range of colors. Its main drawback is that Cadmium Yellow Light lightens the value of blends. If this bothers you, add Burnt Umber to offset the high value of the yellow.

OPTION 4: FIVE COLORS + TITANIUM WHITE

- Alizarin Crimson
- Cadmium Yellow Light
- Ultramarine Blue
- Phthalo Green
- Burnt Umber

This palette creates a wider range of colors as well as vibrant blacks.

OPTION 5: SIX COLORS + TITANIUM WHITE

- Alizarin Crimson
- Cadmium Red Medium
- Phthalo Blue
- Ultramarine Blue
- Cadmium Yellow Light
- Phthalo Green

Based on the so-called "split-primary" or "color-bias" palette, this allows you to create an almost limitless range of colors using a warm and a cool version of each primary. See pages 99–101 for more information about split-primary palettes.

OPTION 6: EIGHT COLORS + TITANIUM WHITE

- Alizarin Crimson
- Cadmium Red Medium
- Phthalo Blue
- Ultramarine Blue
- Cadmium Yellow Light
- Phthalo Green
- Burnt Umber
- Burnt Sienna

Expand your split-primary palette even further by adding Burnt Umber and Burnt Sienna.

OPTION 7: TEN COLORS + TITANIUM WHITE

- Alizarin Crimson
- Cadmium Red Medium
- Phthalo Blue
- Ultramarine Blue
- Cadmium Yellow Light
- Phthalo Green
- Burnt Umber
- Burnt Sienna
- Payne's Gray
- Yellow Ocher

Expand your split-primary palette even more by adding Payne's Gray and Yellow Ocher.

Used for holding and blending paint, a palette is either flat or indented with wells. Today it comes in a wide variety of materials, shapes and sizes to suit every artist's preference.

THE ARTIST'S PALETTE

The palette—from the Old French *palete*, meaning small shovel or blade—is most familiar as a flat, kidney-bean-shaped receptacle made of thin wood, held by the artist by a thumbhole and supported on the forearm. Modern palettes are made of hard, inert, nonabsorbent materials, such as wood, ceramic, plastic, aluminum or glass. Lightweight palettes can be hand held, while the heavier palettes (such as glass or porcelain) can rest on a side table, taboret or caddy.

Store-bought palettes
Wooden and plastic store-bought palettes come in the traditional kidney-bean, oval and rectangular shapes.

Clear plastic or glass palettes can be placed over neutral, mid-tone gray paper or a color printout of the reference photo, which is helpful for mixing accurate colors and values.

Mixing trays—palettes for liquid paints often used for watercolors—have wells to hold and mix liquid colors, and come in many shapes, sizes and materials. Some even have lids. The mixing is done by brush rather than with a palette knife.

The moisture-retaining acrylic or stay-wet palette is a flat plastic tray lined with a moisture-retaining membrane and an airtight lid that keeps acrylic paint workable for days.

Disposable palettes are paper pads where the top sheet is used as a palette. After the painting session the top sheet is torn off and thrown away. These come in different shapes and sizes and in both white and neutral mid-tone gray.

Butcher trays are porcelain enameled metal trays with a convex center so excess

Disposal
Never flush paint flakes down the drain. Instead, strain (dried) paint through a coffee filter or a few paper towels before disposal.

liquid runs to the edges. Because they have a slight rim, they can be easily covered with plastic wrap overnight to keep acrylics from drying.

Homemade palettes
You can use a sheet of clear glass or Plexiglas as a palette. To avoid cuts, smooth the edges of the glass sheet with abrasive carborundum sandpaper or cover them with strong tape.

A moisture-retaining or stay-wet palette can also be made at home (see page 35).

Any number of household objects can be used as a palette as well, especially if you don't use a lot of paint during a painting session. A porcelain or glass dinner plate makes a great palette. Alternatively, the smooth side of a thick, tempered glass cutting board can be used as a palette. Disposable plates, made out of paper, plastic or Styrofoam, are convenient but wasteful and not ecologically sound. Some food packaging, such as plastic yogurt lids and Styrofoam meat or fish trays, can be washed and recycled into a new life as a palette!

Cleaning your palette
Never flush fresh acrylic paint down the sink, as it will eventually contaminate our waters. Instead, wipe fresh paint off with a paper towel if you need to reuse your palette immediately.

It's best to leave your unused acrylic paint to dry before removing it from your palette. Therefore, having several palettes is convenient in order to continue a painting session with a fresh, clean palette.

Dried acrylic paint is easily removed by scraping it with a palette knife or fingernail, as it usually peels off sleek, nonporous surfaces. Alternatively, soak the palette in a basin of warm water with liquid dish soap. After a while, the dried acrylic paint will slide off easily.

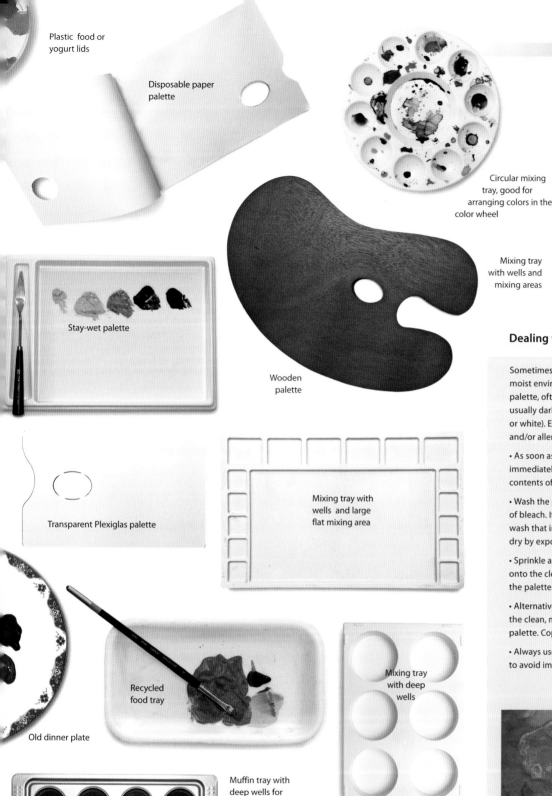

Plastic food or yogurt lids

Disposable paper palette

Circular mixing tray, good for arranging colors in the color wheel

Stay-wet palette

Mixing tray with wells and mixing areas

Wooden palette

Transparent Plexiglas palette

Mixing tray with wells and large flat mixing area

Old dinner plate

Recycled food tray

Mixing tray with deep wells

Muffin tray with deep wells for mixing larger quantities of paint

Enamel butcher tray

Palettes and mixing trays

Depending on your paint's viscosity, you can use either a flat or indented receptacle to hold and mix your colors—as long as the material is nonporous.

Dealing with mold and mildew

Sometimes mold or mildew (fungi that thrive in moist environments) form in the moisture-retaining palette, often producing a tell-tale smell. Mold is usually dark (black or green) and mildew light (gray or white). Exposure to either fungus can cause toxic and/or allergic reactions.

• As soon as you see or smell mold or mildew, immediately discard all the affected paint and contents of the moisture-retaining palette.

• Wash the palette in hot, soapy water, adding a bit of bleach. If the palette has a sponge membrane, wash that in the same solution as well. If possible, dry by exposure to direct sunlight.

• Sprinkle a few drops of ammonia or cider vinegar onto the clean, moisture-retaining membrane of the palette.

• Alternatively, place a few copper coins underneath the clean, moisture-retaining membrane of the palette. Copper has anti-mold properties.

• Always use distilled water instead of tap water to avoid impurities.

Drawing board
The drawing board is an excellent portable work surface for artists on the go, or for those who lack studio space.

The painting surface—whether canvas, panel or paper—needs to be supported in a stable and comfortable position to enable you to paint in a relaxed, unforced pose.

WORK SURFACE

Although purists insist that the correct painting position is to place the full painting surface perfectly equidistant to your eyes, most artists develop their own preferences on painting angle and position. Whether you prefer to place your painting surface horizontally or vertically, or anywhere in between, really depends on personal choice. The choice is also influenced by the size of your work, technique, location and studio space. And, of course, budget.

The most important element of the work surface is stability. There's nothing more frustrating than a wobbly, unbalanced surface, or one that doesn't grip or prop up your painting adequately, allowing it to move or slide around.

Work surfaces can be divided into three categories – namely easels, tables and boards. Sidestepping the above-mentioned, a fourth option is working directly on a wall, to which the painting surface can be taped, tacked or hung onto a railing system.

Boards
A drawing board is very low in price, portable and easily home made. It is ideal for limited

space situations or for artists who enjoy painting in a comfortable armchair in a living room or on a bench outdoors. The drawback is that the size of the painting is limited to slightly smaller than the size of the drawing board.

The simplest and cheapest drawing board is a flat piece of Masonite that is placed on your lap and can be tilted by slightly raising your knees. Use bulldog clips, binder clips or masking tape to secure your paper to the board. If you work on stretched canvas or panel, the drawing board needs a perpendicular ledge at the bottom to hold the painting up so that it won't slide off. You can easily attach a thin slat of plywood or MDF (medium-density fiberboard) with glue or screws to the lower edge of the board at a 90° angle.

Store-bought drawing boards come in different sizes and materials. Some have clips attached. The portable ones have a convenient carrying handle. Some even come with a slanting system to slightly raise them at an angle. These can be used on your lap as well as on a tabletop.

Tables
Painting on a flat surface is another low-budget and space-saving option, as most of us have a dining table, desk or kitchen counter that can function as a painting station. Protect valuable tabletops with plastic sheeting or a vinyl tablecloth. In shared spaces, a Murphy-style bookcase with a built-in drop-down table and bottom drawers offers a neat and efficient solution. For very small spaces, wall-mounted drop-leaf tables or wall-mounted folding desks are an excellent solution.

Many artists paint on an adjustable drafting table that can be positioned at different angles. Drafting tables come in different sizes and price ranges. However, if you work on stretched canvas or panel, the adjustable drafting table needs a perpendicular ledge at the bottom to hold the painting up so that it won't slide off. The

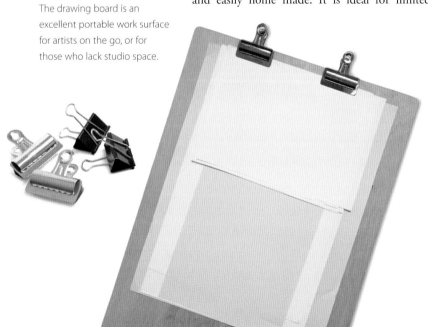

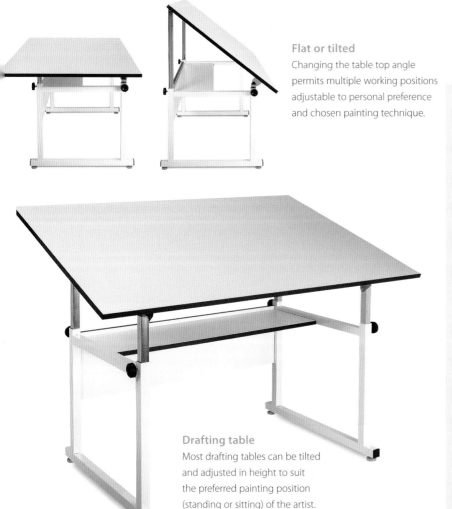

Flat or tilted

Changing the table top angle permits multiple working positions adjustable to personal preference and chosen painting technique.

Drafting table

Most drafting tables can be tilted and adjusted in height to suit the preferred painting position (standing or sitting) of the artist.

Consider the following factors before you buy an easel

- Does it have built-in storage?

- If you need to store it, is it collapsible?

- How easily can the legs be adjusted, and what is the maximum leg height (if applicable)?

- How easily can the shelf be adjusted?

- What's the height of the mast and your ceiling? (In the case of low ceilings, perhaps the mast can be sawn off or a panel of the dropped ceiling removed.)

- What's the maximum size of painting format and weight it can hold?

- For plein-air painting, is it portable and lightweight? Check carrying comfort, adding the weight of paint supplies.

- What's your budget? Buy the best quality you can afford, or consider saving up for it or buying secondhand.

- Is it stable? (Jiggle it in the store!)

- If you do small work in a confined space, would a table or paintbox easel be more suitable?

- If you will need to transport it, what's the weight?

space-saving advantage is that many adjustable drafting tables fold flat and can be stored flush against a wall. The drawback is that the size of the painting is limited to slightly smaller than the size of the table surface area.

Another economical option is to use two trestle supports or trestle legs to create a table. Many trestles are adjustable in height, some can be tilted, and they collapse for easy storage. Place any size board or an old door on the trestles to create a work surface.

Easels

An easel holds your canvas, panel or board in place in an upright position. Most easels allow slanted positions, and some even allow forward tilts and/or adjust to a horizontal position like a table. A good-quality easel is an investment that should last you a lifetime. It needs to be stable, accommodate your painting format and your work space, and be easy to use and adjust. Most easels have a ratchet system—a pull-out pin that moves the shelf up or down a notch to lock it in place. Bigger, heavier easels sometimes have a marine-style winch or electrical switch to easily raise or lower large, heavy paintings. The largest easels often come equipped with four casters that can be secured to avoid rolling. A few types of easel come with built-in storage, which is convenient for confined spaces as well as for plein-air painting.

Work Surface continues over the page ⟶

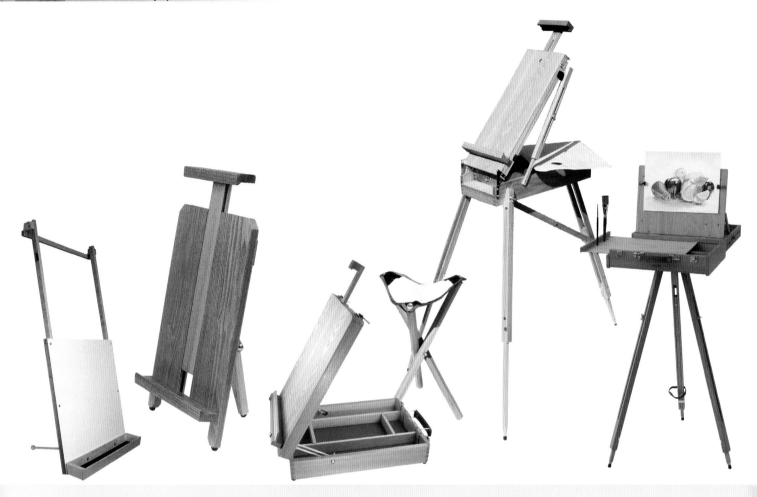

Hanging art easel

A hanging easel, often used in classrooms, can be hung from a shelf, windowsill or open door with a mounting lip. Although it offers limited stability, it is ideal for very compact spaces. It is portable and can easily be stowed away.

Tabletop easel

This small easel comes in two varieties—the A-frame and the H-frame—and is small enough to set up on a table. The A-frame (three-legged or lyre) easel is great for decorative display, but not stable enough to paint on. Most fold flat for easy storage or transportation. Check its stability and the maximum size of canvas it can hold. Make sure you set it up at the correct height for painting with a straight back while standing or sitting.

Sketchbox or paintbox easel

A variation of the tabletop easel is the sketchbox or paintbox easel—a small easel mounted onto a wooden painter's case, which provides convenient storage space for painting supplies, including a palette. Some have handles for easy transportation, but mind their weight because some are too heavy for long walks.

French easel

This easel is a paintbox, canvas carrier and easel in one, with three collapsible legs, making it ideal for transportation and plein-air painting. It comes with a sturdy shoulder strap for easy carrying, but mind the weight because it may be too heavy for long walks. The legs can be adjusted to fit your height and to stand on uneven terrain. The paintbox provides storage and often includes a palette. An added pro is that most French easels allow adjustment of the easel from vertically upright to horizontal.

Pochade

A variation of the French easel is the pochade easel, which is a painter's box on an adjustable tripod (similar to those used in photography). The lid of the box functions as an easel, so the size of the canvas it can hold is limited. The box provides storage. Some come with a shoulder strap or a tote bag for easy carrying.

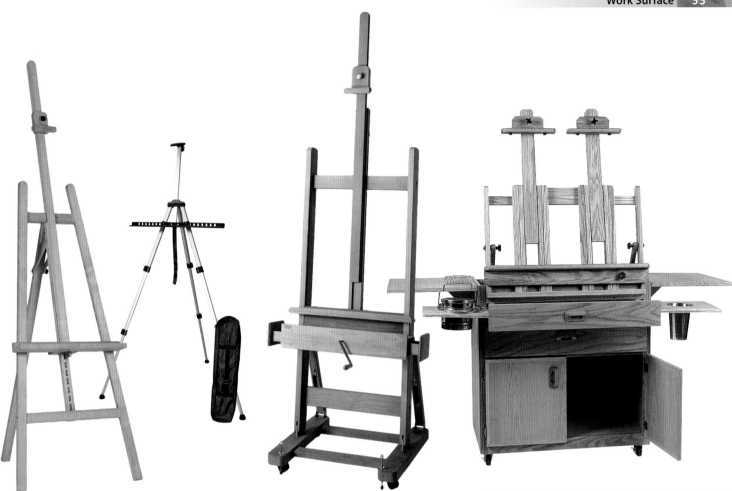

A-frame or lyre studio easel

The A-frame studio easel is a large, floor-standing easel with three legs (two in front and one in the back). It can hold large sized canvases and folds up flat to be stored against a wall. It comes in a variety of price ranges and qualities. Due to its three-legged structure, it can be unstable, especially for vigorous painters.

Lightweight sketching easel

This full-sized lightweight collapsible variety of the A-frame studio easel folds up to fit a small tote bag. It is very basic and not especially stable, but it's ideal for traveling artists.

H-frame studio easel

This large, solid, floor-standing easel is very stable and can hold large canvases, but takes up a lot of room. This easel is based on right angles: two vertical posts with a horizontal crossbar support give this design the "H" shape. Most H-frame easels are fixed in an upright position, but some allow adjusting the tilt in angle, all the way to horizontal.

The largest variations of the H-frame studio easel can easily hold paintings of over 7 feet (213 cm) in height and support weights of over 200 lb (90 kg). They have a counterbalance system for added stability, and their shelf adjusts with a winch or pulley, some of which are electrical. Some have two masts (the upward vertical plank) for maximum support of the canvas. They usually stand on lockable casters for easy relocation around the studio.

The all-in-one painting station

The all-in-one painting station combines easel, desk and ample storage space into one piece of furniture. It is a very organized way of having everything on hand, in one attractive cabinet with a fold-out easel, wing-tables and drawers or cabinets that close up neatly after a painting session. A smaller version is the easel taboret, a caddy with shelves, cabinet or drawers with a collapsible easel on top. The price ranges from expensive to very expensive, but it eliminates the need for separate studio space, making any room multifunctional.

Masking materials allow you to apply paint in very specific areas or, inversely, shield specific areas from paint. The use of stencils, masks and shields produces precise, well-defined patterns and edges.

MASKS AND STENCILS

Masking tape or artist tape

Masking tape or artist tape has low-tack adhesive, specified for either smooth or irregular surfaces. It is available in different widths, including a ⅛-inch (3 mm) narrow fine-line tape, which curves easily to mask rounded lines or edges.

Frisket

This is a plastic sheet with low-tack adhesive backing, in a matte or glossy finish. It is mostly used for airbrushing and is sold in rolls of different lengths, widths and adhesive strengths. Frisket is usually applied in a single sheet covering the entire painting, after which specific parts are carefully removed with a sharp blade; the cut pieces are then carefully lifted with the tip of the blade, exposing the area for painting. Considerable expertise is required to apply the right pressure to cut the frisket without damaging the underground. Frisket with removable backing makes it easy to cut out shapes before it's attached to the painting, but is more difficult to position correctly, especially when cut-out shapes are intricate and delicate.

Masking tape tips

If the masking tape is too sticky and you fear damaging or tearing your painting support, you can reduce its adhesive strength by sticking it to your skin and peeling it off before use. Repeat if necessary. Always test the tackiness of any new tape on your surface, or your tape on a new support.

To gently remove masking tape without damaging the painting support, always peel it back onto itself. Avoid peeling it upward. This also applies to self-adhesive frisket.

TECHNIQUE FILE 06

HOW TO USE SELF-ADHESIVE FRISKET

1 Cut the design with a sharp blade, using enough pressure to cut through the frisket while not damaging the painting support.

2 To remove the scored piece, use the tip of your blade to lift a corner. Keep the excised frisket in case you want to cover that area again.

3 Paint the exposed area. The frisket works just like a stencil.

4 Once the paint is dry, remove the frisket by gently peeling it back.

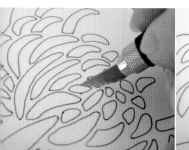
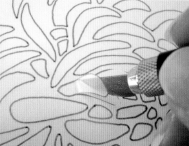

Fine fluid lines.

Fine hollow nib for precise application.

Stopper with fine prong that prevents the liquid frisket from clogging the opening.

Promise the Children
by Lorena Kloosterboer
9¾ x 9¾ inch (25 x 25 cm)
In this painting masking tape was used to create sharply defined lines and the scroll design was stenciled onto the background.

Liquid frisket

Masking fluid can be applied by brush, cotton swab, the Incredible Nib (shown below) or Masquepen (shown above). The latter is ideal for masking fine details, such as leaf veins, lettering and tiny highlights.

Shields

Also called freehand templates, shields are masks with a precut design without adhesive backing that are positioned over a certain area to protect it. Mostly used in airbrushing, shields can also be used for spattering, brushing and sponging. Shields can be held in place by hand or positioned with tape or low-tack spray adhesive.

A great variety of ready-made shields is available for masking edges. Custom-made shields can be crafted from see-through plastic film, such as Mylar or acetate. These materials are durable, waterproof, easy to cut and transparent, making tracing them easy. Paper shields can be cut with precision or ripped to obtain an irregular edge. Paper is too fragile for repeated use; a good alternative is rag vellum, a translucent, strong and flexible paper used in architectural drawing.

Stencils

Ready-made stencils come in many designs and in many materials (cardstock, plastics, metal).

There's a variety of materials available to make your own stencil, including oil board (a high-grade paper board), stencil paper, Mylar, acetate and vellum. Laminated paper also works well, because you can draw or print your design beforehand, laminate it and then cut it out.

To cut your own stencil, use a sharp blade. For cutting stencils out of plastic sheets you can use a hot tool, which looks like a soldering iron with a small precision tip.

Stencils need to be fixed in place before paint is applied. You can use artist tape or a repositionable spray adhesive that provides long-lasting tack without residue, so that the stencil can be adjusted, removed and reapplied.

Liquid frisket

Liquid frisket or masking fluid—a thick liquid that dries to a rubbery consistency and peels off easily—allows you to protect areas of your painting so that paint only covers the unmasked surface. It can be applied to any nonabsorbent dry surface, including dried paint. A liquid mask works well when clean edges and precision are needed, because it prevents paint from bleeding.

Most liquid frisket comes in bottles with a wide rim, sometimes including an eyedropper, allowing easy dipping with an applicator. Others come in plastic squirt bottles with a slender applicator that allows direct, precision application. The size of the opening dictates the amount of liquid frisket released, extremely useful for writing or intricate designs.

You can apply liquid frisket using a (preferably synthetic) brush, a cotton swab, a toothbrush (for spattering) or the Grafix Incredible Nib, a specialized tool that offers precision and cleans up easily.

Shields and stencils

There are numerous styles and patterns of ready-cut reusable shields and stencils on the market.

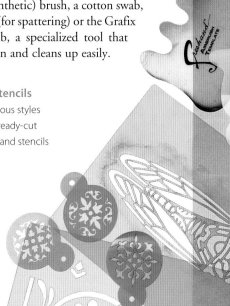

Simple everyday items can become treasured studio accessories for creating special effects and interesting textures and marks. Optical tools improve close-up vision and help evaluate visual information.

SPECIAL EFFECTS TOOLS

Artists often use nontraditional tools to solve practical problems and to achieve a variety of painting effects. Here, you'll find a non-exhaustive list to give you an idea of how ordinary objects can become valued additions to your studio equipment.

Optical accessories allow us to enhance and increase our powers of observation beyond our natural capacities. They enable us to see close-ups of minute details, view large work in the right context and proportions and assess value ranges.

Tools for special effects

Paper towels, rags and cotton swabs are must-have items in the studio. They are great for cleaning up and wiping off mistakes and spills. Because they are absorbent, you can use them to blot off liquid color for wonderful watercolor and decalcomania techniques.

The spray bottle is a multifunctional accessory that helps extend the open time of acrylic paint on canvas and palette, creates beautiful effects with water, liquid color or alcohol, and

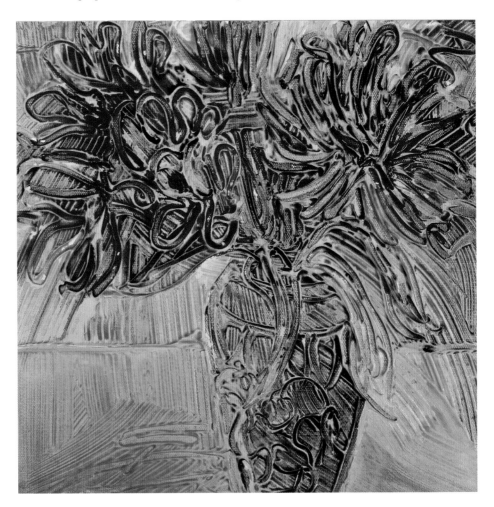

Sunlight

by Flora Doehler

*9¾ x 9¾ inch (25 x 25 cm)
Experiment with nontraditional painting tools to create special effects that enhance contemporary as well as traditional styles. Color shapers were used to create this vividly colored sgraffito painting.*

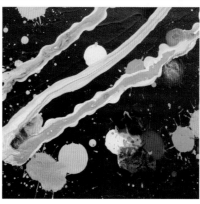

helps settle down airborne dust in the studio. Spray bottles generally have a trigger or pump mechanism to squirt liquid and come in a wide range of sizes, from the household spray bottle to very small spritzers and perfume atomizers. Spray bottles with an integrated piston pump system allow you to build up pressure so that continuous spraying is controlled by finger pressure. Clean clogged spray bottles by immersing them in white vinegar or isopropyl alcohol.

The toothbrush is a valuable tool for spattering, scouring and creating texture, as well as a handy cleaning tool for scrubbing tight corners.

Both natural and synthetic sponges are indispensable in the artist's studio and come in a wide variety of shapes and sizes. Among natural sponges we find sea, silk, wool, grass and vase sponges and flat elephant ear sponges, each with its own unique shape and porous texture. Synthetic sponges, such as the kitchen sponge and make-up sponge, are mostly made of cellulose or polyurethane and have a consistent structure. You can use both natural and synthetic sponges to create wonderful organic textures, blend transitions, dab stencils, wipe away mistakes and spread, streak or lift off color. Synthetic sponges are easily cut into shapes for stamping. Buy a variety pack to experiment with different techniques.

Eyedroppers and plastic syringes efficiently load liquid color, water or alcohol to squirt puddles, create continuous lines, apply a single droplet with precision or release it from a height to form a splotch. Eyedroppers, also called pipettes, are either glass tubes with rubber or latex bulbs, or formed of a single piece of plastic. The easy-to-clean glass pipette can be reused for many years. The cheaper plastic pipette is harder to clean, and should be discarded once it wears out. Plastic syringes (without hypodermic needle) can take up more liquid than an eyedropper, and can also load more viscous paints and mediums.

Spray bottles and atomizers

Ideal for creating spatters and puddles without getting your hands dirty.

Toothbrush

The cheapest, most accessible and easiest way to create random spatters.

Sponges

The multitalented sponge offers incredible versatility in the studio.

Eyedroppers and syringes

Create multicolored rivulets of liquid paint, spontaneous squirts and high-altitude drips.

Special Effects Tools continues over the page ⟶

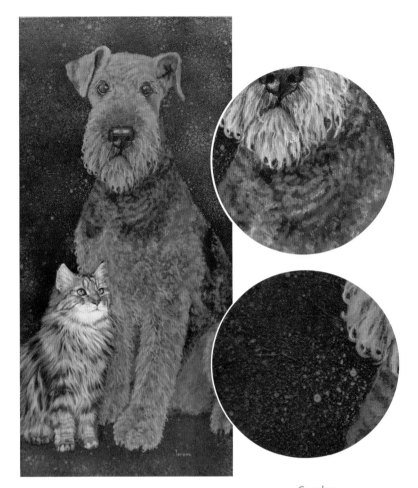

Both eyedroppers and syringes can be purchased at drug stores and some art-supply stores.

Feathers, either store-bought or found, can create original "brush" marks or be used as writing or calligraphy quills. Primary flight feathers are ideal for making a quill pen by diagonally cutting the end of the calamus (hollow shaft). The vanes (the "hairy" tip) can be used for creating textures or unusual mark making, substituting the brush.

Combs and wood-graining tools are used to simulate realistic wood-grain textures. They can be purchased at art-supply stores and sometimes hardware stores. Alternatively, use a hair comb or fork, or make your own using cardboard and cutting out a saw-toothed edge.

PORTRAIT OF MY PETS
BY LORENA KLOOSTERBOER
30 x 15 inch (76 x 38 cm)
The fur of the Airedale Terrier was painted using cotton swabs, achieving the typical short curly wired hair that is difficult to accomplish with a traditional brush. The background was spattered using a toothbrush.

Combs
Combs create realistic wood-graining effects or carve beautiful striated lines into wet paint.

Feather
Feathers can be stamped as well as used for a variety of fluid linear mark making, including subtle marbling textures.

Optical accessories

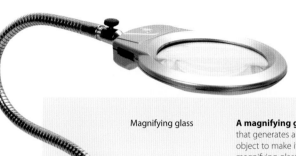

Magnifying glass

Reducing lens

A magnifying glass is a convex transparent lens that generates an enlarged image of a nearby object to make it look bigger. The traditional magnifying glass is fitted with a handle, but more practical are the hands-free models that perch on a flexible arm and can be mounted to an easel or tabletop. Some are fitted with a lamp that illuminates the magnified item. This is an excellent optical tool to paint the smallest details.

Over the counter (OTC) reading glasses with standard strengths ranging from +0.75 to +3.50 (higher strengths exist, but are less common) are practical tools for painting small details, even for artists with perfect vision. When trying on OTC reading glasses, hold your hand or fine print at the distance you expect to paint it, to assess the right strength.

The reducing lens, also called a quilt viewer or wide angle viewer, is a small brass minitool with a reducing glass that optically shrinks objects. It is typically sold at quilting and needlework craft stores and is meant for viewing large quilts from close-up. Despite its slight fisheye distortion, the reducing lens is an indispensable gadget for artists who paint large formats in confined spaces without enough room to step back for adequate distance viewing. Even at close range, the reducing lens allows you to preview a large-format painting as if from across a spacious room.

The value finder is a transparent filter—either red or green—that neutralizes colors without obscuring details, showing contrasts between lights and darks. Looking through the value finder at your artwork and reference material allows you to evaluate and identify value relationships and halftones without being distracted by color. Made of cellophane, acetate or Plexiglas, the red version is the most popular one. However, the red value finder is only effective for nonred subject matter, and the green for nongreen content. I recommend buying both.

Reading glasses

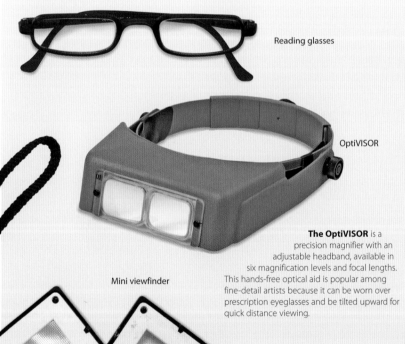

OptiVISOR

A gray scale is a printed card with eight or ten gray-tone values, ranging from light gray to pure black. Hold it next to your artwork, reference material and/or palette to compare values. Combining the use of the gray scale with the red and green value finders will take a lot of the guesswork out of accurately pinpointing halftones.

The OptiVISOR is a precision magnifier with an adjustable headband, available in six magnification levels and focal lengths. This hands-free optical aid is popular among fine-detail artists because it can be worn over prescription eyeglasses and be tilted upward for quick distance viewing.

Mini viewfinder

Miniature viewfinders made from slide frames with mesh and wires offer different sized grids to decide on format and measure perspective.

Gray Scale & Value Finder

The brush is believed to have been invented in China around 300 BCE. Artists had to make their own until the 18th century, when artisan guilds started crafting and selling brushes.

BRUSHES

The modern brush is a highly precise instrument, offering today's artists considerable advantages over our predecessors, who had to make their own. The many shapes, sizes and diverse textures and characteristics of the different bristles on the market today are mindboggling. Besides natural hair brushes, scientific improvements are leading to ever-better synthetic bristles that closely mimic natural hair.

Brush manufacturers produce and market different brushes for different paints. Brushes sold especially for painting in oils, watercolors and acrylics come in a wide array of hair types, shapes, sizes, handles and price range. Don't limit yourself to only using brushes specifically sold for painting in acrylics! Buy the best-quality brush you can afford. Experiment with different brands, shapes and bristles. Only through regular use will you discover which brushes you prefer.

Brush sizes
The size of the brush is imprinted on the handle and is indicated by a number or a size (in inches or millimeters). The higher the number, the bigger and wider the brush—and vice versa. The most commonly used sizes range from 000 (triple zero) to 20.

Unfortunately, brush manufacturers don't follow a standardized numerical system, so brushes with identical numbers can vary considerably in width, length and thickness between brands. This makes ordering previously untried brushes online a bit risky. While the manufacturer may sometimes indicate the width of the brush in inches or millimeters, its thickness, firmness and flexibility will be subject to guesswork. Never buy a full set of brushes from one brand unless you have tried them; it's better to buy different brands to find your favorites.

Note that the width of the brush is almost never the width of the paint stroke it will make. The width of a brush stroke varies according to the angle at which you hold the brush, the amount of pressure applied, the flexibility of the brush hair and the viscosity of the paint.

Qualities of a good brush

Buy the best brush you can afford according to the size of your artwork, the viscosity of the paint and your preferred painting technique(s). Both natural and synthetic brushes range from stiff to flexible.

• A stiff, resilient brush manipulates and controls thick viscous acrylic, and leaves brush marks.

• A softer, springy brush is ideal for fluid or soft body applications, and leaves no brush marks.

• A soft, fine-haired brush allows smooth gradations and soft blending.

• A watercolor brush with good loading capacity is perfect for liquid applications.

• A precisely shaped fine brush with a well-defined tip is used for details, fine lines and stippling.

• A good brush feels balanced in your hand and is comfortable to hold.

• Bristles should be firmly held and not come off.

• Artist's brushes come with long or short handles; try using both to discover which you prefer.

Brand variety
Different brands of number 10 flat brushes vary considerably in both width and length.

Anatomy of a brush

Handle: The part you hold in your hand. The size and brand are printed on the handle, and sometimes the style and type of bristle as well.

Long-handled brushes are held from the middle toward the end of the handle to create distance and make wider, looser strokes using the entire arm.

Short-handled brushes are meant for close-up details and also allow more pressured strokes using the wrist.

Toe: The very top edge of the bristles, the tip.

Bristles (also called the head): The hair filaments, which may be either natural or synthetic or a combination of both.

Ferrule: The part that connects the bristles to the handle. The ferrule is usually metal, but it can be made from wire or plastic.

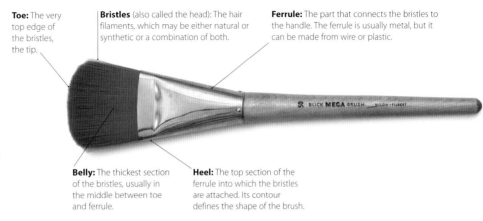

Belly: The thickest section of the bristles, usually in the middle between toe and ferrule.

Heel: The top section of the ferrule into which the bristles are attached. Its contour defines the shape of the brush.

Bristles

Paint brushes are made from either natural animal hairs or synthetic fibers, or a combination of both. The bristles determine the performance and price of the brush.

Synthetic bristles Synthetic fibers such as nylon and/or polyester (also called Taklon) are excellent substitutes for natural bristles. These manmade thermo plastic polymers are narrowed, shaped, roughened, incised, dyed and heated to expertly mimic all the characteristics of natural animal hair. Even the tips of synthetic filaments are split (flagged) to imitate the natural flags (split ends) of the finest natural hair, increasing absorption and allowing smoother strokes. Compared to animal hair, synthetic bristles are much stronger, easier to clean, less prone to damage and breakage, and they tolerate the corrosive nature of solvents and acrylic paints. An added benefit is that no animal fur is harvested to make synthetic brushes.

White and gold sable brushes are synthetic nylon bristles developed to mimic natural sable. Compared to natural sable they offer excellent point and abundant spring but slightly less "snap" (memory or shape-retaining ability). Their downside is that they have less loading capacity and less flow control than natural sable.

Natural badger-hair brush

Natural goat-hair brush

Natural Kolinsky sable

Synthetic bristles

Blends of natural and synthetic bristles

The combination of natural and synthetic bristles offers excellent affordably priced alternatives to natural-hair brushes such as red sable. Usually a blended brush consists of no more than 20% natural fur, the remainder being synthetic filaments. The natural hair increases loading capacity, while the synthetic bristle offers spring and keeps costs down.

Natural animal hair There are many different furs used for brush making. It is often quite difficult to visually identify them, and even when the brush indicates the type of bristle this is not a guarantee, as many brushes contain blends of different animal hairs.

• Kolinsky sable—actually not sable hair at all—comes from the tail of a member of the weasel family, a species of mink found in Siberia and northeastern China, or from its cousins, the Himalayan or yellow weasels or martens. Kolinsky brushes are considered superior among brushes due to their strength, spring, perfect point and "snap." Their downside is the inhumane farming methods and their high cost.

• Red sable is a more affordable alternative to the superior Kolinsky sable, yet offers similar performance and durability. Red sable brushes are made of the tail hair of sable martens. Sable

Brushes continues over the page ⟶

	Angled Shader	Bright or Flat Shader	Egbert	Fan	Filbert	Flat—Short and Long	Mop
Brush							
Brush mark							
Brush shape + name	ANGLED SHADER OR ANGULAR FLAT	BRIGHT OR FLAT SHADER	EGBERT	FAN	FILBERT	FLAT—SHORT AND LONG	MOP
Description	Flat bristles with a sloping diagonal tip	Flat bristles with a slight inward curve at the tip; width and length are about equal	Flat, long bristles with a thick belly and rounded tip; has a larger loading capacity than a filbert	Flat bristles spanning out in an arc	Narrow, flat bristles that come to a rounded oval point	Flat, square-edged bristles; short and long bristles; good loading capacity	Thick, floppy mop of soft bristles that hold large volume of liqui[d]
Use	• Tight shading • Filling in tight, angled corners • Curved strokes	• Short, controlled strokes	• Blending • Soft, rounded edges	• Soft blending • Textural effects	• Used flat it produces a broad brush stroke • Used on its side, it gives a thin line • Produces a variety of marks by varying pressure and angle	• Used flat, it produces a broad brush stroke • Used on its side, it gives a thin line • Confident, sweeping strokes • Edges	• Blending transitions • Softening • Washes

bristles are soft, flexible, have superior loading capacity and taper to form an excellent point. Their downsides are inhumane farming methods, surging prices due to diminishing availability and the fact that cheaper red sable brushes are often blends of weasel hair with ox hair, forfeiting the fine point.

• Brown sable is harvested from various types of martens and is increasingly replacing red sable in brush manufacturing. Good-quality brown sable brushes are affordable alternatives to red sable for students.

• Sabeline is fine-quality, light-colored ox hair dyed to look like red sable. Sabeline is sometimes paired with red sable for lower-priced sable-like brushes.

• Badger hair is widely available and harvested in various regions of the world, but the quality can vary substantially. Badger bristles are thin at the root and thicken toward the tip, giving badger brushes a characteristic "bushy" appearance. They are excellent for blending, smoothing and blurring.

• Camel hair is too woolly and curly to be used for brush bristles, so camel-hair brushes are actually made from other types of soft hair, such as goat, ox, pony, squirrel or a blend of several. They are not recommended due to the unpredictability regarding flexibility, softness and loading capacity. Overall, they lack "snap" and fine point.

• Fitch hair is harvested from the European polecat, a member of the weasel family. Fitch is a great alternative to sable because it's cheaper, but very smooth, with a good "snap" and an excellent point. Ideal for blending, glazing and details.

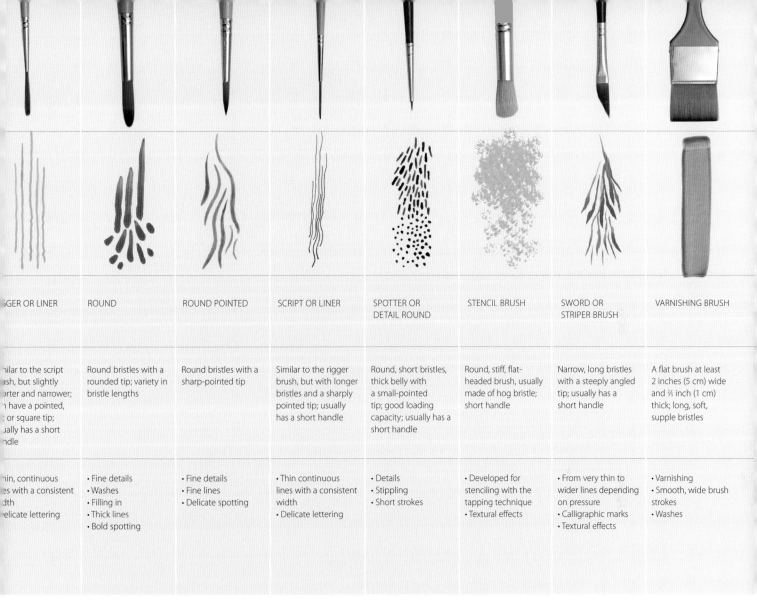

	RIGER OR LINER	ROUND	ROUND POINTED	SCRIPT OR LINER	SPOTTER OR DETAIL ROUND	STENCIL BRUSH	SWORD OR STRIPER BRUSH	VARNISHING BRUSH
	Similar to the script brush, but slightly shorter and narrower; can have a pointed, or square tip; usually has a short handle	Round bristles with a rounded tip; variety in bristle lengths	Round bristles with a sharp-pointed tip	Similar to the rigger brush, but with longer bristles and a sharply pointed tip; usually has a short handle	Round, short bristles, thick belly with a small-pointed tip; good loading capacity; usually has a short handle	Round, stiff, flat-headed brush, usually made of hog bristle; short handle	Narrow, long bristles with a steeply angled tip; usually has a short handle	A flat brush at least 2 inches (5 cm) wide and ⅖ inch (1 cm) thick; long, soft, supple bristles
	• Thin, continuous lines with a consistent width • Delicate lettering	• Fine details • Washes • Filling in • Thick lines • Bold spotting	• Fine details • Fine lines • Delicate spotting	• Thin continuous lines with a consistent width • Delicate lettering	• Details • Stippling • Short strokes	• Developed for stenciling with the tapping technique • Textural effects	• From very thin to wider lines depending on pressure • Calligraphic marks • Textural effects	• Varnishing • Smooth, wide brush strokes • Washes

• Goat hair forms a good point, but lacks flexibility and has an innate kink that cannot be straightened. It is used mainly for calligraphy and watercolor technique washes.

• Hog brushes are very resilient yet supple. Made of the back hairs of the pig, it is obtained in several parts of the world, with the most sought after coming from China. The flags (split ends) of these bristles offer superior loading capacity, and their firmness and natural resistance to fraying allows easy application of heavy viscous acrylics.

• Mongoose hair, also called kevrin, is fine, strong, flexible and very versatile. Mongoose is a great alternative to sable, because it's cheaper and more durable. This oily, stain-resistant hair is easy to clean, offers a good "snap" and an

Ethics and animal hair

There's limited information made available by brush manufacturers about the provenance of animal hair used for brushes. Animal hair is a by-product of the food and fur industries, and neither has a stellar reputation when it comes to the humane treatment of animals. Some countries where the harvested hair originates have downright deplorable animal rights records, especially when it comes to more exotic furs, resulting in a growing illegal fur trade in many regions around the world. Artists who care about animal rights or have ethical concerns about using animal hair should only buy and use synthetic brushes.

Brushes continues over the page ⟶

excellent point, making it good for blending, glazing and detailed brushwork.

• Ox hair is thick, long, springy hair that is harvested from the ears of cattle or oxen. Considered the strongest and stiffest among the soft natural bristles, it is silky, very resilient and has good "snap." Ox-hair brushes are often blended with other natural bristles. Although lacking a fine tip, ox brushes are used for fine lettering and striping, and make excellent flat brushes for washes.

• Pony hair is harvested from mature animals of at least two years of age. Compared to horses, ponies have thicker manes and tails. Tail hair is stiffer than mane hair, so pony brushes vary in texture between soft to slightly stiff, and lack "snap" and fine point. Pony hair is often blended with other bristles and used in cheaper watercolor brushes.

• Squirrel is a fine, thin, very soft bristle

Dos and don'ts of brush care

• Do not leave a brush standing in water.

• Do not leave acrylic paint to dry into your brush.

• Do remove dried acrylic paint with alcohol.

• Don't throw away a worn-out brush; it may come in handy for creating textural effects or applying liquid frisket.

Brush roll
A brush roll enables you to carry your essential brushes without damaging them and easily view and access them when painting on the go.

TECHNIQUE FILE 07

HOW TO CLEAN YOUR BRUSH

If the soap is good enough for my skin, I assume it is good enough for my brushes. So I use a white pH-neutral perfume-free bar of soap, which I keep in a lidded plastic container (sold as a butter dish). This soap-in-a-box saves my hands and avoids skin contact with toxic pigments. When the soap wears out, I simply place a new bar of soap on top.

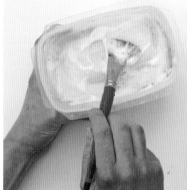

1 Use a cloth or paper towel to wipe excess paint off the brush .

2 Rinse the brush in lukewarm water.

3 Rub or dab the wet brush into the soap dish, creating lather.

4 Work up a lather with the brush by gently rubbing it in the palm of your hand (wearing rubber gloves to avoid your skin absorbing toxic pigments), in the sink or in the soap dish.

5 Rinse the brush in a clear glass bowl. Repeat lather and rinsing until all traces of color are gone.

6 Shake the excess water off the brush.

7 Gently shape the moist brush to its original shape by sliding it over your palm.

8 To dry, place the brush upright, bristles upward, in a jar or vase.

Gently shape long brushes to maintain smooth sides and an even point.

harvested from squirrel tails. It has a fine point, but isn't very strong and lacks "snap." The quality of squirrel brushes is hard to determine, as it varies according to squirrel species. Good-quality squirrel brushes are best used for liquid applications.

Brush care

A quality brush is an investment—taking good care of this precision tool will considerably extend its functional life. To ensure they retain their shape, most brushes are treated with a water-soluble sizing before leaving the factory, which should be washed off before first use. Always thoroughly clean your brushes after each painting session. Incorporate brush cleaning as a closing ritual to wrap up each painting session!

Soaps There are special brush-care soaps available at the art supply store, but you can use virtually any kind of gentle cleanser, such as mild dishwashing detergent, (baby) shampoo, glycerin or laundry soap (such as Sunlight).

Storage and travel

• Natural bristles need protection against moths: moths lay eggs on natural hair to feed their larvae. Moth balls offer extra protection inside cabinets and drawers.

• Natural bristles need protection against mildew and mold. Avoid storing them in airtight, humid places such as plastic bags or boxes.

• Keep little bags of silica gel that come with leather goods or electronics and place them with stored brushes for moisture control.

• To travel with brushes, use a brush mat (a bamboo mat that rolls up), a brush case (a firm flat pouch with a zipper) or a brush roll (see page 66).

Storing brushes

Store clean brushes in such a way that the bristles do not get distorted out of shape. Storing your brushes upright by placing them in a jar or vase is ideal, but natural bristles need additional protection against ambient humidity and insects.

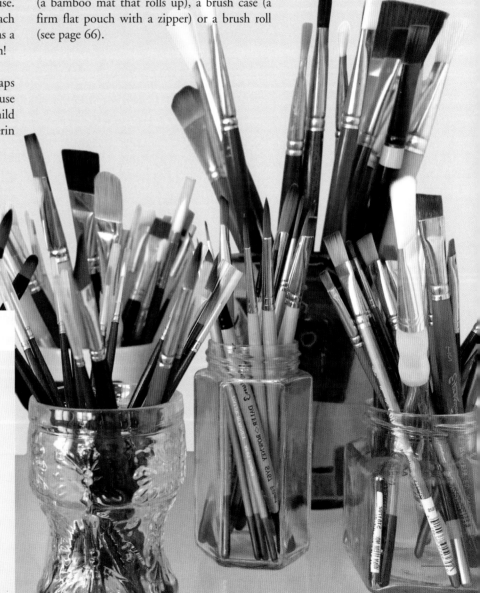

Three ways to reshape deformed brushes

• Soak in hot water to make the bristles supple and reshape by hand. Do not shake off excess water. Leave to dry with bristles upright.

• After cleaning and final rinse, leave a bit of clean soap lather in the bristles and reshape the brush. The lather will dry like sizing, keeping the bristles in shape. Be sure to rinse the brush before use.

• Use hair conditioner to reshape and condition natural bristle brushes. Be sure to rinse the brush before use.

Painting knives, palette knives and color shapers are wonderful tools that allow you to blend, apply, spread, shape, mark and scrape acrylic colors. They are indispensable for impasto and sgraffito painting techniques.

KNIVES AND SHAPERS

Palette and painting knives are not knives at all, but spatulas with dull edges. Many artists interchange the terms "painting knife" and "palette knife" because these tools look very similar. Strictly speaking, there is a difference between the palette knife and the painting knife, although many artists use both tools for blending as well as painting.

A palette knife is a flexible blade used for mixing colors on the palette and scraping it clean—it looks like a putty knife, and the blade and handle are usually rather straight.

A painting knife is a flexible blade used for painting, substituting the brush to apply colors to the painting support. The handle usually curves toward the blade, making it suitable for applying paint without scraping your fingers into it.

Color shapers are wedge shaped or have a straight handle with a flexible silicone or rubber head, designed to create texture by pushing into wet paint. They are specifically designed tools for the sgraffito technique.

Palette knife
The palette knife is either a straight or slightly bent spatula with a rounded tip, well suited for blending colors on the palette and scraping the palette clean. Its typical extended "butter-knife" shape is less appropriate for painting, although of course it can be used for that, too.

Using a palette knife
The palette knife can be used for mixing, scraping and applying paint.

Different painting knives

Painting knives come in a large variety of shapes and sizes. Choose the shape that most appeals to you, making sure it's flexible yet firm.

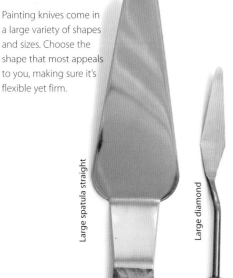

Large spatula straight

Large diamond

Medium diamond

Small diamond

Rounded diamond

Rounded straight

Elongated rounded diamond

Elongated teardrop

Elongated thin teardrop

Painting knife
The painting knife has a bent, trowel-shaped handle.

Palette knife
The palette knife's blade lines up with a straight handle.

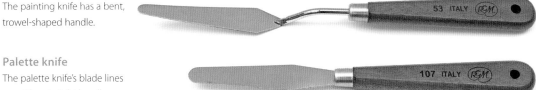

The blade of a palette knife is usually made of stainless steel and is set into a short wooden handle. The best ones have a flexible blade that is neither too pliable nor too rigid. It should allow comfortable, supple blending of acrylic paint, yet be firm enough to scrape viscous or dried paint off a surface.

Painting knife

The blade of a painting knife, too, is usually made of stainless steel set into a wooden handle, although cheaper versions are made out of plastic. The handle is curved like a trowel, so that the blade can touch the painting support without the hand getting in the way. Many artists use them to blend paint as well. Painting knives come in a wide variety of shapes and sizes, from traditionally diamond shaped to oval, rectangular, teardrop and angled. Different shapes yield different textural effects, and different sizes yield marks of different lengths and widths.

Choosing the right painting knife is a personal matter. The right one for you has a comfortable handle, allowing you to work for hours without cramping. It has a flexible blade that is neither too pliable nor too rigid, but bouncy enough to allow comfortable, expressive application of acrylic paint. Blades that are too springy and bendable can prove frustrating when handling very viscous paint. Note that, over time, dull metal blades sometimes become sharp due to corrosive pigments, and may damage your painting support.

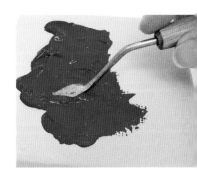

Using a painting knife
The painting knife allows you to apply paint to the support without your hand touching it.

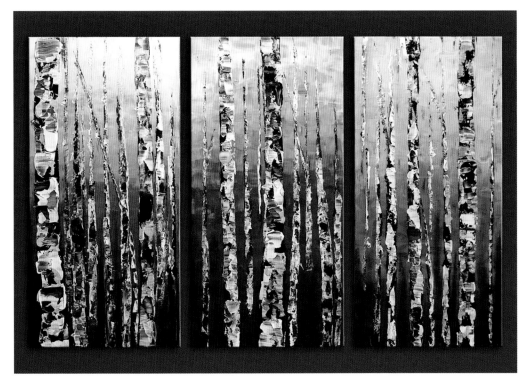

MOUNTAIN ASPENS
BY LENA KARPINSKY
Three panels 36 x 18 inch (91 x 46 cm)
An expressive impasto was skillfully built up with resolute strokes using a painting knife to create the recognizable bark texture of aspen trees.

Knives and Shapers continues over the page ⟶

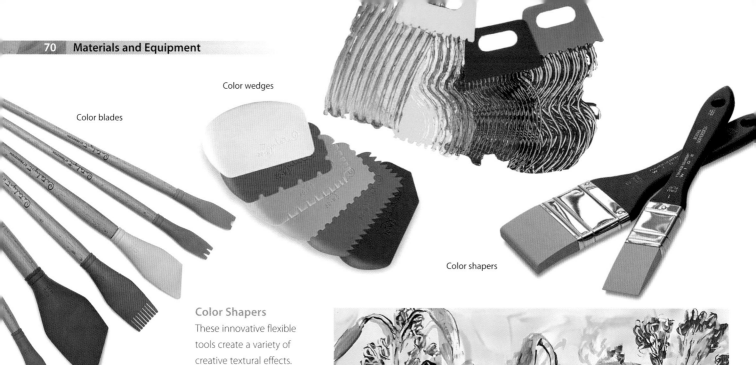

Color blades

Color wedges

Color shapers

Color Shapers

These innovative flexible tools create a variety of creative textural effects.

Color shapers

Color shapers (also called wedges, scrapers or blades) are innovative painting tools made of flexible rubber or silicone, sometimes offering a choice between soft or firm density. Color shapers are ideal for applying and lifting off color, and for carving or drawing into wet paint to achieve exciting textural effects. A delightful addition to more traditional tools such as the brush and painting knife, the color shaper is either mounted on a handle or shaped like a wedge that fits in the palm of your hand.

Color shapers are available in a wide variety of different sizes and shapes; tips can be pointed, tapered, rounded, chiseled, forked, notched and angled. Squeegee-like flat shapes allow you to spread amounts of viscous acrylics for sweeping, flat-color areas. These tools are easy to clean (some are dishwasher safe) and fun to experiment with.

DANCE OF THE LILIES
BY FLORA DOEHLER
16 x 16 inch (40 x 40 cm)
The lilies were sketched with a yellow fluid acrylic paint marker. When dry, a coat of gel and matte medium was applied. Fluid acrylics were brushed onto the medium using as few strokes as possible so that the brush strokes remained visible. While the medium and paint were wet, marks were drawn using a rubber-tipped color shaper. The shaper was dipped into paint and used to draw into the painting to emphasize the lines.

An airbrush is a handheld tool about the size of a large fountain pen that uses compressed air to convert liquid paint into a fine spray, called atomization.

THE AIRBRUSH

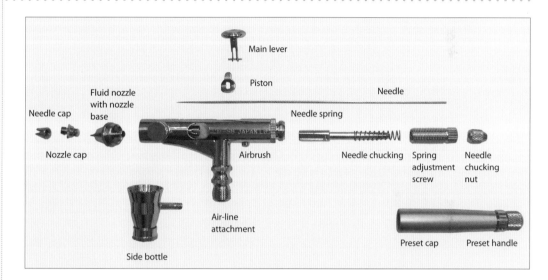

Airbrushing differs from other painting techniques in that the tool doesn't touch the painting surface. In contrast to brush strokes that touch the canvas, giving immediate visual and tactile feedback on pressure and viscosity, the airbrush relies on perceptual skills of trigger control, aim, paint flow and distance. Using the airbrush involves learning a new painting technique as well as learning how to use the equipment.

Choosing the right airbrush system is not easy, so you need to have a basic understanding of the equipment and to know the type of applications for which you will use it. Before investing in expensive equipment, gather information and gain experience by taking airbrush classes, visit an airbrush art fair and talk to professional airbrush artists. Magazines, books and websites about airbrushing also offer valuable information.

Airbrush types

Airbrushes are categorized by four features: trigger action, paint-feeding system, mix point and nozzle and needle size.

Trigger action Pressing the trigger on a single-action airbrush activates the air flow and paint stream simultaneously, maintaining the paint volume and spray pattern at a fixed intensity. The paint stream can be adjusted by changing the needle placement, either by turning the paint tip or turning a dial, but this cannot be done while painting. The single-action airbrush is more affordable, has fewer parts, is easier to use and clean, and offers uniform paint coverage, but is limited when it comes to more artistic applications.

The trigger on a dual-action or double-action airbrush allows separate activation of air and

The Airbrush continues over the page ⟶

The correct double-action airbrush trigger technique

- Press trigger down = air on

- While pressing down, pull trigger back = paint flow

- While pressing down, release trigger forward = stops paint flow

- Release pressure off trigger = air off

See pages 193–197 for more information.

Airbrush studio set-up

This airbrush classroom setting contains all the necessary equipment for the airbrush student to start learning in the most optimal way.

color. Pressing the trigger down activates the air flow, and pulling the trigger backward activates paint flow. This variable press-and-pull action grants control over the amount of paint the airbrush releases during the painting process. The double-action airbrush is more expensive, has a learning curve, but offers a wider range of artistic effects.

Paint-feeding system An airbrush with a gravity-feed system has a cup positioned on top of the airbrush, draining the paint into the mixing chamber of the airbrush by force of gravity. This system requires less air pressure for suction and offers the finest mist spray for delicate details.

An airbrush with a side-feed system has the paint reservoir or cup positioned on the side, parallel to the airbrush. Some side-feed systems can be changed to attach the cup to the opposite side, which is ideal for left-handed artists. Added pros are that the position of the cup doesn't obstruct your view and that the cup swivels for airbrushing in different positions.

An airbrush with a bottom-feed system has the paint reservoir positioned underneath. This type of paint jar comes in various sizes and can hold a larger volume of paint, so it is ideal for larger-scale painting. These reservoirs can be interchanged easily, allowing you to have several colors prepared beforehand. Added pros are that the position of the jar doesn't obstruct your view and that the jar is lidded, preventing paint spills.

Mix point The mix point is the location where the paint and air mix.

The internal-mix airbrush mixes the air and paint inside of the airbrush, at the tip. This system creates a delicate spray mist, but is more expensive and needs more frequent cleaning.

The external-mix airbrush mixes the air and paint upon exiting the airbrush. This system is more affordable and allows use of more viscous paints, but creates a grainier spray pattern.

Needle and nozzle The size of the needle and nozzle combination dictates the volume of paint the airbrush sprays. Your choice of needle and nozzle size is determined by the type of artwork you want to create.

Most manufacturers indicate this diameter in millimeters, but some brands use terms such as "large" or "ultra-fine."

- 0.5 and 0.4 mm are general sizes used for airbrushing large areas. Not suitable for very detailed fine art.

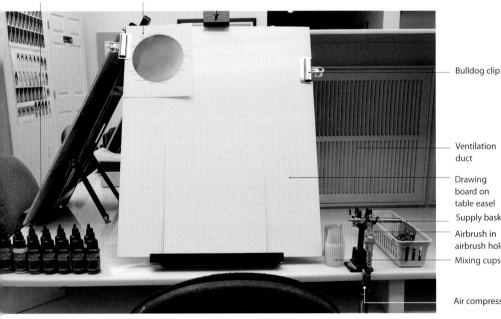

Acrylic airbrush inks

Blair color wheel

Bulldog clip

Ventilation duct

Drawing board on table easel

Supply basket

Airbrush in airbrush holder

Mixing cups

Air compressor

SIL-AIR

• 0.3 and 0.35 mm are considered to be within starting range of "detail" airbrushes.

• 0.2 and 0.25 mm offer a fine spray pattern, allowing finer lines. Compared to larger sizes, a sudden price increase takes place for airbrushes with nozzles of 0.2 mm and smaller.

• 0.18 mm and smaller are considered the best for ultra-fine details, but covering large areas takes a long time. Small-sized nozzles suffer tip dry more often, demanding more frequent cleaning.

The air source

The airbrush needs air to force the paint to break up and nebulize into small droplets, forming a multitude of tiny dots on the painting surface. All airbrushes have a hose attached to the underside that connects to an air-supply source.

There are three basic types of air sources: canned propellant, a compressed CO2 tank and an air compressor.

Canned propellant A compressed-air aerosol (spray canister) can be used for limited-time painting sessions or when electricity is not available. It is a low-cost temporary substitute for an air compressor when the artist is not ready to invest in an air compressor. In the long run canned propellant is an expensive air source, as it depletes quickly, cannot be refilled and only offers low air pressure.

Compressed CO2 tank Also called carbonic gas tank, this contains CO2 (carbon dioxide) or nitrogen under extremely high pressure, typically used by welders. It is a silent and relatively inexpensive air source for small- or medium-scale single airbrush use, needs no electricity and is available in different sizes—a large tank can last months. Safety demands that the compressed CO2 tank is equipped with a regulator to adjust air pressure. All connections must be protected from freezing and caution is advised when connecting it to the airbrush.

Air compressor The air compressor is an electricity-driven device that produces pressurized air; it is the most cost-efficient and practical

air source for long-term use. There are two basic types of air compressor: the diaphragm compressor and the piston compressor.

The diaphragm compressor is relatively inexpensive, but is slow at replacing air. Due to its limited air volume, it only works well for a single airbrush and brief airbrushing sessions. These models do not have an air storage tank and propel air directly into the air line, producing a typical uneven spray pattern due to pulsation.

The piston-driven compressor is more powerful than a diaphragm compressor and has an air storage tank, which eliminates the pulsating spray pattern described above. The air storage tank can range in size from 0.5 to 4 gallons (1.9 to 15 liters) and allows multiple concurrent airbrush use. Depending on size, it can provide air to up to eight airbrushes simultaneously. The most expensive piston-driven compressors are virtually noiseless. The noisy versions can be fitted with a longer air line and moved behind a wall to shield the artist from excessive noise.

Extras for the air compressor

• A high-temperature limit safety switch automatically shuts down an overheating compressor, and prevents you from restarting the compressor until it has cooled down.

• A moisture filter prevents water condensation accumulated in the air storage tank and air line from reaching the airbrush to spoil the paint.

• An air-pressure regulator allows you to turn the air pressure up or down, depending on paint viscosity and technique.

• An automatic shut-off switch automatically deactivates the compressor when maximum pressure is reached in the air storage tank or air line, and automatically turns the compressor back on when the air level reaches a preset limit.

• The oil-lubricated piston-driven compressor needs an oil filter to prevent oil vapor from reaching the airbrush to spoil the paint.

Overspray and health

Miniscule paint droplets that land around your work area and float in the air are called overspray. Airbrushes always create overspray. Airborne

Tips to avoid overheating

To avoid damage to the air compressor due to overheating:

• Make sure that the airbrush is compatible with the air compressor so that it replaces air at the speed at which it is sprayed.

• Plug the air compressor directly into the electrical outlet. Try to avoid using an extension cord— but if you must, use a short one.

All about air

• Air source: A container holding pressurized air or a machine producing pressurized air.

• Air regulator: A mechanism to adjust air pressure (expressed in psi or bar).

• psi: The US measurement of air pressure, psi means pound-force per square inch.

• bar: The metric measurement of air pressure, from the Greek *báros* meaning weight.

• Conversions:

1 psi = 0.0689475728 bar

1 bar = 14.50377 psi

Tip: The lower the air pressure (psi/bar), the slower you are able to move your airbrush, giving you increased control over the color spray.

The Airbrush continues over the page

overspray is a serious health risk, especially when using toxic pigments such as cobalt.

To avoid landing overspray, use less pressure and/or move in closer to your painting surface. Use frisket and masking materials to protect areas from landing overspray. (See Masks and Stencils on pages 56–57.)

To avoid inhaling airborne overspray, wear a mask or respirator, ventilate the studio area well and, if possible, use an air extractor or exhaust fan.

Use a fine dust mask or respirator to protect your lungs from long-term damage. The simplest

is the disposable fine dust mask that covers mouth and nose. The respirator comes in a wide variety of sizes, models and filtration types. The best masks and respirators are lightweight, have comfortable straps for a secure fit, a replaceable filter and, ideally, an exhalation valve for breathing comfort.

Ventilation and good air flow also reduce inhalation of overspray. Besides opening the window during airbrushing sessions, consider installing a bathroom exhaust fan or extractor into a piece of plywood to fit your studio window.

CLEANING YOUR AIRBRUSH

Make it a routine to flush and clean your airbrush to keep your tool functioning at its best.

> ### You will need
> • Concentrated (biodegradable) airbrush cleaning solution for water-based paints or ammonia-free window cleaner
> • A squirt bottle with clean water
> • Cotton swabs
> • Paper towels

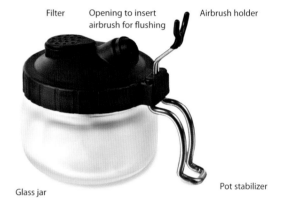

Filter Opening to insert airbrush for flushing Airbrush holder

Glass jar Pot stabilizer

Airbrush cleaning pot
A must-have in the studio, this pot is ideal to spray excess paint and cleaning solution into while avoiding direct inhalation of airborne particles.

Cleaning tip dry Tip dry happens when paint builds up and dries on the tapered needle, clogging the airbrush and causing erratic spray patterns. This happens frequently during a painting session, so you will need to repeatedly clean the needle during use.

Dip a cotton swab into cleaning solution and carefully introduce the soaked cotton swab into the front of the airbrush. Conversely, unscrew the tiny needle cap and gently twirl the cotton swab around the needle. Repeat with a clean soaked cotton swab until no staining occurs. Spray some air to remove any remaining cleaning solution.

Rinse between colors Flush your airbrush between color changes to avoid colors blending and to eliminate build-up. Pour airbrush cleaning solution or ammonia-free window cleaner into the paint cup and spray it through. To avoid

inhaling airborne cleaning solution, spray into an airbrush cleaning pot. Wipe the paint cup with a cotton swab dipped in cleaning solution. Always use clean water for the final flush to prevent cleaning solution from contaminating your paint.

Final cleaning After each painting session it is important to clean your airbrush thoroughly before the paint inside sets and dries. Follow the instructions for rinsing between colors. After this flush, you may want to clean the needle as well. Consult your airbrush manual for proper removal of the needle. Handle your airbrush needle very carefully; it is very sharp yet very delicate! Wipe the needle on a paper towel moistened with cleaning solution, then lubricate the needle with an

airbrush lubrication product or glycerine and reinsert it into the airbrush following the manual's directions.

Cleaning paint cups and bottles When a simple rinse is not enough, clean cups and bottles by submerging them in soapy water or cleaning solution for a while, then scrub them with a (paint) brush or cotton swab. Do not flush water containing acrylic paint residue down the drain, but filter it through a coffee filter or paper towel to avoid contaminating our waters.

EMMY'S NECKHAIR II
BY JOHANNES WESSMARK
20 x 30 inch (71 x 77 cm)
Airbrush painting can be
combined with other techniques,
tools and media. This stunning
portrait was created by airbrush
and enhanced with colored pencils.

Professional airbrush studios have fume extractor filter systems fitted behind the workstation.

An excellent alternative is to invest in a spraying booth, a box-like cubicle that filters and extracts the overspray within. There are table-sized spraying booths, and larger ones on legs. The downside is that the work surface is limited to the size of the booth.

Beginner's guide to airbrush shopping

Although many great airbrush artists are self taught, learning to airbrush on your own can be frustrating. Treating yourself to a basic beginner's workshop will reveal whether airbrushing is for you, and help you decide whether to invest in airbrush equipment. Avoid buying cheaply made equipment—it is well worth saving up to buy good-quality tools that perform well and will last for years. When you are ready to buy an airbrush system of your own, this shopping list (right) can be your guide to get started.

The kind of airbrush equipment you need depends on the artwork you intend to make and your budget. These recommendations should be adapted to your needs. Art supply stores sometimes offer a complete airbrush starter system, including an airbrush, air compressor, acrylic inks and sometimes even frisket and other tools. This can alleviate the anxiety of shopping for airbrush equipment.

Airbrush essentials

- Airbrush: An internal-mix, double-action, side-feed or bottom-feed airbrush, with a nozzle between a 0.3 and 0.18 mm. Make sure you can reverse the side feed cup if you are left-handed.

- Air: A piston-driven air compressor with air storage tank, as silent as possible.

- Airbrush cleaning pot: To blow out excess paint and cleaning fluids. Some come with an airbrush holder.

- Airbrush holder: This gadget mounts onto your tabletop and holds the airbrush upright, avoiding spills. Depending on type, it holds between one to four airbrushes.

- Cleaning solution: Concentrated biodegradable airbrush cleaning solution for water-based paints or ammonia-free window cleaner. Alternatively, buy an airbrush cleaning kit.

- Plastic squirt bottle: To hold water for rinsing.

- Cleaning materials : Cotton swabs and paper towels.

- Paint: An acrylic airbrush ink starter kit (to avoid having to thin and strain regular acrylics). Choose between transparent or opaque colors, or buy both.

- Medium: Acrylic airbrush extender and/or airbrush medium.

- Painting surface: Your choice of canvas, panel, paper or illustration board. See pages 76–87 for more information.

- Frisket, masks, stencils: See pages 56–57 for more information. Ignore if you prefer to work freehand style.

- Additional tools: A sharp blade or X-acto knife.

- Eraser: Regular pencil eraser and/or electric eraser.

- Health: Fine dust mask or dual filter respirator.

Canvas is the generic name used to indicate a textile used as a painting support. A canvas can be natural fabric, such as cotton, or a synthetic fabric, and is generally stretched over a wooden frame.

CANVAS

The word canvas is derived from the Latin *cannabis*, meaning "made of hemp." Painting on wood panels remained the norm until the 16th century, when Italian artists began painting on panels covered in hemp and linen canvas. Renaissance artists primed their canvases to achieve an ultra-smooth surface suited to painting high realism, eliminating any perceptible texture.

Because linen (derived from flax) was more expensive to process, lower-priced hemp was the preferred canvas for poor artists until the early 19th century when cotton began to conquer the canvas market. Hemp production declined, and cotton canvas became increasingly widespread. The advantages of portable, lightweight canvas have had a great influence on the art of painting in the last few centuries.

Today, the majority of artist canvases are made of linen or cotton, although recently the synthetic fiber canvas (made from polyester or nylon) is gaining timid acceptance.

Canvas formats
Canvas for painting comes in many different forms, formats and sizes.

Canvas pads are canvas sheets bound together in a pad. These sheets, usually cotton, are made by manufacturers from canvas roll remnants and are gesso primed in either white or black. They are ideal for experimenting, making color swatches and plein-air painting. They can be mounted on a rigid support or stretched, either before or after painting. Canvas pads should not be confused with canvas paper!

Splined canvas
Splined canvases are secured at the back, leaving the sides free to become part of the artwork.

Deep-edge canvas
Deep edge canvases stand out farther from the wall.

Canvas boards or canvas panels are cardboard, tempered hardboard or wooden panels covered with stretched cotton or linen canvas, gesso primed in either white or black. They offer a rigid, textured painting surface and come in a variety of standard sizes, as well as round, oval, other innovative shapes and even with beveled edges. The quality depends on the manufacturer; the best are neatly finished and archival in quality.

Unstretched canvas comes in rolls or blankets (folded sheets), either raw (unprimed) or gesso primed. Unstretched canvas takes up less storage space and is convenient for artists on a budget, those who prefer to stretch their own canvases, paint very large formats and/or need to ship their rolled-up paintings overseas. Always double check that the canvas is primed for acrylics; oil-primed canvas is unsuitable for acrylic paint.

Prestretched canvas is usually gesso primed and is the most popular and widely used canvas due to its convenience and availability. Prestretched canvas comes in many standard sizes to fit ready-made frames, and usually comes primed with a thin coat of acrylic gesso. It is recommended to add a few additional coats of gesso, and to check that the canvas is primed for acrylics, as oil-primed canvas is unsuitable for acrylic paint.

Prestretched canvases come in several finishes. The cheapest and simplest are stapled on the sides and require framing. Canvases with clean edges without visible fasteners (such as staples or tacks) are also known as gallery wrap, free-edge or creative-edge canvases. The canvas wraps around the sides of the wooden frame and is secured on the back with staples or splining. Splined canvases look very neat because the canvas is tucked or wedged inside a groove (tunnel) and held in place by a cord. Staple-free edges allow you to paint the edges of the canvas and give the painting a contemporary look when it's displayed without a frame.

Comparisons of canvas

Your choice of canvas is subject to many factors, including cost, surface texture and various practical aspects. Canvases larger than 10 square feet (1 square meter) require a higher degree of strength and stability because of handling stresses, environmental fluctuations and the potential need for re-stretching.

Canvas	Texture and color	Archival properties	Pros	Cons
1 LINEN	Irregular, organic texture Brown Weaves vary from very fine to very coarse	Excellent	Belgian linen is considered the best Good resistance to decay Less flexible: It expands and contracts less with changes in temperature and humidity Strong and firm enough to support large paintings	Difficult to stretch properly Expensive Overstretching will strain the wooden support. Weave may continue to show through many layers of paint
2 COTTON	Regular, even texture Off-white	Very good	Flexible Easy to stretch Affordable Cotton duck is comparable to linen but has a more regular texture	Expands and contracts more with changes in temperature and humidity Too flexible for paintings larger than 10 square feet (1 square meter)
3 SYNTHETIC: Polyester or nylon	Smooth, flawless weave Almost transparent Bright white	Unverified but promising	Resistant to bacteria, mold and pollution To retain the translucent quality, it is unnecessary to prime with gesso	Not tested for longevity
4 BLEND e.g., cotton/ polyester or cotton/linen	Variable texture From dark beige to off-white	Unpredictable due to distinct characteristics of the fibers—unless the thread itself is a blend	Variable, depending on manufacturer	Variable, depending on manufacturer
5 HEMP	Strong, tight weave Light brown	Excellent—rivals linen	Durable and very strong Less expensive than linen	Not readily available
6 JUTE (hessian)	Rough, coarse, heavy texture Golden brown	Not archival unless prepared by reputable manufacturer	Inexpensive Very strong	Very rough, absorbent surface If not properly prepared, susceptible to deterioration

Canvas weights

Canvas	Unprimed weight	Recommendation
Lightweight	4 oz (135 gsm) 5 oz (170 gsm)	Unsuitable
Medium-weight	7 oz (137 gsm) 8 oz (271 gsm)	Most used for prestretched primed canvases Depending on brand, may be poor quality and unstable weave
Heavy-weight	10 oz (339 gsm) 12 oz (407 gsm)	10 oz is the most popular canvas weight Good choice
Extra heavy-weight	14 oz (475 gsm) 15 oz (508 gsm)	Very thick and strong Recommended for serious artwork
Super heavy-weight	18 oz (610 gsm) 20 oz (678 gsm)	The best, especially for large paintings with heavy paint applications

Note: Weight classifications can refer to preprimed or primed canvas, or both. Obviously the weight of primed canvas can be misleading, as the added weight of the gesso can amount up to half of the unprimed weight, depending on brand and factory priming methods.

Note: This weight classification mainly applies to cotton and linen canvases—the synthetic variety is much sturdier per weight, and other materials fluctuate in quality depending on the tightness of the weave.

Duck weave

The word "duck," which is sometimes used for canvas, stems from the Dutch *doek*, meaning cloth. Duck canvas is more tightly woven than regular canvas.

Duck refers to a specific weaving method in a 2:1 ratio: two yarns together in the warp (lengthwise or longitudinal thread) and a single yarn in the weft (transverse thread). While duck is strong, it lacks the stability and strength of a 1:1 or 2:2 weave ratio, which uses identical weights for the warp and weft threads.

Canvas continues over the page ⟶

TECHNIQUE FILE 09

HOW TO STRETCH CANVAS

To reduce costs or to create a particular size or shape of canvas, you can stretch your own.

You will need

- Stretcher frame
- Canvas
- Scissors
- Staple gun
- Light hammer

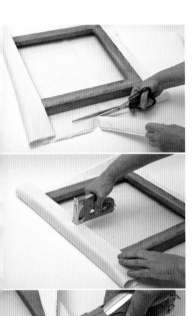

1 Assemble the stretchers. Check whether the corners are true 90° angles by stretching a piece of string across diagonally. Adjust if necessary. Lay the frame on the rolled-out canvas on a flat, clean surface. The beveled side must face the canvas. Cut all around the frame, allowing for a good overlap.

2 Starting in the middle of one side, fold the canvas over and staple to the frame. Repeat on the opposite side in the center, pulling the canvas very tight while ensuring the weave is running straight across.

3 Tugging the canvas to keep it taut, staple again either side of the existing staples.

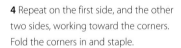

4 Repeat on the first side, and the other two sides, working toward the corners. Fold the corners in and staple.

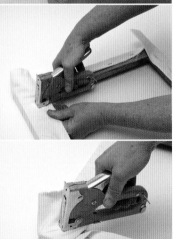

5 Hammer the staples flat and tap the wedges in. Don't overtighten; priming will eliminate some of the slack.

The depth of prestretched canvases may be normal (traditional profile) or deep-edge (deep profile), standing out farther from the wall; the latter are also known as box canvases or chunky canvases. There are no standard measurements for profiles, but the traditional profile starts at about ¾ inch (20 mm) and the deep-edge profile can be up to 2⅜ inches (60 mm) thick.

Watercolor canvas is specifically primed for watercolor painting, so it's ideal for liquid acrylic washes, glazes and fluid wet-in-wet techniques. Watercolor canvas is available as pad, canvas panel and prestretched canvas. You can turn a regular canvas into a watercolor canvas by priming it with absorbent ground (see page 36 for more information).

Weight classification
Canvas is available in different thicknesses classified in weight in either ounces per square yard (oz), grams per square meter (gsm) or a graded number system.

The official number system grades the heaviest quality of canvas as number 1 and the lightest as number 12. However, some manufacturers use their own grading system, so it's best to investigate before jumping to conclusions.

Wooden framework
The wooden framework that supports the canvas is called a stretcher or a strainer. Stretchers are somewhat adjustable because of corner notches that allow the insertion of tightening keys, while strainers are set rigid. Stretchers and strainers of large canvases have cross and corner braces for additional support, to prevent the canvas from eventually sagging.

Priming and cleaning canvas before use

If you have stretched your own canvas you will need to prime the canvas with acrylic gesso, using a household brush (see page 37). If you prefer to keep the natural color of the canvas, prime it with acrylic matte or gloss medium instead. If you have bought a preprimed canvas, it is good practice to clean it, even if it was packaged, to rid it of any dust and grease. Wipe the surface with a sponge or cloth moistened with mineral spirits (white spirits) to ensure a pristine painting surface.

TECHNIQUE FILE 10

TIGHTENING KEYS

These small flat pieces, made of wood or plastic, are inserted into slits in the inside corners of stretcher bars to increase the tension of the canvas.

1 Insert and push the pointed ends of the keys into the corner slots by hand, exerting equal pressure on all keys.

2 The position of the keys is a personal choice: Some artists insert the long side of the keys flush to the frame—the keys will remain parallel to the frame. Some artists insert the short angled side flush to the frame—the keys will point diagonally outward from the frame.

3 Feel the tension of the canvas to assess whether it needs additional tightening. If so, gently tap the backs of the keys with a small hammer until the canvas is tight. You can use a small piece of wood as a buffer between key and hammer.

4 Always apply equal amounts of pressure on all keys to avoid lopsided canvas tension.

5 Avoid overtightening, which may damage the canvas and split the stretcher bar. If unsure, a professional framer will be happy to demonstrate this procedure for you

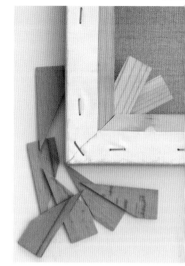

Canvas is pulled and stretched across the frame and either attached at the sides or the back with tacks or staples, or splined (wedged in place with a cord, without staples).

Artists who want to stretch their own canvas but do not want to delve into woodworking, can buy prefabricated stretchers with interlocking corners.

Tightening keys

Over time canvas has a natural tendency to relax and slacken and sometimes the timber frame contracts, which results in sagging. Tightening keys (also called tension keys, corner keys or corner wedges) are used to retighten the canvas. Most prestretched, store-bought canvases come with a little bag of eight tightening keys, two for each corner. Never insert the keys before priming, as gesso contracts canvas and tightens it.

TECHNIQUE FILE 11

HOW TO MOUNT CANVAS

Stretched canvas has a slight give that some painters dislike. If you prefer a firm surface, glue fabric onto the hardboard, using acrylic gloss medium. Either use leftover remnants or buy a piece of canvas off a roll. Choose linen, cotton or synthetic canvas.

You will need
- Board
- Acrylic gloss medium
- Canvas

1 Place your chosen board on top of your sheet of canvas. Cut the canvas all around so it is slightly larger than the board it will cover. Using a stiff brush, cover the board liberally with the gloss medium. Place the canvas over the board, smooth it out, and cover with more gloss medium to secure it to the board.

2 While the panel is still wet, turn over and place it face down onto an easily cleaned, nonabsorbent work surface. Cut across the corners of the canvas and fold in neatly. Secure the edges with more gloss medium. Once dry, prime the board with acrylic gesso primer. When dry, your board is ready.

The invention of paper is attributed to the Chinese in the first century BCE. This groundbreaking skill rapidly spread throughout the world, enabling extraordinary progress in fine arts and literature.

PAPER

Paper is produced by the felting of vegetable fibers (cellulose pulp) derived mainly from wood, rags or certain grasses. The word "paper" comes from the Latin *papyrus*, stemming from the *Cyperus papyrus* plant first used in the production of paper in ancient Egypt.

The Arabs introduced papermaking to Europe via Moorish Spain and the first European paper mill was established in 1246 in Fabriano, Italy. The Fabriano mill was the first to use cotton for papermaking and also invented watermarking. The survival of masterpieces by Michelangelo, Raphael and Leonardo da Vinci is a testament to those papers' high quality.

Today, the best-quality paper for painting is produced from cotton rag. High-quality 100% cotton paper is long-lasting, durable and resistant to scratching, erasing and very wet applications.

Paper surfaces
To paint in acrylics, a paper surface needs to be thick and heavy enough to support wet, transparent watercolor techniques as well as heavy viscous layers without buckling or tearing.

Paper is available as single sheets, in pads, sketchbooks or blocks (stretched paper sheets stacked and glued together on all four sides), as rolls or mounted on board. Many standard sizes are available, although they slightly differ between the imperial measuring system in inches and the metric system in millimeters or centimeters.

Types of paper
Acrylic and canvas paper is not a fabric but a medium-weight paper with a linen-like texture simulating canvas. While comparable to watercolor paper, it is usually more affordable. It is available in pads in different sizes, usually containing 10 or 12 sheets. It has a canvas-like texture that prevents bleed-through and retains high luminosity.

Illustration board is a thick, heavy-duty, one-sided painting surface especially favored by airbrush artists. An illustration board consists of a layer of paper attached to a rigid support backing, and is very resistant to buckling or warping, as well as erasing, scratching and sanding. The best ones are archival, come in different surface textures and are available in several whites and black.

Art board or Bristol board is a heavy two-sided paper without a backing, lighter in weight than illustration board. It allows painting on both front and back. The art board withstands buckling or warping, as well as erasing, scratching and sanding. The best ones are archival, come in different surface textures and are available in white and various other colors.

Note: Art boards and illustration boards are both rated by weight (metric) or by number of plies (layers), but ratings between illustration

Buying paper
Depending on your choice of painting method, and the size and quantity you need, paper can be bought per single sheet (loose or mounted on board), stacked in a pad, sketchbook or block, or in a roll.

Tips for buying paper

Archival paper, also called acid-free or pH neutral paper, resists discoloration and deterioration with aging and is therefore highly valued for serious artwork.

Avoid buying soiled or damaged paper by purchasing it in sealed packaging or taking it from the middle of a stack. Always inspect it for fingerprints, stains and tattered edges and be careful during transportation.

You can identify the quality of your paper by holding it by one corner and shaking it energetically. Dense paper produces a vivid metallic rattle, while spongy paper sounds muffled and opaque.

Paper surface finish

Watercolor paper and some art boards typically come in a choice of surface finishes, although these can vary between manufacturers so it's best to evaluate them in person.

Finish	Texture	Use
HOT PRESS (also called hot-pressed or HP)	Very smooth	Almost no tooth Ideal for highly detailed work and uniform washes Difficult to achieve soft transitions
SOFT PRESS (also called soft-pressed)	Slightly textured: Between hot press and cold press	Slight tooth Highly absorbent May dull intense colors or vivid darks
COLD PRESS also called cold-pressed or NOT (not hot-press)	Somewhat textured: Between hot press and rough	Excellent tooth Ideal for watercolor techniques and allows some detail Paint settles into the texture for grainy effect
ROUGH	Rough, irregular pebble-shaped texture	Prominent tooth Ideal for extravagant textural techniques and loose, expressive painting styles Paint settles into the texture for grainy effect

Transparent acrylic on white paper

Transparent acrylic on cream paper

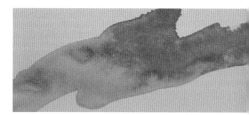

Transparent acrylic on tinted paper

Opaque acrylic on tinted paper

Color of watercolor paper

Watercolor paper is typically white, and ranges from bluish white to creamy ivory. Other colors are also available. The color of your paper has a significant impact on transparent painting techniques, so bright whites are favored to keep colors real. (Beige paper can turn blues and yellows slightly greenish.) Tinted papers are mostly used for opaque painting techniques.

HP illustration board, bright white

HP illustration board, off-white

HP illustration board, beige

HP watercolor paper

NOT watercolor paper with deckle edge

Rough watercolor paper with deckle edge

Mi-Teintes paper, tan

Mi-Teintes paper, gray

Watermarks
When held up to the light, many watercolor papers show a watermarked logo or information (such as brand or content) indicating the paper's authenticity. Watermarks are added during the papermaking process by mold imprint or embossing, slightly thinning the paper in those places. Many artists use watermarked paper on the reverse side to avoid paint pooling in the indentations. Note that the absence of a watermark does not indicate a lack of quality.

Deckle edges
The ragged, irregular border found on some watercolor papers is the natural edge formed during the handmade papermaking process, where the paper pulp thins out at the edges. Because many artists find the deckle edge decorative and display it as part of their finished painting, artificial deckle edges are sometimes added to mechanically produced paper. The width of the deckle edges varies between brands. A full-sized sheet of watercolor paper has deckle edges on all four sides.

The "right" side of watercolor paper
Watercolor paper usually has two distinct finishes on each side, one slightly smoother than the other. Either side can be used for painting, the choice is personal. Watermarks sometimes (but not always) indicate the "right" side of the paper, but this varies between manufacturers.

and art boards are not equivalent. For example, 14-ply illustration board is about equivalent to 5-ply Bristol board.

Watercolor paper lends itself beautifully for acrylic painting, and comes in a wide variety of qualities, weights, colors, sizes and finishes.

The weight of watercolor paper
Knowing the weight of your paper is important to evaluate its quality, density and thickness. As a rule, the higher the number, the heavier the paper. Heavier paper is usually favored because it does not warp and withstands scratching, scrubbing and extremely wet applications.

In the United States paper weight is measured using the imperial system, but the rest of the world predominantly uses the more precise metric system.

The imperial system inadequately formulates the weight in pounds (lb) per ream (500 sheets of paper), regardless of paper size. So the weight of a thin, large-sized paper may well be identical to that of a much thicker but smaller-sized paper. This means that the true thickness and quality of paper are subject to guesswork when using the imperial evaluation.

The metric system formulates the weight in grams per single sheet measuring one square meter (gsm). Because the dimensions of the paper are constant, this weighing method provides an accurate reading.

Due to this incompatible measuring difference, conversions are usually inconsistent and difficult to make. Use the chart on the left as a general guideline; the numbers are approximations. Note that the paper sheets in the imperial column measure 22 x 30 inches (56 x 76 cm).

Basic paper weight comparison chart

Comparative weight	Imperial— pounds per ream (lb)	Metric—grams per square meter (gsm)	Most popular	Comments
TOO LIGHT	80	170		Avoid
	90	185/190/200		Sketchbooks, quick studies
				Better for dry applications
LIGHT	130	280	✔	Needs stretching
	140	300	✔✔	Bestseller for watercolors
				Needs stretching
MEDIUM	190	400	✔	Needs stretching
	260	550	✔	Used in watercolor blocks
	280	600	✔	Resists buckling
				No need to stretch
HEAVY	300	620/640	✔	Stiff board-like, very robust
	400	850		No need to stretch
	500	1060		Ideal for large-format painting
				No need to stretch

HOW TO STRETCH WATERCOLOR PAPER

TECHNIQUE FILE 12

Watercolor paper is treated with sizing (a glutinous product that fills pores) to make it resistant to absorption. To remove excess sizing and prepare the paper for wet painting techniques, you can stretch it by soaking the paper, taping it flat and allowing it to dry. Stretched paper becomes more receptive to heavy, watery applications and resists cockling, buckling and warping.

You will need
- Watercolor paper
- Clean lukewarm tap water or a spray bottle filled with lukewarm water
- Paper towels
- Sponge
- Stretching board
- Brown gum tape

Brown gum tape is not the same as masking tape! It has dried glue on the shiny side, which is activated by moistening it with a water-soaked sponge. It comes in various widths; wider tape is easier for novices. Always use dry hands to cut four strips that are 2 inches (5 cm) longer than the length of each paper edge.

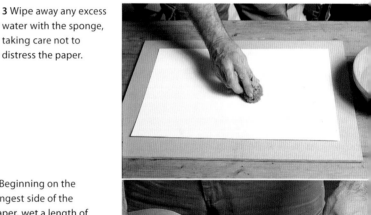

Tip

Soaking paper properly takes time. Allow roughly 3 minutes for 90 lb (between 185 and 200 gsm), 8 minutes for 140 lb (300 gsm) and 20 minutes for 300 lb (640 gsm) paper.

3 Wipe away any excess water with the sponge, taking care not to distress the paper.

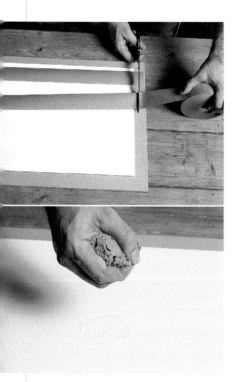

1 Prepare four strips of brown gum tape, cutting each strip approximately 2 inches (5 cm) larger than the paper.

4 Beginning on the longest side of the paper, wet a length of tape using the sponge, and lay it down along one edge. Ensure that one-third of the tape surface is covering the paper, with the rest on the board.

2 Lay the sheet of paper centrally on a wooden board and wet it thoroughly by squeezing water from a sponge.

5 Smooth the tape down with the sponge. Apply the tape in the same way along the opposite edge, then along the other two edges. Leave to dry before painting.

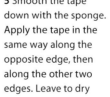

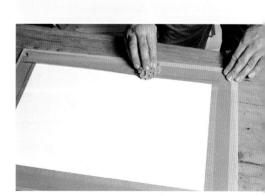

Plywood

Natural-fiber panel

A panel is a flat, rigid, portable painting support that offers a firm consistent surface, ideal for finely detailed brushwork and smooth blending of colors.

ART PANELS

The very first portable painting supports were wood panels, widely used from at least the 6th century BCE up until the time canvas became the preferred support in the 16th century.

Artists typically painted on wood native to their region; oak was the most favored panel wood in northern Europe, while poplar, pine and fruitwood panels were prevalent in southern Europe. Wood was prepared for painting by removing the resins through steaming or boiling, and then coated with size (a glutinous product) and/or gesso to fill the pores. Panels were enlarged by joining several pieces together. Artists would paint directly on the prepared wood, or cover it with canvas or leather. Despite the warping and cracking, many of these old paintings have survived surprisingly well.

Today acrylic artists have a broad range of choices when it comes to choosing a painting panel. We have access to all types of woods from around the world, modern composite materials, perfectly flat metal sheets and plastics such as Plexiglas. As long as it has a minimum of tooth, acrylics adhere to virtually any surface.

Choosing a panel

The choice of material and finish of a painting panel is highly personal. Fortunately, today there are panels to suit any artist's needs and budget. You can choose between natural or manmade materials, untreated or preprimed and with or without cradled edges.

Manufacturers of archival art panels offer ready-made high-quality painting supports in all kinds of sizes and formats, and treated to be acid-free, moisture-resistant and devoid of formaldehyde and other harmful toxins.

If you want to paint right away, you can purchase beautifully finished panels with a choice of factory-primed surfaces, such as gesso or clay, or covered with stretched canvas or paper.

If you prefer to prime your own panels, you can buy finished unprimed panels at your art supply store. And if you want custom-sized panels and/ or you don't mind doing it all yourself, buy your raw materials at a lumberyard, building supply or hardware store. If you don't have access to a circular saw, make sure the supplier has a cutting service available.

Prepared panels Specialized manufacturers offer ready-made archival painting panels in a variety of different finishes, increasing our choices and inviting creative experimentation. It also saves us from spending time and energy on surface preparation. Always make sure that the panel you buy is recommended for acrylic painting. Here are a few examples:
• Gesso boards are primed with—yes, you guessed it!—acrylic gesso.
• Clay boards are covered in white kaolin clay and sold in various styles.
• Watercolor boards are primed with an absorbent ground, ideal for watercolor techniques.
• Canvas boards are mounted with primed cotton or linen canvas.
• Paper boards are mounted with archival watercolor paper in various surface textures.

Wood Wood is an excellent, widely available and durable painting surface that can be easily cut to size and prepared. However, large panels can be quite heavy and may need to be reinforced with bracing struts to avoid warping. Wood is porous

Hardboard

MDF

Wood

and needs to be properly prepared with a sealant that acts as a barrier against leaching oils, resins or acids that produce discoloration.

Steer clear of buying cheap, low-quality wood with knots, voids, seams and other superficial inconsistencies, or woods that are too porous and soft, such as pine. Hardwoods such as birch, maple, oak, cedar, mahogany and walnut make excellent panels.

Hardboard Hardboard or high-density fiberboard (HDF) is an engineered wood product made of highly compressed wood fibers molded into flat panels. Hardboard with one smooth and one wire-mesh textured side is made by a wet process known as the Mason Method. This type of hardboard is generically called Masonite. Hardboard that is smooth on both sides is made by a dry process.

Untempered and tempered hardboard are made using the same process, but tempered hardboard receives a final treatment of linseed oil that is baked at high temperatures, which eliminates any oily residue and makes it stronger and less prone to warping.

The manufacturing process of hardboard has changed dramatically over the last decades, solving past adhesion problems caused by leaching oils that gave tempered hardboard a bad reputation. Good-quality tempered hardboard makes an affordable panel that offers two distinct surface textures (smooth and rough), and is perfectly suitable for acrylic painting.

Please note that Masonite is a trademarked brand name that in some English-language regions has become the generic name for hardboard.

MDF or medium-density fiberboard MDF is an affordable and strong panel with a smooth painting surface. MDF is made from 50% wood source from sustainable forests, and comes in various sizes and thicknesses—between ⅛ and ⅜ inch (3 and 9 mm). It is quite heavy, so is unsuitable for very large paintings. Many MDF suppliers offer a cutting service, which makes ordering custom-sized panels easy. Some manufacturers are currently producing formaldehyde-free MDF-like panels that are an excellent alternative.

Plywood Plywood is made from several thin layers (plies) of glued wood veneer, available in different thicknesses. Plywood containing more plies is stronger than plywood of equal thickness containing fewer plies. The recommended thickness for a plywood panel should be a minimum of ½ inch (12 mm) or thicker. Avoid plywood made of softwoods such as fir, pine and spruce. High-quality furniture-grade plywood (such as Baltic birch, mahogany and poplar) makes a very decent painting panel, although beware of splintering edges and conspicuous knots. Large-format panels may need back bracing to avoid warping.

Natural-fiber panels New archival, eco-friendly panels are developed from composite wood materials and natural fibers (such as bamboo), made from renewable sources using nontoxic processes.

Particle board Particle board, also called chipboard, is a composite panel manufactured by binding and pressing lumber-processing waste such as sawdust, woodchips and shavings. Due to unpredictable contents, it's best to avoid particle board as a painting support.

Support-induced discoloration or SID

SID is a phenomenon that occurs when impurities such as dirt, sap, tannins, resins or starches leach out from a porous substrate and react with the acrylic paint, causing a yellow or amber discoloration after a certain period of time. SID can be avoided by sealing your painting surface with at least two coats of a flexible acrylic polymer. Once dry, acrylic gesso can be applied to improve tooth.

A note about formaldehyde

Hardboard, MDF and other composite wood boards usually contain formaldehyde—a toxic, allergenic and carcinogenic volatile compound. Although low levels of formaldehyde are commonly present in the air inside our homes (present in some furniture, insulation, household products, clothing and, yes, even in make-up), you must decide whether additional studio exposure is desirable.

Art Panels continues over the page ⟶

Cradled panels

You can buy a ready-made cradled panel, but if you prefer to start from scratch you can make your own. Attach four clean, neatly sanded wooden boards about ¾ inch (2 cm) thick and 2 inches (5 cm) wide to fit the exact periphery of all four edges of the panel, creating an upright border (much like a shadow box). Saw the side slats to length so that they sandwich and cover the edges of the upper and bottom slats. Make sure they are flush with the panel's edges, and glue them with a heavy-duty wood or all-purpose glue. Clamp them down until the glue has set. Sand rough edges, and fill any slits with wood filler if necessary. Now your cradled panel can be primed for painting.

Panels can be framed, but many artists prefer cradled panels that have a simulated deep edge, which gives them dimension and saves on framing expenses. Cradled panels create a contemporary, clean look that allows you to either paint the cradles as part of the artwork or leave the wood exposed. Always attach eyelets for wiring on the insides of the cradles, so that the panel hangs flush to the wall. An added benefit of cradled edges is that they reinforce the panel against flexing or warping.

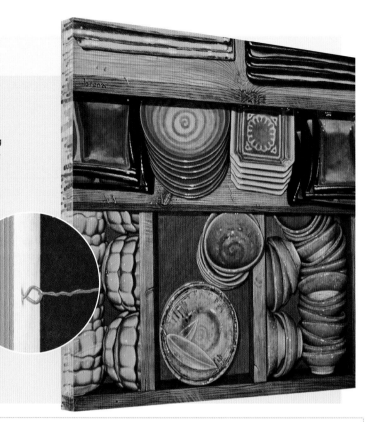

HOW TO PREPARE A PANEL FOR PAINTING

TECHNIQUE FILE 13

All wood and composite-fiber panels are porous and should be sealed before painting, to waterproof the panel, avoid future discoloration caused by chemical reactions and prevent potentially harmful emissions. Applying the sealing agent on both panel sides will inhibit warping.

You will need

- Your panel of choice
- Mask or respirator
- Sandpaper
- Clean, damp cloth
- Flexible polymer acrylic (gloss)
- Broad, flat brush
- Gesso (apply by brush, roller or spray)

- Optional: unprimed cotton or linen canvas or watercolor paper at least 1 inch (2.5 cm) larger all around than the panel, plus a sharp blade or X-acto knife

1 Wearing a mask or respirator, roughen and even out the surface by sanding it. This will create tooth for better adhesion of the sealant.

2 Thoroughly remove all dust using a clean, damp cloth.

3 Apply two coats of a flexible acrylic polymer to both sides and all edges. Respect drying times between coats and do not sand between layers. The first coat will seep into the porous fibers, while the second coat will create a barrier keeping contaminants in and moisture out.

4 For maximum protection, allow the polymer to coalesce into a uniform film by letting it dry between one and three days.

5 Apply a minimum of three coats of acrylic gesso (dilute with up to 25% water if desired), sanding lightly between coats. Your panel is ready to be painted!

6 Canvas or paper surface: Apply acrylic polymer medium or archival glue to your panel and mount the canvas or watercolor paper, smoothing out any air pockets. Once dry, use a sharp blade to cut the protruding edges flush with the panel. Apply gesso to the canvas.

HOW TO PREPARE A METAL PANEL FOR PAINTING

You will need
(for copper, aluminum or ACP)

- Your metal panel of choice
- Mask or respirator
- Steel wool, abrasive pad or sandpaper (320 grit or finer)
- Clean cloth
- Isopropyl alcohol (rubbing alcohol)
- Gesso (apply by brush, roller or spray)
- Flexible polymer acrylic (gloss)
- Broad, flat brush

- Optional: unprimed cotton or linen canvas or watercolor paper at least 1 inch (2.5 cm) larger all around than the panel, plus a sharp blade or X-acto knife

1 Wearing a mask or respirator, abrade the surface with steel wool, an abrasive pad or sandpaper until it's no longer shiny, providing tooth.

2 Degrease the metal surface with a cloth moistened in isopropyl alcohol (rubbing alcohol) and leave to dry until the solvent has evaporated completely. Avoid touching the metal surface with bare fingers.

3 For an opaque surface, apply several layers of gesso by brush, spray or roller, and sand for additional smoothness if desired. The panel is now ready to be painted.

4 For a transparent surface, apply several layers of transparent (glossy) polymer acrylic. Do not sand. The panel is now ready to be painted, leaving the color of the metal exposed if so desired.

5 Alternatively, after cleaning with solvent, apply acrylic polymer and mount paper or canvas to the panel, smoothing out any air pockets. Once dry, use a sharp blade to cut the protruding edges flush with the panel. Apply gesso to the canvas.

Metal panels

Historically, artists have painted on silver, copper, tin and lead. Only nonferrous metals are suitable to paint on with acrylics, because they allow water-based priming that will not cause oxidation. Aluminum and copper are the best metals for acrylic painting.

Copper Copper is a reddish orange, non-oxidizing soft metal, which easily contracts and expands during temperature changes. Despite its fragility, it is an interesting surface to paint on.

Properly preparing the copper plate is essential to achieve a satisfactory painting surface. Be sure to remove all blue or green copper salts during the initial sanding, as described in the panel preparation instructions for metals, see left.

Aluminum Aluminum is a rigid, lightweight, non-oxidizing metal, with excellent archival properties because humidity or fluctuating temperatures don't affect it. Its low weight makes it ideal for large-format paintings and easy transportation.

Aluminum composite panel or ACP An aluminum composite panel, such as Dibond, is a rigid, lightweight panel made of a solid polyethylene center sandwiched between two thin sheets of aluminum. Measuring between 2 and 4 mm thick, they are available in different sizes at sign-makers and/or sellers of building materials. Large sheets are easily cut into smaller panels. ACPs are ideal supports for large murals, because they remain unaffected by moisture and do not buckle, distend or separate. Widely used in the signage industry, ACP is currently being hailed by artists and conservators as the perfect archival, museum-quality panel for fine art.

Please note that Dibond is a trademarked name that is rapidly becoming the generic name for all aluminum composite panels. A variety of manufacturers sell similar products, so the correct terminology is aluminum composite panel—unless, of course, it is made by Dibond.

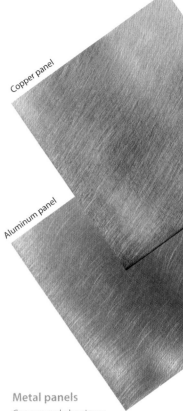

Copper panel

Aluminum panel

Metal panels
Copper and aluminum are the best metals to paint on using acrylics. Once they are properly prepared they do not oxidize, corrode or warp due to atmospheric changes.

Aluminum composite panel

We all fantasize about the perfect studio, imagining the artistic heights we would reach in such a workroom, yet most of us manage and even thrive in whatever available setting we designate as our studio, finding creative solutions to the limitations of the space.

THE ARTIST'S STUDIO

The word studio comes from Italian *studio*, meaning "study room." Another word for artist's studio is *atelier*, from the French meaning "workshop." Both words—studio and atelier—convey the artist's dedication to the continuous process of creative growth and gaining artistic skill.

You can convert almost any space into an art studio, although compact and/or shared areas will demand compromises and ingenuity. The fact that acrylics are odorless and nontoxic permits painting in a shared area or a bedroom, although it is essential to keep paint and mediums out of the reach of children and pets.

Not having a perfectly appointed dream studio isn't a valid excuse not to paint. If you have a roof over your head, you can find a place to set up your studio—it can be the kitchen counter, an allocated corner of the family room, a guest room, or the garage. Or become a plein-air artist and paint outdoors. If you really want to paint, you'll find your studio!

Remember, having the perfect dream studio is wonderful and makes life much more enjoyable, but a physical space won't make you a better artist: that talent lives inside of you!

Whether your studio is spacious, compact or part of a shared space, it has three basic requirements: a work surface, adequate lighting and functional storage.

Work surface and painting position

The first consideration is the surface that holds your painting support, be it canvas, panel or paper (see pages 52–55). Placement of your work surface should allow you to position your body with the dominant hand side slightly turned toward your painting to allow unhindered arm movement.

Linked to your choice of work surface is your preferred painting position. You can paint standing up or seated. Many artists alternate between the two, although when working from a live composition it's best to choose one position in order to maintain the correct perspective.

The standing position offers mobility for a looser, more dynamic expression, and allows you to step back to assess your painting. It also burns calories. To avoid back ache, use a small block or low stepstool to place your foot on, occasionally switching sides. To maintain a correct posture and to avoid straining neck and shoulders, place the painting at the height of your torso.

The seated position offers comfort, stability and more control for detail work. Stepping back is cumbersome, but squinting helps create the effect of distance. Avoid hunching over, and stretch your back and neck regularly. Use a chair or stool for painting at a table or easel. The

Storage solutions
Glass-fronted cupboards enable materials to be kept dustfree and out of the way, yet still visible.

Having colors, equipment and art books within easy reach makes the studio more inviting.

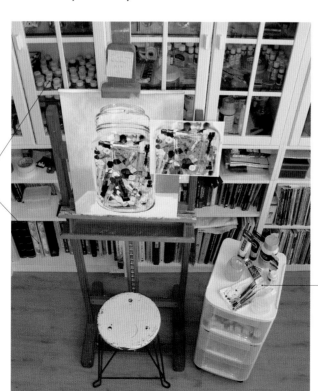

A set of drawers on casters functions as a side table and convenient storage.

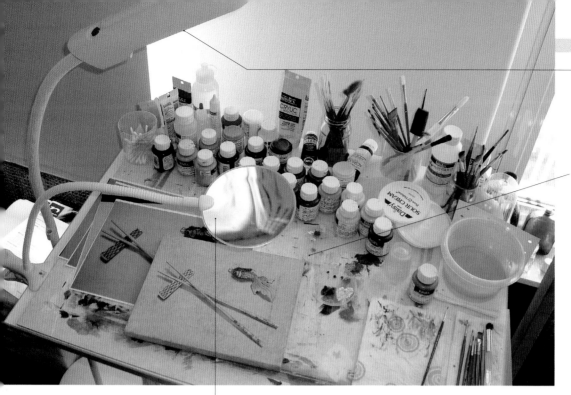

A daylight lamp provides constant unchanging light at any time of day.

Even a small drafting table can offer sufficient space to paint comfortably.

The basics for choosing a full-spectrum lamp

Color temperature (CT) is measured in degrees Kelvin (K).
• 3,500°K mimics neutral or natural white daylight.
• 5,000°K mimics bright white daylight.
• 6,500°K mimics cooler bluish-white north light.
• Below 3,000°K light becomes too yellow—except for the incandescent neodymium light bulb of 2,800°K, which is similar to daylight.

Artificial light
A repositionable light and a magnifying glass ensure great visibility.

A clip-on magnifying glass is ideal for very fine detail painting.

Natural light
Setting up your workstation next to a large window (below) will enable you to make the most of natural light.

drawing board allows you to paint while sitting in an armchair. A high stool, with or without back, makes your seated position similar to standing, and offers the best of both worlds.

Lighting

Most people, including many artists, believe that a good studio needs north light shining in from above. This outdated belief originates from times prior to the invention of electrical light.

Since most of us do not have a choice in the location of our studio and many of us paint at night, we must rely on artificial lighting. In fact, when a window sheds harsh or direct light, it is better to cover it partially or completely. Artificial light offers several important advantages:
• It is reliable, constant and unchanging, whether it's morning, afternoon or night, and it reduces eyestrain due to fading light.

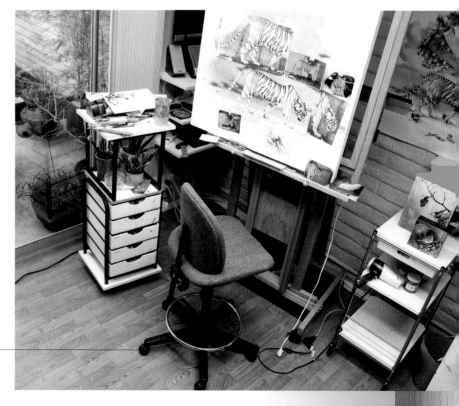

A good-quality office chair offers comfortable seating for long painting hours.

The Artist's Studio continues over the page ⟶

Working from life
Whether working en plein air or in the studio, Flora Doehler surrounds herself with nature.

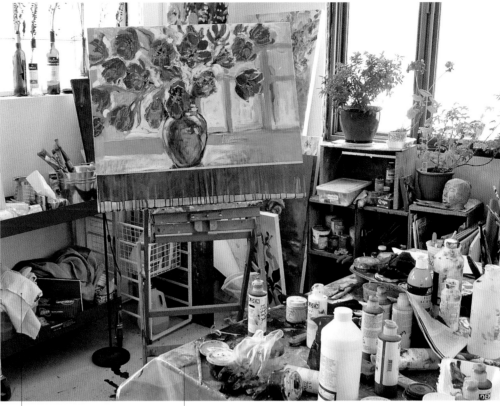

Baskets and shelves provide ample and accessible storage space.

Cover a flat surface to avoid spills and spatters from staining it.

Portable
Keeping your art materials on a portable trolley means you can easily set yourself up wherever there is space in your home.

• It is repositionable and/or dimmable, eliminating distracting glare and reflections.

• It illuminates from a fixed position and angle, which is especially important when painting from a live composition.

• Today most artwork displayed in homes, galleries and museums is viewed in artificial light. Painting under similar lights will ensure that colors and values of the finished artwork are experienced as intended.

• For those of us living in dreary gray climates, artificial light beneficially impacts our mood and sense of well-being.

The most important factor is the light itself, which can be in the form of an incandescent light bulb with screw-in socket, fluorescent tube, LED (light-emitting diode) or halogen. The best illumination for painting is full-spectrum daylight-simulation light—it mimics natural light, allowing us to see the true nature of colors. The right balance between warm and cool light has little to no temperature bias and will not distort colors. Full-spectrum lighting is becoming more affordable.

Storage

Every artist needs adequate storage to keep tools, equipment and paints dust free and out of the way. Studios located in shared areas, such as family rooms, need smart portable or movable solutions for easy clearing up and retrieval. Avoid complicated storage that discourages you from setting up and painting.

Store art supplies such as paints and small tools in clear plastic boxes, bins, baskets, trays or collapsible tackle or sewing boxes. Store brushes upright in pots, jars, vases or jugs or horizontally in a lidded box, brush travel case or roll-up mat.

The ideal storage space is an empty closet—but who has empty closet space these days? Mounted wall shelves, a cubby system, a dresser or even a night stand can hold a multitude of things. Scout for secondhand furniture to save money. Mount casters underneath drawer cabinets for easy moving.

A computer screen can display your reference image and easily zoom in on details.

Use headphones to drown out ambient noise, and listen to music or audio books while you paint.

Cover the floor of your work area with plastic sheeting to keep it clean.

Always set up your palette and tools on the side of your dominant hand.

Keep your painting-in-progress on an easel, in a corner or against the wall. Hang as many paintings in your studio and home as possible—if you lack walls, consider loaning pieces to trusted friends or loyal family members to keep your artwork safely on their walls. Ideally canvas and panels should be stored in a vertical position.

Paper should preferably be stacked horizontally, but large flat cabinets with drawers or open shelves can be expensive and take up space. As an alternative, consider storing paper in paper drying racks, a tie closure portfolio or rolled up in a tube. Print racks also work well for heavy papers, illustration board and panels.

Some easels, drafting tables and paintboxes offer built-in storage, as do most desks. A mobile cabinet, such as a taboret or a small chest of drawers on casters, allows easy access to your tools while you paint.

Physical and geographical considerations

• Artist's studios located in hot or subzero climates need temperature control to protect acrylic paintings from becoming sticky (at 140ºF/60ºC) or cracking (below 40ºF/4.5ºC). Insulate the studio attic, garage or garden shed.

• The height of your studio ceiling impacts the possibility of setting up a large easel.
• Partially or completely cover windows that let in harsh light with white paper, white sheets, diffuser fabric, shades or curtains.

Cleanliness
• An oversized plastic garbage can is a must-have.
• Most carpet stores sell inexpensive remnants to cover your studio floor.
• Protect a nice tabletop or fine desk with a vinyl tablecloth or thick plastic sheet.
• Use a plastic office chair mat underneath your easel to protect the floor from spatters and spills.

Inspiration
• Add a bookcase to have your art and reference books at hand.
• Fresh flowers and plants create a sense of well-being, especially in windowless studios. Your full-spectrum light source will keep plants healthy.
• Hang a notice board to pin up thumbnail sketches, inspiring images and lists.

Working from reference

The modern studio is incomplete without a computer—whether desktop, laptop or tablet. It can be used while painting to display reference or to play music.

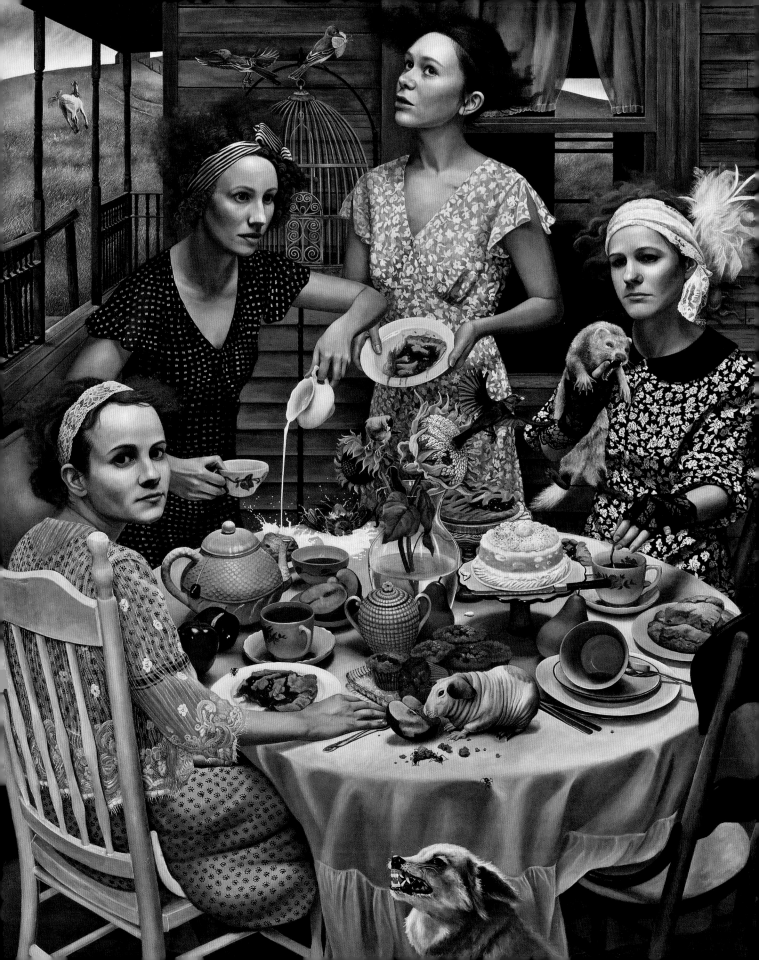

THE FOUNDATION

Color helps us communicate what we want to convey in our artwork. Each color impacts us in a highly personal manner, regardless of subject matter and content. This chapter looks at the rudimentary basics of color theory, color mixing and matching, and the way in which harmonious color choices and the correct values help paintings come alive. This will inspire you to experiment and familiarize yourself with color pigments, leading you toward discovering your favorite color palette. We'll also look at different methods of preparatory work, and the best ways to start a painting and bring it to a successful conclusion. Your choice of approach will depend on your painting style, genre and personal preferences.

Main picture
AN INVITATION
BY ANDREA KOWCH
60 x 48 inch (152 x 122 cm)
Understanding the foundations of art theory will enhance your skills, whatever your art style. This complex, intriguing and accomplished painting skillfully uses a muted color palette to depict a myriad of wonderful textures.

Above from left to right
TEXTURED LANDSCAPE (detail)
BY STEPHEN RIPPINGTON
see page 113

CALAVERAS EN EL FLORIDITA (detail)
BY DAVID NAYLOR
see page 101

BROKEN DREAMS (detail)
BY DON EDDY
see page 107

COLOR SPHERE (detail)
BY PHILIPP OTTO RUNGE
see page 95

Color theory represents color relationships as a wheel and attempts to explain how colors affect and interact with each other.

COLOR THEORY

Light is composed of many colors; the human eye perceives the colors of the visual spectrum, which are yellow, orange, red, violet, blue and green. To describe a color, we typically convey its name, value (light to dark) and level of saturation (intense to dull).

The study of color theory has given us the color wheel as we know it today. The theory behind the color wheel is based on the belief that all colors can be obtained by mixing the primary triad (red, yellow, blue). Since we're not dealing with light, the color wheel is not an accurate formula for mixing paint colors due to the varying properties of pigments—but it is a starting point for understanding color.

History of color theory

The principles of color theory first appeared in texts by Leon Battista Alberti (1404–1472) and Leonardo da Vinci (1452–1519). Ever since, artists and scientists have continued to study color and develop color theories.

The invention of the color wheel is attributed to Sir Isaac Newton (1643–1727). The color wheel links the two ends of the color spectrum together to illustrate the inherent progression of colors. This circular diagram became the paradigm for future color systems based on the three primary colors (red, yellow, blue) and their complementaries (green, purple, orange).

7- and 12-color circles
Attributed to Claude Boutet, ca. 1708. Color theory was originally expressed in terms of three primary or "primitive" colors, namely red, yellow and blue. These colors were believed to be the basis to mix all other colors. Today most color mixing is still based on this premise.

Goethe's color wheel
Goethe's symmetrical color wheel, published in his book *Theory of Colors* (1809), associated colors with symbolic and emotional qualities as perceived under a wide range of environmental conditions.

Runge's color sphere
Philipp Otto Runge's *Color Sphere* (ca. 1806) expanded on the primary color wheel as basis to mix all colors by including black and white to create tones and tints.

Johann Wolfgang von Goethe (1749–1832) created a color wheel evoking the psychological effects of colors, depicting reds, oranges and yellows as warm (positive/plus) colors and greens, violets and blues as cool (negative/minus) colors.

Albert Henry Munsell (1858–1918) expanded the flat color wheel into a three-dimensional diagram mapping not only color but also value (darks and lights) and chroma (saturation).

Munsell created a vertical value scale through the center of the color circle and a horizontal axis for chroma, making a model that accurately maps hue, chroma and value for each color. The vertical pole indicates the value of the color emerging from it, that value being uniform over the entire level going outward. The horizontal "arm" shows chroma—the color's intensity—dulling down toward gray (losing chroma) at the

Munsell color system
Munsell's color system presents a three-dimensional view showing all three color-making attributes: lightness, saturation and hue.

Color Theory continues over the page ⟶

MIXING COMPLEMENT HUES

PY97 **hansa yellow**

cadmium yellow
PY35

hansa yellow deep
PY65

PY151/154 benzimida yellow
PY3 hansa yellow light

anthra-
pyrimidine
PY108

PY153 **nickel dioxine yellow**
PY110 **isoindolinone yellow**
PY35 cadmium yellow deep

6 *violet*

PY35 **cadmium lemon**
PY184 bismuth yellow

phthalo yellow green

PY175 benzimida lemon

benzimida orange
PO62

cadmium orange
PO20

PO73 **pyrrole orange**
PO43 perinone orange

PY150 nickel
azomethine

PY117/129 copper azomethine

chrome titanate
PBr24

quinacridone
gold PO49

PR188 naphthol scarlet
PR108 **cadmium scarlet**
PR255 pyrrole scarlet
PR254 **pyrrole red**
PR108 cadmium red

PY53 nickel titanate

yellow ochre
PY43

PY42 **gold ochre**

perylene
scarlet
PR149

permanent green light

olive green

PBr7 raw sienna

PO48 quinacridone orange

PR209 **quinacridone red**
PR108 cadmium red deep
PR N/A quinacridone pyrrolidone
PR177 anthraquinone red

sap green

PBr7 burnt sienna

quin. maroon
PR206

5 *red violet*

hooker's green

PG36 **phthalo green YS**

PG50

PBr7 raw umber
PBr7 burnt umber

PBr25

PR101
venetian red

PR179
perylene
maroon

PV42 quinacridone pink
PV19 **quinacridone rose**

cobalt titanate YS

PG17 chromium
oxide green

PV19 **quinacridone violet**

PG18 viridian

PBk31 perylene black

sepia

PBr7
mars violet

benzimida
maroon
PR171

quinacridone magenta

4 *red /
deep red*

phthalo green BS

PW6 titanium
white

PG50 cobalt titanate BS

PG26 cobalt
green dark

PBk6
carbon black

*0
CIECAM hue angle*

PG19 cobalt green pale

PB36 cobalt turquoise

indigo

PR88
thioindigo violet

PG50 **cobalt teal blue**

dioxazine violet
PV23

PV16 **manganese violet**

PB16 **phthalo turquoise**

indanthrone blue
PB60

PV49 cobalt violet

PB36 cerulean blue GS

prussian blue
PB27

PV14 cobalt violet deep

3 *red orange*

PB35 cerulean blue

PB17 **phthalo cyan**
PB33 manganese blue

PB15 **phthalo blue**

PV15 ultramarine violet RS

PB15:3 GS

PB15:1 RS

PB28 **cobalt blue**

PV15 **ultramarine violet** BS

PB74 cobalt blue deep

PB29 **ultramarine blue**

2 *orange*

1 *yellow orange*

*chart shows CIECAM hue angle and chroma
of masstone pigments averaged across all
paint brands in the guide to watercolor pigments.
convenience mixtures are labeled in italics*
http://www.handprint.com/HP/WCL/waterfs.html
source: http://www.handprint.com/HP/WCL/cwheel06.pdf

CIECAM chroma

artist's color wheel
©2009 Bruce MacEvoy

center of the system and becoming purer and brighter (increasing chroma) as it goes outward. Visualize this chroma scale extending farther outward to eventually become a strong bright red located at Value 5 and Chroma 24.

Bruce MacEvoy flattened the Munsell Color System to map the hue, chroma and value of color pigments found in modern watercolors—which share a vast majority of pigments present in modern acrylics. This system shows that some colors are represented by many pigments and others by few pigments. Pigments also vary widely in chroma, tinting strength and value. This uneven distribution of color pigments and their fluctuating properties explains why mixing paint isn't as straightforward as the traditional color wheel suggests.

Still, these color wheels and systems can be used as a visual guide to mix new colors and values.

MacEvoy's Artist's Color Wheel

MacEvoy's color wheel maps out the pigments found in modern watercolor paint.

However, because you are dealing with a diversity of pigments with varying personalities it is useful to experiment with color mixing to acquaint yourself with the properties of the pigments of the acrylic colors you use. Making your own color wheels can prove highly enlightening, as well as making swatches of each of your colors for quick reference during painting sessions. Over time you will know exactly what to expect from each color—whether pure, diluted or mixed with other hues.

COLOR WHEEL

The color wheel or color circle is a visual depiction of colors arranged according to their chromatic relationship.

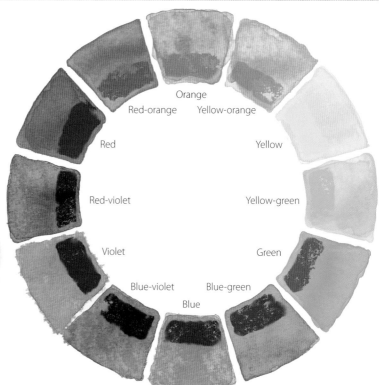

Orange
Red-orange Yellow-orange
Red Yellow
Red-violet Yellow-green
Violet Green
Blue-violet Blue-green
Blue

Primary colors The primaries are red, yellow and blue. Also known as the first or principal colors, these cannot be made by mixing together other colors. There are warm and cool versions of each primary color due to a slight color bias that leans toward one of the other two primaries.

Primary colors

Secondary colors

Secondary colors appear when any of two primary colors are mixed together. Red and yellow make orange, yellow and blue make green, and blue and red make violet. The resulting secondary color depends on which version (color bias) of red, yellow or blue you have chosen as your primary.

Secondary colors

Tertiary colors Tertiary, or intermediate, colors are made by mixing together one primary color with an equal amount of the secondary color nearest it on the color wheel. This results in red-orange, yellow-orange, yellow-green, blue-green, blue-violet and red-violet.

Tertiary colors

Complementary colors

Complementary colors

Complementary colors

Analagous colors

Complementary colors Complementary colors are those directly opposite each other on the color wheel, and always consist of a warm and a cool color. Examples of complementary pairs are red and green, blue and orange or yellow and violet. Placed side by side, complementary colors seem to intensify one another. When complementary colors are mixed together, they subdue or neutralize each other's intensity.

Analogous colors Analogous colors are those located close together on a color wheel. The analogous color scheme produces a harmonious monochromatic look, which can be warm or cool in temperature. This example shows four analogous colors creating a balanced palette.

Color Theory continues over the page ⟶

COLOR TERMINOLGY

To better understand color, it is useful to know the vocabulary used in color language.

Hue Hue is simply another name for color. Red, yellow and orange are all hues. Lemon Yellow, Cadmium Yellow and Indian Yellow, all being yellows, are close in hue to each other. On acrylic paint labels, color names followed by the word "hue" mimic the referenced color but are not composed by its traditional pigments.

Shade A shade refers to a darkened variation of a hue, and describes a color that has been darkened by mixing in a dark color, such as black. A shade can also be obtained by adding its complementary color to darken it without drastically altering the color. The range of possible shades stretches from the pure color through to black.

Tint A tint refers to a lighter variation of a hue, describing a color that has been lightened by adding white or through heavy dilution. The tinted range of any one color can run from the pure color at its maximum intensity through to white.

Saturation, chroma or intensity Saturation, also called chroma or intensity, describes the relative purity of a color in relation to gray. Pure colors are fully saturated. Desaturated, achromatic or neutral colors have been toned down by adding white, gray or black or by mixing them with their complementary color.

Tone Tone describes a color's relative lightness or darkness, and is a term that can be used to describe both a tint and a shade. Lemon Yellow is light in tone, while Indigo Blue is dark in tone—but if you add enough white to Indigo, the resulting tint will be closer in tone to Lemon Yellow.

Value This is another term that describes the lightness or darkness of a color. Independent of hue, values range from the lightest light to the darkest dark. Value should not be confused with brightness or intensity.

Color bias or undertone All colors have a bias toward another color, although at full strength this is often difficult to assess. By brushing out the color thinly on a white surface or by adding white, the undertone or color bias is easier to see. This is important for mixing intense, bright colors, because blends of colors with a bias toward each other are the strongest.

Temperature All colors are described as being either warm or cool. On the color wheel, red, orange and yellow are described as being on the warm side, and green, blue and violet as being cool. However, all colors have warm and cool variants: Alizarin Crimson, although a red, has a definite blue bias, so it is described as a cool red, while Cadmium Red, having an orange bias, is described as a warm red.

Color palettes are fascinating, especially those used by well-known artists, as they provide a little insight into what makes a painting great.

CHOOSING COLORS

Color perception is a complex and highly personal topic; what looks harmonious and exciting to one person may look dull and uninteresting to the next. Some people prefer an overabundance of color, while others prefer a subdued, monochromatic look.

Suggesting or recommending a color palette for a specific subject matter is difficult because there are too many variables. For example, landscapes differ in color not only due to geographical and geological features, but also season and time, and skin tones vary greatly, even among people of the same ethnic background. See pages 234–235 for suggestions on color palettes for painting skin.

Artists who paint realistic colors (exactly what they see) match their color palette to their composition. Artists who diverge from pure realism and alter colors by creating their own color scheme need to plan their palette according to the mood they want to express.

While there are plenty of wonderful suggestions to be found, the truth is that there is no universal formula for the perfect color palette. Most paint manufacturers sell introductory or starter sets, usually consisting of six tubes of color. Some of these sets lack essential colors, yet include colors you can easily mix yourself. Although a starter set can be expanded with other colors, having too many colors can complicate matters. It is very tempting to buy as many different colors as you can afford, but the key to mastering color is to restrict your palette and build it up over time.

The limited or restricted palette
Starting with a limited palette of a few colors will increase your understanding of how pigments interact and improve your color-mixing skills. Blends that originate from a small number of colors are usually well-balanced and harmonious because they are closely related to each other.

Organize your palette

The way you lay out your colors on the palette is a matter of personal preference. Develop a logical arrangement in your color layout, and get into the habit of always using the same pattern so that it's easy to find your colors.

For example, lay out your colors:

• From warm to cool
• Separating transparent and opaque
• From light to dark

You might like to place your paint along the top, saving the middle and lower section of the palette for mixing.

Reserve a larger area for white—either at the beginning of the light colors or somewhere in the middle between light and dark colors.

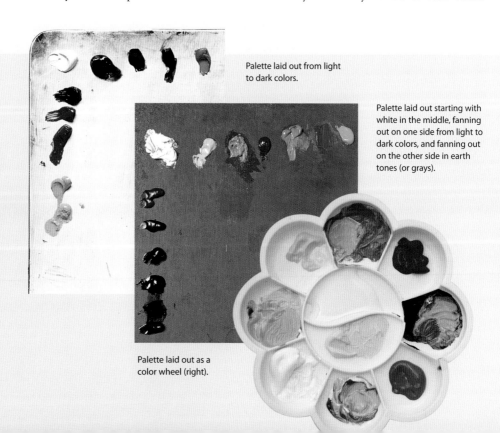

Palette laid out from light to dark colors.

Palette laid out starting with white in the middle, fanning out on one side from light to dark colors, and fanning out on the other side in earth tones (or grays).

Palette laid out as a color wheel (right).

Since you need only a few tubes, a limited palette allows you to buy the best-quality acrylic paint.

Of course, the limited palette has its disadvantages. It can become repetitive or boring, and some color mixes may be impossible to obtain. This is why it makes sense to add additional colors to your palette over time, one by one, taking time to acquaint yourself with the new pigment's properties and possibilities and create new color schemes.

See pages 48–49 for suggestions on how to build up a color palette starting with a restricted palette and adding colors over time.

The Zorn palette

Anders Leonard Zorn (1860–1920) developed a limited palette consisting of Yellow Ocher, Cadmium Red Light, Titanium White and a cool black, such as Lamp Black. While this palette contains no blue, cool gray blends tend to appear blue when offset against warm reds and ochers. The Zorn palette offers a muted, subdued color scheme that lends itself well to portraiture. Although it lacks strong blues and vivid greens, it can also be used for other subject matter, such as landscape.

The Zorn palette offers a harmonious color scheme and is a good place to start if you want to try out a restricted palette. Over time you can add Viridian Green, Cerulean Blue and Alizarin Crimson to extend the color scheme.

The primaries palette

Theoretically the primary triad can produce all colors, but due to the limitations of the pigments and temperature (color bias) of the hues, this isn't straightforward.

Cool primaries mix a wider range of hues than the warm versions can. Therefore, if you are attracted to a palette of primaries, your basic selection should contain the cool version of each primary plus Titanium White.

Expand your basic primary palette into a split-primary or color-bias palette by selecting a cool and a warm version of

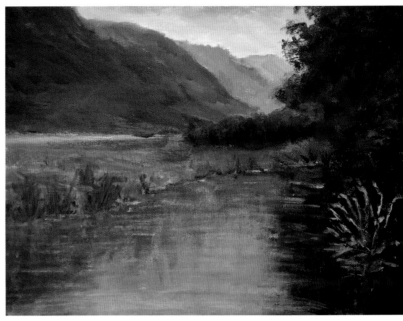

Lake Gunn, New Zealand
by Hazel Persson
12 x 15 inch (30 x 38 cm)
This elegant landscape was painted using the Zorn palette, masterfully counterbalancing cool colors against warm ones to create the illusion of realistic blues and greens.

Zorn palette
The Zorn palette is based on ocher, red, black and white. Despite lacking blue, this palette can be used for most any subject matter.

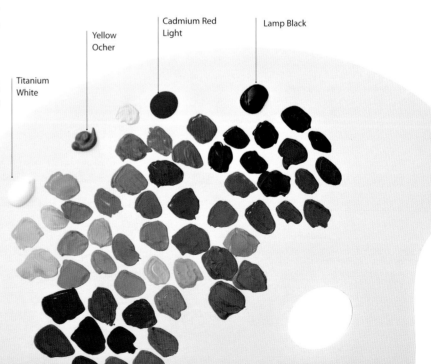

Calaveras en el Floridita
BY DAVID NAYLOR
23½ x 31½ inch (60 x 80 cm)
This delightfully vivid painting was created with a palette of mostly cool primaries, skillfully juxtaposing large areas of intense color and balancing the composition using subtle neutrals.

Choosing a color scheme

• Identify the main color of importance in the composition.

• Look at the other colors in the composition. Determine their relationship with the main color.

• Define one or several color schemes.

• Evaluate whether these color schemes will work for your interpretation of the composition, considering the mood you want to convey.

• Locate colors in the composition that may not suit your color scheme(s).

• Evaluate whether or not these dissonant colors should be altered to align them with your color scheme.

• Select your acrylic paints paying close attention to color, temperature and color bias. Consider using cool and warm versions of each color.

• Premix the colors in large enough quantities to maintain consistency throughout the painting. Keep mixed colors in airtight containers.

Primaries palette
The primaries palette is based on yellow, red, blue and white. The cool primaries offer the widest range of hues you can mix.

each primary color, plus Titanium White. This palette offers a superior array of hues, including vivid greens, bright violets and deep purples.

Developing a personal palette
As you continue to explore the possibilities of mixing colors and create the color schemes that most appeal to you, you will discover that you tend to use some colors more often than others. The colors that you use repeatedly and cannot do without eventually form your personal palette.

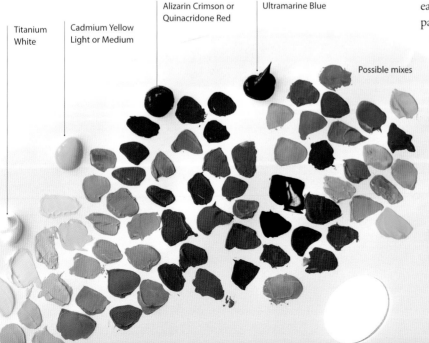

Titanium White

Cadmium Yellow Light or Medium

Alizarin Crimson or Quinacridone Red

Ultramarine Blue

Possible mixes

While many artists make color-mixing decisions based on intuition or emotion, it is valuable to understand the properties of pigments and learn how to modify colors.

MIXING COLORS

Reading about color theory is no substitute for the experience you accumulate by physically mixing colors. Over time you will refine your skills and strengthen your confidence, hence time spent mixing colors is really never wasted—even if you do not succeed in achieving accurate color matches at first. Even the mistakes you make are valuable if you pay attention to the results. Familiarize yourself not only with the colors but also with the properties of the pigments you use, such as their opacity, temperature and tinting strength.

There are several ways of mixing acrylic colors.

• Palette or mixing tray: Mixing colors on a palette is the safest method, especially for beginning artists, as you can start afresh when colors are not satisfactory. Add retarder to give yourself more open time if needed.

• Painting surface: You can also mix paint directly onto the canvas, panel or paper by using techniques common to both oil and watercolor painting, such as wet-in-wet and scumbling.

• Transparent layering: Optical mixing is also executed directly on the painting support by layering transparent colored glazes over each other to create an optical illusion of mixed colors.

Acrylic paint can be mixed with a palette or painting knife, as well as by brush. The more viscous the acrylic, the firmer the brush should be for adequate mixing. Liquid or fluid acrylics should be stirred or combined gently to avoid foam and bubbles. Depending on the effect you want, colors can be mixed completely and evenly or left as an uneven marbleized mixture.

Consider premixing a few base colors for each painting and storing them in a moisture-retaining palette or lidded containers. Mix more than enough of each color to ensure color continuity in your painting.

HOW TO IDENTIFY COLORS

TECHNIQUE FILE 15

Preconceived ideas of the world's colors influence our ability to identify them, and surrounding colors also affect one another. This makes it hard to accurately mix colors and values, especially when applied on a white painting support.

It may prove helpful to isolate the target color and match it to a swatch of a color-matching guide, which can be done in a live setting as well as using a reference image (see below).

If you are working from a digital photograph, you can use computer photo-editing software to isolate the target color by selecting the color area with the dropper tool in the digital image and then making a larger color swatch using the brush or bucket tool (see right). Once you have isolated your target color you can match it using the process opposite.

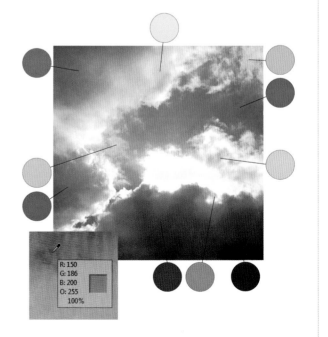

HOW TO MATCH A COLOR

1 Evaluate what hue the target color approximates on the color wheel or color-matching guide. This target color tends toward a medium-value muted pink.

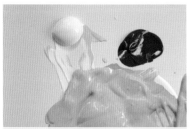

2 Titanium White and Cadmium Red Deep are mixed until the blend approximates the target color's saturation.

3 Obviously the pink needs toning down, so in this case a bit of Bone Black is added until the color is sufficiently muted.

4 Analyze value and chroma by holding a white card with a hole over your target color—use a punch to perforate holes in cardstock. The white card also functions as a matching palette: Brush the mixed color next to the hole and let it dry. Verify your match by positioning the card over the target color.

The range can be extended simply by varying the color ratios.

Although you can mix most of the secondary colors from two primaries, most ready-made store-bought secondary colors are stronger and brighter than those you can prepare yourself. It is almost impossible to mix a purple that equals in intensity to various store-bought purples, and Cadmium Orange cannot be surpassed in brilliance by any yellow–red mixture.

Mixing tertiaries, earth tones and neutrals
Tertiary colors are obtained by mixing together one primary color with the secondary color nearest to it on the color wheel. Earth tones and browns are created by mixing complementaries. Subtle neutrals can be achieved by adding white to these complementary-mixed earth tones. Neutrals and grays (see visual chart on page 105 and Painting Grays, pages 124–127) are made by mixing two complementary colors (such as red and green) and then adding white to obtain the desired value. All these ranges can be extended by varying the color ratios.

To achieve color harmony, prepare one or two base colors that can later be modified by mixing in other colors. For example, by adding different colors to a mid-value base skin color, you can adjust toward lighter and darker values, as well as cool it down or warm it up.

When you stumble upon a particularly successful color blend, make a quick color swatch on white cardstock with color and ratio annotations for future reference.

Mixing secondary colors
The most vivid secondary colors—oranges, violets and greens (see visual chart on next two pages)—are made by mixing the pair of primaries with a temperature bias toward each other, while more muted hues are produced by pairing those with an opposite bias. There are many ways to mix beautiful, subtle secondaries, as well as derivatives such as colorful earth tones.

Violets, purples, mauves, lilacs

Violet and purple are both located between red and blue on the color wheel, and because of their similarity these two color names are often used interchangeably by artists.

• Violet is a true color found at the end of the light spectrum, and purple is a combination of red and blue light.
• Purple leans toward the red, while violet leans toward the blue. Purple can be described as a reddish or pinkish violet. Violet can be described as a bluish purple.
• Mauve is a pale purple color, leaning toward a muted pinkish gray. To add to the confusion, mauve is also described as a pale violet.
• Lilac is a pale tone of violet, also described as mauve or light purple. It represents the average color of most lilac flowers.
• Mauve and lilac come in such a large range of subtle varieties that one cannot adequately describe these colors without showing a visual example.

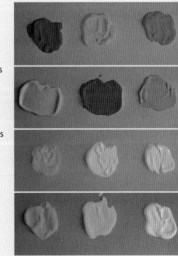

Violets

Purples

Mauves

Lilacs

MIXED ORANGES

A few examples of what kind of oranges you can mix with different yellows and reds. These oranges are frequently more muted and subtle than premixed store-bought oranges, ideal for subjects such as fall foliage or skin tones.

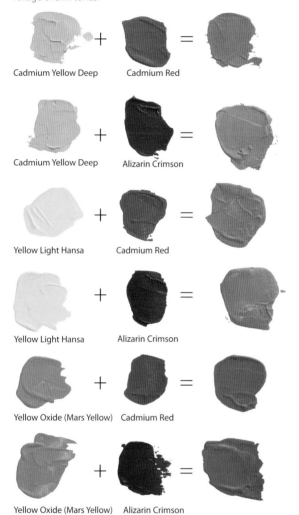

PREMIXED ORANGES

Premixed, store-bought oranges are brighter than studio-mixed oranges. The examples below show vivid and intense oranges that you can tone down by adding minute amounts of gray, black or its complementary, blue.

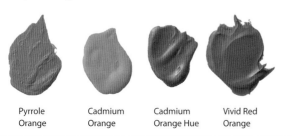

MIXED VIOLETS

A few examples of violets you can mix with different reds and blues. These studio-mixed violets are frequently muted and earthy in nature, lacking the intensity of store-bought violets. These violets lend themselves well to natural subjects, such as landscapes, wildlife and portraiture.

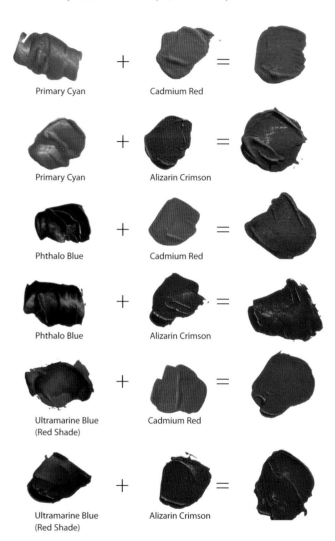

PREMIXED VIOLETS

Premixed, store-bought violets and purples are considerably more vivid than studio-mixed violets and purples. The examples below show vivid and intense hues that can be toned down by adding minute amounts of white or its complementary, yellow.

| Prism Violet | Ultramarine Violet | Quinacridone Blue Violet | Cobalt Blue Violet |

MIXED GREENS

Greens are by far the easiest secondary color to mix. By using different blues and yellows, as well as pairing or varying their temperatures, you can achieve an incredible range of greens—from vivid and bright to subtle and subdued. Very muted, earthy greens are mixed by adding minute amounts of black to any yellow.

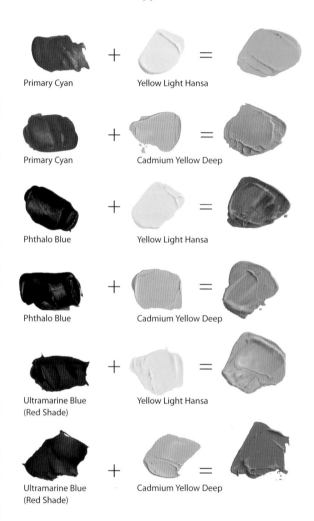

Primary Cyan + Yellow Light Hansa =

Primary Cyan + Cadmium Yellow Deep =

Phthalo Blue + Yellow Light Hansa =

Phthalo Blue + Cadmium Yellow Deep =

Ultramarine Blue (Red Shade) + Yellow Light Hansa =

Ultramarine Blue (Red Shade) + Cadmium Yellow Deep =

PREMIXED GREENS

The range of premixed, store-bought greens is quite impressive. Many artists find them too brash and use them as a base to achieve more subtle greens by mixing in any number of colors, depending on the desired results.

Phthalo Green (Yellow Shade) Hooker's Green Permanent Chromium Oxide Green Sap Green Permanent

MIXED NEUTRALS AND EARTH TONES

Vibrant earth tones and browns are easily created by mixing complementaries. Subtle neutrals can be achieved by adding white to these mixed earth tones. Playing with different proportions can skew neutrals and earth tones toward cooler or warmer temperatures. All of these can be used to mute other colors or to create monochrome palettes.

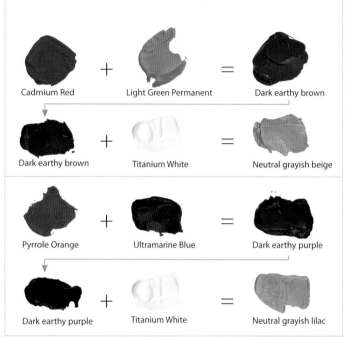

Cadmium Red + Light Green Permanent = Dark earthy brown

Dark earthy brown + Titanium White = Neutral grayish beige

Pyrrole Orange + Ultramarine Blue = Dark earthy purple

Dark earthy purple + Titanium White = Neutral grayish lilac

Cadmium Yellow Light + Prism Violet = Reddish yellow earth tone

Reddish yellow earth tone + Titanium White = Neutral beige

PREMIXED NEUTRALS AND EARTH TONES

An interesting range of store-bought neutrals and earth tones is available. Earth tones are pure single pigments that can be mixed without muddying. Premixed store-bought neutrals usually consist of two or more pigments, and range from sandy colors to grays.

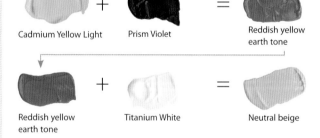

Burnt Sienna Yellow Ocher Burnt Umber Unbleached Titanium

Mixing Colors continues over the page ⟶

Optical mixing

Optical mixing is achieved by layering or glazing a transparent color over a previously applied dry layer of color. As the light shines through these transparent layers, they optically mix to form a new color. The method used by Don Eddy involves applying three separate transparent colors to complete the underpainting.

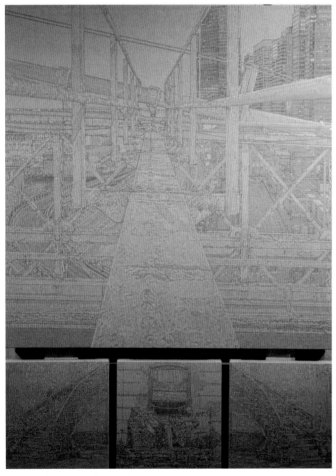

The first stage of the underpainting process begins by airbrushing small circles of transparent Phthalo Blue, a cool blue with a bias toward green. Each of these tiny circles, measuring approximately ¹⁄₁₆ inch (1.5 mm), has a specific value. While no imagery is rendered at this stage, at a distance these circles coalesce into what appears to be imagery.

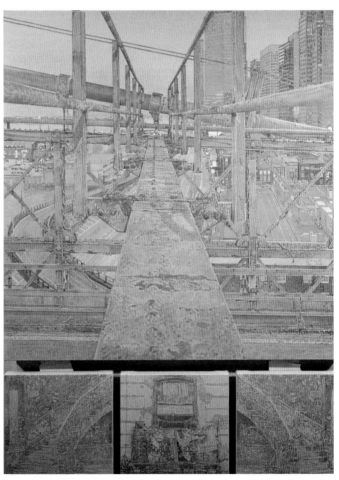

The second stage of the underpainting involves applying a layer of transparent Burnt Sienna to establish a very basic color system, separating the areas that will be cool from those that will be warm.

New hues and contrasting values appear by overlapping different transparent colors over one other.

Broken Dreams
by Don Eddy
51 x 38 inch (130 x 97 cm)
This extraordinary painting method creates colors and values produced by many layers of different transparent colors. White areas and light colors and values are generated by light filtering through to the primed canvas.

During the third stage, transparent Dioxazine Purple is used to further subdivide the color structure. The transparent purple separates greens from blues (on the cool side) and reds from yellows (on the warm side).

Next, the overpainting stage begins, adding between 10 and 20 additional transparent and translucent layers of paint in order to establish exact hue, value and intensity of each area of color.

Working from life
Create your own value filter from colored acetate to check values (above). Pinpoint values by holding a gray scale next to the composition to compare it to the values in your painting (right).

The term "value" refers to the relative lightness or darkness of a color. Values range from the lightest light to the darkest dark.

VALUES

The perception of value is mostly subjective, because values are relative to what surrounds them. The human eye perceives values even when hue and chroma have largely vanished from vision in low light. Value creates the main structure of the world around us, even though we seem to pay closer attention to colors and their intensity. In paintings, the lights and darks not only provide contrast but also suggest three-dimensionality.

How to determine value
A value scale typically starts with white and has a number of steps all the way to black. It often isn't easy to correctly assess value, but there are several techniques to help determine it.
• Squint to reduce the available light coming into your eyes to judge values.
• Look through a sheet of transparent red or green Plexiglas or acetate to assess values.
• Hold a gray scale next to the area you want to assess to find a match.
• Convert a digital image of the scene into a grayscale image, or make a black-and-white photocopy of the image.

Establishing pigment value
We tend to designate values to colors; for example, we tend to think of Cadmium Yellow as light in value, and Ultramarine Blue as dark in value. Yet matching colors to values is not at all straightforward because we are dealing with pigments, not light. Because each acrylic brand and color has different properties, it is worth making a personal swatch chart of your acrylic colors. You can use these swatches to compare against a value finder or

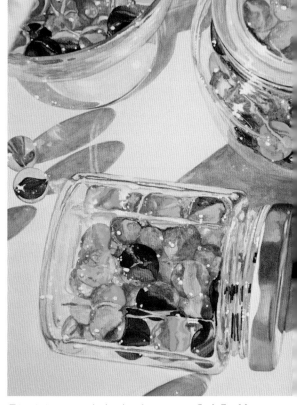

This painting contains both reds and greens, so assessing its values using red and green acetate will vary significantly. It is often helpful to use both color filters to evaluate the balance of your values.

CAT'S EYE MARBLES
BY LORENA KLOOSTERBO
12 x 16 inch (30 x 40 cr

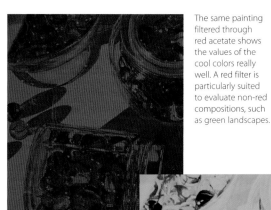

The same painting filtered through red acetate shows the values of the cool colors really well. A red filter is particularly suited to evaluate non-red compositions, such as green landscapes.

The same image filtered through green acetate shows the values of the warm colors well, but washes out the greens and blues.

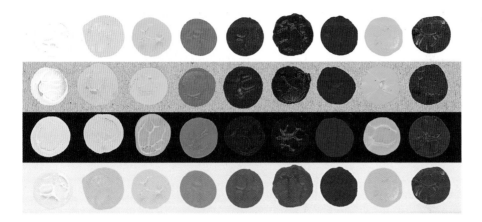

Judging values
Converting hues to black and white reveals their values. It's often easier to judge the values of different hues against a mid-value ground rather than a pale or dark-value one.

First values painted

The values isolated from the final painting

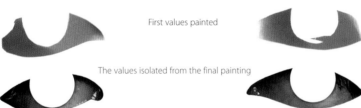

The importance of the correct value
Left and below The whites of the eyes are painted first, but without any surrounding mid-tone values for comparison it is hard to believe the value is correct. These isolated whites look unnatural and much too dark.
Below The finished portrait shows that the value of the whites was assessed correctly. If the whites were any lighter, they would look unrealistic.

your own painted gray scale. You can also scan your color swatches and convert them into a grayscale on your computer.

Color shift affecting values

As the acrylic polymer in acrylic paint dries it clarifies, resulting in a slight darkening of color. Color shift is especially noticeable among dark colors and when adding mediums. This makes it harder to blend the correct value in acrylics, because the value you see on the palette may not be the same as the dry result. It takes time and experience to assess how color shift affects your value blends. When a value has to be precisely matched, it is helpful to test it on a scrap of paper, let it dry, and then compare your swatch to the area you want to match. See pages 102–107 for methods on color mixing.

Painting values

Painting the right values is essential to achieve realism. When values are off, it affects the entire structure of the painting. The wrong choice of values may cause a lack of contrast, or an imbalance leaning toward being too light or too dark. A wrong value choice can severely disturb a painting—as, for example, when the white of the eyes or teeth are too light in a portrait. Note that we tend to err toward the light side more often than toward the dark. When you sense that your painting isn't optimal, assess its values—often a simple value adjustment significantly improves the painting. Remember that you can adjust values by glazing over them.

FLOYD
BY DRU BLAIR
18 x 14 inch (45 x 35 cm)

Every artist has a particular way of dealing with the process of creating a painting. Being conscious of all the stages between conception and completion helps streamline your approach.

APPROACHES TO PAINTING

Some artists are meticulous planners, highly organized in the way they go about the process of taking an idea all the way through to a finished painting. Many more just fly by the seat of their pants, semi-aware of the next phase, often getting lost, which forces them to go back or even just skip an important stage. Being mindful of your creative process and organizing it into logical steps can help a great deal. The emotional journey that accompanies the creative process is hard enough—a thoughtful approach will help avert unintended situations that pepper the process with doubt and anxiety.

Break it down
While most artists are capable of visualizing the stages from idea to completion, analyzing the steps clarifies them because you are forced to think about how and why you do them.

The sequence in which you work, or whether you skip certain stages, isn't important, as long as there's logic in your approach that helps you follow through. The following steps set out a common general approach to the creative stages of representational painting; adapt them to your personal process as well as your painting style.

Painting from beginning to completion
Literally thousands of little steps are required to complete a painting; most of these actions depend on many variables, such as painting style, subject matter and your personal preferences as an artist. Read through this rough list (below), pausing at each entry to reflect on your usual approach. Determine whether you can improve your methods to avoid pitfalls and make it easier to finish your painting without getting stuck or having to wonder what to do next.

Concept stage	Prep stage	Painting stage	Finishing stage
Start with an idea for a painting. (If you feel uninspired, copy an Old Master, experiment, play around, mix colors or try out a new technique.)	Select the type, format and size of your painting support.	Block in an underpainting or grisaille, if desired.	Assess the results every step of the way by stepping back.
	Prepare the painting support, if needed. Consider staining it in a mid-tone value.	Introduce a range of mid-tone values to help you establish the darkest darks and the lightest lights. Working from light to dark is the most common method, but you can certainly work from dark to light, or spread both ways starting from mid-tone values.	Decide whether your painting is finished or whether it can be improved. Put it aside for a few days, then reevaluate it with fresh eyes.
Make a few thumbnail sketches of your concept. Decide whether it works as a painting. If not, reformulate.	Sketch or transfer the line drawing onto the support, unless you prefer to paint direct.	Either block in the entire painting quickly, preparing it for later refinement, or work in sections.	
Gather reference material, if applicable. This can include sketches, color swatches, photographs, setting up a still-life composition, finding a plein-air location or getting a model to sit for you.	Select your acrylic colors, mediums and tools (e.g., brushes, knives, sponges).	It is easier (but not imperative) to work from back to front—paint or rough in the background first.	When finished, sign your painting (front and back).
	When mixing colors ahead of time, prepare more than you expect to need. Keep mixed colors in airtight jars or a lidded moisture-retaining palette.	Blend colors on the palette or blend directly on the painting support.	Photograph your painting.
		Unless you work wet-in-wet or alla prima, let paint dry between layers. Use a hair-dryer to speed up drying, or work on other areas.	Varnish your painting.
	Apply masking or frisket, if this is applicable.	Build up layers. Mind your brush strokes.	
		Start rough and gradually introduce more detail as you progress.	
		Add opaque hazy highlights first, hard-edged shiny highlights last.	
		Depict the finest details at the end.	
		Superimpose fuzzy edges such as grasses over the painted background.	

THREE APPROACHES

There are as many different approaches to painting as there are artists. Finding the approach that best supports your painting style and preference sometimes takes time. Experiment by changing the way you build up your painting to find which method best suits you.

Texture brushwork by Stephen Rippington

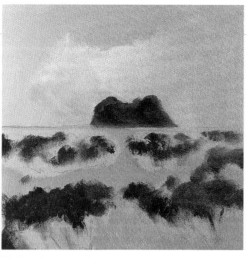

Block in the main colors and shapes with loose and expressive brushwork.

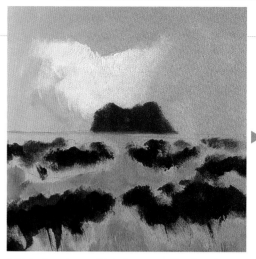

Add depth and consolidate the composition by using the same shadow color mix across the piece.

Grisaille or monochrome by Freda Anderson

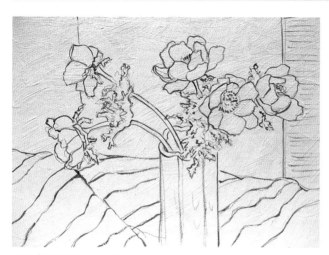

Use a fine brush to paint the linework.

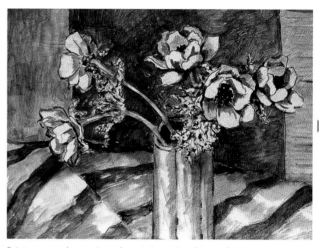

Paint a monochromatic underpainting using thin washes to build up tonal depth.

Light to dark by Ian Sidaway

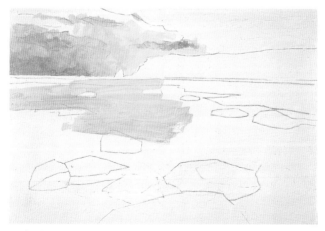

Establish the light source, painting the lightest areas first and—working wet-in-wet—gradually adding darker tones.

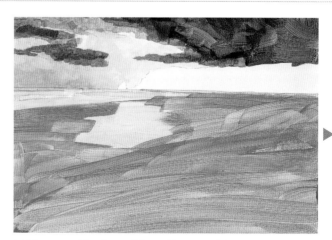

Add the sea and the sky, carefully working around the lighter areas.

Approaches to Painting continues over the page ⟶

Texture brushwork

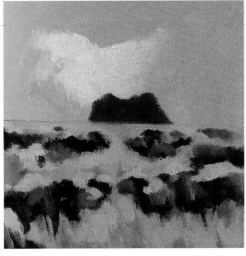

Build up the color by adding each one individually.

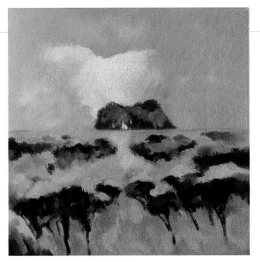

Build up the color, lights and darks with increasingly thick paint, applied using short dabs and rough scumbles.

Grisaille or monochrome

Add the color in thin glazes using simple mixes.

Add the darks to the background and shadows to add depth.

Light to dark

Develop the colors by creating new mixes that unify and enhance the existing colors in the clouds and water.

Position the details—here, the rocks draw the eye to the horizon.

Add detailed and precise textural marks over the image. The scumbled layers of paint have created an interesting surface that matches the rough appearance of the subject.

Tips to improve your process

• With each new painting project, consider revisiting previous subject matter while incorporating one new, unfamiliar or difficult element. By combining the familiar with the untried, the painting will offer you areas you can confidently tackle as well as areas that will push your limits.

• Don't be afraid to scrape away mistakes to paint over them. If a painting isn't working at all, be brave and start over.

• Observe your painting in progress during other activities. Set it next to the TV or dinner table to glance at it occasionally. Errors often reveal themselves at times when you are away from the easel.

• When you sense a flaw but you cannot detect what or where it is, it sometimes helps to look at your painting in the mirror.

• Photograph your painting several times during different painting stages. Looking at it in a smaller format gives you a different perspective on your work.

• Assess your painting with a critical eye. Do not be too complacent or easily satisfied with your efforts. Each painting demands the best of you.

• Do not rush through the process. Enjoy each stage; savor each brush stroke or gesture. Take your time.

• When you want to paint but have little time for a full session, paint using just one color. Grant yourself the luxury of painting on a daily basis, even if it's just for 20 minutes. Eventually you will finish your painting.

Add the details that bring the image to life—reflections on the vase and the texture of the foliage and petals.

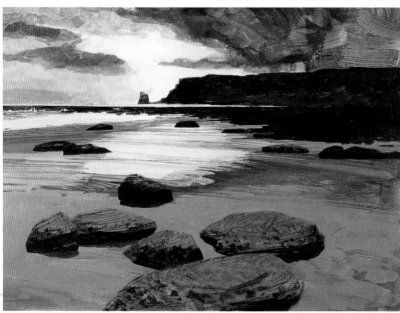

Add the darks to the coastline and to the shadows of the rocks—these will emphasize the light areas.

Some artists paint from pure imagination, but many artists see the world around them as a limitless source of reference material for their paintings.

FINDING AND USING REFERENCE

Sketching and painting from life is essential to develop eye–hand coordination and observational skills. While artistic license is every artist's prerogative, life drawing and painting help you understand the anatomy of your subject matter, and allow you to interpret it from different angles and perspectives. Working from life has enormous benefits, yet it's not the only available option.

Photographic reference
Sometimes it is useful to use photographs as reference material. A photograph captures fleeting light and shadows in an ever-changing landscape, records the momentary appearance of an animal, catches the image of an active child or alleviates the tedium of a model sitting for a portrait. The camera can capture details that we may overlook due to movement or time, such as rushing water or wilting flowers. The photograph captures what you observe firsthand and functions as an aide-mémoire at a later time.

Our vision is stereoscopic; tilting our head even slightly gives a different view that makes painting from life gestural. Photographs are monoscopic, freezing one particular angle.

Always carry a sketchbook and pencil to capture the essence of an interesting scene or composition, taking notes on atmosphere and color palette for future reference.

So painting from life and using reference photos simultaneously can enhance our understanding of the subject matter.

It is always best to create your own reference material, and to keep records of the creative process just in case you need to prove provenance. Sometimes we are inspired to paint someone else's image. Copyright belongs to the creator, whether it's a painting, illustration or photograph. So to use any image you find online, in a magazine or elsewhere, you need written permission from the creator—unless the image is in the public domain and free to use. Sometimes we need a reference that is impossible to obtain due to geographical location or practical reasons—for

CROPPING OPTIONS

Crop a reference image to suit the format of your painting surface and to emphasize a point of interest. Use photo-editing software or scissors to crop prints or copies of your reference photo to try out various arrangements before choosing one.

These are just three possible crops of many.

Square format: Gives a modern look, but limits the sense of space.

Color sketches are helpful to capture atmosphere and as a guide for choosing a palette.

Keen observation allows you to record minute details that help you understand the subject matter.

Tips for taking reference photographs

• Always take multiple photographs from slightly different angles to get a feeling for the subject matter. These photos will be your aide-mémoire to later help you remember and capture the atmosphere and character of the subject.

• Determine which elements attract your eyes in order to find the center of interest, and use that area as a starting point.

• Always photograph a larger area than you expect to need, because you can always crop afterward.

• When shooting a landscape or cityscape, move around and capture different perspectives by sitting on your haunches or standing on an elevation.

• Focus on the value patterns between lights and darks when photographing reflective surfaces.

• When setting up a still life or portrait, consider using different lighting, such as strong directional artificial light, colored light, multiple light sources, natural light and even candlelight.

• Shoot the still life or portrait from different positions, and don't be afraid to try very extreme angles and close-ups.

• Pay attention to the form of the shadows. When shooting portraits avoid weird shadow shapes across the face, unless it is intentional.

Vertical crop: The eye travels from the foreground up into the distant horizon.

Horizontal crop: Reduces the perspective and focuses on a feeling of distance.

Finding and Using Reference continues over the page ⟶

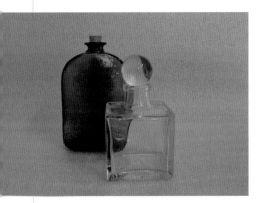

LIGHTING OPTIONS

Trying out different lighting options and angles while taking reference photographs will give you a wider selection of choices to decide which looks best as your final composition.

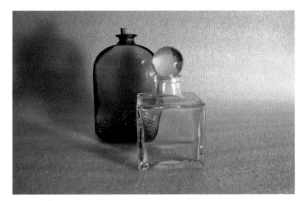

Taken in normal ambient daylight the glass objects lack contrast, depth and interesting highlights.

Taken with strong directional lighting from the right the highlights and shadows become more alive.

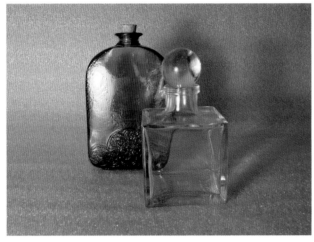

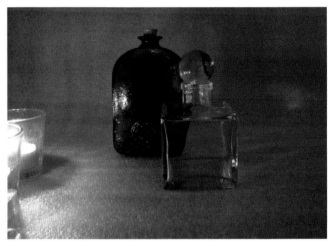

The strong directional lighting from the left seems to intensify the colors even more, creating interesting highlights.

Taken by candlelight the still life becomes elegantly subdued, giving it a traditional chiaroscuro look.

Using different lighting on the sitter can create interesting changes to the physical structure and overall atmosphere of the portrait.

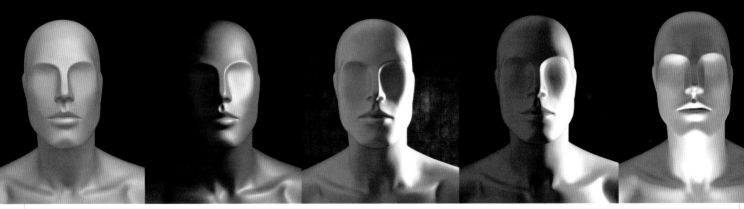

An evenly lit portrait reference is always practical.

Carefully aimed directional light from the side creates a dramatic chiaroscuro portrait and enhances facial features.

The directional light is too bright, producing an exaggerated shadow in the eye socket, creating a visual eye patch.

The light produces intense shadows along the midline of the face, creating a visual moustache and nose bleed.

Uplighting creates a sinister look that lights up the nostrils and broadens the bridge of the nose.

Straight-on front view: perfectly spaced and balanced, perhaps too textbook to garner attention.

VIEWPOINTS AND ANGLES

Photographing a composition from different angles and directions will offer a variety of views, some of which may be surprising alternatives to what you had at first intended. Take roomy shots to allow for cropping; zoom in for interesting close-ups.

View from the left: the composition has depth and perspective.

Angled view from the right: fails as the cat is vertically aligned with the vase, isolating the jar to the right.

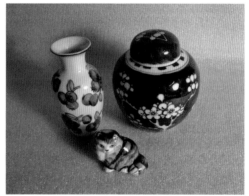

Overhead angle: gives a more modern look, but resolve potential distortions in perspective by shooting from farther away.

example, a deep ocean, an exotic animal or a bird's-eye view of a city. In that case you can purchase royalty-free and/or stock images as reference for your painting.

Working from reference

Select photographic references by scrutinizing their composition carefully. Remember that colors and values can be enhanced, reduced and changed—not only digitally but also during the painting session. Cropping a composition often makes it more exciting. Cropping works especially well for portraits; a close crop will make a portrait look more contemporary. Don't be tempted to paint every single detail of your reference photograph. It's your choice what to depict and what elements to ignore.

Inspiration

All artists are influenced by other artists' work; whether consciously or subconsciously, there's a continuous visual cross-pollination happening between artists, alive and dead.

Studying and copying the Old Masters is a long-standing tradition among classical art students and artists, and museums will sometimes allow sketching or painting during opening hours. Attending workshops and classes can be motivating as well. As long as you do not present a copy or classroom project as your own original artwork, these exercises can teach you a lot about color, composition, expression and technique, leading to new ideas and creativity.

Stock images

Royalty-free (RF) images, stock images and stock photography are commercially available paintings, illustrations or photographs that are licensed for specific uses. For a fee you can acquire such an image for a specific use, such as reference material, but it does not become yours exclusively as the owner can sell the image multiple times. Stock and RF images are available in books, catalogs and online databases.

There are several ways to transfer the outlines and details of reference material, be it from a sketch or a photograph, to your painting surface.

TRANSFERRING IMAGES

Good freehand drawing skills are essential to painting, but not all artists want to spend time and energy sketching the composition onto a painting support when they can use a shortcut. While purists object to using tools to transfer line drawings, most artists agree that it is not the means but the end result that's important. Transfer methods simply speed up the creative process so you can start painting sooner.

Graphite

You can use ready-made graphite paper or create your own to transfer an image. The image to be transferred, such as a photocopy or computer printout, needs to be at 100% the size of your painting. Use transparent tape to join multiple prints or photocopies together if you are creating large-scale paintings.

The grid method

Used by artists since ancient Egyptian times, the grid method is the simplest way to transfer a reference image onto a painting support. It involves drawing a grid on the reference image and then drawing a grid of equal ratio on the painting support, so that you can accurately copy the lines inside each square of your reference image into the painting grid. It allows you to draw the correct proportions and, if desired, enlarge the painting image.

Although it is more time-consuming than other transfer methods, the grid method compels you to focus on one small area at a time, making visual translation of lines easier while enhancing your observation skills.

Both grids should always be equally spaced and perfectly square in order to avoid distortion.

TECHNIQUE FILE 17

USING GRAPHITE Use ready-made graphite paper or make your own to trace your reference image onto the painting support.

Shop-bought gray, colored or white (not shown) graphite paper is ideal to trace onto a colored or dark painting surface.

1 To make your own graphite paper, use a soft pencil to completely cover the back of your reference image with a layer of graphite. Note that the back of your reference image will be dirty afterward.

2 Position the reference image over the graphite paper with the graphite side down on the painting support and securely tape one edge. Trace over the reference image using a mechanical pencil. Check how hard you need to press for the image to transfer through.

Using the grid method with a photograph

A reference image can be enlarged using the grid method. Determine where important compositional points cross the grid lines, mark them on your painting, and then connect the lines with each other drawing the sketch. Add as many details as you need.

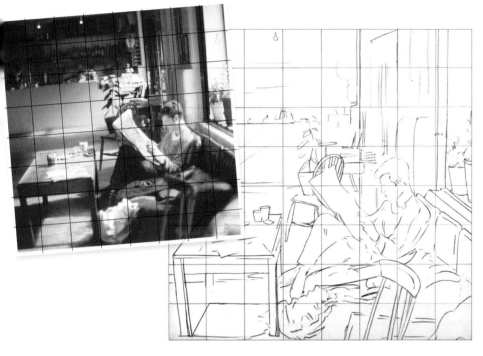

Card frame with acetate

If you are painting a subject from life you can use a frame with a grid drawn onto acetate. Stick it carefully and squarely onto the back of the frame, then hang or support it, making sure it is perfectly straight and square.

3 Occasionally flip up the print to see the progress and check whether you have forgotten to trace certain sections.

Both your reference image and painting support should have the same number of squares, irrespective of the size of those squares.

This means that the format (height and width) of both reference image and painting support need to be equal in proportion; in other words, if the width of the reference image is multiplied by x, then the height should also be multiplied by x to obtain the size of the painting support. Consider cropping the reference image to match the format of the support.

How to use the grid method Use a ruler and a mechanical pencil to draw a perfectly square grid on a copy of your reference image (e.g., photocopy or computer printout). If you need a lot of detail, make the grid smaller. Number the rows and columns to make it easier to find your way.

Use a ruler and a pencil or sharpened charcoal to draw a grid onto your painting support,

Transferring Images continues over the page ⟶

USING THE GRID METHOD WITH A SKETCH

If you are working from a sketch or sketchbook, you may prefer to avoid drawing a grid over your reference drawing.

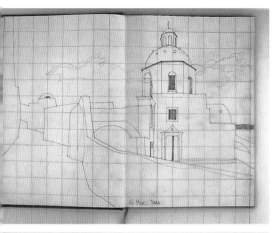

1 You can make a master grid on transparent acetate using a waterproof fiber-tip pen, and position it over the drawing. The acetate grid can later be reused.

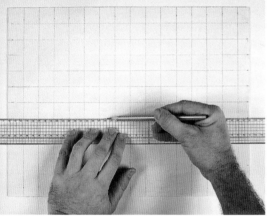

2 Draw a grid onto your painting support using pencil or charcoal. This grid should have an equal number of squares as the reference grid. Divide both the width and height by the number of squares in the reference grid to calculate their size. You can crop little discrepancies in format around the edges, or you can add areas by painting from memory.

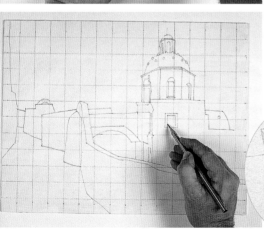

3 Carefully copy the drawing square by square, working out where the various points of reference cross the lines of each square.

Softening and fixating lines

After you have transferred your composition onto your painting support, you may want to soften harsh lines and/or fixate them before you start painting.

Heavy or dark lines made in graphite or charcoal can be softened by gently patting them with a kneaded eraser.

To prevent graphite or charcoal from smudging or contaminating light acrylic colors, you can fixate the line drawing. Using a soft, broad, flat brush, lightly cover the sketch with heavily diluted gesso, the consistency of milk. This will slightly lighten and "set" the sketch.

creating the same number of columns and rows as the reference grid.

Copy what you see in the reference image by focusing on one square at a time, drawing lines into each square of your painting support. Once done, use a kneaded eraser to gently remove the grid lines from your painting surface, taking care not to smudge your line drawing.

Projectors

A projector is an electrical appliance with a light source and a lens that projects an image onto a surface, so that it can be traced. This device is especially practical when enlarging images for large-sized paintings. The size of the projected image is adjusted by moving the projector closer or farther away from the painting surface, while focus and definition are regulated by adjusting the lens. There are a number of different types of projectors available.

Opaque projector

Opaque projectors have a small copy area to place a reference image of between 3 x 3 and 7 x 7 inches (7.5 x 7.5 and 18 x 18 cm). They are especially suited for projections of 18 x 18 inches (45 x 45 cm) and larger. However, the studio needs to be really dark in order to see the projected image well, so you need to darken your studio or project at night.

Slide projector

Slide projectors are less popular today due to the advances in digital photography and desktop printers. Buying one secondhand can save money, but the drawback is that you need to have slides made of your reference material; some photography websites offer these services online. A slide projector gives crisp, clear projections for accurate tracing but, like the opaque projector, it needs a darkened room for best results.

Digital projector

Digital projectors are more expensive but have clear advantages over both slide and opaque projectors. They provide brilliant, crisp images under almost any lighting condition (including daylight), and can accurately project sizes of 15 to over 80 inches (38 to 200 cm). Digital projectors directly connect to most digital sources (such as computers, digital cameras, memory cards, even smartphones), eliminating the need for photographs, prints and slides. If you only use the digital projector occasionally, consider renting one.

 TECHNIQUE FILE 19

HOW TO SET UP A PROJECTOR

1 Make sure your painting support is at a perfectly perpendicular 90° angle to avoid a skewed or distorted projection.

2 Adjust the projector's distance and its focus to perfectly and sharply fit the size of your painting support.

3 Trace the composition in one sitting, as it's very difficult to realign the projection with a previously traced drawing.

4 Avoid moving or bumping into the projector during projection to prevent having to realign your composition.

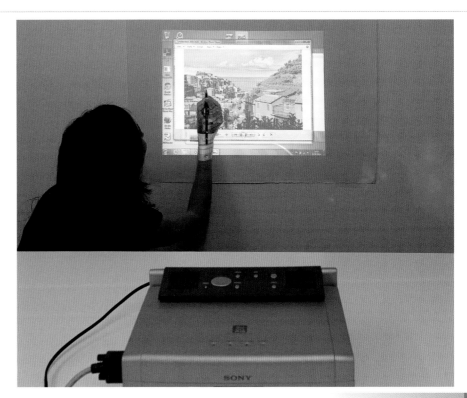

One of the first colors used by Paleolithic artists was lime white, prepared from ground calcite or chalk. Just like us, our prehistoric forerunners used white for backgrounds, as well as to highlight their striking cave paintings.

PAINTING WHITES

The question whether white is a color is really a matter of semantics. Humans see white when looking at full bright light comprised of all the wavelengths of the visible spectrum. Theoretically speaking, pure white is the absence of color.

When we speak of white paint, however, we do think of it as a color—especially as color in paint is produced by pigments. The two basic pigments used to create the different types of white acrylic paint are titanium and zinc, and there are important distinctions between them. Depending on your artistic requirements, both can be very useful.

Titanium White
The most popular, most widely used white is Titanium White—it is bright, opaque and gives good coverage. Mixed with other colors it rapidly produces opaque pastel hues, due to its high tinting strength. It is the ultimate must-have color in every artist's studio.

Zinc White
Less prevalent (many brands do not carry Zinc White acrylics) but no less valuable is Zinc White, which is very transparent and has very low tinting strength. It blends particularly well with other transparent pigments, such as the hansa, phthalo and quinacridone colors, because it will not instantly change the mixture into a pastel hue as Titanium White does. Zinc White is particularly suitable for lightening the value of a color without changing it too much. It is also very suitable for glazing.

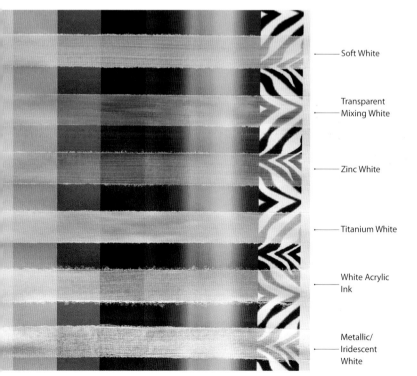

- Soft White
- Transparent Mixing White
- Zinc White
- Titanium White
- White Acrylic Ink
- Metallic/ Iridescent White

Qualities of different whites
The bands of different white acrylics to the left demonstrate how the covering power, opacity and even the hue of the paint can vary from one white to another.

Veil

A transparent white glaze, called a veil, can be used to render a misty or hazy scene. It can also be used to subtly highlight areas in a painting that need delicate, indirect lightening.

Highlights

Pure, undiluted white is often used to finish hard-edged highlights in a painting, such as those found on eyes, or on hard shiny surfaces such as metal and glass.

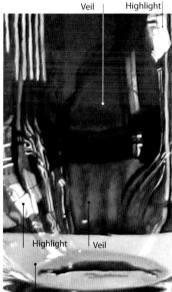

Veil | Highlight

Highlight | Veil

Veil

Mixing White and Soft White

Many acrylic brands offer an alternative to Zinc White, often as a blend of Titanium White and Zinc White, or a special formulation of Titanium White with a lowered tinting strength. Like Zinc White, when mixed with transparent colors they lighten value while avoiding pastel hues and chalkiness. Depending on the brand, the colors of these Mixing Whites or Soft Whites can range from bright white to off-white and ivory white.

Iridescent White

Iridescent White acrylic is a shimmering, pearlescent paint made of titanium pigment coated with microscopic powdered mica flakes. It relies on reflected light to make its presence known. Its transparency makes it an interesting paint to use by itself, over color or blended with other colors, especially transparent or translucent ones. Iridescent White will lose its reflective, metallic quality when mixed with opaque colors or with matte mediums and gels.

White Acrylic Ink

This very highly tinted, fluid white paint (pigment titanium) is often used for airbrushing, but it can be applied with a brush or technical pen as well. It gives excellent coverage, but tends to have a bluish hue that can be balanced and corrected by adding a minute amount of orange.

The most straightforward way to acquire gray is to simply mix black and white, starting with white and adding small amounts of black until you achieve the desired value.

PAINTING GRAYS

Mixing black and white is not the only way to obtain grays. You can buy a variety of premixed grays, or blend your own to create interesting grays, avoiding the use of black altogether.

Premixed grays
A number of premixed gray acrylics are sold; however, despite having the same names, the colors and values of premixed colors sometimes differ between brands.

Davy's Gray A transparent greenish gray or steel-blue color, Davy's Gray is usually composed from powdered slate, iron oxide and carbon black. Davy's Gray is named for artist Henry Davy (1793–1865), but there's debate on the date of the first recorded use of this color. There's also a lot of discrepancy in this color between brands.

QUEEN OF THE WATER TROUGH
BY JANE CRISP
20 x 27½ inch (50 x 70 cm)
The subdued warmth in this painting was achieved by blending Titanium Buff and several earth tones with Carbon Black to achieve luminous, subtle grays.

———— Graphite Gray

———— Payne's Gray

——— Neutral/ Medium Gray No. 5

——— French Gray/ Blue

———— Davy's Gray

——— Bright Silver/ Iridescent Gray

Qualities of premixed grays
Premixed grays can vary in hue from dense, almost black through blue-toned shades, to light and silvery. They all have their uses, but it is well worth experimenting with mixing your own. Bear in mind, too, that as with all colors (but especially neutrals), the optical qualities of grays depend on their surroundings; adjacent colors and values all have an influence.

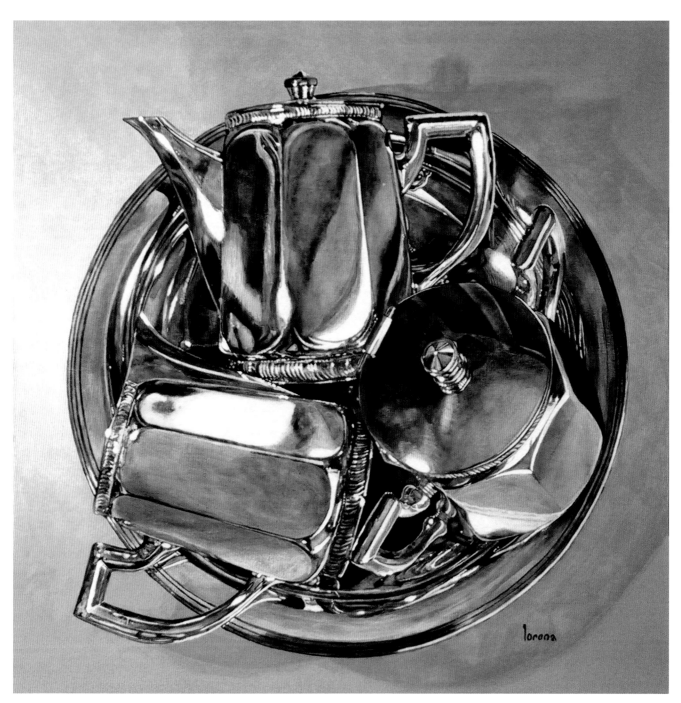

ABUELA'S SILVER

BY LORENA KLOOSTERBOER

12 x 12 inch (30 x 30 cm)

This painting shows effective juxtaposition of different
shades of chromatic grays. While the overall impression of
this painting's temperature is warm, the contrasting cool
grays help portray the distinct texture of metal.

Painting Grays continues over the page →

Noteworthy grays

Optical grays
When painting in thin transparent layers, washes or glazes, the same principle of mixing RGB applies for obtaining optical off-grays. Red, green and blue need not be premixed, but can be painted in separate translucent layers on top of each other. You can adjust the temperature by applying additional transparent layers of color.

Cool grays
Cool grays are grays with a cool temperature. Grays mixed with small amounts of blue, violet, cyan or green will cool down.

Warm grays
Warm grays are grays with a warm temperature. Grays mixed with small amounts of warm yellow, orange, red, warm brown, rose or amber turn warm.

The example on page 124 shows Davy's Gray by Winsor & Newton Artists' Acrylic, which has an earthy hue.

Payne's Gray Best described as a dark, muted, bluish gray, Payne's Gray is often used instead of black because it's less intense. It's a perfect dark color for shadows. Mixed with white, it will offer wonderful cool shades of gray. Payne's Gray is named for artist William Payne (1760–1830); its first recorded use as a color name in English was in 1835. Payne's Gray was originally obtained by mixing Iron Blue, Yellow Ocher and Crimson Lake. Additional blends of Payne's Gray can be obtained by mixing Indigo, Raw Sienna and Madder Lake; or Ultramarine Blue, Ultramarine Violet and Bone Black; or Ultramarine Blue and Raw Sienna.

Neutral Gray or Medium Gray Neutral Gray is a premixed blend, the most readily available being Neutral Medium Gray No. 5, which indicates it's in the center of the value scale. Some brands offer a whole line of Neutral Grays, numbered from 1,

which is the darkest, to 9, the lightest. Different acrylic brands use different color pigments: a Neutral Gray by one brand is a mix of Bone Black, Raw Umber and Titanium White, while another brand uses Titanium White, Carbon Black and Yellow Iron Oxide. Premixed Neutral Gray No. 5 is convenient for toning down colors, and to help compare values of colors by laying the gray acrylic next to the comparison color on a piece of paper or white cardstock. The temperature of Neutral Gray can be cooled down by adding blue, green or violet, or warmed up by adding orange, red, rose or warm brown. Some brands also offer a premixed Warm Gray, which is a blend of white, black and a red.

Graphite Gray A very opaque, steel-black gray with high tinting strength, Graphite Gray gives excellent coverage and a matte finish. The color is reminiscent of the graphite used in pencils. Because of its high opacity it lends itself well to blocking in dark areas quickly, but it is not a color recommended for glazing.

Bluish grays Premixed bluish grays are toned-down pastel hues that offer different qualities depending on the brand. Liquitex, for example, offers a French Gray/Blue, which is best described as a softly muted pastel blue. It is easy to mix your own bluish gray by blending any blue pigment with a bit of white, then adding a small amount of black, brown or gray to dull its intensity.

Achromatic and off-grays
Achromatic grays are colors in which the use of red, green and blue is equal. This is theoretical, because it is difficult to get the proportions exact when squirting paint from a tube.

Off-grays are colors that are very close to achromatic grays, in which the amount of red, green and blue are not exactly equal. An off-gray is what most of us will achieve when mixing RGB, and makes for very interesting grays, which can be mixed with white to lighten them.

MANHATTAN MORNING
BY NEIL DOUGLAS
49 x 49 inch (125 x 125 cm)
Departing from a black underground,
a variety of warm and cool grays were
applied gradually building up lighter
values. Cool blues and warm neutrals,
such as Naples Yellow and Flesh Tint,
embellished the grays to become
more vibrant.

Mixing your own grays

Some artists prefer not to use black straight out of a tube to obtain grays. Noteworthy grays can be achieved by mixing two complementary colors—found opposite each other on the color wheel—such as red and green, violet and yellow or blue and orange. These can then be mixed with various amounts of white to obtain the desired value of gray (see Mixing neutrals, page 105). Grays can also be obtained by mixing the three primary colors, namely red, yellow and blue. Most often artists use Cyan, Magenta and Cadmium Yellow in various degrees to obtain interesting grays.

Another way of obtaining gray without using black is to mix your own black first, and then blend it with white. Many artists prefer to mix their own blacks because they seem more "alive" and vibrant than those from a tube. A studio-mixed black can be obtained by blending equal amounts of Ultramarine Blue with Burnt Umber. Mixing Phthalo Blue, Sap Green and Alizarin Crimson in equal amounts also makes a wonderful black. Adding white in different quantities to these studio-made blacks results in lively grays.

A lot of preconceptions exist surrounding black paint. Many traditionalist artists reject the use of store-bought blacks, and many others are afraid of it, fearing it will muddy their colors or dim their artwork.

PAINTING BLACKS

Is black a color? This is a query that provokes debate. Humans see color through the influence of a specific wavelength of light reflected on it. According to the science of nature, black is not a color because it does not reflect light back, as it absorbs all the colors of the visible spectrum. But of course we see black objects, because they still reflect some light. And as color in paint is produced by pigments, even if these pigments absorb light, black can be described as a color.

Premixed blacks
There are many store-bought black acrylic paints on the market. It is useful to know the general properties of the most popular, noted in the table opposite, as sometimes these differ between brands. Always test your black in order to obtain the painting result you seek.

The high tinting strength in black acrylic paint means that you need only a very small amount of it for mixing. Most premixed blacks have a color bias toward either the browns or the blues, which will affect the colors you mix them with. Therefore, it is important to test your premixed black by adding white to it. Knowing the color bias of your black and knowing the basic blending rules of the color wheel will allow you to tone down other colors confidently, without the murky results that so many artists fear.

Chromatic or studio-mixed blacks
Chromatic blacks are blends of chroma; in other words, they are a mixture of colors not containing black pigments. Many artists prefer to mix their own blacks because they seem more "alive" and vibrant than those straight from a tube.

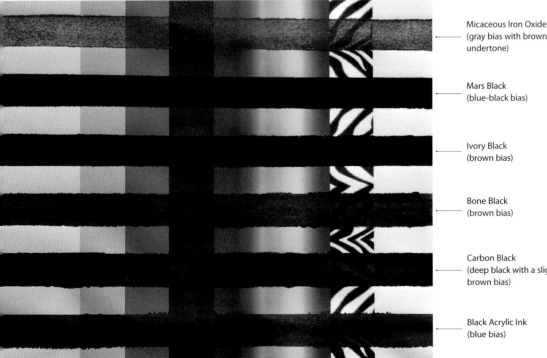

Micaceous Iron Oxide
(gray bias with brown undertone)

Mars Black
(blue-black bias)

Ivory Black
(brown bias)

Bone Black
(brown bias)

Carbon Black
(deep black with a slight brown bias)

Black Acrylic Ink
(blue bias)

Color bias of premixed blacks

In the swatches to the left, you can clearly see how different blacks have a different color bias toward either browns or blues.

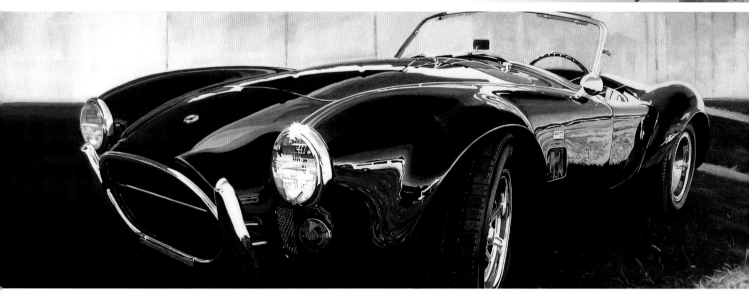

SLITHER
BY KEN SCAGLIA
20 x 60 inch (51 x 153 cm)
*Flat black areas become vibrant when warm and
cool hues are juxtaposed, and colors and abstracted
details of surrounding reflections are depicted as if
bouncing off the black metal surface.*

Compared to premixed blacks, chromatic blacks tend to be more delicate and understated, and often produce beautiful neutrals when blended with other colors.

To obtain a rich chromatic black, blend equal amounts of Ultramarine Blue and Burnt Umber, or Prussian Blue with Burnt Sienna. A studio-mixed black allows you the flexibility to cool down or warm up your black by balancing the additions of either blues or reds. Experiment with blending your very own chromatic black by mixing your darkest reds and blues, or darkest reds and greens. Do make sure none of your colors contains black pigment by checking the label for PBk (pigment black).

Enhancing premixed blacks

Adding colors to store-bought blacks can influence and adjust their tones. For example, adding a bit of Burnt Sienna to Bone Black creates a warm black, while adding a bit of Cobalt Blue to Mars Black will result in a cool black.

Name	CI pigment	Color bias	Opacity
Intense Black	PBk 1	Brown to reddish brown, or black to bluish black	Opaque
Lamp Black	PBk 6	Black with brown, blue or neutral undertone	Opaque
Carbon Black	PBk 7	Deep black with brown undertone	Opaque
Iridescent Black or Pearlescent Black	PBk 7 with mica	Brownish undertone	Opaque
Bone Black or Ivory Black	PBk 9	Brownish undertone	Semi-opaque
Mars Black or Oxide Black	PBk 11	Bluish gray to black	Semi-opaque
Transoxide Black	PBk 28	Bluish black to jet black	Semi-opaque
Black Acrylic Ink: highly tinted, fluid black paint often used for airbrushing, but can be applied with a brush or technical pen as well	Different pigments in different brands	Depending on brand	Depending on brand, usually very opaque with excellent coverage

For CI Pigments and names, see pages 312–315.

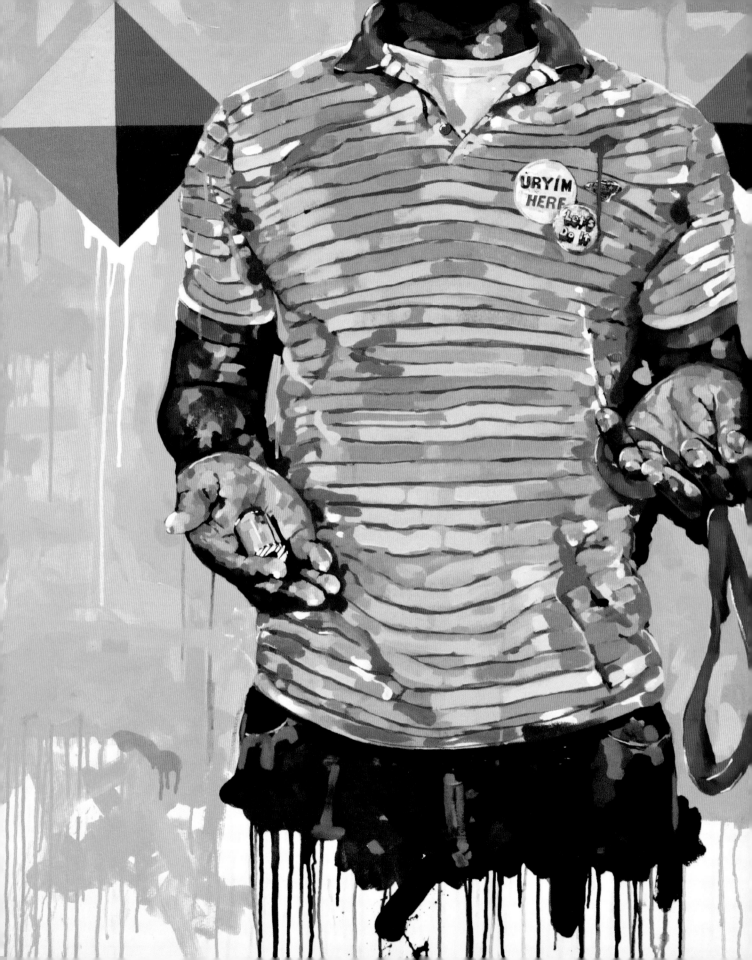

ACRYLIC PAINTING TECHNIQUES

Acrylics lend themselves to a wide variety of techniques, from modern methods offering characteristics not attainable using other media to those mimicking more traditional paints, such as watercolors, gouache and oils. The following pages showcase a selection of painting techniques for both traditional and contemporary fine-art genres. Be inspired!

URYIMHERE (main picture)
BY JEREMY OKAI DAVIS
45 x 45 inch (114 x 114 cm)
The immense range of effects that can be achieved with acrylic paint allows artists complete creative freedom. This energetic painting juxtaposes drips, hard lines and loose brush strokes over an underpainting, giving it a strong, contemporary look.

Above from left to right
BOX OF 64 (detail)
BY CESAR SANTANDER
see page 194

FLUID PAINTING 69 (detail)
BY MARK CHADWICK
see page 156

WAVING NICOTIANA (detail)
BY FLORA DOEHLER
see page 177

Navigator

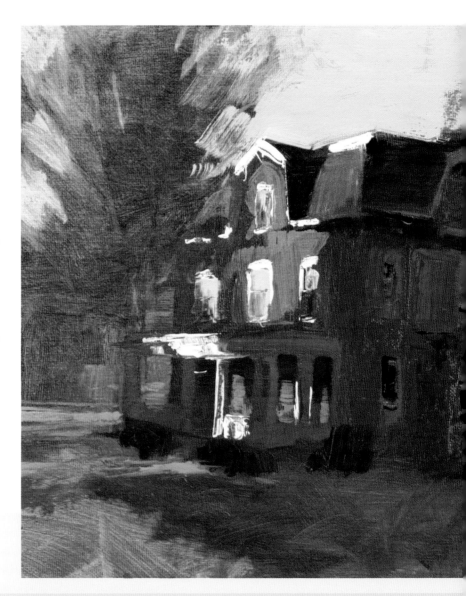

F&M
BY HANK BUFFINGTON
11 x 14 inch
(28 x 35 cm)
Loose brush strokes of vivid hues applied over a base layer of earth tones allow the colors of the underpainting to peep through, creating exciting color relationships, especially noticeable in the sky and grass areas.

Warm Cadmium Yellow over cool Dioxazine Purple: The yellow is toned down.

Neutral Medium Gray No. 5 over warm Burnt Sienna: The gray appears cooler due to the contrast of the warm underpainting.

Cool Vivid Lime Green and Hooker's Green over warm Cadmium Red: The greens become deeper and brighter.

The first layer of color—the underpainting or imprimatura—sets the mood, eliminates the whiteness of the ground and establishes values and tones. The process of painting on a wet ground is known as wet-in-wet, or alla prima, and is characterized by finishing a painting in one sitting.

UNDERPAINTING OR IMPRIMATURA

Most artists paint an underpainting or imprimatura—an Italian term meaning "first paint layer"—as an initial coat. This first layer, usually done in transparent or semi-transparent acrylics, forms a tonal basis for further development and refinement of subsequent brushwork. Values can be balanced in relation to each other without the intrusion of a white background.

While it is traditionally done in earth tones or grays (grisaille), the imprimatura can be painted in any color, even complementary colors. The greens of foliage are enhanced by a red underpainting; the blues of a sky gain brilliance from an orange imprimatura; the yellows of a sunflower become more vibrant against a violet ground. Cool colors will be enhanced by an underpainting in warm colors, and vice versa. No matter how subtle, the color temperature of the underpainting influences the look of the overlying colors in the painting, especially if parts of the underpainting can still be seen through open brush strokes or glazed layers.

An underpainting need not be perfect—it is a means to establish tonal values and set the atmosphere and, if used as a sketch, to judge the composition. It offers the freedom to paint quickly without worrying about brush strokes or details.

An underpainting can start as an initial sketch made by brush, or can be painted over a previous line drawing. The classic approach of beginning with an underpainting is called indirect painting, which establishes the overall composition of the painting. If it is allowed to dry, this first layer is called the underpainting—the basis upon which subsequent layers will be added.

THE INFLUENCE OF TEMPERATURE OF THE UNDERPAINTING

The color temperature of the underpainting influences the appearance of colors painted on top, especially if the underpainted color is seen through open or translucent brush strokes. Warm colors enhance underpainted cool colors, and vice versa. The underpainted color may either energize or tone down the overlying color.

Warm Cadmium Orange and Cadmium Red over cool Cobalt Blue: Oranges and reds become more vibrant.

Cool Cobalt Turquoise over warm Red Iron Oxide: The turquoise becomes more intense.

Warm Cadmium Yellow and Cadmium Red over Neutral Medium Gray No. 5: The yellow, orange and red look subdued, less flamboyant.

UNDERPAINTING FOLLOWED BY ALLA PRIMA

Here, the underpainting in blended earth tones sets the atmosphere for a landscape that glows with warmth and light, while also allowing the artist to establish the tonal values of the painting. The bold shapes of the mountains and trees call for lively, spontaneous brush strokes.

You will need
- Primed panel
- Slow dry blending medium
- Filbert brushes #6 and #10

Palette for the underpainting
- Burnt Umber
- Raw Sienna
- Raw Umber
- Titanium White

Palette for the alla prima
- Alizarin Crimson
- Cadmium Red Light
- Cadmium Yellow Light
- Lemon Yellow
- Phthalo Blue
- Titanium White
- Ultramarine Blue

1 On a primed panel the lightest-value areas are blocked in with Burnt Umber, Raw Sienna and Raw Umber mixed with Titanium White, suggesting the landscape in quick brush strokes. An underpainting can be monochromatic—like this one—or painted in colors.

2 Add dark and mid-tone values using Burnt Umber, Raw Sienna, and Raw Umber to the middle and foreground; this helps reinforce perspective.

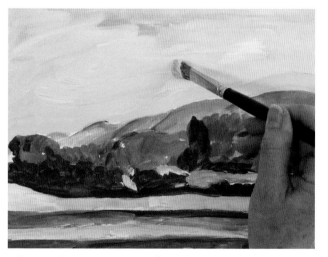

3 The underpainting or imprimatura is now complete and can either be worked on wet-in-wet or left to dry to be continued in a next painting session. An underpainting is useful to set the atmosphere as well as values and tones. The finished underpainting also helps you evaluate whether changes need to be made in the composition.

4 Continue the painting session and complete the painting in one session: this is known as alla prima (see also page 141). Blend pale mixtures of Phthalo Blue and Titanium White lightly into the underpainting to suggest the sky.

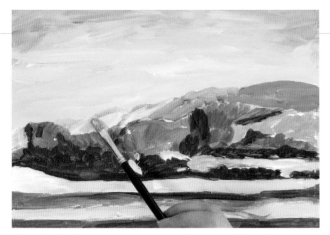

5 Paint the far-distant mountain range in Ultramarine Blue and Titanium White, with a touch of Burnt Umber, using the values of the underpainting as a guide.

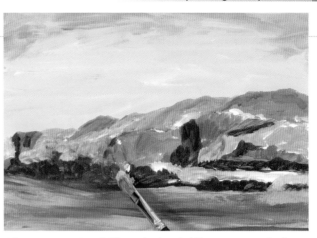

6 Suggest vegetation of different kinds with different greens and yellows made by blending Cadmium Yellow Light with Phthalo Blue, and Lemon Yellow and Ultramarine Blue; these stand out beautifully against the blues.

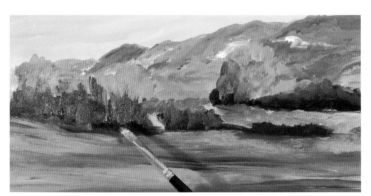

7 Put in the dark values, blended by adding more Phthalo Blue to the mid-toned greens used before, to add depth and a sense of drama.

8 Add details by applying contrasting values and colors to suggest dappled sunlight on foliage, smoothing and scumbling (see pages 150–153) the brush strokes to create a softer look.

NEW MEXICO
BY BECKY BENING
9 x 12 inch (23 x 30 cm)
The luscious look of a traditional oil painting is achieved using acrylics to build up several layers of wet color over a monochromatic underpainting.

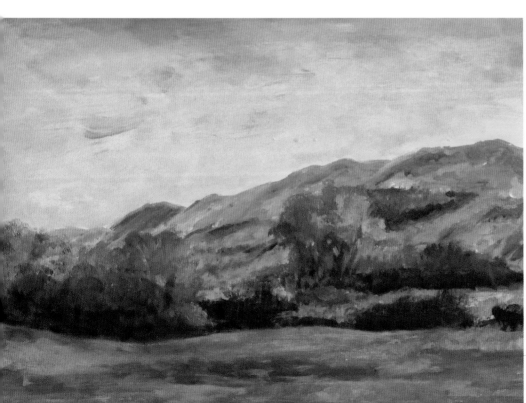

A wash is a thin coating of diluted paint, often applied in the early stages of a painting to obtain a uniform or graduated layer of color without visible brush strokes.

FLOOR PLAY
BY LINDA McCORD
14 x 19 inch (36 x 48 cm)
Carefully applied color washes, while paying close attention to the direction of light and reflections in the glassware, successfully use the white paper to create the illusion of luminous transparency.

WASHES

There are three main types of wash:
• The flat wash, which is applied in one even color and value.
• The graduated wash—one color progressing in value from dark to light.
• The variegated wash, in which colors bleed into each other.

A wash—also called a stain—can be opaque, but due to the heavy dilution of the paint it often appears semi-transparent. A wash can be applied to a dry support, but a wet ground makes it easier to apply and minimizes the appearance of visible brush strokes.

Prepare acrylic paint by mixing it with water and acrylic medium, adding flow improver to the water if desired, in order to obtain the consistency of ink. Make sure all pigments are well dispersed. Prepare plenty of paint to avoid running out during the application of the wash.

To work wet-in-wet, brush, mist or sponge your painting surface with clean water first: it should be damp, but not soaking wet. A large, soft-haired brush works best for creating a wash, especially for large areas.

FLAT WASH

A flat wash is painted from top to bottom, in broad, uninterrupted, horizontal strokes. Ideally your brush should not leave the surface until it arrives at the edge of the painting.

TECHNIQUE FILE
21

1 Place the paper at a slight angle so that the wet paint accumulates at the bottom of each stroke. Load your brush and make a broad, horizontal stroke across the paper; to make the next stroke, pull the brush back across the paper, slightly overlapping the base of the first stroke.

2 Load paint on your brush between strokes and continue working down the paper until the wash is complete. Avoid changing the angle of your painting before it's dry as the paint may flow in a different direction, creating unevenness in the wash.

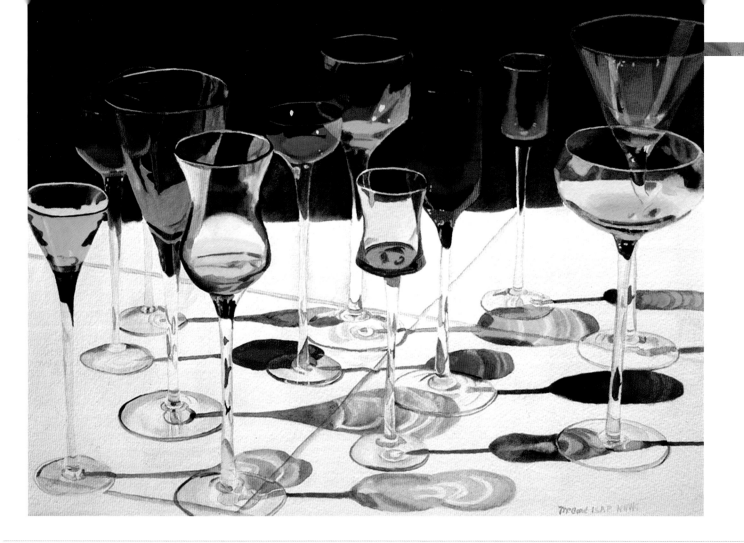

GRADUATED WASH

A graduated wash progresses in value from dark to light, starting with full color saturation at the top and gradually getting lighter toward the bottom.

1 Work in the same way as for a flat wash—but instead of re-loading your brush with paint, gradually load it with clear water mixed with acrylic medium, progressively diluting your strokes.

2 Here, the final strokes are so pale that they give only a hint of color.

Washes continues over the page ⟶

VARIEGATED WASH

A variegated wash is a transition between two or more colors. It is less predictable than a graduated wash. Analogous colors—those adjacent to each other on the color wheel—are easier to handle for beginners. Select colors with single pigments, because they are less likely to turn muddy. Prepare your diluted color mixes before you begin painting. A dampened ground is ideal for this technique.

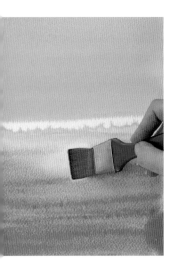

1 As with the graduated wash, start at the top with full color saturation, loading the brush with clear water for subsequent strokes until you reach the point where you want the transition to occur. Turn around your surface (so that the top becomes the bottom) and repeat the previous sequence with the second color, until they reach each other. Smooth out the transition with a clean water brush and let the colors bleed into each other. If streaks occur, lightly smooth them with a clean damp brush.

2 The transition from one color to the next is almost imperceptible. To intensify the colors, brush on more water-diluted paint over the previous wet washes, making sure you use a clean brush each time.

Wash effects

Once you've mastered the basic principles of applying washes and have a feeling for how the paint is likely to behave, experiment a little! Tilting the wet painting, adding mediums and allowing the paint to spread unevenly are somewhat unpredictable, but can create some exciting and interesting effects.

A flat wash with added granulation medium, giving it a mottled, granulated appearance.

After wetting the ground thoroughly, a few brush strokes of different colors are applied randomly. Tilting the moist painting surface at a slight angle encourages diluted acrylic color to leave a trail of interesting shapes.

Tips for successful washes

• Achieve a fluid horizontal stroke by moving your arm instead of only the wrist.

• Add an acrylic binder (such as gloss medium) to your water-diluted paint to stabilize the pigments.

• Add a bit of flow improver to your water to ease the spread of the wet paint.

• Avoid the temptation to correct "mistakes," as this often ruins the wash. If necessary, start anew.

• Canvas primed with absorbent ground is ideal for a wash.

• Evenly dampen your painting surface with clean water to help the paint flow.

• Watercolor brushes are ideal because they hold a lot of liquid, allowing you more time to paint before you reload the brush.

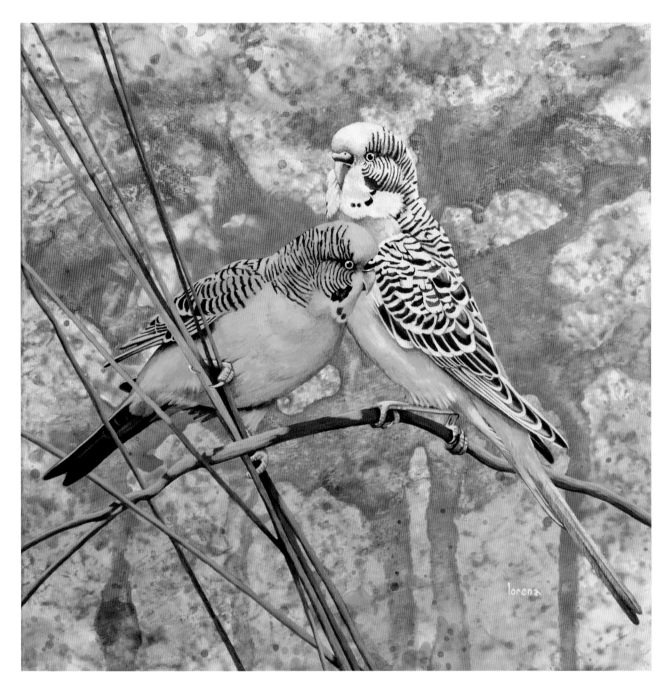

DUET
BY LORENA KLOOSTERBOER
12 x 12 inch (30 x 30 cm)
A canvas primed with absorbent ground was covered in a marbleized,
multicolored wash and left to dry. The wash was sealed with transparent
gesso, and then the composition drawn onto the wash. In preparation, a
layer of white gesso was carefully painted inside the composition without
disturbing the background. The vibrant and flowing background contrasts
and complements the delicately painted budgerigars.

Wet-in-wet is the application of diluted paint to a surface that is moist with either paint or water. This method creates distinctive, striking painterly effects, reminiscent of watercolors.

WET-IN-WET

The wet-in-wet technique involves applying paint to a damp surface, allowing the colors to intermingle in an unpredictable way. Originally a method used by watercolorists to create diffuse edges and exciting distributions of color, the technique also works well with acrylics. Blending the paint with water, acrylic medium (such as gloss medium) and flow improver will grant wonderful watercolor-like results. Because acrylics are waterproof when dry, the wet-in-wet technique can be layered over existing washes as long as they are completely dry.

Moisten the painting surface by applying clean water by brush, spray or sponge. Start with a large brush, loading abundant acrylic paint, using confident strokes and using increasingly smaller brushes as you progress to finish details with the smallest brush. Mistakes can often be smoothed over with a clean water brush.

When using diluted acrylics like watercolors, the wet-in-wet method requires skill to manipulate the unpredictability of the liquid colors interacting. Because acrylics dry fast, it is advisable to use a restricted palette, planning your pigment choices and value progression to avoid muddiness. Some artists prefer to paint from light to dark, others from dark to light; whichever you choose, keep your darks and lights clean to ensure their optimal value saturation.

WATER NOT INCLUDED
BY LORENA KLOOSTERBOER
11 x 14 inch (28 x 36 cm)
Transparent acrylics painted wet-in-wet were applied to paint the vibrant shadows over a mottled pink ground. The trompe l'oeil corner simulates a folded crease in a cardboard backing.

Three characteristic wet-in-wet techniques

Blooms A bloom (also called backrun, backwash, blossom, oozle or runback) is the shifting of pigments into an irregular shape that occurs when one wet color floods into another. Liquids tend to migrate from wet to drier areas of a surface. When the liquid color pushes into the drier paint, it deposits a stronger band of pigment along the irregular edge. Depending on the viscosity of the paint and the difference in moisture between adjacent areas, blooms can be subtle or distinct. You can create blooms by adding more water and/or paint to a drying area or by blotting an area with paper to cause an adjoining wetter area to bleed into it.

Dropping in color When you touch or stroke a wet or moist surface with a brush loaded with highly pigmented paint, the paint will bleed and feather into its surroundings, creating a delicate and distinctive feathery edge around the color area. Although it is unpredictable, this effect yields exciting and lively color gradations that cannot be achieved in any other way.

Dropping in water Touching or stroking a damp painted surface with a brush loaded with clean water leaves a feathered, lighter area within the painted color. Spraying or spattering water onto a wet colored area creates subtle dappled texture.

Alla prima

Alla prima—an Italian term meaning "first attempt" or "at once"—describes a painting that is finished in one sitting (see page 134–135). The technique is also called "direct painting" or *au premier coup*—French for "at first stroke." It is the traditional approach of the plein-air artist. Regardless of painting location, alla prima entails finishing a painting in one sitting by adding layers of wet paint over previous layers of wet paint, without waiting for them to dry. The result is spontaneous, intuitive and fresh.

Wet-in-wet effects

Diluted colors yield exciting, unpredictable results when liquids and gravity are allowed to act freely.

Irregular shapes known as blooms occur when one wet color floods into another.

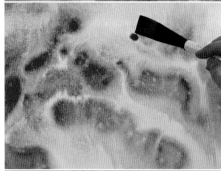

Dropping or brushing wet acrylic paint onto a damp surface allows distinctive bleeding reminiscent of watercolors.

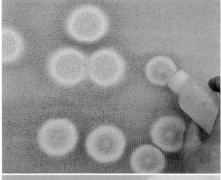

Dropping water onto wet acrylic paint opens up the paint surface, revealing the ground underneath.

Stroking a clean, damp brush on wet acrylic paint creates subtle transitions, as the brush absorbs and lifts off some of the pigment.

Wet-in-wet continues over the page ⟶

WET-IN-WET LANDSCAPE

The wet-in-wet technique is wonderful for painting clouds and sunrises or sunsets, as colors can bleed and spread on the damp support to create billowing forms without hard edges. The key is to work with a limited palette, so that your colors don't muddy.

TECHNIQUE FILE 24

You will need	Palette
• Flat brush #18 • Cold-press watercolor paper	• Alizarin Crimson • Azo Yellow Deep • Burnt Umber • Payne's Gray • Quinacridone Burnt Orange

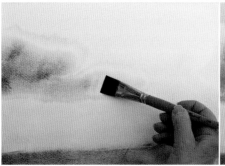

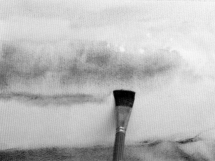

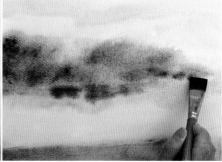

1 Using broad brush strokes with diluted acrylics in a limited palette, lay down the first impressions of the landscape on moist cold-press watercolor paper. Selecting unconventional colors to paint a landscape can create unusual results. Burnt Umber applied in the lowest area suggests the foreground. Paint the lake in Azo Yellow Deep, and then add Payne's Gray to suggest the misty wooded area in the distance.

2 Add Quinacridone Burnt Orange to delineate the embankment across the water. Paint sky above the wooded area with Azo Yellow Deep to suggest a misty morning sunrise. Allow the diluted acrylics to bleed into each other, creating subtle variegated effects.

3 Add more diluted Payne's Gray to intensify the chroma of the trees on the embankment across the lake. The wetness of the paint and the paper cause the colors to shift continuously, diffusing pigment strength.

LAKE IN THE MORNING
BY BEATRIZ SCOTTI FRANCHINI
8 x 11½ inch (21 x 30 cm)

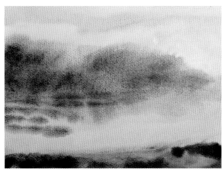

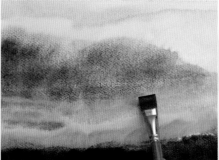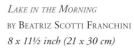

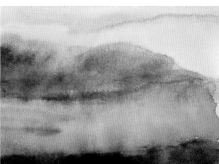

4 Using the top of the brush, touch in thin horizontal strokes in the lake to suggest reflections of the woods in the water. Allowing the acrylics to find their way on the wet painting surface yields spontaneous accidental effects and remarkable organic textures.

5 Apply final touches to adjust the color strength; remember that the paint will dry to a lighter value. To avoid muddying colors or damaging the delicate paper surface, do not overwork the scene.

6 Once dry, colors are more subdued and delicate transitions have settled down. During the drying process, wet paint continues to behave in unpredictable ways. The final result often looks quite different from the wet version.

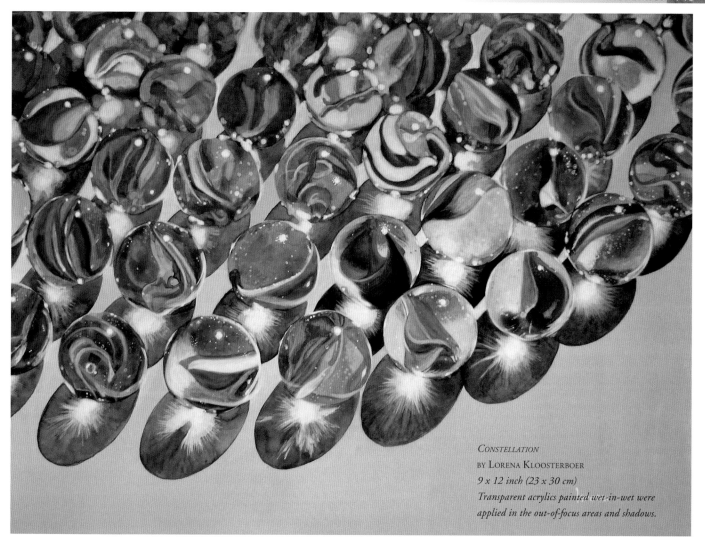

CONSTELLATION
BY LORENA KLOOSTERBOER
9 x 12 inch (23 x 30 cm)
Transparent acrylics painted wet-in-wet were
applied in the out-of-focus areas and shadows.

Tips for successful wet-in-wet

• Add an acrylic binder (such as gloss medium) to your water-diluted paint to stabilize the pigments.

• Add in a bit of flow improver to your water to ease the spread of the wet paint.

• Canvas primed with absorbent ground is ideal for the wet-in-wet technique.

• Keep darks and lights clean.

• Rinse the brush in clean water and blot it on a paper towel before changing colors.

• Select colors with single pigments, because they are less likely to turn muddy.

• Tilt your wet painting for additional wet-in-wet bleeding effects.

• Watercolor brushes are ideal because they hold a lot of liquid, giving you more time to paint before you have to reload your brush.

Due to its hygroscopic qualities, salt absorbs liquids. Salt crystals scattered on wet paint absorb moisture and color pigments, creating abstract, star-like shapes.

Tips for successfully adding salt

• Coarse salt gives better results than fine table salt.

• Experiment with different levels of moisture.

• Experiment with different strengths of color saturation.

• Experiment with different varieties of salt.

SALT EFFECTS

Adding sodium chloride to a wet layer of paint creates striking textures and shapes, which can be used to depict snowflakes, flowers, foliage, lichen, moss or starry skies, or as an organic texture in a landscape or background.

The trace minerals contained in salt dictate the level of absorption and retention of liquid. The size, purity and coarseness of the salt grains also influence the resulting textural effect. Different varieties—sea salt, kosher salt and rock salt, for example—produce different results.

Pinpointing the ideal time to add the salt is important: if the paint is too wet the salt will dissolve, creating very large marks. If the paint is too dry, the salt will not absorb the pigment. The painted surface should be damp yet still shiny when you sprinkle the salt onto it.

Note that salt may influence the stability, longevity and archival quality of your painting. Seal the final painting with protective varnish to shield any leftover traces of salt from future contact with moisture.

CREATING TEXTURE WITH SALT

TECHNIQUE FILE
25

Try this experiment with different types of salt and different levels of moisture to get a feel for the effects you can create. Here, coarse sea salt was used.

1 Loosely apply diluted acrylic paint, in the consistency of ink, to the area you want to texturize, then lay your painting flat on a horizontal surface.

2 Sprinkle coarse sea salt onto the wet surface. Each crystal of salt attracts wet pigment.

3 Leave to dry; it's important that you do not disturb the salt during the drying process.

4 Once dry, gently remove the salt granules from the painting surface by hand or using a soft, dry brush or sponge. Salt is abrasive, so be gentle when removing it to avoid scratching the painting surface.

Alcohol and water repel each other. Sprinkling alcohol onto wet acrylic paint will cause it to shift and push the pigments outward, creating spontaneous organic rings.

Tips for successfully adding alcohol

• Experiment with different layers of colors.

• Experiment with the size and number of droplets of alcohol.

• Use an old brush, toothbrush, dropper, spray bottle or cotton swab to scatter the alcohol.

• Close the bottle of rubbing alcohol as soon as you have finished using it to prevent it from evaporating.

ALCOHOL EFFECTS

Isopropyl alcohol, generally called rubbing alcohol, repels water. Adding rubbing alcohol onto wet acrylic paint results in a distinctive organic textural effect, not achieved using any other technique. It can be used to depict stone or water, or to add interest to a background.

Rubbing alcohol is mostly used as a solvent and a topical antiseptic; it is sold in pharmacies and supermarkets. It is volatile (it evaporates easily), so use it in a ventilated area to avoid inhalation. It is also flammable, so avoid smoking, heat tools and open flames when using it.

Alcohol evaporates faster than water, so you may need to continue adding alcohol onto your wet paint until you see that the paint is drying or you have achieved the desired effect. Absorbent surfaces, such as paper, do not yield good results, so always seal them with acrylic paint or acrylic medium beforehand.

Alcohol may influence the stability, longevity and archival quality of your painting. Always varnish the final painting to seal and protect the surface.

CREATING TEXTURE WITH ALCOHOL

This is a random, somewhat unpredictable technique, but it can create wonderfully organic textures. Because the alcohol repels the wet paint, the underlying dry color will be revealed—so this color will be part of the final texture.

TECHNIQUE FILE **26**

1 Over a previously painted dry color, apply a color wash or wet glaze of fluid acrylic paint, working quickly with a broad flat brush.

2 Immediately spatter, drizzle, drip or sprinkle the alcohol onto the wet surface. You will see the alcohol interacting with the acrylics at once. Continue until you are satisfied with the effect. Leave to dry.

3 If desired, add another layer of fluid paint in a contrasting color or value. Again immediately spray or spatter the wet paint with alcohol and allow to dry; do not disturb the surface while it dries.

4 The alcohol creates a beautifully random texture. To add another layer repeat the previous process. To paint over this effect, seal the thoroughly dry surface with an acrylic medium, such as gloss or matte medium.

The essence of blending is to achieve diffuse edges and gradual transitions between colors and values. There are several ways of accomplishing successful gradations using acrylic paint.

BLENDING

Painting gradations with acrylics can range from fluently continuous to more graphic transitions. The airbrush is the ultimate tool for ultra-smooth gradations, but they can also be achieved by brush. To increase blending time and gain additional time for brushwork, mix fast-drying acrylics with retarder medium or use special open acrylics with a slow-drying formulation.

Smooth, wet-in-wet gradations

Soft, continuous gradations are achieved by blending the colors wet-in-wet on your painting surface. Apply two different colors or values next

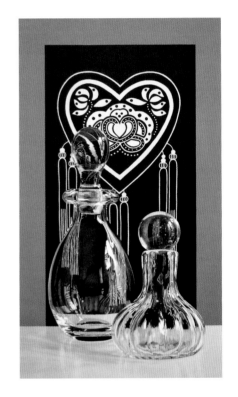

Sequitur Cor (detail)
by Lorena Kloosterboer
31½ x 15¾ inch (80 x 40 cm)
*Smooth transitions were obtained by softly feathering
thin glazes to create shadows and reflections.*

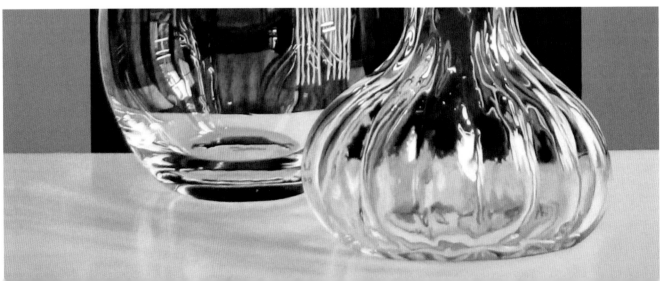

Blending continues over the page ⟶

to each other and, while they are still wet, stroke the boundary between them with a dry, clean brush to smooth the transition. Blending in one direction while using a long, deliberate stroke will prevent the colors from contaminating one another, avoiding unevenness.

Plan your process and have your paint, mediums, a number of dry, soft-bristled brushes and paper towels at the ready. Blot excess paint from your brush to avoid cross-contaminating values or colors. To achieve even blending, use a clean, dry brush to softly feather paint. Using a wet brush dilutes the paint, which makes it hard to maintain the same consistency where colors or values meet. Uniform paint consistency is the key to fluent gradations.

Crosshatched or hatched gradations

The wet-in-wet technique of crosshatching or hatching creates painterly gradations. Brush the paint in a crisscross or variable linear motion from one color or value into the other, using

SUNDAY MORNING
BY JOHAN ABELING
19¾ x 31½ inch (50 x 80 cm)
The delicate misty atmosphere of an early summer morning is beautifully accomplished by superb blending skills using soft brushes to lightly apply many layers of fluid acrylic in analogous colors.

short, brisk movements. A thick layer of paint can result in interesting brush strokes.

Stippled gradations

A stippled gradation—based on pointillism—gives a more graphic transition when viewed up close, while from afar it appears to be continuous. It can be achieved using either wet-in-wet or wet-on-dry techniques. Start by painting both values or colors in their respective areas, then stipple or dab the lighter value or color into

Tips for blending

- It is easier to blend smooth gradations in small areas than in large areas.

- A thicker application of paint is easier to blend than a thin layer.

- Soft-bristled flat or bright brushes are best suited for blending.

- Travel with your brush in the same direction to avoid cross-contaminating the colors or values.

- Wipe excess paint off your brush regularly.

DIFFERENT TRANSITION METHODS

Gradations can be achieved using different methods. Creating the impression of a continuous gradation can be just as effective as painting an ultra-smooth transition.

Wet-in-wet gradation
Create a smooth, continuous gradation by painting different colors or values next to each other and, while wet, stroking the edge between them with a dry, clean brush. To avoid premature drying, apply a thicker layer of paint and/or add retarder medium or gel.

Wet-on-dry gradation
A smooth gradation between complementary colors, such as yellow and blue, will create a third band of color between them if blended wet-in-wet. To avoid blending a third color, use the wet-on-dry method: first paint the darker color and let it dry, then add the lighter color. Blot your brush, then dry-brush over the edge of the darker area to create a smooth fuzzy transition.

and over the other, using a pointed round brush. Where the two colors or values meet, the stippling can be closer-set larger dots. As you work farther away from that border, allow more space and stipple smaller dots. Using a clean brush, stipple the other side of the gradation using the other color or value. This technique allows you to continue adding dots of paint long after the first stippling has dried until you achieve the desired result.

Line gradations

Following the contour of your composition, paint lines in ever-changing colors or values to achieve a graphic gradation. The number and thinness of the lines dictate the sleekness of the gradation. Using a mixing tray, mix increasing amounts of one color or value with the next, and then paint a narrow line next to your previous color. Repeat this until you reach the other edge of your gradation.

Gradation between complementary colors

Making successful gradations between complementary colors is challenging. A transition from yellow to blue will necessarily create a green band between them if the colors are blended wet-in-wet. Wet-in-wet transitions from green to red or from purple to orange result in a band of muddy gray and loss of chroma.

To avoid creating an intersection of a different or muddy color, you need to work wet on dry, (above and inset) starting with the darker color and feathering the edge. Once dry, brush in the lighter color, being careful not to load the brush too heavily, and dry-brush it over the dried area until you attain an adequate transition.

Hatched gradation

Create a hatched gradation by brushing paint in a crisscross or variable hatched motion from one wet color or value into the other. Use energetic brush strokes to blend the colors on the painting surface.

Stippled gradation

Start a stippled gradation by blocking in the colors. Then stipple dots using a pointed round brush. Where the two colors or values meet, stipple the dots close together, progressively allowing more space between dots as you work farther away from the transition.

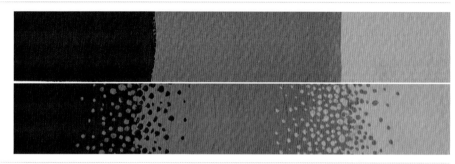

Line gradation

Paint a line gradation in progressive values or tones. The number and narrowness of the lines determine how smoothly the transition is perceived.

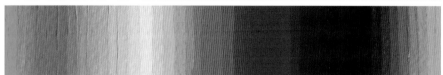

ROCCO RESTING
BY BARBARA LOUISE PENCE
16 x 20 inch (41 x 51 cm)
The soft, backlit fur was rendered by small, dappled brush strokes purposely applied in the direction of the hair growth, while the striking shadows were created with longer, smoother brush strokes.

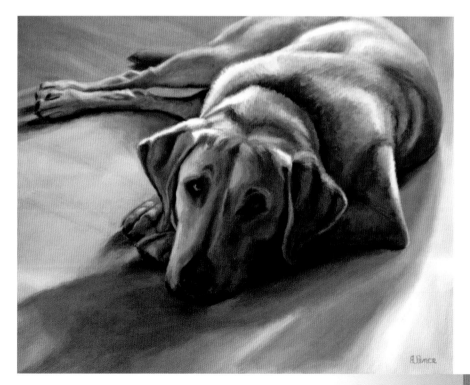

Dry-brushing and scumbling are similar techniques that involve the application of small amounts of paint, either brushed or scrubbed onto the textured surface of a painting.

DRY-BRUSHING AND SCUMBLING

Also known as sfumato, from the Italian *sfumare*, meaning "to evaporate like smoke" or "to tone down" the techniques of dry-brushing and scumbling were developed during the Italian Renaissance. They allowed more realistic shading, the rendering of atmospheric effects and the elimination of harsh lines and blunt transitions between lights and darks. Leonardo da Vinci was one of the first artists to use these methods, describing his sfumato technique as "without lines or borders, in the style of smoke or beyond the picture plane."

Scumbling and dry-brushing are wonderful techniques to create subtle color variations in a painting. Because the surface is not covered evenly in one layer of paint, the underlying ground peeps through. Hence scumbling and dry-brushing allow optical mixing as well as

Woodland Light
by Hashim Akib
24 x 30 inch (61 x 76 cm)
Several applications of undiluted acrylic paint were scumbled over a blue base to build up a rich texture. Then, smaller details were added using the dry-brush technique resulting in a delightful, expressive painting.

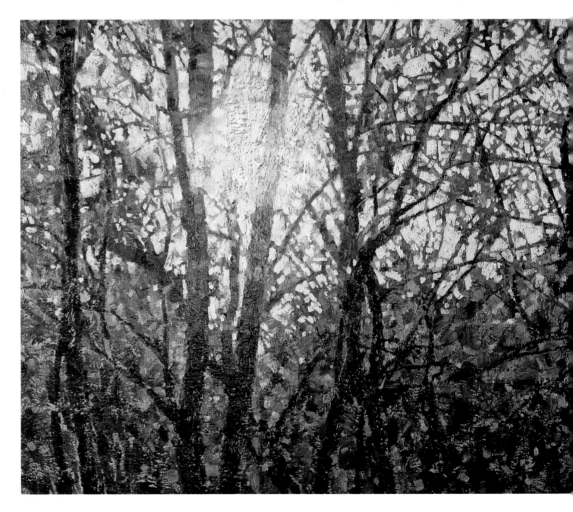

Tips for successful dry-brushing and scumbling

• Short-bristled brushes are best. Create a short-bristled brush by cutting the bristles of a worn, battered brush that has lost its shape with scissors.

• Some artists prefer to use stiff-bristled brushes (such as natural hog) to create distinctive, striated brush marks, while others prefer soft-haired brushes (such as synthetic) for a more subtle, smoky application. Experiment with both types to find your favorite expression of the sfumato technique.

• Load the dry brush with a minimum amount of viscous, undiluted paint.

• Avoid adding any additional moisture.

• Blot the brush on a paper towel or rag to remove excess paint.

• Lightly brush or scrub the dry surface of the painting ground, gently stroking the paint onto the texture of the surface.

• Do not overwork to avoid covering the entire surface.

• Allow the paint to dry before applying the next layer.

• You can make different marks by regulating the amount of pressure you apply to the brush—experiment!

• Try dry-brushing or scumbling light colors and/or values over dark, and vice versa.

DRY-BRUSHING OVER WASH

TECHNIQUE FILE 28

Dry-brushing can be combined with virtually any other painting technique.

Here, the tree trunks and branches are dry-brushed over a wash painted in Dioxazine Purple and Quinacridone Burnt Orange on cold-press watercolor paper, enhancing the composition with contrast and details.

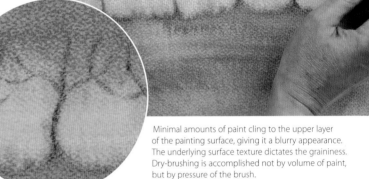

Minimal amounts of paint cling to the upper layer of the painting surface, giving it a blurry appearance. The underlying surface texture dictates the graininess. Dry-brushing is accomplished not by volume of paint, but by pressure of the brush.

A sphere dry-brushed with Titanium White on black hot-press paper. Apply more pressure to the brush for more opacity and less pressure for softer translucency.

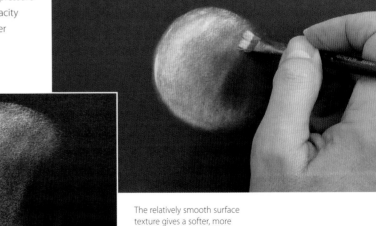

The relatively smooth surface texture gives a softer, more delicate result.

Dry-brushing and Scumbling continues over the page ⟶

TECHNIQUE FILE 29

SCUMBLING STILL LIFE

Scumbling results depend on the absorbency and tooth of the painting surface. Scumbling on a porous or very toothy surface will absorb the paint faster, reducing open time. In contrast, scumbling on a nonabsorbent or smooth surface will allow more time to work the paint.

You will need	Palette
• Tan-color hot-press paper	• Brilliant Yellow Green
• Long flat brush #3	• Naples Yellow
• Short flat brush #6	• Payne's Gray
• Filbert brush #10	• Sap Green
	• Taupe
	• Titanium White

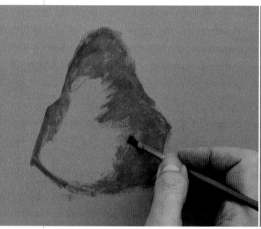

1 On a tan-color paper, using Sap Green, quickly scumble in the pear shape with a scrubbing motion.

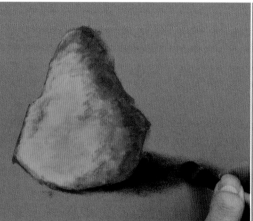

2 Dry-brush the shadow with Payne's Gray, feathering the edges.

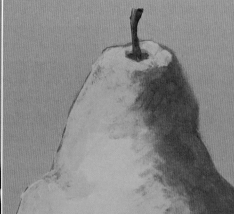

3 Scumble on Brilliant Yellow Green to modulate the lighter area of the pear, then add the stem with Sap Green and Payne's Gray with a loaded brush. Highlight the stem with a hint of Brilliant Yellow Green to indicate the direction of the light source.

subtle feathering, which is especially suitable for delicate transitions.

The difference between dry-brushing and scumbling lies in the amount of paint used and the gesture of the application. Dry-brushing requires a bare minimum of undiluted paint on a dry brush, which is then brushed over the painting surface so that just a smidgeon of paint is left, showing distinctive brush marks. Scumbling is similar, but uses slightly more paint on the brush; the paint is applied in a scrubbing motion to gently force the almost-dry pigments to cling to the upper surface texture.

Dry-brush strokes are scratchy in appearance, while scumbled brush strokes look hazy. Paint does not cover the entire painting surface, but only catches on the textured upper layer. This allows the original paint layer to show through, achieving optical blending and blurry transitions.

Dry-brushing and scumbling are ideal for building three-dimensional depth and form, applying highlights and rendering the illusion of out-of-focus perspective. Acrylic paint lends itself beautifully to these techniques because of its fast-drying properties and strong pigments, which allow multiple layers of dry-brushing or scumbling.

BRICK LANE STROLL
BY HASHIM AKIB
24 x 30 inch (61 x 76 cm)
The scumbling and dry-brushing techniques work especially well for applying layers of different colors over each other, resulting in strikingly vibrant areas in which previous colors are still somewhat visible.

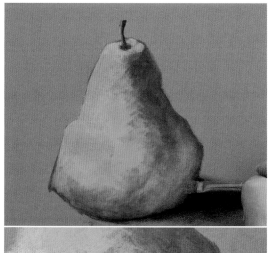

4 Scumble Naples Yellow over the previous layers to give volume and form to the pear.

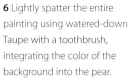

5 Scumble in the highlights with Titanium White. Different layers of overlapping colors as well as the tan background show through, adding an organic quality.

6 Lightly spatter the entire painting using watered-down Taupe with a toothbrush, integrating the color of the background into the pear.

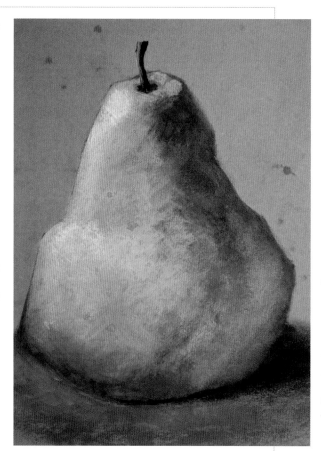

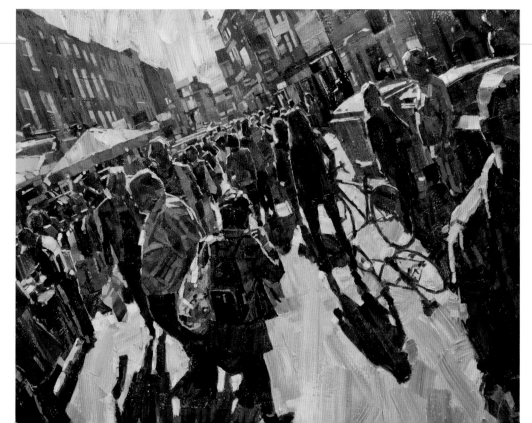

Acrylic paint can be poured or drizzled to create beautiful marbled patterns and shapes in a mesmerizing swirl of colors with an ultra-smooth surface finish.

POURING

Prepare acrylic paint with acrylic medium to obtain a viscous fluid (the consistency of heavy syrup) that can be poured, drizzled or puddled. The thicker the paint, the slower it will travel—and vice versa.

Any acrylic medium that dries transparent or translucent will work for pouring, but there are specialized mediums on the market that eliminate guesswork and dry without crazing (small cracks that form upon drying in the surface of the paint film). Only use water if necessary, and always read the product label for the recommended ratio of medium to water. Do not over-dilute—adding too much water to acrylic paint makes

Acrylic mediums for pouring

• Golden clear tar gel
• Golden GAC 500
• Golden GAC 800
• Golden polymer mediums gloss
• Golden self-leveling gel
• Liquitex pouring medium
• Winsor & Newton gloss medium

Maman et bébé
by Eric Marette
32 x 47 inch (81 x 120 cm)
Fluid acrylics poured to create seemingly random abstract rivulets beautifully enhance this realistic wildlife painting, giving it a distinctive and contemporary look.

Commissioned Portrait
by Lorena Kloosterboer
22 x 28 inch (55.5 x 71 cm)
Pouring in different directions creates an
interesting backdrop in this commissioned trompe
l'oeil double portrait.

pigments unstable, so always mix in enough acrylic medium to ensure permanence.

Use bowls, squirt bottles, disposable cups or any container that can be tilted, allowing thick liquid paint to be poured or squirted.

Premixed pour

Premix any number of colors by blending acrylic medium and acrylic paint in separate containers. Only add water if necessary. Gently blend the paint with a spatula to avoid the formation of air bubbles. Note that the colors will intensify once the medium has dried. Remember to cover the containers with a lid or a piece of plastic wrap to keep your paint fresh until you're ready to start pouring.

Straight pour

Pour medium into a large container or bowl (if necessary, add water to ensure you obtain the right consistency). Then sprinkle in a few drops of fluid acrylics or acrylic inks in different colors. Do not blend this mixture. The pigments will float freely and will mingle in swirls when poured.

Pouring effects

The pouring technique adds interesting irregular patterns of color. The pour can stand on its own as an abstract painting, or be used as an attractive background for other techniques.

Close-up of the beautiful luminous patterns created with transparent colors suspended in pouring medium.

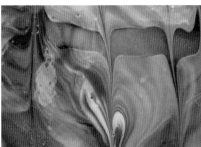

Pour or drizzle liquid paint from the top of a canvas and allow gravity to let it trickle down.

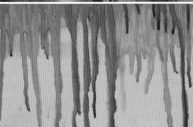

Rotate the canvas while the paint is still trickling down to create interest and tension.

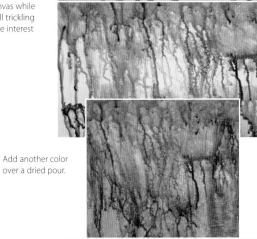

Add another color over a dried pour.

Add different colors wet-in-wet.

Pouring continues over the page →

STRAIGHT POUR

The straight pour is the most unpredictable among the pouring techniques, because the colors are not premixed but mingle on the painting surface during the pouring and tilting process.

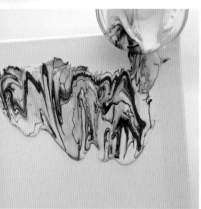

1 Scatter drops of fluid acrylic inks into a container holding pouring medium.

2 Without stirring, pour the medium straight onto the canvas.

3 The movement of the liquids causes the liquid colors to disperse, forming irregular ribbons and random marbleized patterns.

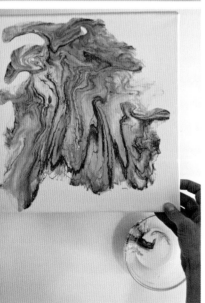

4 Tilt and rotate the support allowing the paint to slowly travel toward the lowest area to cover the surface.

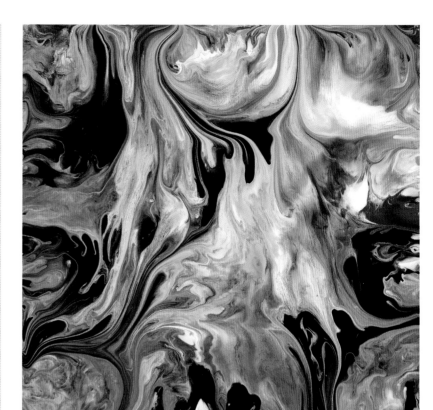

Support
Any primed surface can be used for the pouring technique, either unpainted or pretinted. The lighter the value of your support, the richer the colors of your pour will be. The smoother the surface, the easier the paint will travel.

Work area
Before pouring, cover your work area with plastic sheeting—this technique can be quite messy. If your support is large, it is easier to place it on the floor. Rigid supports (such as panel or canvas) can be elevated on four corners so that drips of paint flow over the edges.

Pouring
There are many ways to implement the pouring technique successfully:
• Pour straight into the middle and continue adding different colors in that same spot to create concentric circles of color that travel outward and run off the support. The support should be level if you want the paint to disperse evenly.

FLUID PAINTING 69
BY MARK CHADWICK
14 x 14 inch (36 x 36 cm)
Marbleized rivers of liquid colors form an exquisite abstract yet organic configuration that seems to be infused with energy and light.

• Drizzle figures, stripes or doodles. Pour colors next to each other or layer them. You can allow gravity to form the paint layer or use a palette knife to spread the paint.

• Alternatively, tilt the support and turn it this way and that, allowing the paint to travel toward the lowest area to cover the surface.

• Create swirls and patterns while the paint is still wet by dragging a toothpick, fork or any other pointed tool through the colors.

Air bubbles may form, which can be a charming addition to the overall look. Obtain a smooth, bubble-free surface by pricking the bubbles with a needle or spraying with isopropyl alcohol while still wet.

Drying

The painting needs to dry on a level surface to avoid uneven results. Drying time depends on the thickness of the paint film, the support and environmental conditions, but expect a minimum of at least 24 hours to up to a week. While the upper skin may feel dry to the touch, underlying layers may still be wet—be careful when handling. To prevent dust or pet hair from sticking to the wet surface, cover your project with a large cardboard box.

Pouring tips

• To avoid crazing use a minimal amount of water.

• Limit each layer to about ⅛ inch (3 mm) thickness. Specialized pouring mediums allow deeper pours of ¼ inch (5 mm).

• To prevent paint from dripping over the edge, use tape to construct a barrier around the rim of the canvas to enclose the surface.

• Use a level to ensure that your work surface is flat. Dry on a level surface to stop the paint from shifting.

• Spray with isopropyl alcohol to eliminate bubbles.

PREMIXED POUR

TECHNIQUE FILE 31

The premixed pour technique allows you to prepare all your colors in advance, and gives you freedom to decide on the quantity of each color as well.

1 Blend different colors with pouring medium (each color in a separate container), then lightly drizzle onto a canvas in random squiggles.

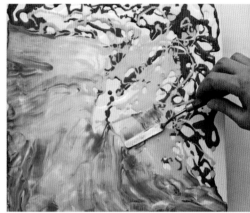

2 To cover the entire surface, gently spread the paint toward the edges of the canvas. Here, a painting knife is being used, but you could continue to pour paint until it flows off the edges by force of gravity.

3 While the previous layer is still wet, add another color mixed with pouring medium. The pouring medium ensures self-leveling of the paint, so that this new layer amalgamates with the previous coating of wet paint.

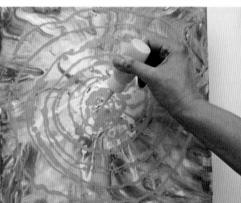

4 Drag a pointed tool through the wet paint to create swirls and patterns. Self-leveling will continue to occur as long as the medium has not started drying.

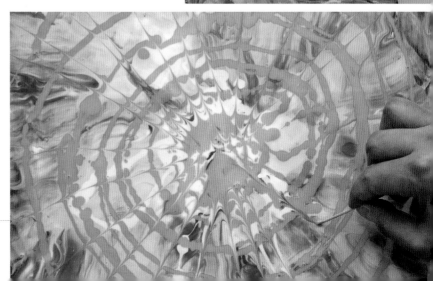

Oceana III
BY ANDREW DENMAN
11½ x 20 inch (29 x 50 cm)
Skilled use of masking tape
formed the emerging and
fading lines and quadrangular
geometric shapes that perfectly
balance this interesting trompe
l'oeil and give it an innovative
contemporary look.

Human hands were the first masks to be used in painting, as seen in the outlines of hands in prehistoric cave art around the world. Early forms of stenciling, used on fabrics, appeared about a millennium ago in China.

MASKING AND STENCILING

Modern masking materials and stencils are widely used in fine art, especially for airbrushing and watercolor techniques. Many artists use masking tape to create straight edges, shields and stencils for decorative designs and lettering, and frisket (liquid masking fluid) to create intricate patterns or random spatters.

Solid self-adhesive masks

Always test adhesive masks on a similar surface before painting, to assess whether damage occurs when the mask is removed. To protect your painting surface you can reduce the adhesion of masking tape by sticking it to your skin and peeling it off—if necessary, repeat.

It is important to attach your masking tape and frisket film meticulously, as paint has a tendency to seep underneath the edge. Always paint away from the mask, not into it. Lift the mask by gently peeling it back onto itself. Remove it as soon as possible to avoid the adhesive setting too strongly on your painting surface—preferably while the paint is still wet so that you can wipe away any paint that crept underneath the edge with a wet cotton swab. To remove an adhesive mask, carefully peel the edge and pull it back onto itself very slowly.

Frisket film is usually applied in a single sheet covering the entire painting after which specific parts are carefully removed with a precision blade, such as a scalpel or an X-Acto knife. It's important to change your knife blade frequently to achieve precision, so make sure you have plenty of extra blades on hand. Considerable expertise is needed to apply the right amount of pressure to cut the frisket without damaging the underground. Cut pieces are carefully lifted,

Liquid frisket tips

- Use colorless liquid frisket to avoid staining.

- Never apply liquid frisket to a wet or damp surface, as it will absorb and become impossible to remove.

- Liquid frisket should set solid before you apply any paint—test it by touch.

- When working on paper, first test it to make sure that the surface remains undamaged upon removal.

- If the liquid frisket is too thick, you can add a bit of water to it.

- To avoid bubbles, never shake the bottle but gently stir it.

- Apply thin coats of acrylic paint over liquid frisket—never paint thick layers, because heavy dried acrylic will tear when the frisket is removed.

- When removing the frisket, roll it into a ball and use it as an eraser to help remove the rest of it.

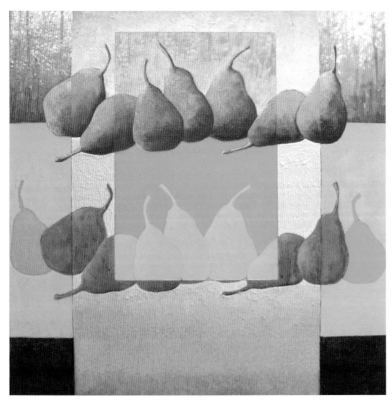

Pear Dilutions #7
by Louisa Wallace Jacobs
24 x 24 inch (61 x 61 cm)
Liquid frisket and masking tape were used to create straight and fluid lines to paint abstract shapes and recognizable silhouettes that seem to weave in and out of the stylish background.

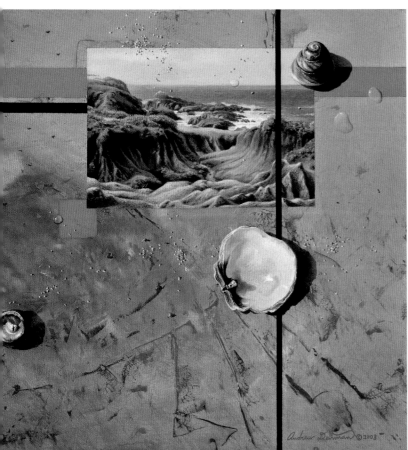

exposing the area for painting. Self-adhesive frisket with removable backing can be cut before attaching it to your painting surface.

Shields and stencils

To cut your own shield or stencil use resilient materials such as cardstock, Mylar, acetate or vellum.

To design your own stencil, it's important to create the image without unconnected spaces or "islands." You always need a bridge to connect and hold the stencil material together. For example, the letter "O" cannot be cut without the center falling out and turning into a full circle. So you need to "bridge" the center of the "O" by adding two bridges to connect the outside with the inside of the design. Your "O" stencil will look like two mirrored "C" shapes—afterward, you can paint over the bridges if necessary.

To hold the stencil in place while working, use masking tape or spray the back with repositionable spray adhesive. For storage, stick plastic wrap or wax paper to the adhesive side and lay flat.

Use a stencil brush, or a regular brush that is short haired and rather stiff, so that the hairs won't crawl under the stencil's edge while you apply paint (not too fluid) in vertical dabs. A sponge works well for stenciling as long as it's not too wet. You can use one color or work in gradations.

Island

Bridge

Masking and Stenciling continues over the page ⟶

Pressing a shield against the surface of your painting will produce hard edges, while raising the shield slightly will create a soft edge. Whether you paint with an airbrush, spray, brush or sponge, always experiment with using masks, shields or stencils beforehand.

Liquid mask

Liquid frisket can be applied to any nonabsorbent dry surface, including dried paint. A liquid mask

Sikia Says
BY ANDREW DENMAN
16 x 12 inch (41 x 30 cm)
This background was achieved by pulling high viscosity acrylics through a decorative, perforated metal sheet with a squeegee, creating texture and contrasting geometric patterns.

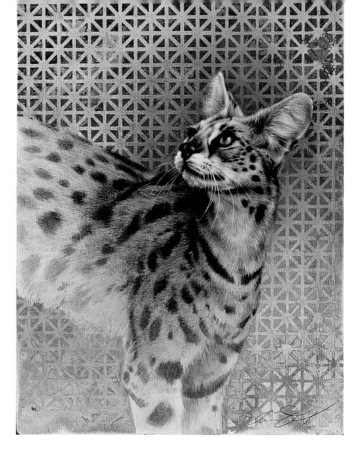

MASKING

Provided they are correctly applied, self-adhesive frisket, masking tape and liquid frisket all protect the surface, allowing you to create crisp, detailed edges.

1 Apply your chosen mask.

2 Before painting, make sure the liquid frisket has set into solid rubber. Apply paint with a light touch, brushing it away from masking edges to avoid the paint seeping underneath.

3 Carefully and slowly peel all self-adhesive frisket and masking back onto itself—not upward—to avoid damaging the surface underneath. The dried rubbery liquid frisket can be rolled off by rubbing it with a finger—but only do this after the paint has dried!

Matte self-adhesive frisket in which a design of a paint tube has been cut out with a sharp blade.

Fine line tape (⅛ inch or 3 mm) applied in curves.

Colorless liquid frisket applied in a pattern with brush (top and middle) and spattered by toothbrush (bottom).

Masking tapes in different widths.

works well when clean edges and precision are needed, because it prevents paint from bleeding.

Apply liquid frisket using a brush (preferably synthetic), a cotton swab, a toothbrush (for spattering) or the Grafix Incredible Nib.

Dip your applicator in a bowl of lukewarm, soapy water before, during and after the application process to remove dried frisket. Never use this soapy water to clean your paint brushes to avoid mixing paint with particles of frisket.

Before painting, make sure the frisket has set into solid rubber. After your painting is completely dry, you can safely remove the frisket by gently rubbing it with your finger.

Keep your frisket dispenser clean by removing the dried rubber around the rim or piercing the applicator with a straightened paperclip.

STENCILING

The key to successful stenciling is to ensure that the stencil is taped down, so that it doesn't move while applying paint. Apply paint in a vertical upright motion to avoid paint seeping under the stencil.

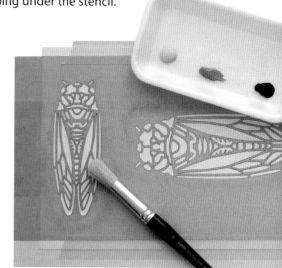

1 Tape the stencil to your painting surface to avoid shifting the pattern. Set out your paint and choose your brush—a stencil brush or any brush with short, stiff bristles will be suitable; alternatively a sponge can also be used.

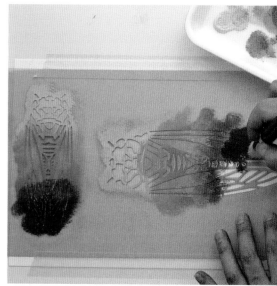

2 Load the brush with paint, blot it to remove excess and tap the brush vertically onto the stencil. Do not press the brush down too hard to avoid bristles from crawling underneath the stencil's edge.

3 Paint the stencil in one color, or create beautiful gradations by tapping different colors wet-in-wet over each other.

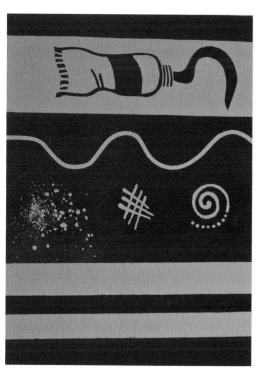

4 The results of using masking and frisket are crisp, precise edges.

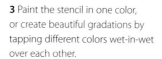

4 Remove the tape carefully and lift the stencil away without touching the wet paint, revealing the stenciled design with delicate edges. If seepage occurred, quickly clean the edge by wiping it with a damp cotton swab before the paint dries.

Grisaille (from the French word *gris*, meaning "gray") describes a painting executed entirely in monochrome or near monochrome, usually in shades of gray ranging from the darkest dark to the lightest light.

GRISAILLE

Another way to describe grisaille (pronounced griz-eye) is that it looks like a black-and-white photograph. This same technique using brown tones is called brunaille, and using muted green tones (a base often used for the underpainting of skin tones) is called verdaille. Grisaille achieves a dramatic effect of lights and darks, creating a distinct sense of three-dimensionality.

The history of grisaille
The grisaille technique dates back to at least the 15th century with a strong tradition of grisaille in the Low Countries. Flemish and Dutch Masters often painted grisaille on the outer wings of triptychs. A wonderful example is the 1432 Ghent Altarpiece (The Adoration of the Lamb of God) by the Flemish painter Jan van Eyck. In those times the outsides of the triptychs were primarily on display, as the doors were normally kept closed except on holidays.

Grisaille was often used for frescoes, as well as for trompe l'oeil effects in buildings to simulate sculptured reliefs. The imitation of sculpture was intended, since sculpture was more expensive than painting. More notably, grisaille was done as an underpainting in preparation for colored glazes (transparent color overlays). Many of the great Masters used grisaille, including Hans Memling, Johannes Vermeer, Rembrandt and Michelangelo. A revival of grisaille in the late 18th century favored this trompe l'oeil method for imitating classical sculpture on walls and ceilings. A well-known example can be found at Hampton Court Palace, just outside London, where the decoration of the The King's staircase by Antonio Verrio (1636–1707) is in grisaille.

As the emphasis shifted toward direct painting (alla prima), grisaille became less popular in

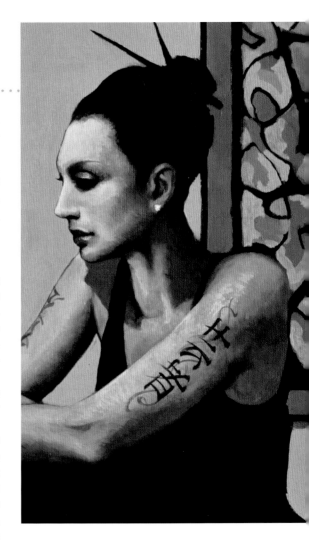

Geisha (detail)
by Raoof Haghighi
12 x 15¾ inch (30 x 40 cm)
This graceful grisaille portrait does not need additional color due to its strong composition. The beautiful gray tones were applied over orange and ocher, creating an elegant, captivating mood.

Judging values

There are several practical tricks to help you mix a good value scale and determine their location in your grisaille painting:

• By simply squinting you see fewer hues, as images blur into values and shapes. This is the easiest way to determine overall values, but it is not accurate for mid-tone values or small details.

• If you have a photograph of your composition, you can change it into a grayscale image on your computer or a photocopier.

• Red acetate or cellophane is a wonderful aid. Used as a filter it neutralizes color without obscuring details—the world turns into a red-tinted grayscale when you look through it. If you cannot find this product, look for transparent red gift paper (at hobby or flower stores), or buy a pair of inexpensive cardboard 3D glasses and cut off the red lens to use in the studio.

• Using a cardboard gray scale and value finder is a good way to isolate and identify values. Hold it near your painting and your palette to determine the accuracy of your values.

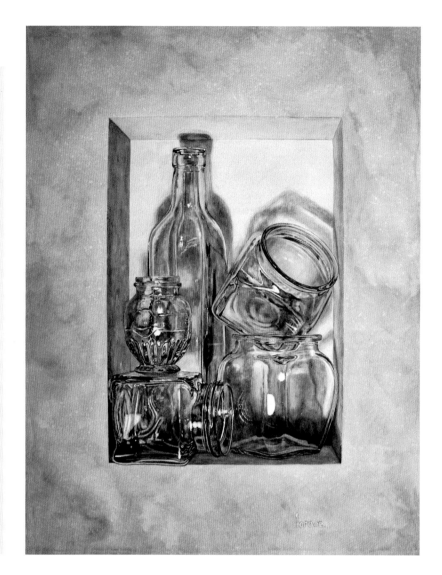

painting can hold its own as finished, emphasizing a rich array of values instead of colors. For artists of every skill level this technique can be incredibly liberating—you are free to focus on form and values, unhampered by the burden of mixing colors.

The importance of values cannot be overstated—it makes or breaks a painting, especially when it's realism. You can paint a grisaille in any dark color you choose, adding white to create a gray scale from the lightest light to the darkest dark.

CLARITY No. 1

BY LORENA KLOOSTERBOER

15¾ x 12 inch (40 x 30 cm)

A trompe l'oeil still life painted in the verdaille method, using a near-monochrome range of green tones, from the darkest dark to the lightest light.

the 20th century. However, there are plenty of notable examples of grisaille to be found in contemporary art. Picasso used the grisaille technique in his monumental mural-size oil painting *Guernica*. Photorealist Chuck Close also used grisaille in many of his early acrylic portraits. Today an increasing number of artists are rediscovering the grisaille technique using modern methods and mediums.

While grisaille is most often used as an underpainting, a well-executed monochromatic

Grisaille continues over the page ⟶

TECHNIQUE FILE **34**

GRISAILLE STILL LIFE

A grisaille painting is always a challenge, but it will teach you a lot about assessing values—a skill that is essential in representational work, as it enables you to convey the impression of three dimensions on the two-dimensional support or canvas. Because acrylic paint dries fast, prepare a complete gray scale in little airtight containers before you start, or use a stay-wet palette.

You will need
- Pointed round brush #0 and #1
- Flat brush #3, #4, and #8
- Pencil
- Primed panel

Palette
- Burnt Umber
- Neutral/Medium Gray No. 5
- Pale Umber
- Payne's Gray
- Raw Umber
- Titanium White
- Unbleached Titanium

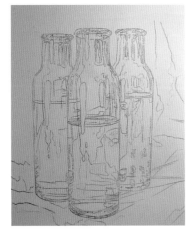

1 Sketch the composition onto a primed panel with a pencil.

2 Cover the entire composition with a rough wash in Raw Umber. Next reinforce some shapes and mid-tone values with diluted Titanium White and Payne's Gray, creating a base to judge other values against.

3 Darker areas are reinforced with Burnt Umber, Payne's Gray and Neutral/Medium Gray No. 5. Build up multiple layers of lighter values in Unbleached Titanium and Pale Umber.

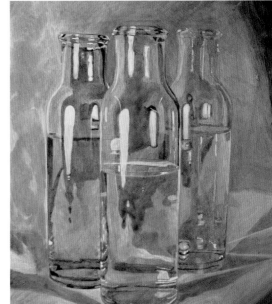

4 Continue with the painting, alternating between toning down and lifting up values; the transparency of the paint layers gradually vanishes and becomes more opaque.

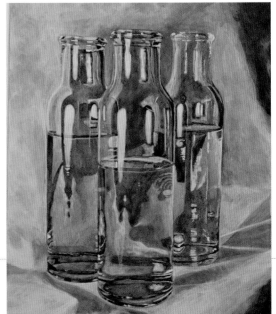

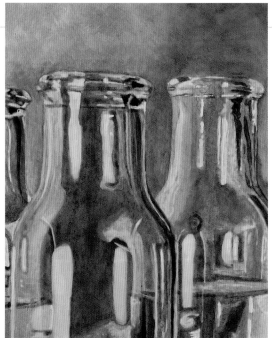

5 To retain an intentional "rough" look of brush strokes, build up layers by scumbling over the larger areas of the glass and the background while continuing to "push and pull" light and dark values.

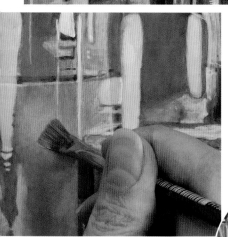

6 Dry-brush areas of the glass where you want to suggest transparency to create subtle value differences and transitions.

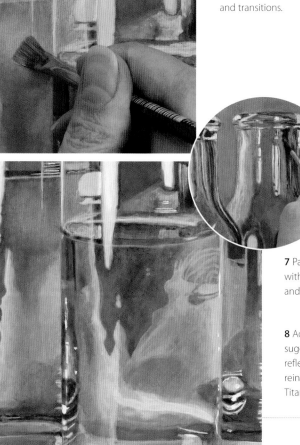

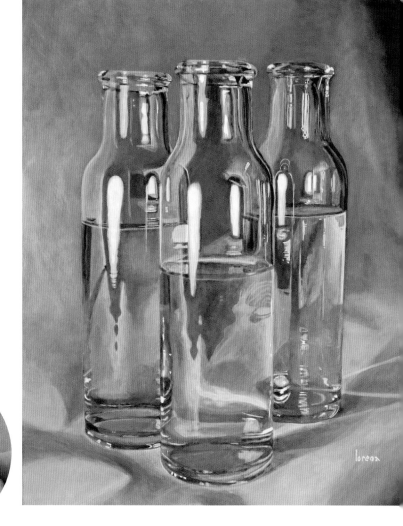

7 Paint in the darkest darks with a blend of Payne's Gray and Burnt Umber.

8 Add sheer gradations to suggest transparent light reflections with white veils and reinforce highlights in pure Titanium White.

TRINITAS
BY LORENA KLOOSTERBOER
10 x 8 inch (25.5 x 20 cm)
This near-monochrome painting of three glass bottles holding water is a prime example of a brunaille in which grays have also been used. The warm browns contrast well with the cooler grays, resulting in a simple, yet elegant, realistic still life.

A glaze is a thin layer of transparent color applied to the surface of a painting to modify the tones. Multiple glazes can be layered to create vibrant color depth through optical mixing.

SHADES OF YELLOW
BY SHAWN GOULD
9 x 12 inch (23 x 30 cm)
Dappled transparent glazes have built up various shades of yellows, greens and blues.

GLAZING

Famous artists such as Leonardo da Vinci, Rembrandt van Rijn and Johannes Vermeer are known for painting numerous layers of glazes to achieve exquisite colors, often in an optical blend. Optical blending occurs when, instead of mixing colors on a palette, you paint them separately over one another. Light shining through these transparent layers amalgamates them into another color, adding depth and richness. Optical mixing also avoids muddiness, because the pure pigments remain separated inside their own layers of binder.

Although the above-mentioned artists worked in oils, today's acrylics lend themselves particularly well to glazing, especially in multiple layers, because of their fast-drying property and excellent tinting. Glazing makes it easier to render subtle color changes, such as those found in skin tones or foliage. A finished painting can also be unified by giving it a final glaze all over— or you can glaze specific areas of your painting to emphasize them.

While transparent or translucent pigments work best for making glazes, you can also use opaque colors, thinning them down until they become diaphanous. When a glaze made with semi-opaque or opaque pigments isn't completely transparent, it is called a velatura (Italian for "veil"). A velatura made with white acrylic paint and medium, for example, produces a veil or fog, which can be useful for lightening areas or painting delicate atmospheric effects. A dark velatura can tone down colors and create shadows. Glazes and veils are extremely useful for adjusting and perfecting the color and value balance of your painting.

How to glaze

Use a transparent binder, such as glazing medium or gloss medium, to make a glaze. The proportions are approximately 10 parts binder to one part paint—but you should always test your glaze on a white piece of paper, because some pigments have higher tinting power than others. Adding a little bit of water may help to make the glaze flow better, and adding a bit of slow-drying medium will extend working time.

Always paint your glaze on a dry underground using a soft-bristled brush. Some artists paint glazes in one direction, while others use a light, beating brush stroke.

Be careful not to disturb the glaze that is in the process of drying—which doesn't give you much time. The film that forms on the glaze is easily disturbed, so touching it during the drying process can ruin the glaze. When that happens, simply use a wet sponge or mop brush to wipe the entire glaze off before it dries completely. Once your surface is dry again, start over.

Wait for your glaze to be completely dry before adding another layer. It is much better to apply several very thin glazes than one thick one. When mixing your glaze, it is better to start with a low pigmentation that you can later intensify by a second layer.

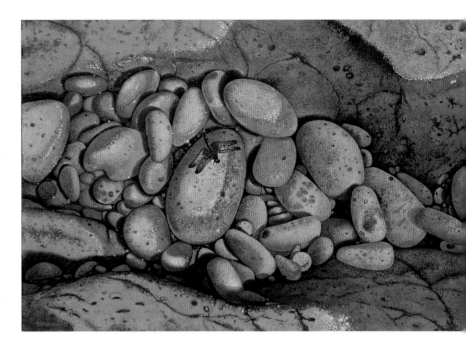

Water Hazard 2
by Gregory Simmons
24 x 30 inch (61 x 76 cm)
Multiple transparent glazes modulate the stones in subtle hues, and perfectly capture the exquisite reflective and ever-changing qualities of water.

Glazes and optical mixing effects

Four horizontal bands of thin glazes (using Zinc White, Cadmium Red Medium Hue, Hansa Yellow Light and Cobalt Blue) have been applied over a range of vertical glazes over a white ground. The effects vary, depending on the color intensity and opacity of each pigment. All the glazes have been blended with glazing medium.

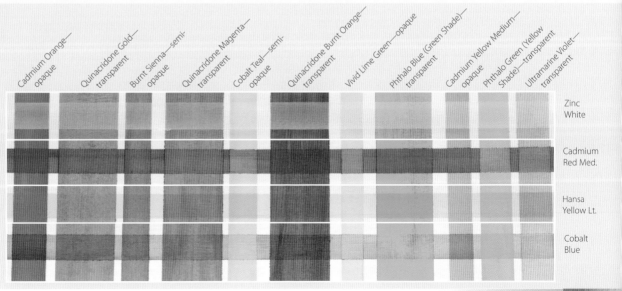

Glazing continues over the page ⟶

GLAZED GLASS MARBLE

Clear glass is a challenging subject to paint, as it has no color of its own: any color that you see comes from surrounding objects that are either reflected in it or seen through it. In this demonstration, the subject is a classic glass marble with colored glass swirls inside. To make it look three-dimensional you need to pay careful attention to subtle shifts in value produced by the way the light affects the sphere. Glazing is the perfect technique, as it allows you to build up very thin layers of color gradually until you achieve the correct tone.

You will need
- Primed panel
- Pencil
- Gloss medium
- Flow improver
- Sandpaper, medium grit
- Pointed round brush #1
- Filbert brush #10
- Flat brush #4 and #14
- Fan brush #4

Background palette
- Burnt Umber
- Cadmium Orange
- Medium Magenta
- Neutral/Medium Gray No. 5
- Payne's Gray
- Titanium White

Shadow palette
- Cobalt Blue
- Neutral/Medium Gray No. 5
- Payne's Gray
- Titanium White

Marble palette
- Burnt Sienna
- Burnt Umber
- Cadmium Orange
- Cadmium Yellow Medium
- Cobalt Blue
- Naphthol Crimson
- Phthalocyanine Blue
- Raw Umber
- Titanium White

1 Cover a primed panel with quick random strokes of Cadmium Orange and Medium Magenta. Let it dry. To obtain a vibrant mid-tone gray, blend Burnt Umber, Neutral/Medium Gray No. 5, Payne's Gray and Titanium White, then cover the surface in smooth strokes with a broad brush. Once dry, sand it lightly with sandpaper to smooth the surface in preparation for glazing. Specks of the underlying layer of orange and pink show through, adding a hint of color to the otherwise dull gray backdrop.

Affected by the tinted underground, overpainted grays fluctuate from warm to cool.

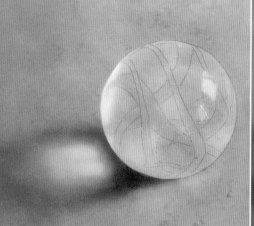

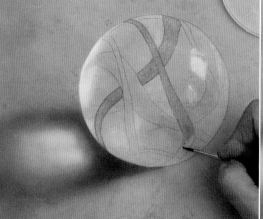

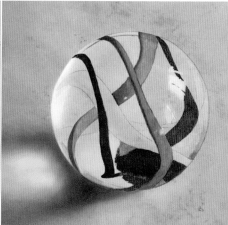

2 Lightly draw the marble onto the support with a pencil. Dry-brush and feather the shadow using Payne's Gray, Neutral/Medium Gray No. 5, Titanium White and Cobalt Blue. Cover the entire sphere with a thin white veil glaze, using Titanium White mixed with gloss medium, enhancing some of the lighter areas with a stronger tinted veil.

3 Glaze the blue ribbon in Cobalt Blue. Continue to build up even layers of Cobalt Blue glazes as this intensifies color strength and value. A glaze of Phthalo Blue reinforces contrast of the edges and shadow areas of the blue swirl.

4 Glaze the red ribbon with a blend of Burnt Umber and Naphthol Crimson, then cover it with a Burnt Sienna glaze to increase the warmth of the reds. Apply additional glazes in Cadmium Orange and Burnt Umber to intensify color and darken values along edges and in shadow areas.

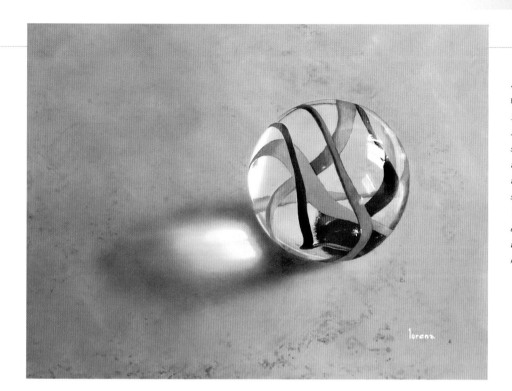

SOLO
BY LORENA KLOOSTERBOER
9 x 12 inch (22.5 x 30.5 cm)
Except for the background and the shadow, this entire still life is painted in transparent glazes. Multiple layers of thin colors build up into exceptional color strength and a wonderful variety of values. The optical mixing that occurs when different colors are layered gives the artist the freedom to change the hue without having to repaint an entire section.

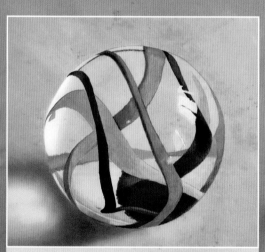

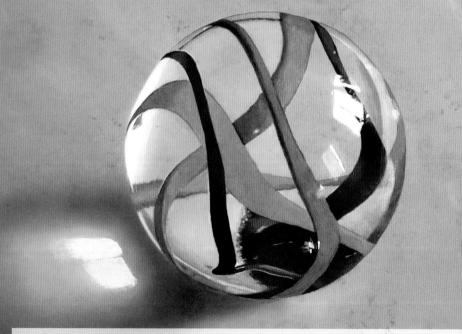

5 Layer the yellow ribbon with Cadmium Yellow Medium glazes and darken the shadow areas with a Raw Umber glaze. Note that paying particular attention to the shadows and highlights of each colored swirl inside the glass marble will help define the three-dimensional appearance of the object.

6 Touch up the final details of subtle light reflections with white veils, and reinforce the highlights of the glass marble and the light reflected in the shadow in pure Titanium White.

Sometimes artists find it difficult to create a full range of values using color. A grisaille underpainting makes it easier to get all the lights and darks right, which then becomes the foundation for adding transparent color glazes.

GLAZING OVER GRISAILLE

This method is especially valuable in achieving realism. During the grisaille phase, you can focus exclusively on the values of the painting. Once the grisaille is in place, you can dedicate your attention exclusively to color. Acrylics lend themselves perfectly to grisaille glazed with color.

One of the most important characteristics of the glazing over grisaille technique is the light reflected down through the transparent color layers to the opaque grisaille, which then reflects back opulent color. Renaissance and Baroque artists called this luminosity the inner light.

Once the grisaille has completely dried, transparent glazes can be painted over it. During this process it's important to focus on the intensity of light and subtle color nuances, building up the concentration of color with layers of thin glazes. Make sure that each glazed

TIBETAN GOLD
by LORENA KLOOSTERBOER
15¾ x 15¾ inch (40 x 40 cm)
Similar to the technique shown on the following pages, this piece was painted in Ivory Black grisaille first, after which layers of transparent glazes were added to introduce color.

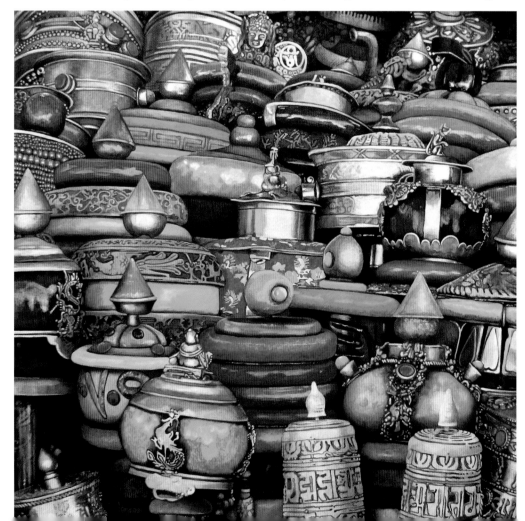

Historic grisaille with glazing

• Johannes Vermeer (1632–1675) famously used grisaille for his underpaintings, working out every detail to perfection before he established the many layers of luminous color glazes in oils.

• Between 1508 and 1512, Michelangelo painted portions of the ceiling frescoes of the Sistine Chapel in grisaille. The Sistine Chapel ceiling is a prime example of High Renaissance art.

layer dries well before adding the next—if the glaze is not completely dry, brushing it may disturb the skin of the paint, which will coalesce or amalgamate, creating lumps on the surface.

While the grisaille can be executed in opaque darks, mid-tones and intense whites, the color glazes must be transparent or translucent. This is accomplished by mixing glazing medium or gloss medium with a tiny amount of acrylic paint, adding a bit of water if necessary. Adding flow improver to your water helps spread the glaze more easily to achieve a thin continuous layer of transparent color. While one can certainly dilute opaque colors enough to become a glaze, the most resplendent results are obtained using transparent or translucent acrylics. When blending your glaze make sure that the pigments are well dispersed without any remaining globs of pigments. The color glaze will modify the values of the underlying grisaille, but these can be easily readjusted after all the glazes have been executed and left to dry in order to achieve the desired result.

GLAZING OVER GRISAILLE STILL LIFE

Grisaille, used as underpainting, allows you to focus on values first, without having to worry about accurate color blending. A successful grisaille is composed of the entire value range, from the darkest darks to the lightest lights. It becomes the perfect foundation for the subsequent application of vivid, see-through glazes, bringing the composition to life.

You will need
- Primed linen canvas
- Pencil
- Liquid frisket (and applicator brush or the Incredible Nib)
- Pointed round brushes #00, #0 and #1
- Fan brush #4
- Flat brush #4 and #6
- Watercolor brush ¾ inch
- Synthetic flat brush 1½ inches
- Gloss medium
- Flow improver
- Cotton swabs

Palette
- Cadmium Orange
- Cadmium Yellow
- Cerulean Blue
- Hooker's Green
- Naphthol Crimson
- Neutral/Medium Gray No. 5
- Payne's Gray
- Titanium White
- Unbleached Titanium
- Vandyke Brown Hue

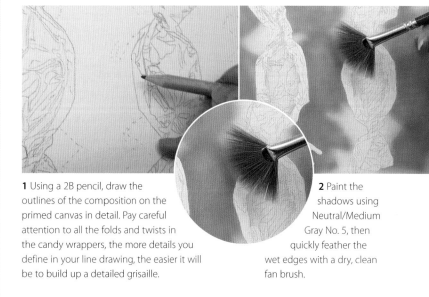

1 Using a 2B pencil, draw the outlines of the composition on the primed canvas in detail. Pay careful attention to all the folds and twists in the candy wrappers, the more details you define in your line drawing, the easier it will be to build up a detailed grisaille.

2 Paint the shadows using Neutral/Medium Gray No. 5, then quickly feather the wet edges with a dry, clean fan brush.

Glazing over Grisaille continues over the page ⟶

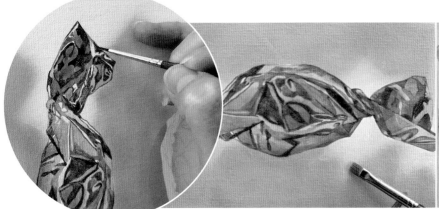

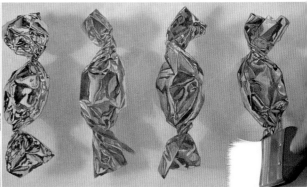

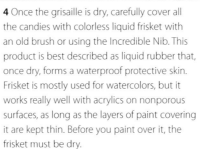

3 Using a #1 pointed round brush, paint the metallic candy wrappers in the grisaille technique, using only Payne's Gray in different consistencies and pigment strengths to create different values—from pure strength to very diluted with gloss medium and water.

4 Once the grisaille is dry, carefully cover all the candies with colorless liquid frisket with an old brush or using the Incredible Nib. This product is best described as liquid rubber that, once dry, forms a waterproof protective skin. Frisket is mostly used for watercolors, but it works really well with acrylics on nonporous surfaces, as long as the layers of paint covering it are kept thin. Before you paint over it, the frisket must be dry.

5 Now that the candies are covered, brush the background in a wash of Unbleached Titanium adding color without affecting the candies. Once dry, cover the entire painting with another thin transparent wash of Neutral/Medium Gray No. 5 to darken and tone down the background, scumbling and softening the color with a clean, dry brush.

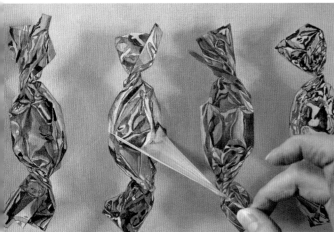

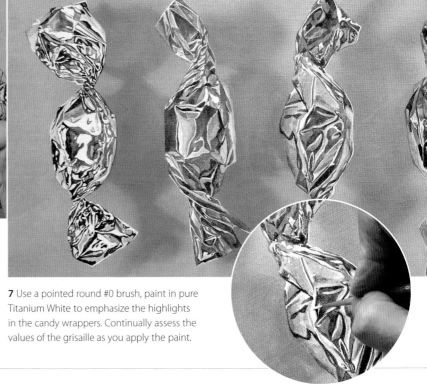

6 When you are satisfied with the background, remove the frisket by gently rubbing it with a finger and pulling it off the canvas, exposing the original grisaille.

7 Use a pointed round #0 brush, paint in pure Titanium White to emphasize the highlights in the candy wrappers. Continually assess the values of the grisaille as you apply the paint.

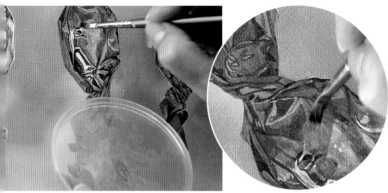

8 Prepare each color glaze separately by mixing a small amount of acrylic paint with a larger amount of gloss medium (acrylic glazing medium can also be used) and a little water laced with flow improver. This liquid medium increases leveling, flow and stability of the paint. Use a #4 or #6 soft flat brush for glazing—select your brush according to the size of the area to be glazed, so that you can comfortably respect the outer edge. If glazing occurs outside of the line you can quickly wipe it clean using a moist cotton swab.

9 Carefully glaze each candy, covering the grisaille up to its edges and adding subsequent layers of glaze to enhance the intensity of the color. The glazes tone down the original grisaille considerably so, after glazing, reinforce the darker values of each candy.

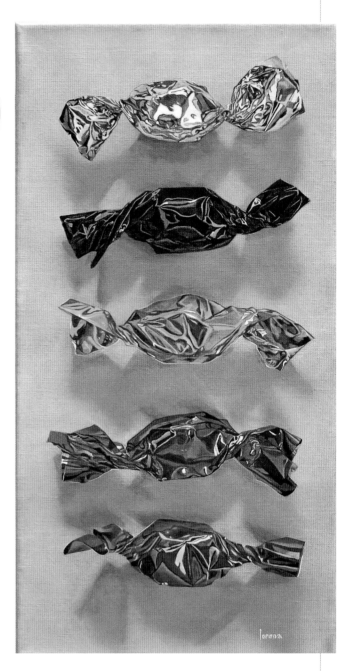

Deliciae I
by Lorena Kloosterboer
8 x 15¾ inch (20 x 40 cm)
The combination of the grisaille method with color glazing is exceptionally suitable to highlight the contrasting value range and to introduce highly saturated jewel-like colors to this composition. The initial focus starts with value, then moves to color, and ends with a final evaluation of both value and color. Adjustments can be made throughout the painting process with excellent results.

10 Emphasize the highlights, mixing Titanium White with a very small amount of each color glaze. Finally, intensify the background shadows, scumbling and feathering a thin layer of Vandyke Brown Hue over parts of the existing shadows.

An impasto painting is created by expressive layers of thick acrylic paint, emphasized by striking textures, opulent color and spontaneous movement.

IMPASTO

Impasto, from the Italian word meaning "dough" or "paste," refers to the technique of heavily applying paint with a brush or a painting knife. Brush strokes or knife strokes are clearly visible, giving a three-dimensional low relief to the painting surface.

Impasto painting holds a long tradition and was used by notable masters such as Rembrandt van Rijn, Claude Monet and Vincent van Gogh for aesthetic reasons and to enhance compositional details. Later, abstract expressionists used impasto to show the tangible action of painting as the main focus of their artwork. Nowadays the impasto technique is used in a wide variety of approaches, from abstract art to portraiture and landscapes and from very loose, sweeping gestures to finely detailed artwork.

The acrylic paint used in the impasto technique needs to be quite thick. Heavy body acrylics are most suitable, but you can also add thickening medium to acrylic paint to acquire a viscous consistency that holds its peaks. The inclusion of texture gels and mediums can also add interest. Often the paint is used straight out of the tube or jar and applied to the canvas directly—this is a practical way to avoid your paint from drying out on the palette. During work you can also spray your palette and/or painting surface with water or palette wetting spray to keep the paint open. It is important to avoid adding too much moisture, as the paint may lose adhesion and start sliding around. If this happens, it is best to wait for a few minutes for the water to evaporate.

The painting knife, a flexible steel spatula with a trowel-shaped handle, is best for applying paint to a flat surface. When using a brush, load

Thickening mediums	
• Heavy gel medium	• Modeling paste or molding paste
• Structure gel	
• Thickening gel or medium	• Marble dust
	• Silica sand
• Texture gel	

Impasto effects

Practice making different impasto marks with a painting knife and brush, from fluid, random motions to controlled precise application. Experiment to find which underground you prefer: The surface can be unprepared, painted by brush or covered with dried impasto or even dried sgraffito (see pages 177–179).

Short strokes in one direction offer the look of mosaics.

Striated brush marks and rich impasto texture show up in heavy body acrylic paint.

Quick, variable strokes in different directions suggest movement.

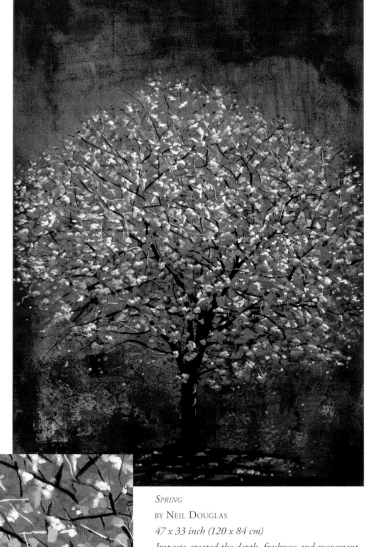

Spring
BY Neil Douglas
47 x 33 inch (120 x 84 cm)
Impasto created the depth, freshness and movement of spring blossoms over a surface texture built up using clay and collage.

Late Spring Birch
BY Raette Meredith
40 x 30 inch (102 x 76 cm)
Sweeping gestural marks using a painting knife suggest movement, while the supple blending of colors evokes the untamed beauty of nature.

Different marks—from long, straight strokes to quick, circular dabs—can be combined in the same work.

Acrylic paint scraped into the texture of dried sgraffito with a palette knife, so that the high points and peaks of the underlying sgraffito show through.

With a palette knife, colors can be blended into a subtle gradation.

IMPASTO LANDSCAPE

The impasto technique is perfect for this bold, impressionistic landscape. Make your marks more heavily textured in the foreground, smoothing them out in the middle and far distance to create a sense of recession.

You will need
- Primed canvas
- Painting knife with rounded edge of about 2 inches (5 cm)

Palette
- Burnt Sienna
- Burnt Umber
- Cadmium Yellow
- Cobalt Turquoise
- Light Violet
- Payne's Gray
- Perinone Orange
- Permanent Light Green
- Sap Green
- Titanium White
- Ultramarine
- Yellow Ocher

the paint heavily so that the bristles essentially become a trowel. Always use a dry brush—no water or other thinning mediums should be used to avoid losing the viscosity and adhesive quality of the paint. Wipe your painting knife or brush on a dry cloth or paper towel after every stroke to avoid contaminating paint colors.

Apply bright colors first, working from light to dark. Do not apply too much paint; it is better to add paint by bits. Any mistakes can be scraped off. If you paint a very large surface, finish one section completely before moving to the next.

You can start your impasto painting with or without a drawing, and your primed surface can be prestained if you so desire. While impasto is often painted in one alla prima sitting, many artists paint over previously dried layers of impasto with excellent results. Keep your arm and hand relaxed for smooth, easy movements; this will translate into freshness while building up layers and depth. Experimentation in using different gestures and working in a rhythmic way will lead to creating different marks.

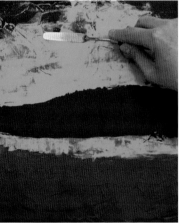

1 Mix a dark, neutral brown from Burnt Umber, Payne's Gray and Sap Green and scrape it over the support, keeping the texture rough and uneven, then let it dry. Roughly "sketch" in the landscape using Burnt Sienna and Permanent Light Green. Scraping paint over the rough surface of the underpainting creates additional texture.

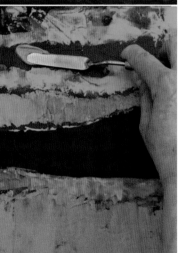

2 Apply Yellow Ocher over the bands of Burnt Sienna in light vertical strokes, blending it delicately with the wet impasto underneath. To avoid too much blending, frequently wipe the painting knife clean.

3 Apply horizontal strokes in Ultramarine and Titanium White to suggest the sky. While most of the Permanent Light Green has been covered, the faint impression of its brilliance still has an impact on subsequent layers.

4 The sky has been corrected by more vigorous blending. Warm up and balance the impressionistic landscape with hints of Light Violet, Cobalt Turquoise, Cadmium Yellow and Perinone Orange.

In the Distance
by Lorena Kloosterboer
12 x 12 inch (30 x 30 cm)
The textural low relief of the impasto adds visual interest to this sunlit landscape, even in the darkest areas.

Sgraffito is the technique of scraping away a layer of paint to reveal parts of the ground. Sgraffito (sgraffiti in the plural) comes from the Italian word *sgraffire*, meaning "to scratch."

SGRAFFITO

The sgraffito technique can be applied to any acrylic paint layer while it is still wet to reveal contrasting color underneath. The ground can be a previously applied layer of dry paint (in one single or in multiple colors) or simply the pale surface of your paper or canvas.

Apply a top layer of acrylic in a contrasting color over your dry unprepared or painted surface—regular and heavy body acrylics work best, because they maintain their shape and allow themselves to be sculpted. Add some retarder medium to give yourself more time to work.

Sgraffito can be achieved using virtually any blunt tool or object, as long as it doesn't damage the underlying surface. Most common is the use of the tip of a brush handle to write, draw or doodle through a wet layer of paint, producing thin lines, contours or edges. Broad streaks

WAVING NICOTIANA
BY FLORA DOEHLER
16 x 16 inch (41 x 41 cm)
Clean, strong sgraffito
marks are best made
by scratching into wet
layers of colored acrylic
gel or medium revealing
the painted surface
underneath.

Sgraffito continues over the page ⟶

SGRAFFITO TECHNIQUE

The sgraffito technique not only creates low-relief, three-dimensional textures, but also allows exciting color combinations by exposing part of the underground.

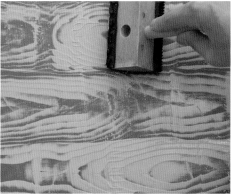

1 Blend acrylic color with gloss medium or glazing medium to achieve the consistency of light cream. Add a bit of retarder medium and/or water to gain more open time. Using quick strokes, apply the paint to a dry underground.

2 Pull the wood-graining tool in parallel strokes to scrape away the wet layer of paint, exposing the color underneath. The wood-graining tool has a convex head. Pull it across the surface in a rocking motion to rasp different areas of the rubber surface on the paint. This creates different patterns, mimicking wooden planks side by side.

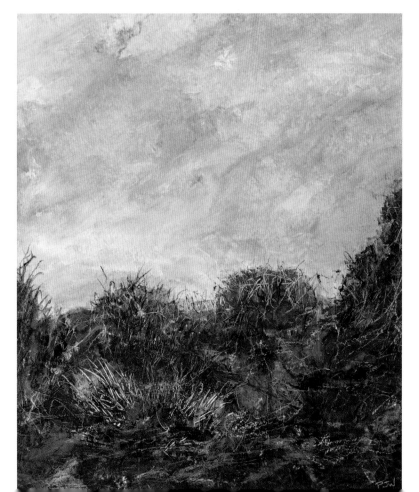

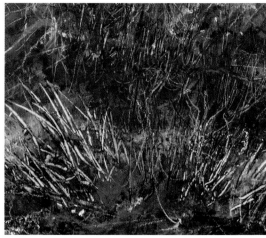

BRINTON WALK
PETER WILLARD
14 x 11 inch (36 x 28 cm)
This elegant landscape was built up using both brush and fingers. Sgraffito marks were then created by scratching nails, pen knife and wire into wet as well as dried paint layers.

or large areas can be scraped with a piece of cardboard, a credit card or a large painting knife; when this is done on a textured surface, such as canvas, it will also show the grain of the fabric.

There is a variety of specialized tools for sgraffito, from strangely shaped metal painting knifes to innovative wedges, scrapers and blades with patterned edges made of silicone or rubber composite. A more representative approach to sgraffito—often used in trompe l'oeil—can be obtained with wood-graining tools, simulating different wood-grain patterns. Although not generally referred to as sgraffito, wood-graining is one of many unique sgraffito techniques based on the principle of scraping a top layer to shape paint in a pattern and reveal the underlying color. Combs, also used for wood-graining, make lines and stripes of different widths to create a variety of decorative patterns.

Many household objects such as hair combs, forks and spoons (both ends), or even your fingernails, make great sgraffito tools. You can also make your own tool to achieve depth and define texture by cutting out shaped edges in a piece of heavy-duty cardboard or a sturdy rubber or silicone kitchen spatula.

Ideas for sgraffito tools

- Color shapers—soft and firm tips
- Comb
- Credit card or hotel key card
- Fork
- Hardened paint brush
- Kitchen spatula
- Painting knife or spatula
- Piece of cardboard
- Blades and mini-blades (for example, Princeton Catalyst)
- Wedges and contours (for example, Princeton Catalyst)
- Painting knives (for example, RGM New Age)
- Squeegee
- Wood-graining tools

Sgraffito effects

Sgraffito marks can produce many different looks— experiment to discover your favorite!

Wavy parallel lines made with a rubber comb.

Different sgraffito marks made with a double-ended rubber shaper. The wavy lines on top were made with a chiseled tip; the scribbles on the bottom were made with a pointy tip.

Paint scraped with a plastic key card, showing the surface texture.

Parallel lines made with a serrated rubber scraper, with progressively wider teeth.

Sgraffito made with a malachite comb.

Sgraffito scraped with a metal wood-graining comb over a prestained underground.

To spatter is to mark a surface with drops, splotches or speckles of scattered paint. Spattering is an easy but messy, uncontrolled technique that produces haphazard, organic-looking textures.

SPATTERING

The spattering technique can be used on its own to create an abstract painting, as a texture for a background or on a specific area in a painting, for example, to create droplets in a splashing sea wave or speckles on a stone. Spattering can be done with a minimum of tools, which makes it accessible to all artists. Because it's a messy procedure, you need to cover the surrounding area of your work surface before you start. While you can, to some extent, guide where you spatter, there's limited control over the amount and size of droplets, so be prepared for some surprises. To avoid spattering certain areas of your painting you can mask them with tape, frisket or a piece of loose paper cut or torn in the shape you want.

Acrylic paint lends itself especially well to this technique because it dries quickly, which allows subsequent layers to be added almost immediately. If you make a mistake, quickly wipe the spatters off with a moist sponge, paper towel or cloth before the paint dries.

Tools for spattering
The simplest tools for spattering are a stiff bristle brush or a toothbrush. Dip the brush in liquid acrylic paint, then hold it above your work.

There are three ways to spatter:
• Flick the brush with a quick movement of your wrist.
• Tap the brush with a hard object such as another brush or a wooden spoon.
• Run your fingertip, a brush handle or pencil through the bristles. Always move your finger or tool toward yourself, so that the paint spatters away from you.

You can also improvise spattering tools using everyday household items. Plastic spray bottles filled with thinned acrylic paint are convenient when you want to spatter a large surface area with the same color. Remember to use very liquid acrylic paint to avoid clogging, and to flush the spray bottle after each use to prevent obstructing the nozzle and tube.

Alternatively, you can use a metal spatter screen, which looks like a small, flat strainer or sieve. Fill a brush with liquid acrylic paint and brush it onto the mesh, then hold it over your horizontal painting surface and blow through it, spattering the area below.

To create irregular spidery splotches, use a drinking straw to blow drops of liquid paint in different directions.

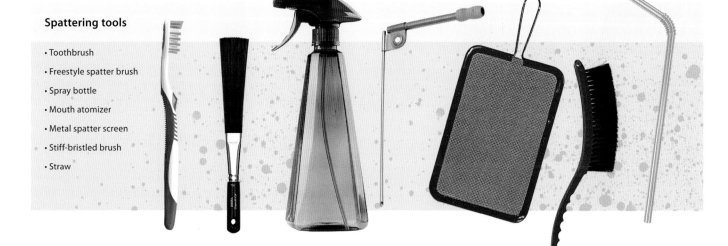

Spattering tools

• Toothbrush
• Freestyle spatter brush
• Spray bottle
• Mouth atomizer
• Metal spatter screen
• Stiff-bristled brush
• Straw

Lighter areas were built up by increasingly mixing more white into the colors for new spattering layers.

Mid-tone areas were built up by alternating layers of dark and light colors until the desired look was achieved.

Apricot Mallow
by Lorena Kloosterboer
24 x 12 inch (60 x 30 cm)
The soft-lit gradation of the
background was achieved
by spattering many layers
of transparent paint with
a toothbrush.

Spatter size

The consistency of the acrylic paint will influence the size of the spatters: the more liquid the paint, the smaller the droplets, and vice versa. The distance between tool and surface also alters the size and range of the spatters. Take time to experiment.

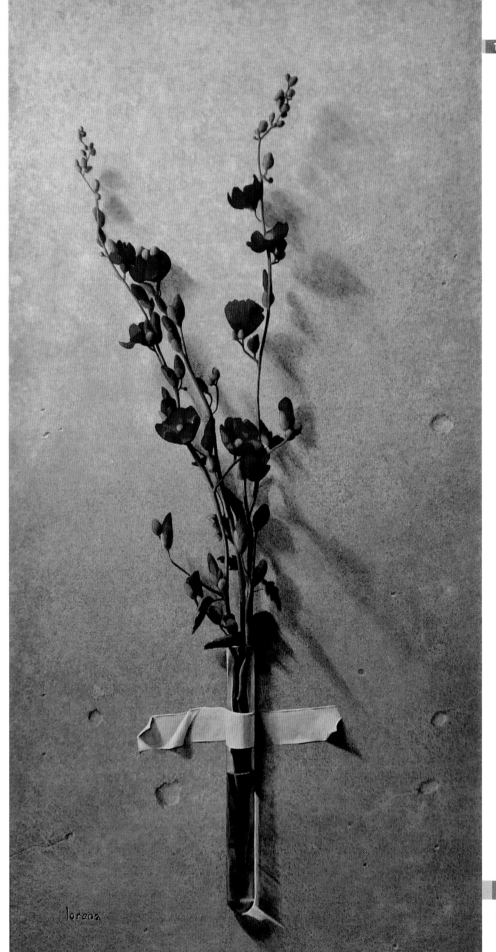

Solar Plunge 20
by Bill Agee
20 x 20 inch (51 x 51 cm)
This striking spattered abstract, based on the universe as conceptual idea, displays a wonderful interaction between colors, shapes and textures.

Summer Wildflowers
by Tammy Northrup
5 x 5 inch (13 x 13 cm)
Highly precise spattering in vivid colors applied to a painted underground shaped this stunning meadow of flowers.

The mouth atomizer is an ingenious instrument consisting of two hinged tubes that form a right angle or upside-down L. Place the longer, narrower tube in liquid acrylic paint and blow into the shorter wider tube with your mouth. This siphons the paint upward and propels it, creating fairly even spatters. This tool comes in two versions: the portable fold-up version is compact and practical for traveling, but sometimes difficult to calibrate into the right angle. The fixed atomizer, already set at the correct angle, is easier to use. It is important to keep the mouth atomizer clean as dried acrylic paint will clog the tubes.

For artists who want to spatter large-scale paintings, Liquitex offers the Freestyle Short Handle Splatter brush in both round and flat shapes. This innovative synthetic brush is especially designed to spatter fluid acrylic paint or ink to create distinctive spatter effects covering a large area.

Spattering effects

Although spattering is fairly random and somewhat unpredictable, with practice you will learn how each tool is likely to behave. The swatches below were made using a variety of tools, sometimes on a wet support and sometimes on dry; experiment to see what effects you can create.

Multiple layers of different colors spattered with a toothbrush. Each new layer was added after the previous layer had dried.

Drops of fluid acrylic paint blown into spidery branches with a drinking straw.

Diluted transparent acrylics spritzed with a spray bottle onto a wet underground.

A sunburst pattern created using the lid of a jar as a mask while spattering with a toothbrush.

Fluid acrylic colors spattered with a large spray bottle from a slanted angle, creating elongated spatters.

Spattering done by briskly flinging a loaded paint brush, with a sprinkling of metallic powder added into the wet paint.

Using a sponge to apply or remove paint is a wonderful technique for creating loose, organic-looking, open textures. Sponging offers a limited amount of control, encouraging artistic "accidental" results.

SPONGING

Reminiscent of childhood painting, the sponge is a wonderful tool to dapple, stipple, smear, spread, smooth, blend and build up layers of acrylic paint with. It is also useful for gently lifting small amounts of paint off a surface, blocking in areas quickly and wiping away an entire area of wet paint. This simple tool is one of the most versatile; its possibilities of expression are virtually unlimited.

There are many different sponges on the market, both natural and synthetic, and they come in a great variety of shapes and sizes. There's a marked difference between natural and synthetic sponges. Natural sponges have irregular shapes and textures, while artificial sponges are more structured. Natural sponges hold moisture better than their synthetic counterparts, so they offer a greater paint load and longer working time. Synthetic sponges are easier to form into a shape. Both natural and synthetic sponges are very easy to clean. Natural sponges last longer— synthetic sponges often crumble or tear over time. A well-kept natural sponge can last up to a decade and beyond. Always wash your sponge before the acrylic has time to dry, and leave it to air dry before storing to avoid mold or decay.

Natural sponges
Natural sponges are very absorbent, they hold moisture and paint really well, and although they are very pliable, they are tear resistant. Each one has its own unique shape and porous texture. There is great variety among natural sponges, such as natural sea sponges, silk sponges, wool

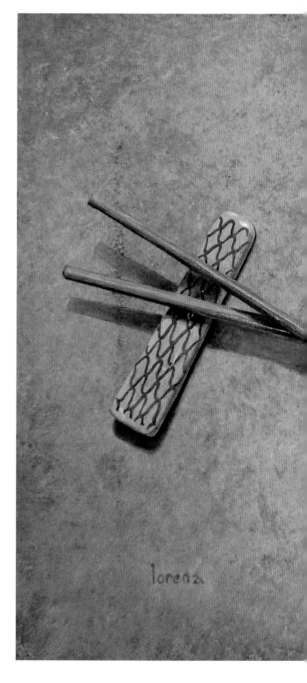

ARIGATÓ
BY LORENA KLOOSTERBOER
8 x 10 inch (20 x 25 cm)
The subdued, rich texture of the background was created by sponging on multiple layers of colors (from dark to light) with a natural sea sponge and then sanding them down.

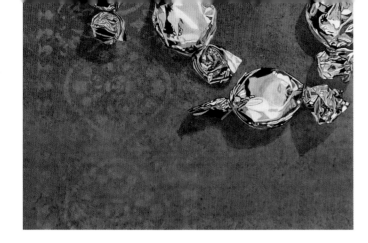

DELICIAE II (DETAIL)
BY LORENA KLOOSTERBOER
24 x 20 inch (61 x 51 cm)
*The background was created by using
a natural sea sponge for a dappled,
layered texture. The sponge was also
used to stencil in the understated
designs in the background.*

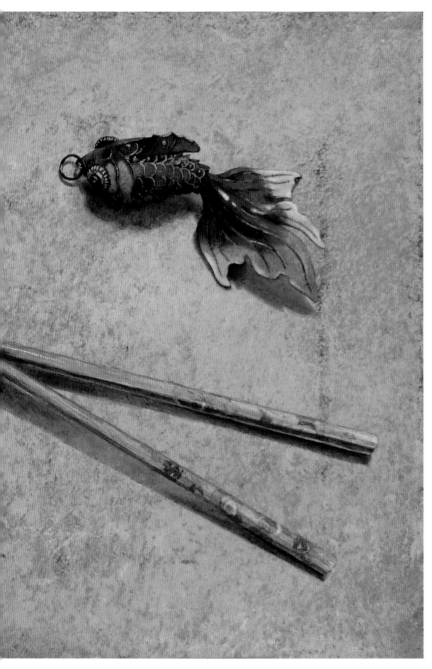

Lifting off paint with a sponge

Sponges can be used to lift off paint, as well as to apply it. If you made a mistake, for example, you can remove wet acrylics by quickly wiping the area with a moist sponge.

To attain subtle, organic textures, paint a layer of acrylic paint mixed with glazing or gloss medium. When that layer is almost dry, gently dab the surface with a sponge slightly dampened with water. This will lift off part of the paint layer exposing the underlying surface creating negative space.

sponges, grass and vase sponges and the flat elephant ear sponges.

Synthetic sponges

Among synthetic sponges, the kitchen sponge is the most widely accessible. Synthetic sponges are mostly made of cellulose or polyurethane. At hobby stores you can find a great variety of interesting shapes and sizes meant for children, but these may offer innovative ways of adding textures and shapes to your painting, too.

A foam paint roller is useful to quickly cover large surface areas with paint and is also extremely useful for applying gesso. It is available in different widths, usually with a smooth texture, but is also sold with cut-out shapes that create repeat patterns, such as stripes, dots or squares.

Foam or sponge brushes—typically little rectangular sponges with a slanted edge, attached to a wooden handle—are useful for covering

Sponging continues over the page →

Sponging effects

Experiment with different sponges—have fun discovering the effects you can create. Buying a variety pack of sponges is a good way to discover which sponges best suit your artistic needs.

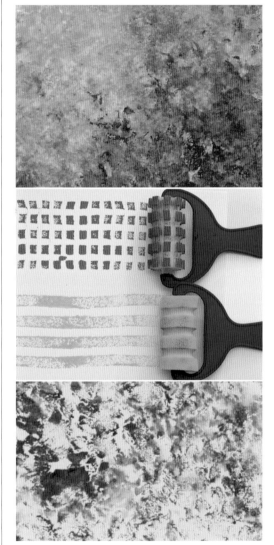

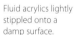

Heavy body acrylics sponged wet-in-wet with a dappling motion.

Pattern of dots created with transparent acrylics applied using a little round synthetic sponge on a stick.

Roller brushes with different cut-out shapes create amusing patterns.

Gradation created by blending colors wet-in-wet with a sponge.

Fluid acrylics lightly stippled onto a damp surface.

Layers of different colors built up with a natural sponge, with each layer allowed to dry before the next is added.

areas and for stenciling. Foam brushes also come in a variety of precut shapes—to create dots, for example.

Cutting your own shape out of a kitchen sponge is easy. However, there's also the Miracle Sponge by The Color Wheel Company, a compressed sponge that is ⅛ inch (3 mm) thick when dry. Because it is flat you can draw a design on it, after which it can be cut following the design's shape. Once wet, it expands to its full size.

Paint consistency for sponging

For sponging it is best to dilute acrylics to a syrupy, liquid consistency by adding water, with or without glazing or gloss medium. The sponge's affinity for absorbing large amounts of fluids will give you more control to apply paint through pressure or squeezing. If the paint is too thick or heavy, it will cling to the sponge and quickly dry out.

Stamping is when a layer of acrylic paint is applied to a low-relief pattern that is then pressed onto a surface, leaving a mirror image.

STAMPING

Stamping can be used on its own, as part of a painting or for its background; it presents virtually limitless possibilities for creating innovative artwork. Stamping has made its appearance in fine art and is here to stay.

Any low-relief design can be used for stamping by dabbing acrylic paint onto it with a soft-bristled flat brush, roller brush or sponge and then pressing it to your painting surface. In addition to ready-made rubber, silicone, polymer and sponge stamps, you can use household items: plastic bubble wrap to create a pattern of dots, for example, or the rim of a glass to create circles. You can also use natural objects such as feathers or leaves for delicate realistic shapes— or even your own body, as seen in several of Chuck Close's realistic portraits made with his own fingerprints.

Studio-made stamps
Make your own stamp from a sheet of linoleum or any synthetic rubber-like material

CELEBRATION
BY RAECHEL SAUNDERS
4 x 4 inch (10 x 10 cm)
Keeping the tradition of Australian Aborigine art alive, wooden skewers in various sizes are used to meticulously stamp earth colors in concentric circles, creating a beautiful and culturally meaningful painting.

Stamping continues over the page ⟶

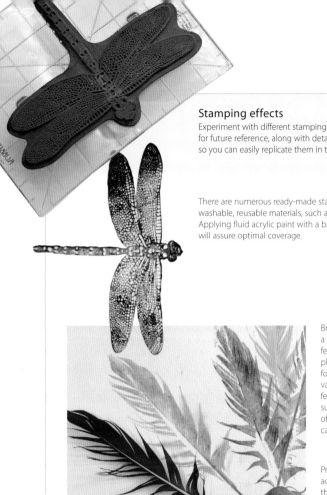

Stamping effects

Experiment with different stamping materials; save your swatches for future reference, along with details of how you created them, so you can easily replicate them in the future.

There are numerous ready-made stamps available in washable, reusable materials, such as rubber and foam. Applying fluid acrylic paint with a brush or make-up sponge will assure optimal coverage.

Brush fluid acrylic paint onto a flight feather (avoid down feathers, which are too soft) placed on a paper towel, gently following the direction of the vanes with the brush. Press the feather down onto the painting surface, cover with a clean piece of paper and press down. Lift carefully to avoid smears.

Press your fingertips into fluid acrylic paint, then press onto the painting surface to leave a unique imprint.

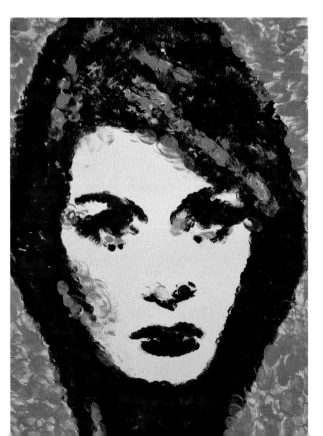

DIGITAL PRESENCE
BY LORENA KLOOSTERBOER
11¾ x 8¼ inch (30 x 21 cm)
This portrait was created using fingertips dipped in fluid acrylics to imprint paint onto the surface. Digit stamping is partly "accidental" due to the limited control over mark making created through pressure.

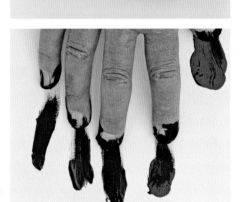

You can use the side of your hand or even your feet to create a variety of marks.

sold specifically for relief printmaking. These materials can be easily cut with precision using specialized carving tools. They are also easy to clean and can be used many times. Note that the part that's carved out will leave an open space, while the sections left intact are those that will print the image.

Make your own sponge stamp by cutting a household sponge with scissors, or use the Miracle Sponge, a compressed sponge that is ⅛ inch (3 mm) thick when dry, which allows detailed cutting with an X-acto knife.

Keep in mind that anything you carve out will print in mirror image—it is especially important to remember this when making stamps with letters, words or numbers. Always test your stamp on a scrap piece of paper to determine the consistency and amount of acrylic paint you need, as well as how much pressure you need to apply to achieve the result you want. Note that when stamping on a textured surface, the stamped image may not be as clearly defined: Smooth surfaces lend themselves better to stamping effects.

Tips for stamping

- Use fluid acrylic paint, not too wet and not too dry.
- Smooth surfaces are easier to stamp.
- Add retarder to your paint to gain open time.
- Work swiftly before the acrylic paint dries.
- Use a make-up sponge to apply acrylic paint to a very intricate or delicate stamp.
- Use a soft, flat brush to apply paint to a feather or a leaf.
- Apply one color or apply a gradation.
- Clean your stamp with soap and warm water after use, making sure you remove all paint from the crevices of the design with a stiff brush.
- Always experiment before stamping your painting.
- To remove flawed stamping, quickly wipe your painting surface with a moist sponge.

CREATE YOUR OWN STAMP

Creating your own stamp generates a unique pattern or design that you can use multiple times. Some artists even "sign" their paintings with their own personal signature stamp.

TECHNIQUE FILE 39

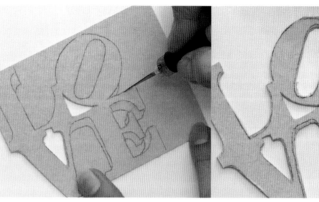

1 The LOVE stamp was inspired by Robert Indiana's iconic 1964 pop art design. After tracing the outline onto the dry compressed Miracle Sponge, cut it out with a sharp blade.

2 Remove the cut-out pieces carefully to avoid ripping the fragile sponge. The Miracle Sponge is only ⅛ inch (3 mm) thick when dry.

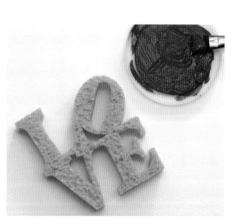

3 Soak the Miracle Sponge in water and squeeze out excess moisture. Dip the damp sponge in paint or brush the paint onto it. When stamping letters or numbers, remember to apply paint to the reverse side in order to stamp the mirror image.

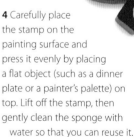

4 Carefully place the stamp on the painting surface and press it evenly by placing a flat object (such as a dinner plate or a painter's palette) on top. Lift off the stamp, then gently clean the sponge with water so that you can reuse it.

The decalcomania technique was developed by Surrealist artists to achieve spontaneous, accidental images. The term comes from the French words *décalquer*, meaning "to transfer" and *manie* meaning "obsession."

DECALCOMANIA

The process of decalcomania can be compared to the Rorschach inkblot test used in psychology, in which paint is sandwiched and pressed between a folded piece of paper. Once opened, it reveals organic textures and mysterious mirror images.

Although he was not the first artist to use decalcomania, Max Ernst (1891–1976) is famous for using this technique in his oil paintings of bizarre landscapes, curious vegetation and fanciful figures. Ernst reportedly used a sheet of glass to press blobs of paint onto his canvas, moving the glass around and then detaching it to reveal unpredictable results. Afterward, he would search for figures and other images to elaborate by brush. The method can be replicated with acrylic paint.

You can use a great variety of smooth or textured sheet materials for this technique, and the acrylic paint can be used in any of its consistencies, from fluid to thick heavy body. You can even use paints in different viscosities at the same time, so that the fluid paint will spread at a different speed than the heavy body paint.

The simplest way to do decalcomania is to apply paint to a piece of paper and press it against your painting surface, or vice versa. But you can also use rigid objects, such as a sheet of glass or Plexiglas. Flexible, nonporous materials lend themselves especially well to decalcomania. You can use any material that allows the paint to be pressed down and distributed on a painting surface and peels away from it without leaving

HEARTBREAK RIDGE
BY LINDA MURRAY
22 x 30 inch (56 x 76 cm)
This dramatic decalcomania landscape was created by skillfully manipulating fluid orange, yellow and gray acrylic on wet paper with plastic wrap, which was removed once the paint was dry.

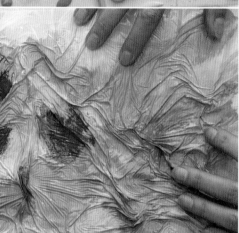

1 Drop different colors of heavy body paint straight out of the tube onto the support and cover with plastic wrap—or any other flat material, such as paper, acetate, lint-free fabric or a pane of glass.

2 Squish down the paint and move or slide it around so that colors merge. If necessary, use a ruler or the back of a large spoon to squeeze and guide thick paint around.

3 Lift off the plastic wrap to reveal wonderful abstraction and a texture with beautiful peaks and ridges. As long as the paint is wet, you can repeatedly cover, press and lift it until you are satisfied with the results.

DECALCOMANIA WITH HEAVY BODY PAINT AND NON-TEXTURED MATERIAL

TECHNIQUE FILE 40

With heavy body acrylics and a nonporous untextured material (here, plastic wrap), the textures that are created are random and unpredictable, with the paint forming into masses of ridges and furrows.

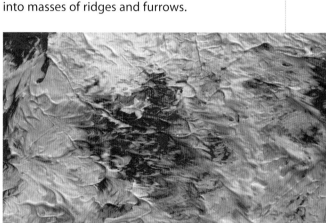

DECALCOMANIA WITH THIN PAINT AND TEXTURED MATERIAL

TECHNIQUE FILE 41

With thin paint and a porous textured material (here, paper towel), the grain of the material itself is left behind.

1 Mix fairly liquid paint with gloss medium and/or retarder medium to the consistency of syrup and apply it to your painting surface.

2 Press the paper towel down, marking the paint with the pattern of the material. Do not reposition or shift the upper layer.

3 Remove the paper towel quickly before it absorbs the paint and dries onto it.

4 Close-up of the subtle patterned texture.

Decalcomania continues over the page ⟶

Decalcomania effects

The decalcomania technique allows you to create beautiful accidental low-relief textures and random organic patterns.

Regular body acrylics pressed with a glass sheet.

Fluid acrylics moistened with gloss medium, pressed with a plastic shopping bag, left on until dry.

Fluid acrylics pressed with a sheet of foam packaging material.

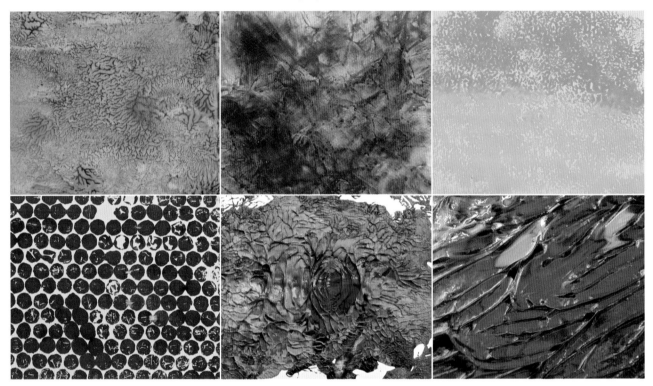

Fluid acrylics pressed with bubble wrap.

Heavy body acrylics on paper folded onto themselves vertically and horizontally.

Heavy body acrylics pressed with satin fabric.

debris behind, such as plastic wrap, newspaper, metal foil and even lint-free fabric. You can experiment to your heart's content. If you use a relatively porous material (such as paper or fabric), you will need to remove it fairly quickly before your paint dries. With an impermeable material (such as plastic) you have more time to continue spreading or squishing the paint, because it won't be exposed to air and hence will dry more slowly.

Paint application can be done randomly, by brush or straight out of the tube. For best results use at least two different colors—the more colors you use, the more interesting and adventurous the results become. Once you press the surfaces together, you can spread the paint around using your hand, a ruler or other firm object, or you can slide the material around on the painting surface. The colors will coalesce and merge together. Peeling off the material upward or back onto itself will reveal a random, abstract texture and, if the paint has a thick consistency, it will create beautiful sculptural bifurcations, ridges or creases.

Afterward, the resulting texture can be presented as is, further developed or used as a background. As with all techniques involving fast-drying acrylics, you must work expeditiously. To give you more time, add retarder or glazing medium to slow the drying process.

Decalcomania materials

- Bubble wrap
- Lint-free fabric
- Metal foil
- Paper, newspaper, tracing paper
- Plastic (trash bags, dry-cleaner bags)
- Plastic wrap (cling film)
- Wax paper (baking paper)

Airbrushing is often considered a contemporary art technique but it was first implemented by prehistoric artists who blew paint through hollow bones or reeds, creating magnificent paintings on cave walls.

AIRBRUSH TECHNIQUES

The airbrush is a handheld, air-operated spraying tool that nebulizes paint by way of a compressed (fast-moving) airstream. The trigger on the airbrush allows you to control both the amount of air and paint application, offering extremely smooth, seamless gradations.

The airbrush is exceptionally versatile. Used freehand—without frisket or masking—the airbrush produces soft, feathery edges; used with frisket or masking, edges are sharp and pronounced. Special effects are achieved by "carving" details into the fresh airbrushed paint with a sharp blade or eraser, and by using stencils, shields and other types of masking. Layering transparent and/or opaque acrylics also influences the appearance of the painting.

AN IMMIGRANT'S LAMENT BY DON EDDY *34¼ x 36 inch (87 x 91 cm) Masterly applied airbrush marks using transparent acrylics establish numerous different values by varying paint density, and create distinctive colors by superb optical blending.*

Airbrush Techniques continues over the page ⟶

Tips for successful airbrushing

• Keep your airbrush meticulously clean to keep it running in optimal form.

• Mind your health: Wear a mask and allow for good ventilation while airbrushing.

• Practice will help to develop your confidence in making different marks.

• The closer the airbrush nozzle is held to the painting surface, the smaller and denser the paint mark.

• The farther away the airbrush nozzle is held from the painting surface, the larger and more diffuse (scattered) the paint mark.

• Scratch highlights and details in fresh paint with a scalpel, X-acto knife or eraser.

• Use frisket, masking and shields for hard edges.

• Hold loose shields a few millimeters above the painting surface for feathery edges and contours.

• The airbrush is the ideal tool to apply varnish without having to worry about creating visible brush marks.

The most important difference between the airbrush and the paint brush as painting tools is that the airbrush doesn't physically touch the painting surface.

Airbrush paintings can stand alone, or can be combined with brushwork and/or other media, such as colored pencil. The results achieved by airbrush can be highly detailed and incredibly realistic, making it the favored painting tool of many photorealist and hyperrealist artists. Acrylic paint is ideal for the airbrush and ranges from liquid acrylic inks to regular acrylics mixed with airbrushing medium, flow improver and/or water. Needless to say, the numerous techniques the airbrush offers are too varied, detailed and

Box of 64
BY CESAR SANTANDER
48 x 60 inch (122 x 152 cm)
This airbrush painting was created by using a variety of vivid colors to convey the textures of frayed cardboard, opaque wrappers and glossy crayons.

complex to fully explain and do it justice within a few pages. If you feel inspired to use the airbrush, do follow a workshop or visit an airbrush art fair to watch demonstrations and talk to the artists. Once you decide to buy your own airbrush equipment, you will be able to continue developing new skills in your studio and/or by taking additional classes.

Airbrush effects

The variety of effects that can be achieved by airbrush is staggering. Combining the use of airbrush with the paint brush and/or using other mediums (such as colored pencils) exponentially broadens the creative expression for artists.

Left: Hard edges are obtained when a shield is placed flush with the painting surface (left). Soft edges are achieved by lifting the shield slightly above the painting surface (right).

Right: The airbrush is ideal for smoothly filling in stencils of any size, but especially for finely detailed stencils, such as those sold for embossing.

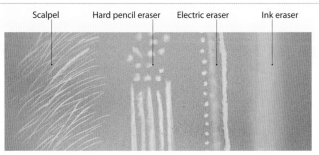

Scalpel Hard pencil eraser Electric eraser Ink eraser

Rub or scratch into an airbrushed surface.

HOW TO HOLD THE AIRBRUSH

Each artist must find the most comfortable way to hold the airbrush.

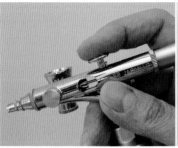
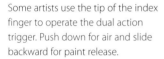
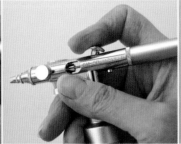
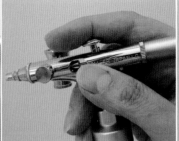
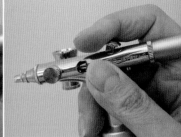

Some artists use the tip of the index finger to operate the dual action trigger. Push down for air and slide backward for paint release.

Operating the airbrush trigger with the fingertip can feel awkward and may strain the finger and joints.

To avoid cramping, try placing the trigger in the nook of the first joint of your index finger. Pressing down for airflow will take less effort.

While pressing down, curl your fingertip over the trigger, pulling it backward. This will avoid tensing the finger into an unnatural curve.

AIRBRUSH PORTRAIT

This demonstration shows the method Dru Blair uses to create photorealistic portraits using an airbrush. The airbrush is the perfect tool to establish ultra-smooth gradations and soft and hard edges, and to layer transparent and opaque colors.

You will need
- Reference photo
- HP illustration board
- Airbrush
- Air compressor
- 2B pencil
- Eraser pencil
- Regular white paper to cut masks from
- Transparent frisket or masking film (self-adhesive)
- X-acto knife
- Plastic containers with lids to prepare skin colors (minimum of three)

Palette acrylic inks
- Burnt Sienna—transparent
- Burnt Umber—transparent
- Opaque White
- Red—transparent
- Red Violet—transparent
- Sepia—transparent

1 Prepare a line drawing of the portrait. Make a paper mask to protect the face from overspray and to define the edge of the cheek. Using Burnt Umber mixed with Sepia, airbrush the dark area of the hair to create an area of contrast with the face; this makes it easier to judge the correct values for the skin tones later on. Bring the airbrush close to the surface of the board to create fine hair lines. To create the negative space between the hairs, scrape off paint with an X-acto knife, revealing the white board beneath.

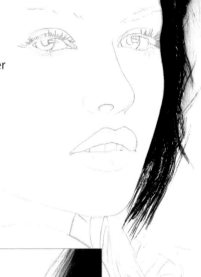

2 Airbrush the right side of the hair with a blend of Burnt Umber and Sepia. Add fine hairs freehand with the airbrush, and create the highlights by allowing the white of the board to remain exposed.

Airbrush Techniques continues over the page ⟶

3 Cut a paper mask for the shoulder and neck. Blend a dark skin tone using Opaque White, Burnt Umber, Red Violet and Sepia. Mixing transparent colors with Opaque White creates a buffered color and prevents it from becoming too dark. The term "buffered" is used when a transparent color is opacified by adding an opaque color to it. Apply this buffered skin color to the neck.

For the earring, scratch off small highlights with an X-acto knife to reveal the white of the board.

4 Apply transparent frisket or masking film over the eyes, and carefully cut all the lines that correspond to hard edges. Remove the frisket covering the whites of the eyes. Blend Opaque White, Sepia, Red and Burnt Umber to match the whites of the eyes. These appear very dark against the surrounding white of the illustration board, but once the skin is rendered they will look more appropriate. Replace the frisket over the whites of the eyes. Remove the frisket covering the eyelashes and irises and airbrush them using Sepia.

5 Replace the frisket, leaving the irises exposed. Blend Burnt Umber and Opaque White to airbrush the irises. To reveal the white of the board, use an X-acto knife to add reflection details and a pencil eraser to create softer highlights within the irises. Now replace the frisket to protect the eyes from the overspray of the surrounding area. Cut a paper shield to create the eyelids and nostril. Airbrush the eyelids using a lighter-value blend of Opaque White, Red Violet, Sepia and Burnt Umber. Use Sepia for the nostril. Note that the nostril has a hard edge at the top and a soft edge at the bottom.

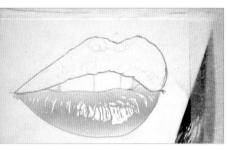

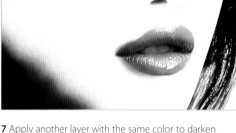

6 To avoid contaminating the skin area with overspray from the lip color, apply frisket to the mouth. Cut out and remove the entire lower lip. Blend a buffered lip color using Red, Red Violet and Opaque White. Apply it lightly. Create highlights by removing paint using the X-acto knife.

7 Apply another layer with the same color to darken and shape the volume of the lips. The overspray will fill in the highlights, so reestablish them with the blade again. Repeat this process with the upper lip. Apply a transparent blend of Red Violet and Burnt Umber to darken the shadows of both lips. Next, render the teeth a buffered blend of Burnt Umber and Sepia mixed with Opaque White.

8 Premix three values of skin tones (light, mid-tone and dark) using Burnt Umber, Red Violet, Sepia and Opaque White. First, apply the lightest color on the right side of the forehead and nose. Create some skin texture with the blade and eraser, and then apply the mid-tone value of skin color. Use the darkest skin color to establish the eyebrows and develop the eyes. Finally, use transparent Sepia for the very dark shadows on the outsides of the eyes.

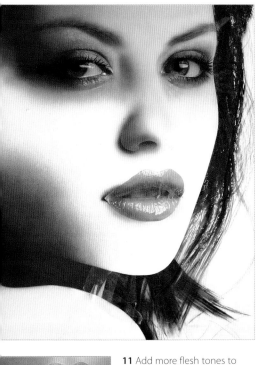

9 Apply frisket to cover the mouth and hair on the right side of the face. Mix a dark shadow color using Burnt Umber, Red Violet, Sepia and Opaque White, then apply, blending it with the shadow color of the neck. Establish the nostril area using a paper mask for the nostril line, and spray the rest of the nostril freehand. If blotchy areas occur, add another layer of buffered paint.

10 Apply more light-value skin tone paint to smooth and transition the skin toward the right side of the face. Note that the surrounding white board gives the illusion that the paint is too dark.

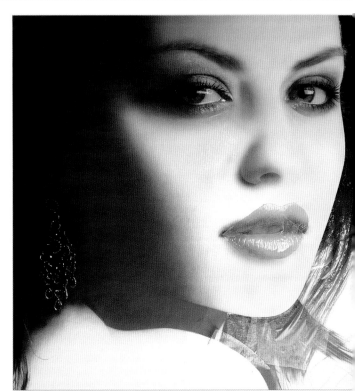

11 Add more flesh tones to the face. Remove the frisket from the mouth. You will notice the lips are too light in value and the transitions around the lips are too severe. Darken the lips slightly using the skin tone blend. Use the eraser pencil to create subtle highlights and texture on the lips, and delineate the left side of the upper lip. Finish the shoulder using the three different values of previously blended skin tone. Remove the frisket on the hair.

KAREN
BY *DRU BLAIR*
13 x 22 inch (33 x 55.75 cm)
The realistic skin tones are achieved by preblending several values of skin colors matching the reference photo. This also ensures smoother rendering and more delicate gradations, which are the signatures of airbrush painting.

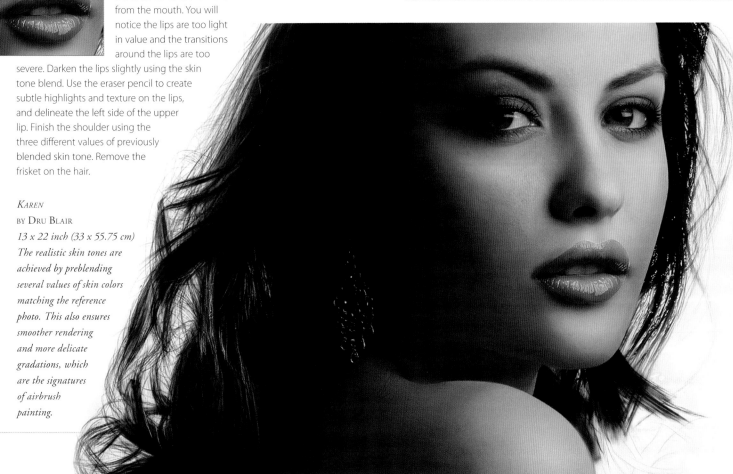

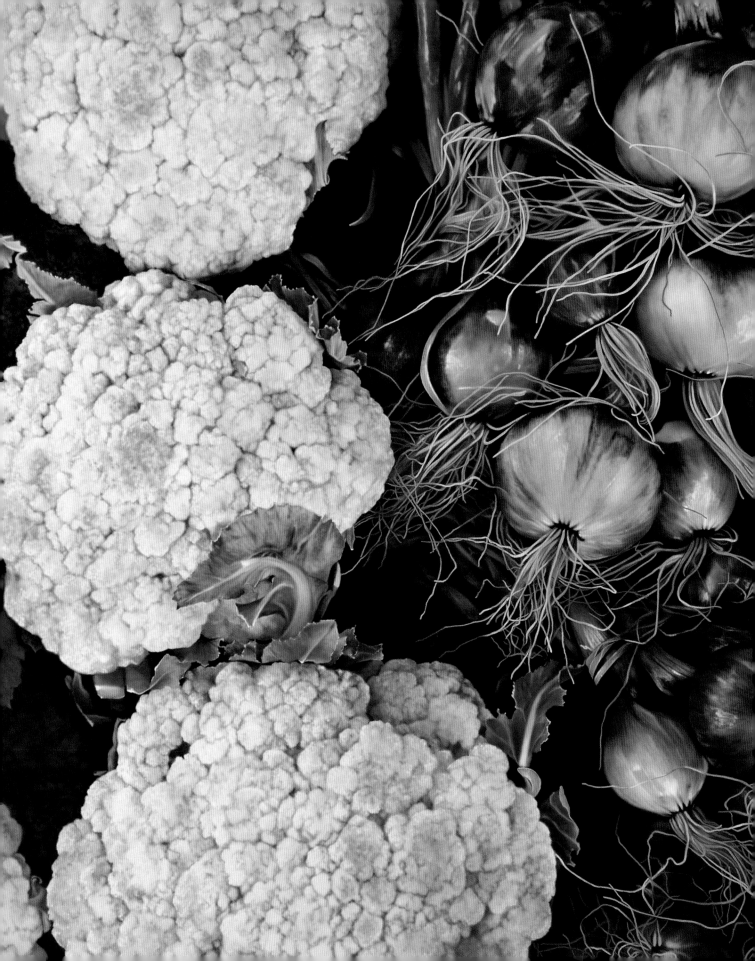

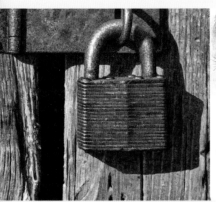

EXPRESSING FORM & SURFACE

This chapter looks at a range of textures and surfaces that you may wish to paint, from soft fabric and fur to harsh, reflective metal and glass, and from intangible, billowing clouds to splashing water. It is not possible to touch upon all textures and surfaces within these pages, let alone show all conceivable forms and methods of expressing them, so the step-by-step demonstrations merely present a few possibilities among numerous equally valid approaches. The palette colors, brushes and painting methods shown are suggestions—certainly not rigid instructions. They are meant to inform and inspire you to experiment, practice and find your own artistic voice.

SOLVANG MARKET (main picture)
BY BEN SCHONZEIT
72 x 72 inch (183 x 183 cm)
The challenge to depict recognizable and convincing textures, shapes and subject matter is an important quest for many artists. This painting superbly captures the exquisite organic textures of the highly recognizable surfaces of various common vegetables.

Above from left to right
LOCK AND RUST (detail)
BY BRIAN LaSAGA
see page 202

ALLAN GORDON BELL:
COMPOSER—LISTENING
(detail)
BY LAARA CASSELLS
see page 243

SUNDAY BEST (detail)
BY LORENA
KLOOSTERBOER
see page 216

Still life painting has endured throughout history, from paintings of foods and material possessions in Egyptian tombs to the 16th- and 17th-century Dutch and Flemish still lifes, all the way to today's contemporary expressions.

STILL LIFE

A still life (plural, still lifes) is a painting of primarily inanimate objects. Still life is also the term used to describe this genre of painting. The English term "still life" stems from the Dutch word, *stilleven*. The French use the term *nature morte* (meaning "dead nature"), as do all Latin languages, such as Spanish, Italian and Portuguese. In Spanish we also find the term *bodegón* (plural, *bodegones*), which describes a painting depicting foods and drinks, often shown in a kitchen or tavern.

In contrast to painting landscapes or portraits, the artist has considerably more freedom to arrange the components of choice in a still life.

Still life subcategories
Within the still life genre we find many subcategories. Still lifes with allegorical, mythical, historical and religious symbolism depict objects that are meaningful in evocative, sometimes hidden ways. This kind of symbolism has expanded to include a wealth of secular philosophies, metaphors and sociopolitical messages.

The vanitas still life (from the Latin word for "vanity") symbolically depicts the fleeting nature and the meaninglessness of earthly life. Objects such as a human skull, a burning candle and an hourglass as symbols of mortality, amidst extravagant displays of (sometimes decaying) flowers and fruits, books, coins, jewelry, musical instruments, fine silver and crystal, are all emblematic reminders of life's brevity.

The trompe l'oeil (French for "deceive the eye") is a specialized type of still life seeking to trick the viewer into thinking the scene is authentic by creating a realistic optical illusion depicting inanimate and relatively flat objects

RED SHOES

BY MOJTABA TAJIK

61½ x 80¾ inch (156 x 205 cm)
Today's photorealistic still life
includes the representation of any
imaginable object, focusing on
the faithful depiction of instantly
recognizable forms and textures, such
as this exquisite shiny leather.

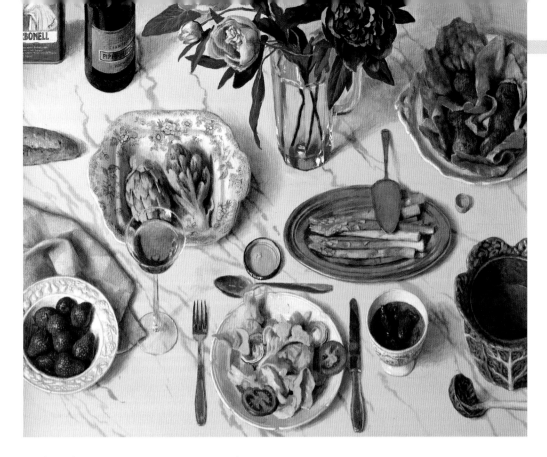

Lente (Springtime)
by Kenne Grégoire
31½ x 35½ inch
(80 x 90 cm)
The beauty in this "slice
of life" still life lies in
the meticulously detailed
portrayal of a table set for
a feast, while its interesting
skewed perspective gives it
an almost surreal tension.

Orange Slices
by Brian Simons
16 x 20 inch (40 x 50 cm)
This loose expression of
the traditional fruit still
life focuses on the vibrant
arrangement of colors
and shapes, making
the objects themselves
almost irrelevant.

in three dimensions, sometimes using niches to create greater depth.

Flower and plant still lifes can range in style from loose and painterly representations to incredibly detailed depictions bordering on scientific botanical illustrations. Traditionally, still lifes show dead animals, often birds or game, sometimes crossing over into zoological illustration or wildlife genres. However, some include living creatures, such as insects or motionless animals, and can be called still lifes because of their composition. Foods, such as fruits, vegetables, seafood, even modern packaged groceries, also make wonderful subjects for still life paintings.

The "slice of life" still life relies on an array of components depicting mundane everyday household or commercial objects. Examples are the contents of a kitchen cupboard, a bathroom sink or tools in a workshop.

Evolving expression

Whether a still life is precisely rendered or painted in broad painterly strokes, in a classical or a contemporary setting, as an artist you have considerable freedom when it comes to choice of subject matter, as well as in the expression of color, mood, form and style. A still life can be

simply decorative in its compositional structure or offer strong emotional content. Changing the perspective into different viewing angles, deconstructing the subject into almost abstract geometrical forms or outlines, tight cropping and ultrarealistic close-ups offer the still-life artist a wealth of possibilities.

Still Life continues over the page ⟶

When painting wood—whether in the form of an object or its texture—your challenge is to portray the distinctive qualities that make each wood type so recognizable.

STILL LIFE: WOOD

Wood, in all its fabulous diversity, appears in paintings in numerous forms, colors and styles, from afar to close-up. Landscapes sometimes include wooden boats, fences and architectural structures, occasionally weathered and showing peeling paint. Paintings of interiors and portraits may show wooden furniture, paneling, window frames and doors, stairs, wood flooring or parquetry. In still lifes we may find wooden utensils, vintage toys, musical instruments, wooden crates or sports equipment. Not surprisingly, detailed close-ups of wood frequently appear in trompe l'oeil paintings.

Whatever style you are painting in, you must observe the main characteristics of wood's surface and appearance in order to paint it successfully. Unlike manmade materials such as plastic, wood has a certain organic warmth to it that begs to be captured.

Tips for painting wood

• In whatever style and expression you choose to portray wood, become familiar with its anatomy, surface and structure.

• Study the direction and color temperature of the light hitting your subject: subtle changes in value will enable you to convey the texture of the wood and whether a particular area is raised or recessed as it turns into or away from the light.

• Add imperfections such as scratches, holes, knots or peeling paint to accentuate visual effects.

Lock and Rust
by Brian LaSaga
10 x 14 inch (25 x 35 cm)
The rich sheen and intricate grain of weathered wood is beautifully enhanced by the contrasting texture of the rusted metal lock.

Exit #3
by Hisaya Taira
28¾ x 20¾ inch
(73 x 53 cm)
*The timeworn wood floor
and the light reflecting
in the patina have been
perfectly captured by
multiple transparent
glazes and subtle details,
such as cracks and stains.*

Wooden objects not only have a particular grain, but also a certain patina—a sheen acquired through age, wear and exposure. It's useful to study different types of wood up close—their structure, grain and colors. Visit a historical museum or antique store to examine antique furniture. Some hardware and flooring stores offer wood samples (sometimes for free), which are useful to have as models in the studio.

In addition to brushes and painting knives, wood-graining tools offer an alternative method of achieving very realistic effects. There are many dedicated faux painting books and workshops on painting convincing wood-grain finishes.

Still Life: Wood continues over the page ⟶

PAINTING WOOD: FRAME

In this trompe l'oeil still life of a pencil and scrap of paper pinned to a wooden frame, the wood grain is created using a wood-graining tool. Although the wooden background might at first glance appear to be rather dull and monochromatic, the subtle variations in tonal values and the textural lines suggesting the grain create a convincing three-dimensional effect.

You will need
- Primed canvas, approx.
12 x 12 inches (30 x 30 cm)
- Black and white gesso
- Ruler
- Waterproof fine-liner brown fiber-tip pen
- Masking tape
- Gloss medium
- Wood-graining comb (rubber or metal)
- 2B pencil

Brushes
- 1½-inch (4.5 cm) stiff house painter's brush
- Long-haired badger softener #16
- Round #0 and #2
- Bright #3

Palette for wooden frame
- Burnt Sienna
- Burnt Umber
- Naples Yellow
- Payne's Gray
- Titanium White
- Yellow Ocher

Palette for trompe l'oeil objects
- Cadmium Red
- Cadmium Yellow
- Cobalt Blue
- Payne's Gray
- Titanium White
- Unbleached Titanium

1 Prime the canvas with black gesso. Then cover it loosely with a blend of Naples Yellow and Yellow Ocher. Let it dry thoroughly. Using a ruler and a brown fine-liner fiber-tip pen, draw in diagonal lines from the corners inward, then connect the diagonal lines with sets of horizontal and vertical lines to create the shape of the frame niche.

2 Mask off one section with masking tape to create a crisp division. Blend Burnt Umber with gloss medium to create a thick glaze. Using a stiff house painter's brush, apply the glaze following the direction of the wood grain. Don't forget to include the sides of your canvas.

3 Swiftly drag the wood-graining comb through the wet glaze in the direction of the wood grain. If necessary, repeat this motion. It need not be perfectly straight.

4 While the glaze is still wet, lightly tap the striated paint with the tip of a long-haired badger softener, slightly smudging the lines. Remove the masking tape carefully and let the paint dry completely before moving on to mask and glaze the next section.

5 Once all sections have been painted individually, use a #2 round brush to reinforce some lines, and paint a few small knots and eyes using Yellow Ocher and Burnt Umber. If desired, warm up the color of the wood by coating the entire painting with a transparent glaze of gloss medium and Burnt Sienna. Leave to dry.

6 The wood is now finished. To create the illusion of depth, draw the outline of small objects, such as the little pencil tied to a string tacked to the side, and a little piece of paper pinned onto the back of the "wooden frame." Cover them with white gesso and, once dry, draw in additional details with a pencil onto the gesso in preparation for painting.

7 Paint the objects with a small #0 round brush in the colors described in the palette. Once dry, paint the shadows of the objects as well as the shaded sides of the frame using a dark transparent glaze of Payne's Gray with gloss medium. Use masking tape to demarcate the upper and right side border of the frame, and glaze in the shadows to mimic depth. The shadows establish the trompe l'oeil effect.

8 To heighten the illusion of wood, use a #0 round brush to paint small scratches and little holes. Use Payne's Gray for the dark abrasions, then use Yellow Ocher lightened with Titanium White to paint highlights. Make sure the highlights are placed in the opposite direction of the imaginary light source.

THE MESSAGE
BY LORENA KLOOSTERBOER
12 x 12 inch (30 x 30 cm)
The variations in direction and the irregularity of the lines make the wood grain look natural. The warm browns and yellows visually reinforce the notion of authentic wood, while the shadows underpin the impression of depth and indicate the direction of the light source. The illusion of credible wood is enhanced by the trompe l'oeil effect of the objects painted onto the wood, by contrasting different textures.

Still Life: Wood continues over the page ⟶

PAINTING WOOD: DOOR

Acrylic paint is the ideal medium to use when rendering the rough surfaces of textured objects. By applying multiple layers of loose, coarse brush strokes you can quickly create the illusion of a weathered surface.

Old Wooden Door
BY MARK DANIEL NELSON
16 x 12 inch (40 x 30 cm)
There is no limit to the textural effects you can achieve when you layer acrylic paint. Just remember to allow each layer to dry before applying additional layers.

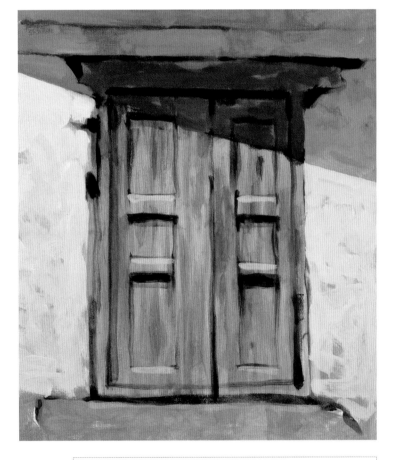

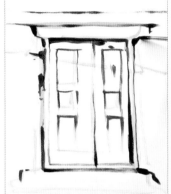

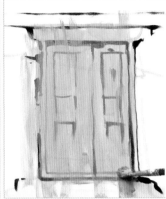

1 Using a #10 round brush, paint a rough sketch of two doors with thin Yellow Ocher paint. Darken the edges, the gaps between the doors and the shaded undersides of the door panels with Mars Black. When you have completed this step, wait for the underpainting to dry.

2 Using a #8 filbert brush, apply a mixture of Yellow Ocher and Unbleached Titanium, using vertical strokes to begin to establish the lighter tone of the wood grain.

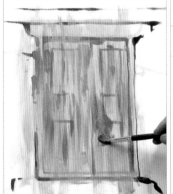

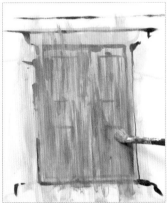

3 Use a #10 round brush and Burnt Sienna to paint rough, vertical strokes. This will further develop the pattern of the wood grain. Make sure that some of the underlying color shows through. Allow this layer to dry before proceeding to Step 4.

4 Using a #8 filbert brush, apply another thin layer of Yellow Ocher and Unbleached titanium, using vertical strokes. This will unify the surface of the doors.

You will need
- Primed canvas, approx. 16 x 12 inches (40 x 30 cm)
- Water or acrylic painting medium
- Rag or paper towel

Brushes
- Round #10
- Filbert #8

Palette
- Burnt Sienna
- Mars Black
- Titanium White
- Unbleached Titanium
- Ultramarine Blue
- Yellow Ocher

5 Using a #10 round brush, apply Mars Black to reestablish the shaded areas between the doors and under the individual panels, using the lines from the underpainting as a guide.

6 Paint a thin layer of Yellow Ocher on the wall surrounding the doors using a #10 round brush. Allow this layer to dry for 10 minutes before proceeding to Step 7.

7 Using a #8 filbert brush, paint a triangular shadow of Mars Black across the top of the doors. While the paint is still wet, drag a rag or paper towel across it to thin the layer enough to see the underlying painting.

8 Paint the plaster walls with Unbleached Titanium and Titanium White, allowing some of the underpainting to show through so that it looks as if the paintwork is crumbling. Block in the shaded part of the stonework with a mixture of Ultramarine Blue and Unbleached Titanium.

DIARY
BY MOJTABA TAJIK
44 x 44 inch (112 x 112 cm)
In this example of painted wood the natural texture is visually enhanced by variations in the direction of the wood grain, differences in the surface sheen, and the warm yellows and browns. The credibility of the wood is further reinforced through the trompe l'oeil effect using shadows to suggest protruding drawers and handles.

Still Life continues over the page →

The challenge of painting glass is how to depict the reflections and distortions of a material that is both solid and transparent.

STILL LIFE: GLASS

Glass is a hard yet fragile material found in a myriad of objects, from windowpanes and light bulbs to bottles and glasses, and from statuettes and paperweights to marbles and beads. While we mostly think of it as optically transparent and smooth, glass can be colored, as well as cut with decorative patterns.

Glass objects such as carafes, drinking glasses and vases, have been popular subjects in still life paintings throughout history. Today we also find glass painted in cityscapes, automotive art, portraiture and many other genres.

In contrast to opaque objects, the transparency of glass itself cannot be painted—it can only be suggested. To paint glass successfully, you need to set aside your preconceived ideas of what glass looks like.

Sapientia (Wisdom)
by Lorena
Kloosterboer
*31½ x 31½ inch
(80 x 80 cm)
The illusion of transparent glass is enhanced by the distorted patterns of the background design, and the overall composition enriched by a vibrant complementary color scheme.*

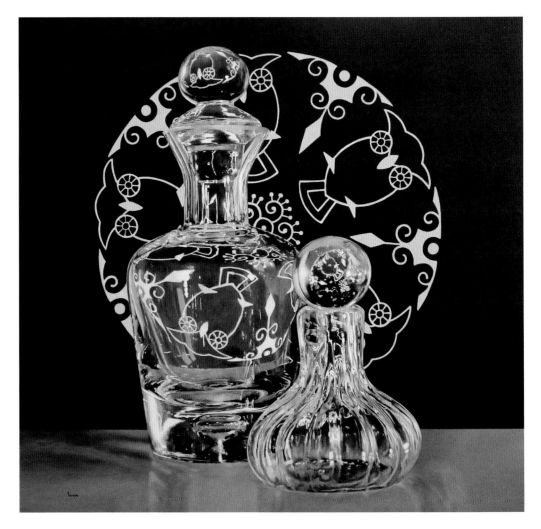

REVITALIZING
BY ANGELA BANDURKA
24 x 12 inch (61 x 30 cm)
The beautifully executed clarity of the water-filled glass was captured by working from life, starting with a Naphthol Red underground, and then painting values from dark to light.

Paint what you see, not what you know

Whether you paint glass in quick painterly strokes or ultra-detailed hyperrealism, set aside all notions of what you believe your subject should look like and concentrate on painting what you see. Even when you're painting from a live composition, a reference photo of glass is a useful two-dimensional guide. It also allows you to turn both the reference photo and the canvas upside down to focus on painting shapes, colors and values.

Characteristics of glass

• Highlights from one or multiple light sources can be diffuse, fractured or ultra-sharp. Highlights need not necessarily be pure white: intense highlights sometimes appear to have brightly colored edges.

• Reflections in glass can range from vague impressions to highly detailed depictions of the surroundings.

• Shadows cast by the glass object itself are sometimes solid and other times translucent. Sometimes these shadows also contain refracted light areas, creating bright spots and unusual shapes.

• Even when it's clear, glass itself has a subtle gradation of colors that fluctuate in chroma and value.

• The volume and shape of the glass object, especially when it has rounded contours or corners, distort and warp whatever is seen inside it or behind it. Contours and straight lines curve and sometimes fragment or disappear altogether. Distortions are especially striking when looking through a glass sphere (a marble, for example) in which the background is refracted upside down.

WINE
BY JAMES ZAMORA
30 x 40 inch (76 x 101 cm)
These wine bottles were loosely painted in the alla prima method. The artist skillfully selected a minimum of visual information to accurately capture this modern still life.

Still Life: Glass continues over the page →

TECHNIQUE FILE 46

PAINTING GLASS: CUT CRYSTAL

Painting crystal objects seems daunting, but it is actually quite simple when the shapes and values are deconstructed. Hard edges combined with fading transitions within the object help define the solid transparency of the material. The incised facets are painted loosely, almost as an impression, but will visually come together as highly realistic.

1 Draw your cut-glass object on the primed panel with a pencil. Add as much detail as possible, focusing on shapes and delineating value areas.

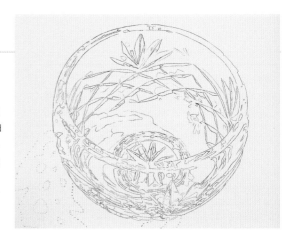

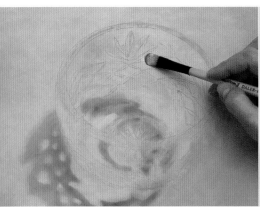

2 Using a #3 filbert, dry-brush the shadows and darker areas with Ultramarine Blue. Using a #10 filbert, cover the panel with a glaze of Light Blue Violet with gloss medium, making sure that the composition lines are still slightly visible. Softly feather the edges of the darker areas.

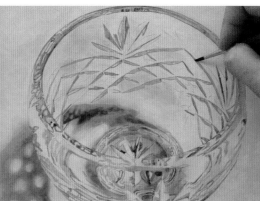

3 Using the #10 filbert, lightly dry-brush Titanium White to lighten areas within the glass object and around the shadow area. Using a #2 round brush, paint the darker details of the cut glass and shadows in a diluted mid-tone Payne's Gray. Don't go too dark and keep the paint transparent, so that darker details can be added later.

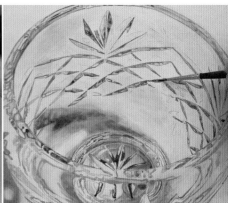

4 Using the #0 round brush, continue adding darker details to the cut-glass shapes with diluted Payne's Gray.

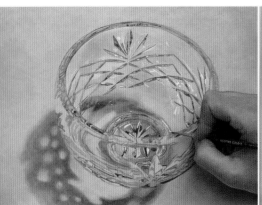

5 With the same #0 brush add highlights in Titanium White. For strong highlights, use it pure; for soft highlights, dilute it with gloss medium and a bit of water.

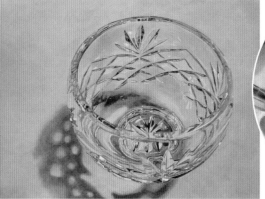

6 Once all the details are painted in the glass and the paint has dried, assess the values. Sometimes Titanium White "sinks" into the previous layers of paint and needs an additional second or even third layer to reinforce the lightest values.

7 Use the #0 round brush to add minute color details using diluted Deep Portrait Pink. Small color accents help to bring cut-crystal and transparent glass objects to life.

You will need
- Primed panel, approx. 8 x 10 inches (20 x 25 cm)
- 2B mechanical pencil
- Gloss medium

Brushes
- Filbert #3 and #10
- Pointed round #0 and #2

Palette
- Deep Portrait Pink (or a blend of Burnt Sienna, Naphthol Crimson and Titanium White)
- Light Blue Violet (or a blend of Ultramarine Blue, Dioxazine Violet and Titanium White)
- Payne's Gray
- Titanium White
- Ultramarine Blue

HALCYON BLUES
BY LORENA KLOOSTERBOER
8 x 10 inch (20 x 25 cm)
The cut-glass votive sparkles with light. The warm color accents balance the cooler temperatures of this composition. In this case premixed portrait pink was used, but crystal objects often show many rainbow colors. Experiment using hot pink, bright green, orange, violet or yellow!

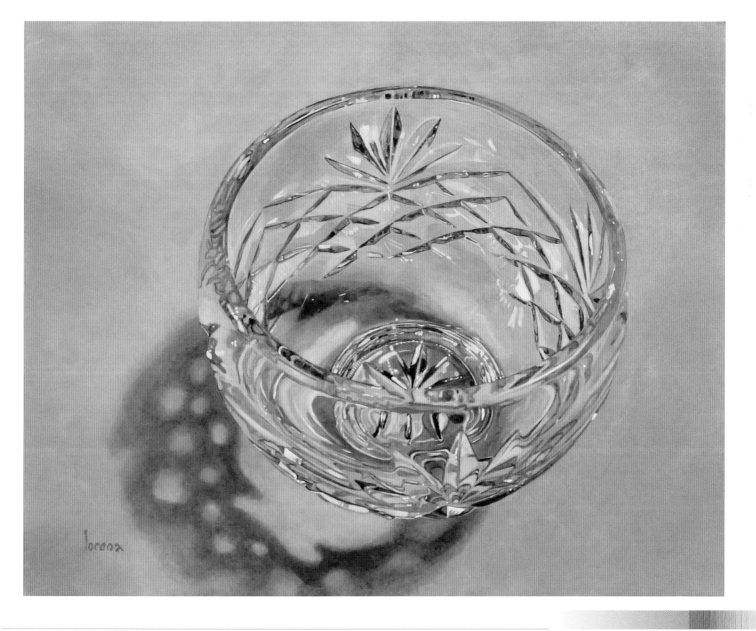

Still Life continues over the page ⟶

Metal, an easily recognized material despite its many forms, colors and finishes, is portrayed by painting hard edges, reflections and distortions.

STILL LIFE: METAL

We find metals in almost all painting genres: metal escalators, phone booths or cars in cityscapes; metal boats, fences or padlocks in landscapes; metal engines, instruments, tools and machinery in mechanical paintings; metal jewelry in portraits; and modern-day metal objects such as kitchen appliances, tin cans, scientific and medical instruments, even robots in contemporary still lifes.

We can easily identify whether an object is made out of bronze, copper, pewter, tin, steel or a precious metal such as gold and silver, because each metal has its own recognizable tint, luster and color temperature. For example, sterling silver has a warm, white sheen while stainless steel has a cold, white-bluish sheen. Metal surfaces range from a high polished shine to a low luster, to oxidized, tarnished and/or corroded appearance.

The main quality of metal is its solid edges. To paint metals successfully, you need to differentiate between their surface finishes. Shiny metals need to be deconstructed into areas of color, value and shapes, paying particular attention to intense darks and highlights. Shiny polished metals reflect nearby objects so the metal is subjected to mirrored colors and shapes. With low-luster metals you need to observe the subtle nuances of their understated appearance, the subtle tonal values that create smooth transitions.

A reference photo of shiny metal, even when painting from a live composition, is a useful unchanging two-dimensional guide. You will notice shapes and forms in the reference photo that are less apparent when looking at a still life set-up in person. It also allows turning both the reference photo and the canvas upside down to focus strictly on shapes, colors and values.

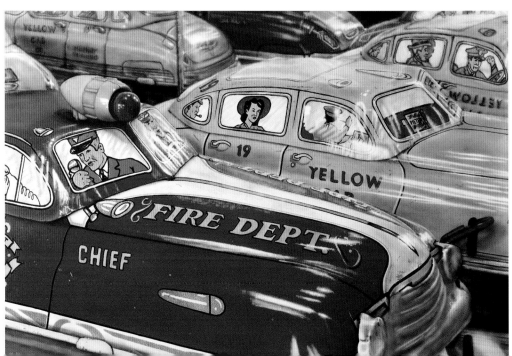

RUSHING THROUGH TRAFFIC
BY CESAR SANTANDER
33 x 48 inch (84 x 122 cm)
The delicate sheen of aged tin is beautifully captured in this photorealistic painting of vintage toys. The vivid colors give this nostalgic piece an eye-popping vibrancy.

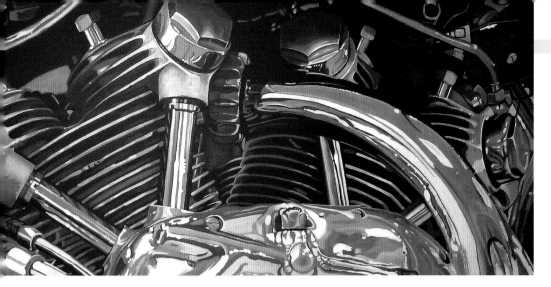

ARRANGEMENT IN GRAY AND
BLACK: KNUCKLES
BY KEN SCAGLIA
20 x 60 inch (51 x 152 cm)
The rubber and metal in this
engine are superbly rendered
by offsetting matte and highly
polished surfaces, and by
balancing warm and cool
highlighted grays in the
chrome details.

Characteristics of metal

Matte or low-luster metals

• Colors are dictated mostly by the metal itself, or the nature of the tarnish or rust.

• Shadows and highlights are blurry or diffuse and are tinted by the color of the metal as well as the light source.

• Low-luster metal shows a wide range of gradations between colors and between values.

• Reflections are either nonexistent or very faint. Any reflections are tinted by the base color of the metal— white metals tint reflections in cool grays, yellow metals tint reflections in yellows, oranges or ambers.

• Rust colors range from reds to oranges to browns, and rust has a distinct grainy texture. Verdigris, the natural patina on weathered brass, copper or bronze, is painted over a dark brown base in different shades of blue-green or turquoise.

Highly shiny metals

• Highlights can be diffuse, fractured or ultra-sharp. Highlights are affected by the temperature of the light source and the color of the metal itself.

• Reflections can range from vague impressions to highly detailed depictions of the surroundings in a full range of values and colors.

• The base color of metal tints the reflections, modifying their colors: polished silver is practically colorless, so reflections keep their original color, while reflections in shiny steel have a distinct cool blue tint, and the base colors of shiny yellow metals tint reflections with yellows, oranges or ambers.

• The shape of the metal object distorts and warps whatever is reflected in it. Distortions are especially striking when looking at rounded, convex or concave metal objects, such as a spoon in which reflections appear upside down.

AROUND THE HORN
BY LINDA MCCORD
21 x 24 inch (53 x 61 cm)
When painting metal it is key to capture
surrounding colors that affect the metal surface.
Note the sky and the player's clothing reflected
in the brass horn.

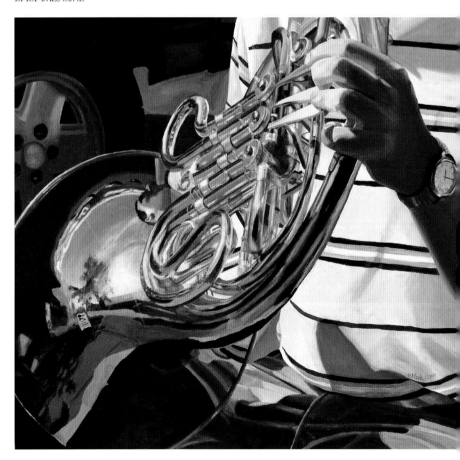

Still Life: Metal continues over the page ⟶

TECHNIQUE FILE 47

PAINTING METAL: TEAPOT

When rendering highly reflective surfaces, it is helpful to squint your eyes when observing the subject. This will make it easier to see the basic shapes and will help to keep you from becoming overwhelmed by the details.

You will need
- Primed canvas, approx. 12 x 16 inches (30 x 40 cm)
- Water or acrylic painting medium

Brushes
- Round #10

Palette
- Burnt Sienna
- Mars Black
- Titanium White
- Unbleached Titanium
- Yellow Ocher

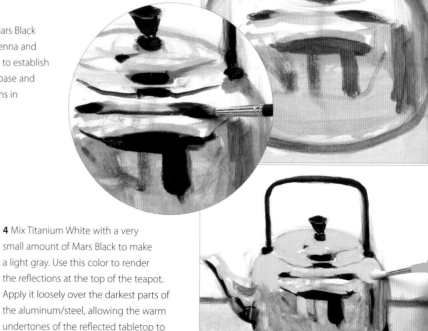

METAL TEAPOT
BY MARK DANIEL NELSON
12 x 16 inch (30 x 40 cm)

When painting any reflective surface, pay attention to the way the surroundings are "mirrored" in the object.

2 Use Burnt Sienna to clarify the details in the teapot. Since you will be using cool, steely gray colors to complete the painting, having a warm-toned underpainting will help to balance the color range.

3 Now mix Mars Black with Burnt Sienna and use this color to establish the handles, base and dark reflections in the teapot.

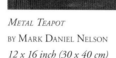

1 Using a #10 round brush and Yellow Ocher, sketch the basic outline of the teapot. Painting a guideline through the center of the teapot will help to keep your shapes symmetrical.

4 Mix Titanium White with a very small amount of Mars Black to make a light gray. Use this color to render the reflections at the top of the teapot. Apply it loosely over the darkest parts of the aluminum/steel, allowing the warm undertones of the reflected tabletop to show through around the rim of the pot and in the main body.

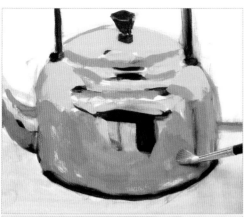

5 Using the color mixture from Step 4, add a small amount of Burnt Sienna and fill in the lower half of the teapot. Apply the paint with loose strokes, varying the direction to make the surface more lively.

6 To paint the highlights on the spout and the side of the teapot, use pure Titanium White. Keep in mind that the light is coming from overhead, and the surface of the teapot is reflecting the light as a mirror would. You may need to paint two or three layers (allow paint to dry a few minutes between each layer) before the paint becomes fully opaque.

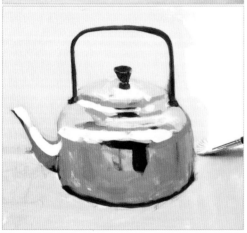

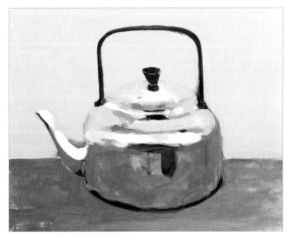

7 Clean up any stray brush strokes and redefine the edges of the teapot by applying Unbleached Titanium to the background.

8 Fill in the tabletop with a thin wash of Burnt Sienna mixed with Yellow Ocher. Use a very thin mixture of this same color to represent the table's reflection in the teapot. Reestablish the dark accents and light highlights one final time.

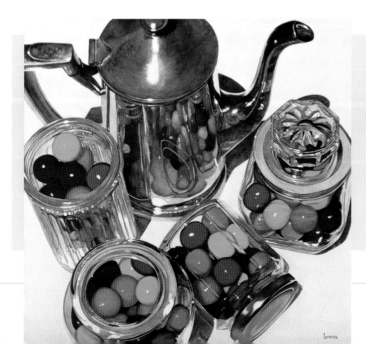

TWICE AS MUCH
BY LORENA KLOOSTERBOER
24 x 24 inch (60 x 60 cm)
The subtle scratches, the muted highlights and the dark, distorted shapes of the gumballs reflected in the coffeepot help to enhance the pictorial illusion of worn, tarnished silver.

Still Life continues over the page ⟶

To create authentic-looking drapery or clothing using acrylic paint takes practice, mostly because the fluidity and folds of fabric demand precise gradations and smooth transitions.

STILL LIFE: FABRIC

Fabric in a painting can be a supporting design element or it can be the starring subject. It can create a certain mood and present meaningful information, such as spaciousness, informality, opulence and intimacy, and can even indicate weather conditions. While painted fabric is inert, it can still suggest movement. The way fabric drapes can suggest the contours of an object underneath—for example, furniture or a human figure.

Flowing folds, swooping drapery, sharp pleats, neatly folded cloth, patterned and embroidered textiles—wrinkled, creased, smooth, dense or sheer—all have a specific charm and demeanor. We can often recognize the painted fabric by its sheen or opacity, as there's a pronounced

He Loves Me, He Loves Me Not
by Paula Oakley
14 x 18 inch (36 x 46 cm)
The flowing fabric, straw hat and flower were masterly painted by deftly applying several thin washes over thicker opaque layers, creating depth and detail. Shadows and highlights were added as a final touch, bringing it all to life.

Sunday Best
by Lorena Kloosterboer
42 x 26 inch (107 x 66 cm)
The meticulous rendering of the wrinkled lace dress is enhanced by the contrasting textures of the smooth wood panel background, the shiny satin hanger and the worn leather shoes.

Characteristics of fabric

- Highlights depend on the opacity or sheen of the fabric; they can be diffuse and opaque (as in velvet) or shiny and bright (as in satin). The edges of the highlights are usually feathered, and some highlights shift not only in value but also in color.

- Shadows in the folds are sometimes opaque and at other times almost seem translucent, with a darker edge surrounding a lighter shadow. Shadows shed by objects surrounding the fabric are distorted, as they are projected onto an uneven surface.

- The orientation, color and intensity of the light source determine the make-up of the shadows and the highlights.

- There are many types of folds and it is useful to study them to become familiar with their anatomy, characteristics and "behavior."

- You can suggest the outline of objects underneath fabric by the way the cloth drapes and folds around their contours—for example the silhouette of a woman's body underneath a dress.

difference between satin, silk, linen, cotton, burlap, velvet or wool.

The simplest way to paint patterned or embroidered fabric is to paint the unadorned fabric first in its base color, including shadows and highlights, and then add the pattern or needlework details on top.

Whether you paint in quick painterly brush strokes or detailed realism, always think of fabric as a complex configuration of abstract geometric planes. Unless fabric is smoothed completely flat, there will be numerous small folds and creases within it, some sharp (as with a starched piece of cotton), some soft and undulating (as with a soft woolen fabric). To make these folds look convincing, you must carefully assess the subtle value transitions. Beware, however, of including too many elaborate folds, as this often leads to

unrealistic-looking textures that spoil the visual impact of painted fabric.

Look for geometric forms within the fabric that establish its volume and shape. Try to see these as defined areas of color and value: it can be very useful to start by making a detailed sketch of these geometric shapes.

Huída desesperada
by Carlos Saura
39½ x 39½ inch (100 x 100 cm)
This powerful portrayal of dramatic fabric is established by the changing values created by the intensity of sunlight, skillfully capturing the flow of movement on a two-dimensional surface.

Still Life: Fabric continues over the page ⟶

TECHNIQUE FILE 48

PAINTING FABRIC: PATTERNS
Keeping light and shadow relationships consistent is the key to painting a believable representation of patterned fabric.

AMERICAN WRAP
BY RODERICK E. STEVENS II
24 x 36 inch (61 x 91 cm)
The wrinkled, folded fabric is expertly suggested by the interrupted, irregular patterns of stars and stripes. The interaction of opaque highlights and shadows with the bold colors invokes a sense of heightened reality.

1 Sketch the basic outline of a shirt using a thin mixture of Yellow Ocher and Unbleached Titanium and a #8 round brush.

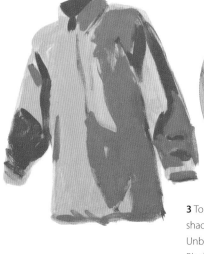

3 To create the color for the dark shadows on the shirt, combine Unbleached Titanium with a little Mars Black and a touch of Cadmium Red Medium. For the medium-dark shadows on the shirt, simply add a little more Unbleached Titanium to the mixture.

2 Fill in the sketch with an opaque mixture of Unbleached Titanium, Yellow Ocher and a very small amount of Cadmium Red Medium.

4 Now it's time to paint the stripes on the fabric. There will be two separate colors for the stripes: a light blue and a shadow blue. To mix the light blue, combine Unbleached Titanium and Ultramarine Blue. Use this color for any stripes that are not in shadow.

You will need
- Primed canvas or panel, approx. 12 x 16 inches (30 x 40 cm)
- Water or acrylic medium

Brushes
- Round #8

Palette
- Burnt Sienna
- Cadmium Red Medium
- Mars Black
- Ultramarine Blue
- Unbleached Titanium
- Yellow Ocher

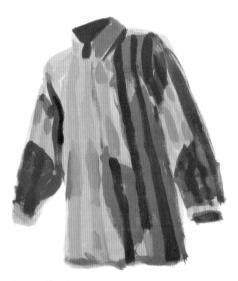

5 Mix Unbleached Titanium, Mars Black and Ultramarine Blue to create the color of the stripes in shadow. Make sure that these stripes line up with the stripes you painted in Step 4.

6 Use Unbleached Titanium to fill in the light areas of the shirt. Be sure to avoid painting over any of the light blue stripes.

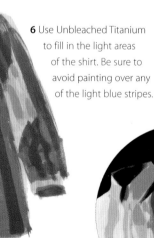

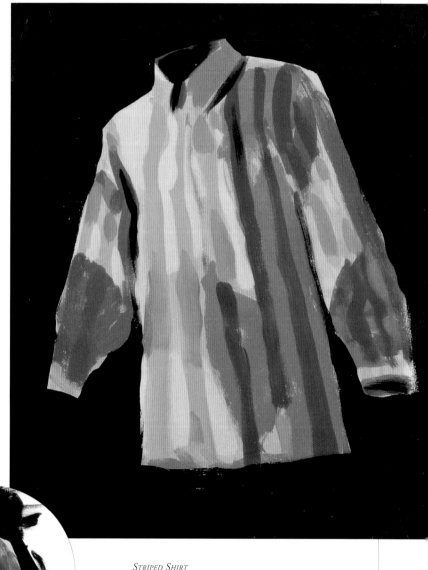

7 Make a dark gray color by mixing equal parts Ultramarine Blue and Burnt Sienna. Use this color for the deep shadows on the collar of the shirt and to fill in the background.

Striped Shirt
by Mark Daniel Nelson
16 x 12 inch (40 x 30 cm)
It's helpful to imagine a "light family" and a "shadow family" in order to maintain accurate value relationships any time you paint a patterned surface.

Still Life: Fabric continues over the page ⟶

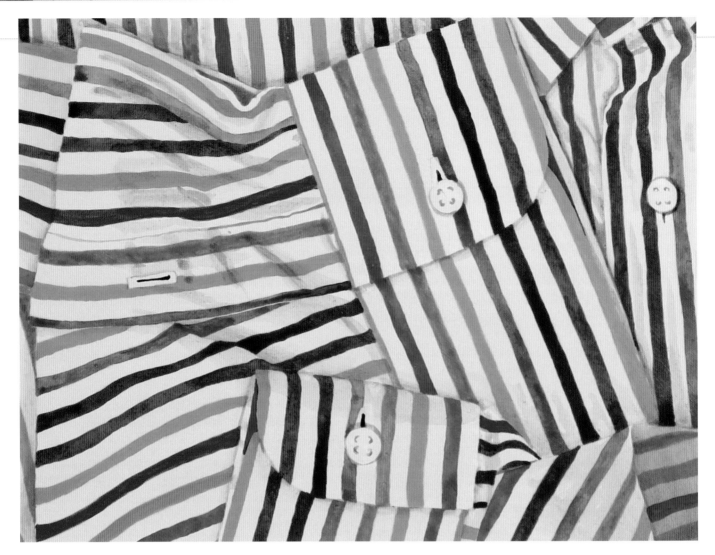

 TECHNIQUE FILE 49

PAINTING FABRIC: STRIPES

The loose folds of this casually dropped men's shirt make the flowing striped pattern look jumbled yet organized. The directions of the stripes create the basis for the portrayal of the fabric. Although the shirt is fairly flat, there are many small shadows within the fabric indicating small wrinkles and folds. Once the striped pattern has been painted there's no need to render every tiny shadow that you can see as the piece may become overworked. The striped shirt doesn't cast shadows on the white background and the colors are flat and vivid, resulting in a fresh, contemporary look.

You will need
- Primed panel, approx. 12 x 16 inches (30 x 40 cm)
- A grayscale print of your composition photo
- Graphite tracing paper
- 2B pencil
- Gloss medium
- Cotton swabs
- White gesso

Brushes
- Round #2
- Flat #6

Palette
- Burnt Umber
- Cadmium Red
- Cerulean Blue
- Hooker's Green
- Light Magenta
- Naples Yellow
- Payne's Gray
- Phthalo Blue
- Prism Violet
- Titanium White

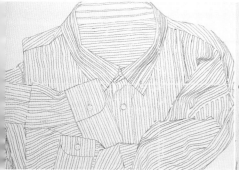
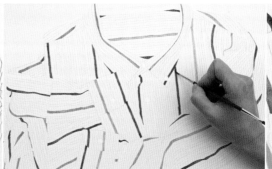

1 Trace all the lines of the composition photo onto a primed panel or draw your composition with a 2B pencil. Make sure you don't overlook any lines!

2 Using a #2 round brush, paint the colors of your choice filling in the stripes of the fabric. Paint these colors flat, without modulating values, using a bit of gloss medium to extend brush strokes. Make sure there is a white gap between each stripe and the next, and that the flow of colored stripes correlates with folds in the fabric.

3 Some colors may need a second or third layer if they look too transparent. If you make a mistake (for example, if you paint the wrong stripe), quickly wipe off the color with a wet cotton swab. If the paint has dried, you can cover it with several layers of pure Titanium White or white gesso.

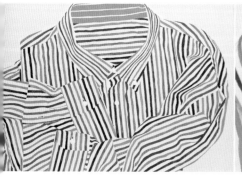
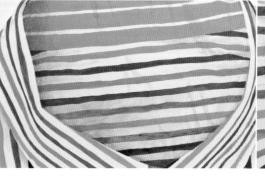
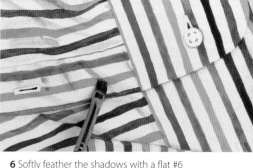

4 Once the stripes are finished, let the painting dry thoroughly. Clean up any color mistakes and get rid of obvious pencil lines using pure Titanium White or white gesso.

5 Prepare a diluted glaze with Payne's Gray, gloss medium and a little bit of water. Using both brushes, softly modulate the shadows of the fabric. It is better to use very thin transparent glazes, so that you can build up values in several layers where needed. Buttons and buttonholes are indicated by painting their rim and holes with the same Payne's Gray glaze.

6 Softly feather the shadows with a flat #6 brush to indicate subtle creases in the fabric. Add more layers to deepen the value where necessary. The beauty of using a transparent glaze for the shadows is that the colors of the stripes show through and darken at the same time.

7 Continue reinforcing the shadows, paying particular attention to overlapping fabric, edges, seams and the tiny puckered wrinkles that are so typical of fabric.

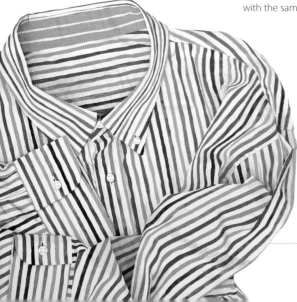

AFTER HOURS
BY LORENA KLOOSTERBOER
12 x 16 inch (30 x 40 cm)
The finished painting looks realistic in a graphic kind of way. Try this technique to paint wrinkled, crumpled or gathered fabric with plaids or other well-defined patterns.

Still Life continues over the page ⟶

Always think of paper as a reflective substance. Light bounces off it and frequently shines through it, creating subtle translucencies.

STILL LIFE: PAPER

Historically, artists have painted paper money, postage stamps, books, scrolls and newspapers. Contemporary realism includes modern forms such as origami, comic books, magazines and paper bags. Paper comes in a great variety of guises, making it an interesting subject for paintings. Unsurprisingly, because of its flatness, paper plays a prominent role in many trompe l'oeil paintings.

Crumpled, creased or folded paper consists of abstract geometric planes. Look for geometric forms that establish the volume and shape of the paper. Deconstruct these into distinct areas of color and value by making a detailed sketch.

Characteristics of paper

- Stiff paper has the tendency to buckle. This distinctive characteristic can be described as an understated curvature combined with a small, hard crease—it is probably the hardest detail to paint successfully.

- Paper usually has a nonglossy matte texture, so its highlights are matte as well.

- Paper is reflective, so surrounding objects influence its color and vice versa.

- Shadows in folds and creases sometimes have a backlit shadow due to the reflective nature of paper.

- White paper is never pure white; it has many subtle hues.

- Paper objects become translucent when a light source is placed behind them. Capture this luminosity by paying close attention to shifts in value and color.

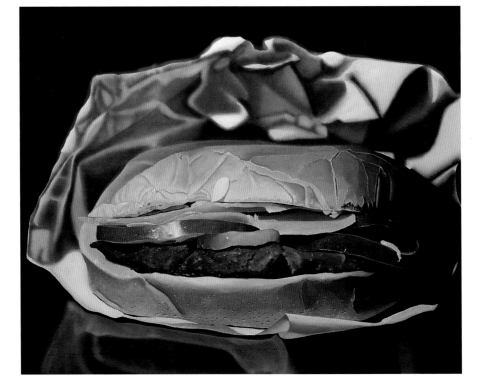

WHATABURGER
BY JAMES ZAMORA
*48 x 60 inch (122 x 152 cm)
In this impressive contemporary still life the paper wrapping creates a backdrop for the sharply painted main subject matter. Although softly blurred, as if out of focus, the paper texture remains highly recognizable.*

WRAP 01
BY RODERICK E. STEVENS II
36 x 30 inch (91 x 76 cm)
The texture of stiff paper is created by the subtle play of
light and shadows, and enhanced by the expert portrayal
of translucence, backlit shadows and delicate creases.

LARGE FINANCIALS
BY CESAR SANTANDER
24 x 24 inch (61 x 61 cm)
The characteristic texture
of newspaper is skillfully
expressed in the serrated
edges, little tears and
rolled-up folds, enriched by
the delicate rubber bands
and meticulous lettering
that changes from sharp to
out-of-focus.

Smooth, flat paper—such as a letter or postcard—requires subtle details, such as small understated creases, to reinforce the expression of texture. Avoid painting a flat plane. Adding small details such as tears, creases, tucks, frayed edges or stains adds interest to flat paper.

To depict the three-dimensionality of this wafer-thin subject, paint an ultra-thin highlight indicating the paper's edge.

Painting paper with text

Painting the handwritten or printed marks found on newspapers, music sheets or letters may seem daunting but it need not be perfect. Normally, the best way is to paint the paper object first, including highlights and shadows, and then add the script. There are three ways to paint text:
• It can be painted in detailed precision so that it is clearly legible.

• Text can be suggested by a series of repeated marks or scribbles that mimic the cadence of the lettering, creating an illegible pictorial impression.
• A transition between precise text and an impression is called the Etcetera Effect. Part of the painted text is readable and sharp, but then fades into indistinct marks that mimic the modulation and rhythm of the legible text. The Etcetera Effect is effective because the eye is drawn to the legible part, so the brain conceives the blurry marks as realistic.

Whichever you choose, remember that the shape of text is distorted as it wraps around creases, curves or folds. Pay close attention to the perspective of the font as well as to the decreasing size of the gaps between words or marks. Use the base color of the painted paper background to clean up mistakes or thin out lines.

Still Life: Paper continues over the page →

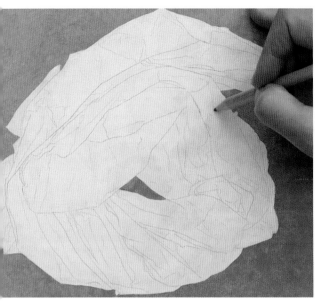

PAINTING PAPER: CRUMPLED MUSIC

Painting crisply crumpled paper is easier when you deconstruct its shapes and values. Adding many subtle color glazes helps bring the white paper alive.

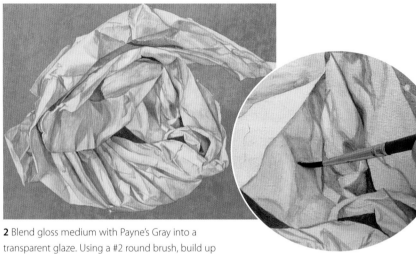

1 Sponge your canvas with a dappling motion, alternating between Neutral/Medium Gray No. 5, Titanium White, Ultramarine Blue and Burnt Umber diluted with some gloss medium. Apply several layers until you achieve an interesting yet neutral-looking background. Let it dry thoroughly. Draw or trace the outline of the crumpled paper onto the background, then fill it with several layers of white gesso using a #6 short flat brush. Once dry, use a 2B pencil to sketch in the details of the creases, folds and wrinkles.

2 Blend gloss medium with Payne's Gray into a transparent glaze. Using a #2 round brush, build up thin layers of this glaze, paying particular attention to fluctuations in value. Always let glazes dry well before applying additional layers.

3 Think of your object not as paper, but as a collection of shapes and values. Look for abstract shapes in the paper surface. Look for curved as well as straight lines.

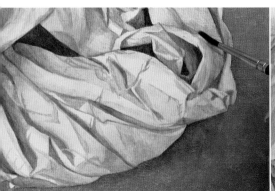

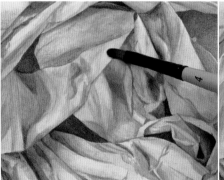

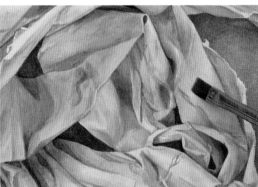

4 Next, use a #4 filbert and the same Payne's Gray glaze as before to suggest the shadows underneath the paper. Softly feather the edges. Use a #2 round brush, Burnt Umber and gloss medium to glaze in the warmer areas of the paper.

5 Repeat the glazing process with a #4 filbert, first with Ultramarine Violet and then, once this glaze is dry, with Ultramarine Blue. The blue glaze cools down some areas. The violet glaze becomes a transitional temperature between the warm brown and the cool blues.

6 Using a #6 flat brush, apply a subtle glaze using Naples Yellow and gloss medium. The yellow areas make the paper look both translucent and aged. Once this glaze is dry, you may notice color and value differences due to color shift and the paint "sinking" into previous layers. If desired you can reinforce any color or value by repeating the glazing process.

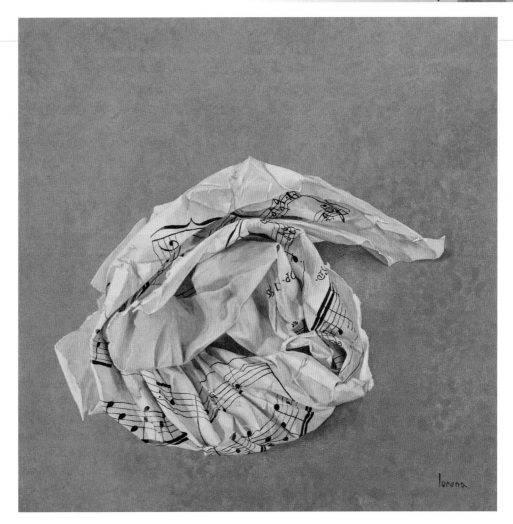

You will need
- Primed canvas, approx. 12 x 12 inches (30 x 30 cm)
- Natural sea sponge
- Gloss medium
- A grayscale print of your composition photo
- Graphite tracing paper
- 2B pencil
- White gesso
- Masking tape
- Cotton swabs
- 2H mechanical pencil

Brushes
- Short flat #6
- Round #000 and #2
- Filbert #4

Palette
- Black Acrylic Ink (or highly diluted Carbon Black)
- Burnt Umber
- Naples Yellow
- Neutral/Medium Gray no. 5
- Payne's Gray
- Titanium White
- Ultramarine Blue
- Ultramarine Violet

ÉTUDE

BY LORENA KLOOSTERBOER

12 x 12 inch (30 x 30 cm)

Multiple colored glazes built up the shapes of the white paper, faithfully depicting its typical texture. Subtle changes in value and color suggest reflectivity and backlit shadows resulting in understated elegance. This technique also works well for painting paper with lettering, calligraphy and other written or printed characters.

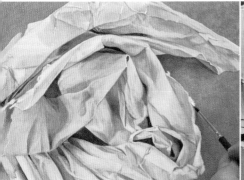

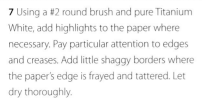

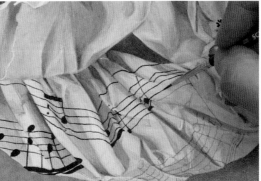

7 Using a #2 round brush and pure Titanium White, add highlights to the paper where necessary. Pay particular attention to edges and creases. Add little shaggy borders where the paper's edge is frayed and tattered. Let dry thoroughly.

8 Position the reference print precisely over the painted paper and fix it in place with masking tape so that it won't move. Place graphite tracing paper underneath and trace the musical notes with a hard mechanical pencil. Using a #000 round brush and Black Acrylic Ink (or highly diluted Carbon Black), carefully paint the lines and notes. If you make a mistake, quickly wipe it away with a moist cotton swab. Finally, use a Titanium White veil to glaze over the lettering in the highlighted areas of the paper, integrating the dark musical notes as part of the paper.

Still Life continues over the page ⟶

Throughout history, artists have been drawn to depict flowers, both as aesthetic objects and as religious symbols. The challenge of painting flora involves the accurate rendition of intricate shapes awash with vivid colors.

STILL LIFE: FLOWERS AND LEAVES

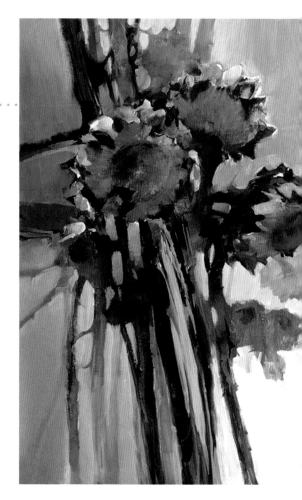

Floral painting flourished in the 17th century, when bouquet still lifes became fashionable in the Low Countries. Minute observation of natural flora is best complemented by studying floral art in all genres—from classical realism and impressionism to naïve and pop art.

Floral painting offers a virtually limitless number of distinctive compositions, ranging from detailed botanical close-ups to still lifes of single blooms, and from extravagant mixed bouquets in pots or vases to natural settings with clumps of earth and roots exposed. Conveying your composition through the application of values and colors will lead to a highly personal expression of this subject matter.

Painting from a live arrangement presents drawbacks: colors change, blooms open, stems grow, foliage deteriorates. Be sure to always take reference photographs of your composition.

Observation is key. If you lack direct access to nature, visit a flower shop, botanical garden or a greenhouse to study your subject.

DRIED SUNFLOWERS
BY MORTEN E. SOLBERG
22 x 15 inch (56 x 38 cm)
This vibrant, loosely painted still life masterfully captures the warm, rich browns of dried sunflowers. The strength and beauty of this composition stem from the minimal depiction of carefully chosen details.

Painting intricate flora and foliage
Painting grasses, wildflowers or cherry blossom can be daunting due to the complexity of jumbled stalks or a multitude of flowers. Even some single flowers, such as carnations or chrysanthemums, have a complex configuration of petals. Capturing the overall textures and shapes of foliage is essential to achieving effective results, whether you paint detailed realism or in broad abstracted strokes.

There are several ways to paint complicated, disordered or tangled flora:
• Paint in meticulous precision so that each detail is well defined.

• Suggest a pictorial impression by a series of abstracted marks or planes.
• Use the Etcetera Effect: Paint part of the foliage in detail, making it the focal point. Paint the rest in indistinct marks or planes that mimic the rhythm of the foliage. This is effective because the eye is drawn to the detailed area, and the brain perceives the abstracted marks as realistic.
• Paint the background first to make it easier to superimpose stems later.

Characteristics of flowers

• Each flower species has a particular geometric silhouette—for example, the daisy is saucer-shaped, the tulip is cup-shaped and the petunia is trumpet-shaped. Analyzing these basic shapes will provide guidance on placement and perspective, making them easier to draw.

• The texture and shape of petals is key to capture the essence of the flower you are painting. For example, the poppy has crinkled papery petals, rose petals are velvety smooth, daisy petals are ribbed and orchids are waxy.

• Highlights and shadows help depict texture. Colors help depict translucency and delineate stamens and other small details.

Characteristics of leaves

• Each plant species has a distinct leaf shape (contour) and edge (for example, serrated, undulated, smooth).

• Each species has a characteristic pattern of leaf veins, which can be expressed as superficial impressions or by different colors or values.

• Leaf texture can be glossy, opaque, leathery, rubbery, fuzzy, etc.

• Highlights and shadows help depict texture. Colors help depict translucency and luminosity.

Characteristics of stems

• Stems are often overlooked elements that can make or break an otherwise excellent floral painting.

• Each plant species has a particular stem curvature and slant.

• Observe the thickness, color and surface appearance (silky, opaque, glossy, fuzzy).

• Observe the surface texture: there are smooth stems (the daffodil), segmented stems (the carnation) and textured stems (e.g., the sunflower stem has ridges).

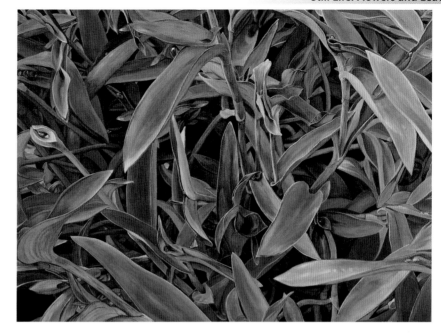

PURPLE HEART
BY WILLIAM COLCLOUGH
THOMAS
*30 x 40 inch (76 x 101 cm)
This exquisite, near-monochromatic still life was built up using transparent acrylics painted wet-in-wet, paying particular attention to deep shadows and delicate out-of-focus areas while creating elegant contrasts between cool and warm hues.*

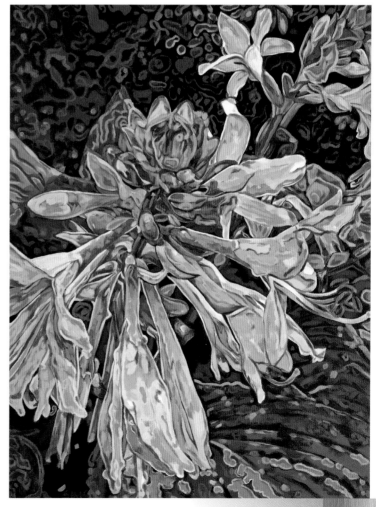

THE DANCING QUEEN
BY CAROL SIMS
*40 x 30 inch (101 x 76 cm)
This elegant, playful still life of Hosta blooms (plantain lilies) was superbly rendered using energetic brush strokes, vivid, saturated colors and strong contrasting values.*

Still Life: Flowers and Leaves continues over the page ⟶

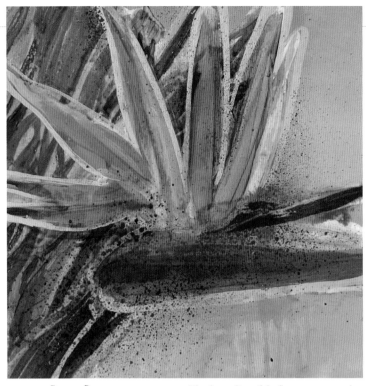

Bird of Paradise
by Carol Carter
8 x 10 inch (20 x 25 cm)

The elegant lines of the flower are captured in a simple way, and the piece is given interest and texture with spattering.

TECHNIQUE FILE **51**

PAINTING FLOWERS AND LEAVES: BIRD OF PARADISE

Flowers are the perfect subject to be experimental with color and technique. This piece was made by simplifying the main shapes and focusing on conveying a sense of spontaneity.

You will need
- Primed paper, approx. 8 x 10 inches (20 x 25 cm)
- 2B mechanical pencil
- Gloss medium
- Masking tape
- X-acto knife
- Spray bottle
- Toothbrush

Brushes
- Filbert #3 and #10
- Pointed round #0 and #4
- Flat brush

Palette
- Cadmium Orange
- Cadmium Yellow Light
- Dioxazine Violet
- Light Blue Violet
- Naples Yellow
- Permanent Green
- Permanent Light Blue
- Pthalo Green
- Titanium White
- Transparent Red Iron Oxide
- Yellow Medium Azo

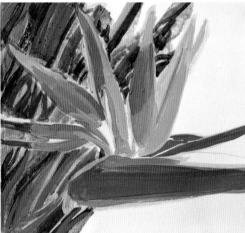

1 Using a pointed round #0 and Cadmium Yellow Light, paint the outline of the bird of paradise flower.

2 Using a #4 pointed round brush, begin blocking in the color of the flower with Cadmium Orange, Permanent Light Blue, Naples Yellow and Titanium White. Add the background foliage with Permanent Green and Naples Yellow. Add the tongue of the flower with Light Blue Violet, Dioxazine Violet and Titanium White.

3 Cover the whole painting with Transparent Red Iron Oxide mixed with gloss medium as the extender. This will deepen the value of your painting by adding richness and transparency. Let this fully dry before proceeding. Use a flat wash brush and follow the outline of the flower. Be loose and generous with the application, allowing the glaze to puddle and flow. There will be striations of pigment and striations of clear glaze, which create depth and complexity.

4 When the glaze is completely dry, cover the whole painted image with masking tape, then seal the edges of the tape with gloss medium. The masking tape acts like a barrier, preventing any paint from reaching the area underneath.

5 Cover the whole paper, including the mask, with a wash of acrylic paint gradating from blue to yellow, using Light Blue Violet, Titanium White and Naples Yellow. Mix the paint as seamlessly as possible, allowing no stripes or drags. Make this passage of paint look like atmosphere or air. Wait for the wash to completely dry, then remove the masking tape, carefully peeling it up. You may need to use an X-acto knife to lift the edge to start with.

6 Add a super-wet glaze of Yellow Medium Azo over the whole painting. Spritz with water and let it drip. Allow to completely dry. Add a white line around the flower to bring it forward in the picture plane. Allow to dry.

7 Apply the wet glaze of Yellow Medium Azo across the whole painting again. Spritz with water and let it run. This fluidity creates interest and depth. Allow to dry completely.

8 Add depth and character by spattering on Transparent Red Iron Oxide with a toothbrush, being careful not to go outside the outline of the flower. Be careful to not add too much or make the flower too dark.

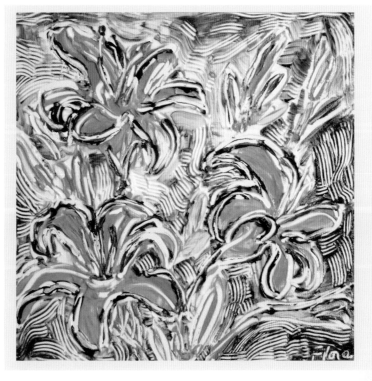

REACHING OUT
BY FLORA DOEHLER
12 x 12 inch (30 x 30 cm)
This strong, energetic floral still life shows a great balance using dramatic complementary colors. The lively textural background and accentuated contours were shaped in the sgraffito technique using rubber-tipped color shapers, creating interesting patterns and lively movement showing the white canvas.

Still Life: Flowers and Leaves continues over the page →

PAINTING FLOWERS AND LEAVES: CHRYSANTHEMUM

Intricate flowers with an abundance of petals are exciting subjects to paint. Focus on painting petal by petal to build up a realistic flower in beautiful jewel-tone colors.

You will need
- Primed panel, approx. 9 x 12 inches (23 x 30 cm)
- 2B mechanical pencil
- Masking tape
- Liquid frisket
- Gloss medium

Brushes
- The Incredible Nib or an old #2 round brush
- ⅛-inch (3-mm) long flat
- Flat #8 and #11
- Round #0 and #2

Palette
- Burgundy (or a blend of Burnt Umber and Naphthol Crimson)
- Burnt Umber
- Cadmium Red
- Cadmium Yellow Light
- Cadmium Yellow Medium
- Hooker's Green
- Light Green Permanent
- Payne's Gray
- Sap Green
- Titanium White

1 Draw the chrysanthemum on the primed panel. Put in as much detail as possible, paying particular attention to the complex pattern and direction of the flower petals.

2 Mask the inside of the flower with tape, staying within the edges of the petals. Using the Incredible Nib or #2 round brush, carefully cover the surrounding petals with liquid frisket and leave to dry. Using a ⅛-inch (3-mm) long flat brush, block in the stalks and leaves with Cadmium Red. Repeat to create a deep red underpainting, which will liven up the greens.

3 Using a #11 flat brush, paint the background using different value blends of Payne's Gray and Titanium White. Feather and blend the shadows with a #8 flat. You need not worry too much about smoothness as long as the values are accurate. Leave the background painterly, because when the painting is finished the eye will be drawn to the flower.

4 Using Hooker's Green and a #2 round brush, block in the greenery. Add some gloss medium to extend your brush strokes if necessary. Brush thinly over areas where the highlights will be, so that you don't lose their position. Once dry, carefully remove the masking tape and roll off the dry frisket with your fingertip.

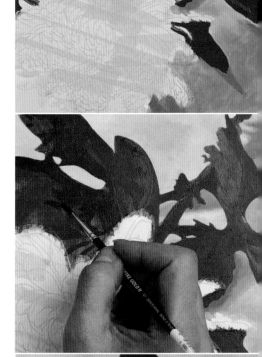

5 Using the same brush, add Light Green Permanent to the highlighted areas of the foliage. Blend it with some Hooker's Green for the transitional areas and feather the gradations.

6 Dilute Sap Green with water and gloss medium to an inky consistency. Paint the heart of the flower (left) with a #0 round brush. Make sure to cover any pencil lines accurately and thinly glaze in the green areas, reinforcing darker values by adding more color.

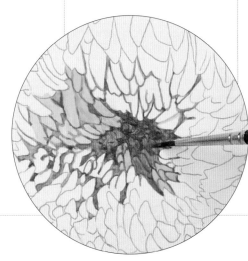

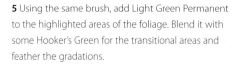

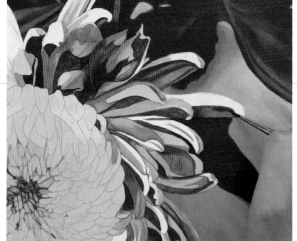

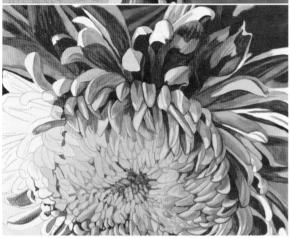

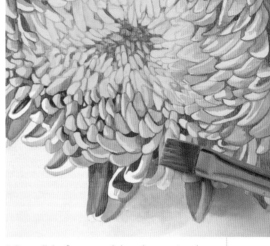

7 Once the green heart is in place, cover the entire central area of the flower with a transparent glaze of Cadmium Yellow Light. Paint the outside petals of the flower with the #0 round brush, using Burgundy (or a blend of Burnt Umber and Naphthol Crimson) blended with gloss medium in the same way that you painted the green heart.

8 Work your way toward the green heart with transparent and opaque layers of Burgundy. Note the optical blending that takes place when transparent colors are layered. Reinforce dark areas with pure color.

9 Once all the flower petals have been painted, cover the rest of the flower with a transparent layer of Cadmium Yellow Medium. This integrates all the petal colors and gives the flower a warm, sunny look. Finally, add a glaze of Burnt Umber and gloss medium to darken the darkest areas inside the petals. Lighten the petal tips with pure Cadmium Yellow Light.

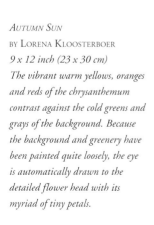

Autumn Sun
by Lorena Kloosterboer
9 x 12 inch (23 x 30 cm)
The vibrant warm yellows, oranges and reds of the chrysanthemum contrast against the cold greens and grays of the background. Because the background and greenery have been painted quite loosely, the eye is automatically drawn to the detailed flower head with its myriad of tiny petals.

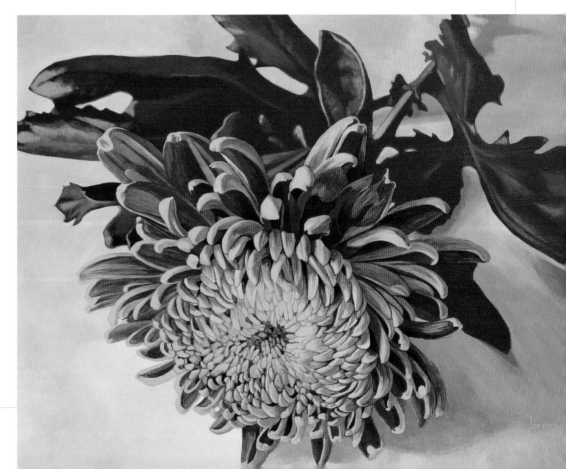

The creative desire to capture the human likeness is deeply ingrained in our psyche and can be traced back to prehistoric times. Our fascination with portrait painting continues today.

PORTRAITURE

The oldest known portrait, believed to be 27,000 years old, is a prehistoric cave drawing of a face in the Vilhonneur grotto in France. Portrait painting has endured throughout history, from funeral portraits in Egyptian tombs to religious figures in early Christian art, and from delicate miniatures in the Renaissance to bizarre cubist portraits in the 20th century—all the way to today.

Portraits have been painted in virtually every style, portraying people from every level of society, from royalty to paupers, although the commitment to realistic likeness has fluctuated. Today a portrait can be anything from a romantic idealization or a social caricature to unflattering realism or a conceptualized impression. Regardless of the style the artist employs, a portrait should capture the spirit of the sitter.

The classic portrait
Traditionally the aim of a portrait is to capture the likeness of the sitter, with the principal focus on facial expression, intended to show his or her personality or frame of mind.

Conventional portrait poses include full-length (entire body), half-length (from the waist upward, usually in seated position showing hands), bust (head and shoulders) and head. Traditionally the face is depicted either fully frontal, in a three-quarter view or in profile.

YELLOW GOWN
BY LINDA MCCORD
26 x 27 inch (66 x 68 cm)
Almost resembling a still life, the innovative pose of this compelling portrait is enhanced by the adept use of a limited color palette focusing on recurring shapes formed by changing values.

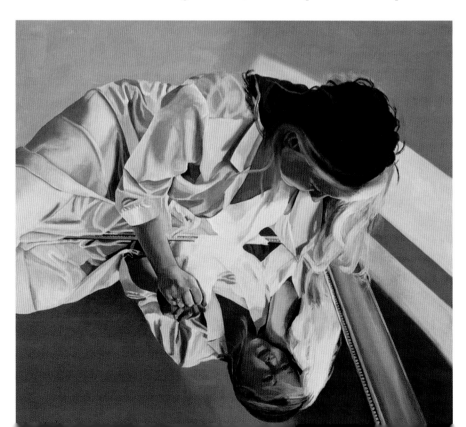

Don't Look at the Yellow Flower
BY STEPHEN BENNETT
30 x 24 inch (76 x 61 cm)
Portraits do not need realistic skin tones to be true to life—as exemplified by the radiant light and vivid colors in this painting.

Patricia
BY ANDRÉS CASTELLANOS
60 x 40 inch (152 x 101 cm)

Contemporary portraiture encourages strong, original compositions, masterly exemplified by this striking full-length profile pose which is skillfully enhanced by a fading background and vanishing perspective.

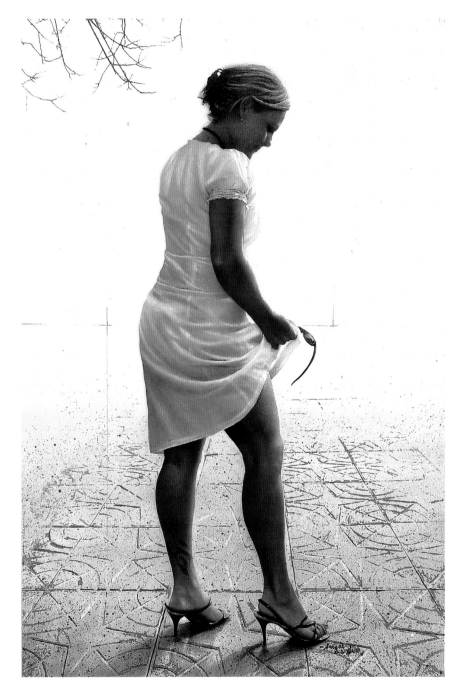

The human figure can be viewed from numerous perspectives, depicted in a wide range of expressive poses—from nude to fully dressed—and placed in a myriad of settings—from indoors to alfresco.

The contemporary portrait

With the invention of the daguerreotype in the middle of the 19th century, photography became widespread and many feared it would portent the end of portrait painting. While photography has become the most prevalent method to capture a person's image, portrait artists continue to be commissioned all over the world: photographs cannot replace the captive charm of a well-painted portrait, which often becomes a beloved family treasure.

Today many artists use photographs as a practical compositional aid, which eliminates time-consuming sittings in part or altogether.

Self-portraits

Self-portraiture is traditionally accomplished by direct observation in a mirror. However, the mirror image is a reversal of reality, so many artists use a second mirror to reverse the first mirror-image. Classical self-portraits are typically three-quarter views. Since the advent of photography, self-portraiture has become a lot less complicated, and offers the artist the possibility to paint a self portrait in any pose and setting.

Evolving expression

Contemporary portrait artists have considerable freedom of expression when it comes to posture, setting, color preferences, mood, form and style. Besides having choice in technical and artistic considerations, the portrait allows the artist to express human emotion in a very direct manner. Today portrait painting continues to evolve in provoking and groundbreaking ways.

Portraiture continues over the page →

Skin colors range from dark to light, vibrant to ashen, and from radiant to pallid. This great variety in human coloring often makes blending flesh tones a challenge.

PORTRAITURE: SKIN

Besides being familiar with human anatomy— the skeletal and muscular structure—blending credible skin tones is essential to painting a realistic portrait.

Many portrait artists develop their own personal blending formulae. Flesh tones can be blended from a very wide or quite a restricted palette—many portrait artists recommend using three colors (plus white) only. Some artists use the Old Masters' method of glazing over a monochromatic underpainting. And some paint realistic skin in unorthodox colors, such as purples or greens.

Acrylic brands offer premixed flesh tones and portrait pinks, but they cannot capture the sheer variations in skin colors. These ready-made colors should never be used by themselves, but they can be used as a base from which to create more vibrant blends.

There are many books and websites offering skin-tone recipes. These are a good place to start, but once you recognize the incredible variety of human coloring it will lead you to create customized flesh tones for each new portrait. Whether you paint a portrait in painterly impasto or smooth realism, think of your subject as a three-dimensional structure shaped by colors and values.

The adage, "paint what you see, not what you know" is especially relevant when it comes to skin tones. Abolish your preconceptions of what skin looks like, as they can sabotage effective color blending: Caucasian skin isn't pink; dark skin isn't brown, red or black; Asian skin isn't yellow. Matching a skin area to a color wheel can prove invaluable in assessing the color tendency as well as temperature. Contrast and strong value ranges are also important in creating a realistic

HANDS
BY JANTINA PEPERKAMP
12 x 9 inch (30 x 23 cm)
This expressive portrait started with a verdaille underpainting over which many layers of skin tones modulate the values.

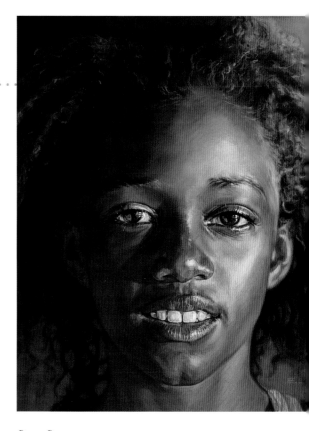

BEACH BABY
BY STEPHEN BENNETT
80 x 64 inch (203 x 162 cm)
The sunlit glow of flawless young skin is strikingly expressed by the pragmatic use of a limited palette of warm colors.

Characteristics of skin

• Observe the distinguishing qualities of your subject's skin—matte or shiny (oily, wet or sweaty), leathery, wrinkly or smooth, slack or taut, vibrant or dusty, scarred, freckled or flawless.

• Male pigmentation is usually darker than female coloration. Children's skin tones are akin to female coloring but with more intensity of color in the nose, ears and lips.

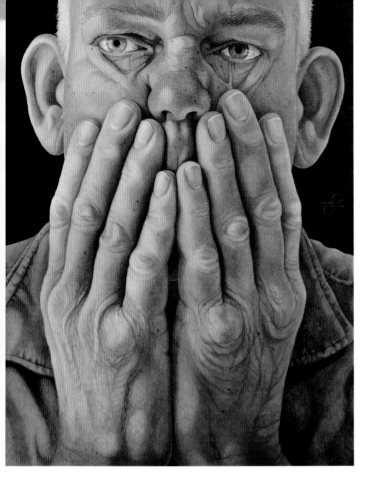

Basic skin blend

Using one basic recipe for all skin colorings has obvious limitations. Start with a basic skin blend and go on to develop your own recipe through experimentation. Do not prepare a huge amount of basic skin color, but rather blend fresh colors for each skin area. Select one color from each primary list below.

Suggested primary colors

YELLOWS:
Yellow Ocher, Cadmium Yellow Medium, Indian Yellow or Naples yellow.

REDS:
Cadmium Red, Alizarin Crimson, Naphthol Red or Burnt Sienna.

BLUE:
Ultramarine Blue

1 Start by blending a tiny amount of red into yellow to obtain an orange.
2 Add a small amount of blue to tone it down.
3 This basic skin blend can now be adapted:

• For lighter skin, add white.
• For darker skin, add Ultramarine Blue, Raw Umber, Burnt Umber or Dioxazine Purple.
• For shadows, experiment by darkening the basic skin blend with Raw Umber, Burnt Umber, Burnt Sienna, Ultramarine Blue, Dioxazine Purple or green (Viridian, for example).

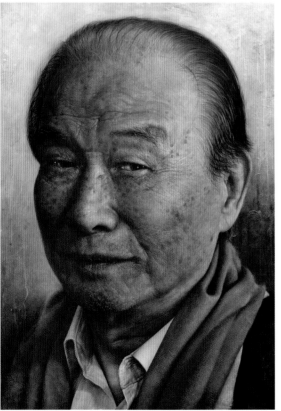

GRANDPA

BY JOONGWON JEONG

46 x 31¾ inch (116 x 80 cm)
The fragile quality of elderly skin, with its web of delicate wrinkles and subtle flaws, has been skillfully expressed in a beautiful, sensitive way, without the harshness usually expected in sharp realism.

portrait—many portraits lack depth because of the artist's fear of using dark values.

Glazing an underpainting can significantly improve realistic portraiture by separating color from value and form (see pages 162–165 for grisaille and 166–169 for glazing). Final color and temperature adjustments can be glazed without losing preceding painting efforts.

Lighting, background and setting also affect skin colors. Skin is reflective, conveying subtle traces of the colors surrounding it. Using these nearby colors to enhance skin tones and shadows is an excellent way to integrate the person with the background, and make the skin look more natural. You may find that blocking in the background colors around the figure first makes it easier to assess skin color and values.

It's also important to remember that the whites of the eyes and teeth are never white! The eye whites are usually grayish and often much darker in value than expected. Teeth tend toward yellows or browns. Isolate these areas to assess the correct values and colors.

Portraiture: Skin continues over the page ⟶

TECHNIQUE FILE 53

PAINTING SKIN: FACE

Painting a portrait is as much about the appearance, expression and personality of the portrait subject as it is about what the artist perceives and reveals. The base skin color in this demonstration is a blend of Yellow Oxide, Titanium White, Venetian Red and Bone Black.

You will need
- Primed panel, approx. 14 x 11 inches (35 x 28 cm)
- Masking tape
- 2B mechanical pencil
- Gloss medium
- Water with flow improver

Brushes
- Filbert #4 and #10
- Round #2

Palette
- Bone Black
- Burnt Sienna
- Burnt Umber
- Light Magenta (or a blend of Magenta and Titanium White)
- Light Violet (or a blend of Dioxazine Purple, Phthalo Blue and Titanium White)
- Naphthol Crimson
- Pale Umber
- Phthalo Green (Blue Shade)
- Prism Violet
- Raw Sienna
- Raw Umber
- Titanium White
- Venetian Red
- Yellow Oxide

1 Apply masking tape to the borders of a primed panel—this unpainted area will function as a visual mat or passe-partout framing the portrait. Sketch the portrait with a 2B pencil. Add light crosshatched shading to indicate dark areas.

2 Prepare a diluted blend of Phthalo Green (Blue Shade) with a bit of Raw Umber, gloss medium and water with flow improver. Start the underpainting by brushing the entire panel with quick random strokes using a #10 filbert brush. Paint the lines of the wrinkles, and build up the darker values around the jaw, mouth, nose, hairline and eyes. This green-toned underpainting is called a verdaille.

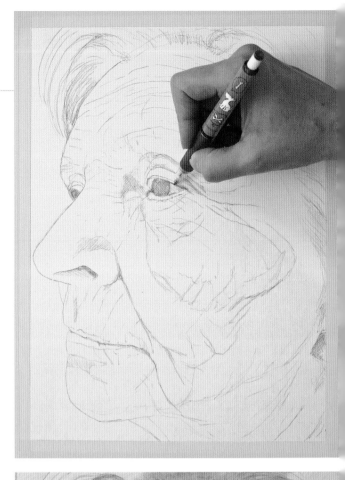

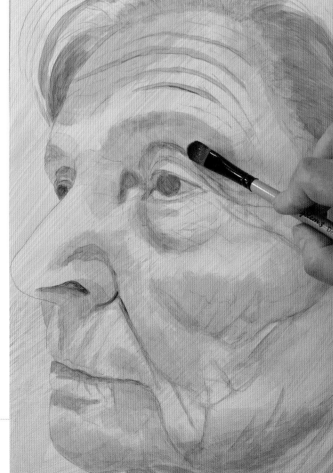

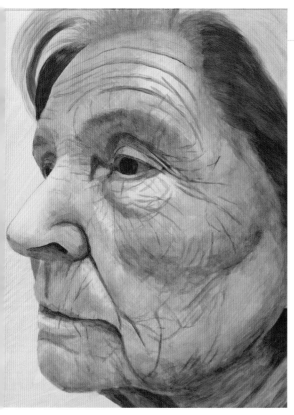

3 Using the same brush, add glazes of Burnt Umber to the darkest areas, including the whites of the eyes. Use a #2 round brush to define the wrinkles in the skin. Prepare the base skin color. Add gloss medium and use the #10 filbert to apply the first layer of skin tone.

4 Use a #2 round brush to depict the hair, changing colors between strokes using Pale Umber, Phthalo Green, Raw Sienna, Yellow Oxide and Titanium White. The strokes should be light, not blended, and always in the direction of hair growth.

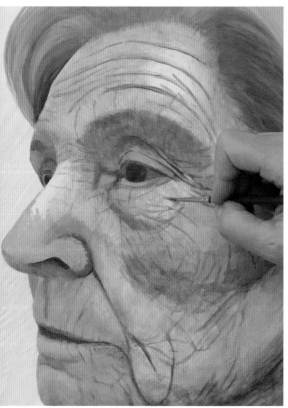

5 Apply the second layer of skin color, using a #2 round brush and blending the base skin color with Prism Violet for the darker areas of the skin, and with Light Magenta for the lighter areas. Apply loose brush strokes between the darks of the wrinkles, not covering the underpainting completely.

6 Add some strokes of base skin color into the hairline where the roots are visible. The face is now loosely painted with the flesh tones and looks a bit more realistic, despite the greens and violets. It is still too pallid and needs warming up.

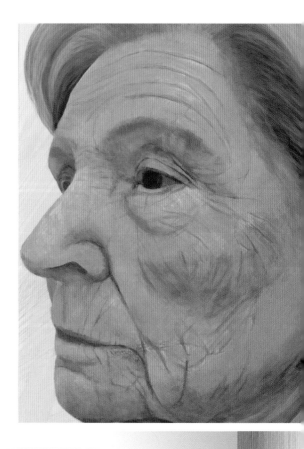

Portraiture: Skin continues over the page →

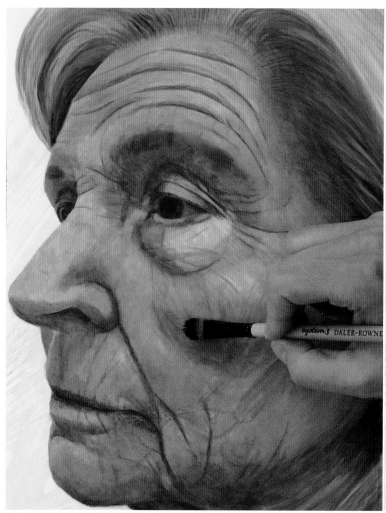

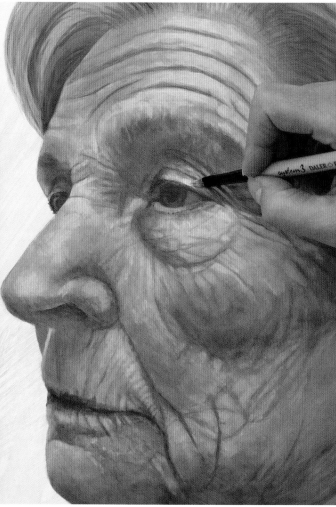

7 Reinforce the facial lines once more with a #2 round and Burnt Umber. Add the roots of the hair line, making sure your brush strokes follow the direction of the hair growth. Warm up the skin with Burnt Sienna mixed with gloss medium. Use a #10 filbert to quickly glaze the darker areas, adding additional layers underneath the nose and jawline, the brow, the forehead and temple. Use Naphthol Crimson with gloss medium to glaze the lips and cheek.

8 The color used in the fourth and final layer is Light Violet— a blend of Dioxazine Purple, Phthalo Blue and Titanium White. Using a filbert #4, lightly pat this color in between the darker areas to depict highlights in the skin. Also add it very lightly to the iris, to achieve a subtle faraway gaze.

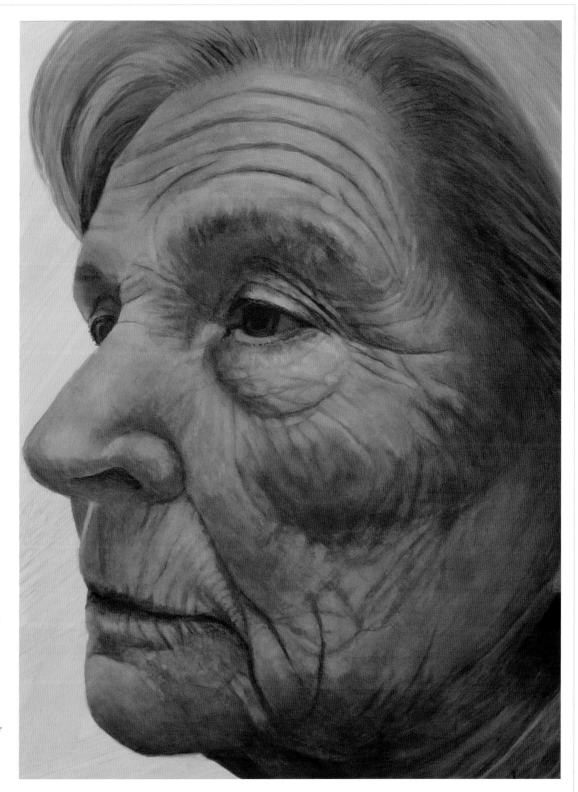

JENNY
BY LORENA KLOOSTERBOER
14 x 11 inch (35 x 28 cm)
Remove the masking tape to
reveal a crisp edge on the white
border of the portrait. The skin
in the finished painting looks
vibrant, alive and interesting.
It takes time and practice to
assess how color shift and paint
sinking in affect the end result,
but the beauty of painting in
acrylics is that you can continue
layering glazes until you are
satisfied with the outcome.

Portraiture: Skin continues over the page ⟶

TECHNIQUE FILE 54

PAINTING SKIN: HANDS

Painting wrinkled skin can be an incredibly challenging undertaking. Dramatic light will create high contrast between the bright peaks and dark recesses of the wrinkled skin. Building up thin layers of color will create luminosity as well as give you a chance to make subtle corrections to the painting as you progress.

You will need
- Primed canvas, approx. 12 x 16 inches (30 x 40 cm)
- Water or acrylic medium

Brushes
- Round #8

Palette
- Burnt Sienna
- Cadmium Red Light
- Cadmium Red Medium
- Mars Black
- Titanium White
- Ultramarine Blue
- Unbleached Titanium
- Yellow Ocher

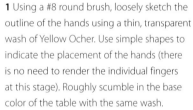

1 Using a #8 round brush, loosely sketch the outline of the hands using a thin, transparent wash of Yellow Ocher. Use simple shapes to indicate the placement of the hands (there is no need to render the individual fingers at this stage). Roughly scumble in the base color of the table with the same wash.

2 Once you are satisfied with the placement of the hands in the preliminary sketch, use Burnt Sienna to establish stronger, darker outlines. This will help to further develop the form of the hands. Continue developing the shape and shadows in the hands with Burnt Sienna. Use full-strength Burnt Sienna to make your darkest darks.

3 Mix Ultramarine Blue with Burnt Sienna to make a very dark brown. Use this color to define the darkest areas of the painting (interior of the sleeves, creases between fingers). These lines will serve as a guide to the placement of the darks as you begin to add layers in the subsequent steps.

4 Allow the paint to dry. Glaze over the hands with a thin, transparent layer of Unbleached Titanium. This will unify the colors and give you an initial indication of the skin tone.

5 Add a very small amount of Cadmium Red Medium to Unbleached Titanium and use this color in the pink/peach areas of the hands. This will add some variety to the flesh tones and give them warmth.

6 Now paint the shadows and wrinkles using a mixture of Burnt Sienna and Unbleached Titanium. You can mix many shades of the flesh tone by varying the amounts of these two colors.

7 Continue adding details to the hands, knife and apple and indicate a cast shadow on the tabletop. For dark colors, mix combinations of Burnt Sienna, Ultramarine Blue and Unbleached Titanium. For light colors, mix combinations of Unbleached Titanium, Cadmium Red Light and Burnt Sienna. Begin to define the apple with Cadmium Red Medium.

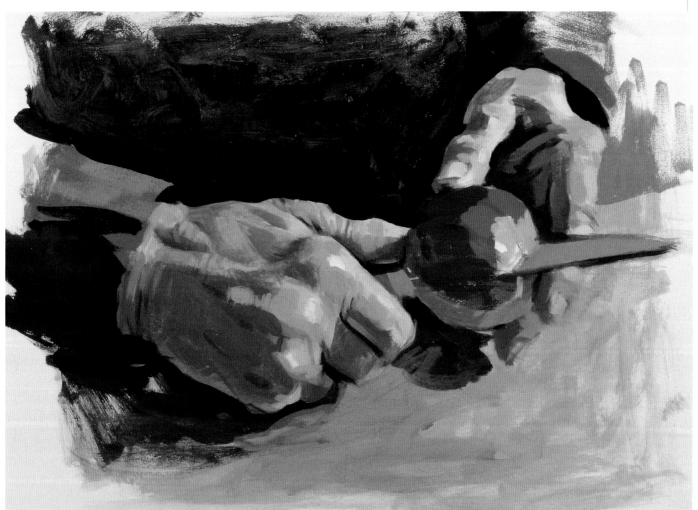

HANDS
BY MARK DANIEL NELSON
12 x 16 inch (30 x 40 cm)

By building up multiple thin layers of acrylic paint, you can create luminosity and sharp detail that is not possible using direct painting methods.

Portraiture continues over the page ⟶

Hair color and hairstyles in portraits not only identify cultural and historical periods, but also suggest gender, age, health, social status, ethnic ancestry and sometimes even religious beliefs.

PORTRAITURE: HAIR

Hair is a dynamic, flexible mass composed of many tresses, curls or wisps of hair strands. Hair itself has no fixed anatomy, as its growth pattern, structure, length and weight dictate how it falls and reflects light. Well-painted hair enhances a portrait significantly.

Hair should be painted in the same style and level of complexity as the rest of the portrait. A common mistake is to paint highly detailed hair (including eyebrows and eyelashes) when other features in the portrait are less defined. Except for the ultra-realistic close-up, hair should be depicted as an impression, a suggestion of locks with highlights that evoke reality.

Look at hair as an abstracted arrangement of shapes and values. Once again, the motto "paint what you see, not what you know" applies: when

Characteristics of hair

• Observe hair structure—both straight and curly hair can be subdivided into different categories.

• Straight hair can range from thick and full, to flaccid and limp.

• Curly hair can range from tightly packed mop, to frizzy halo, to loosely spiraling ringlets.

• Close-cropped hair and facial and body hair all have specific textures. Deconstruct by comparing them to other familiar textures. For example, a crew cut can look like shiny velvet.

observing your subject from a certain distance you know the hair is made out of numerous single hairs, but what you see are the shapes of the locks and tresses.

Blocking in the background and the portrait first makes it easier to assess hair color and values. It also avoids having to paint around the hair later.

Hair is best painted from dark to light—start with flat areas, build up detail and finish with highlights. Block in shapes in the darkest values to establish the undertones. All hair, even the lightest blond, has a dark underground.

Once the darkest undertones are in place, loosely paint the forms that suggest the movement, direction and flow of the locks using a range of mid-tone values. Brush strokes should follow the direction of the movement.

Finally, use a finer brush to paint the highlights in the lightest values following the direction of hair flow.

Glazing an underpainting can significantly improve realistic hair by separating color from value and form. (See pages 162–165 for grisaille and 166–169 for glazing.)

To make it easier to paint hair that doesn't cover skin uniformly, paint the skin into or over the hairline—this includes forehead, temples and the line where hair is parted. Likewise, paint

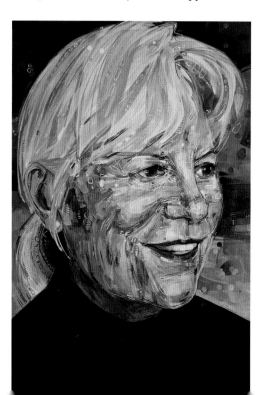

LYNN

BY GWENN SEEMEL

36 x 24 inch (91 x 61 cm)
This portrait is composed of many layers of quirky shapes and spontaneous marks in vivid colors and subtle values that dramatically come together to form the recognizable tessellated texture of white hair.

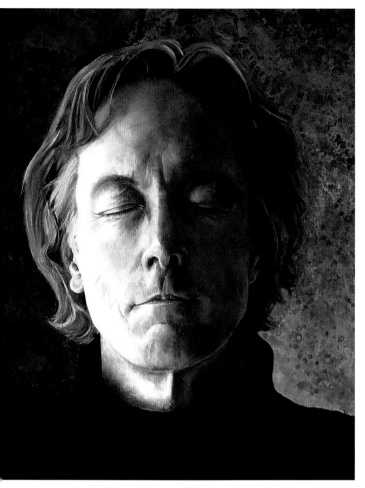

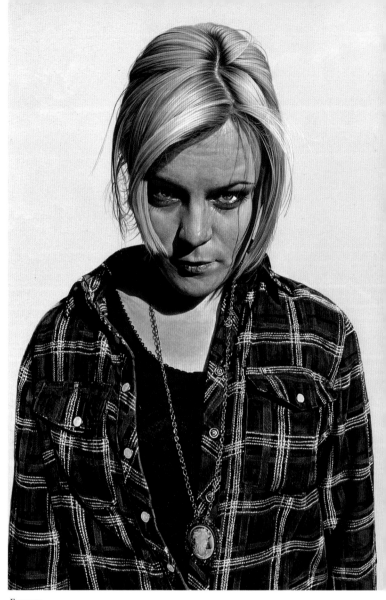

Allan Gordon Bell: Composer—Listening
by Laara Cassells
29 x 23 inch (74 x 58 cm)
This portrait marries chiaroscuro with a
contemporary abstracted background. The
distinguished "salt-and-pepper" hair plays a
crucial role in making this painting a success.

Frankie
by Steve Caldwell
40 x 30 inch (101 x 76 cm)
A well-chosen array of both warm and cool colors was used
to expertly depict sleek blond hair in a detailed, confident
manner that reinforces and beautifies the entire portrait.

skin underneath eyebrows or facial hair first.
Include loose strands escaping the hairstyle for a
more natural look.

Eyebrows and lashes (without make-up) are
usually the same color as the hair. Paint eyebrows
and lashes subtly—suggest them. Avoid heavy
definition unless it's a detailed close-up.

Natural hair colors
Natural hair colors range from the darkest black to the brightest white.

Black hair can tend toward warm brown or purple, or toward cool blue.	Brown hair can range from a cool raw umber to a warm burnt umber, with earthy yellow or red undertones.	Red hair can be dark chestnut, auburn, burnt orange or intense copper.	Blond hair from dark gold, to warm strawberry blond to a light platinum. Pale blond hair often has cool green undertones.	Gray and white hair ranges anywhere between a warm "salt and pepper" to a very cool, reflective white.

Portraiture: Hair continues over the page ⟶

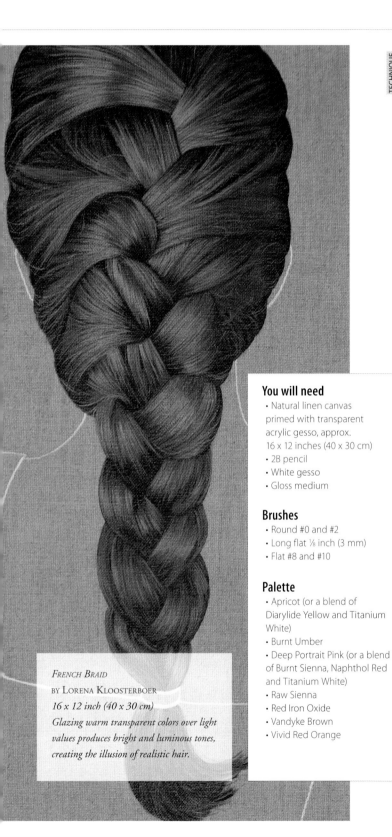

TECHNIQUE FILE 55

PAINTING HAIR: BRAID

Build up this French braid of luscious auburn hair by layering opaque and transparent acrylic paint, always brushing in the direction of the hair flow.

1 Make a quick sketch in pencil, and then cover the hair area with one or two layers of white gesso. Cover the pencil lines of the silhouette with white gesso using a #0 round brush. Once the gesso is dry, roughly sketch in the movement of the hair forming the French braid.

You will need

- Natural linen canvas primed with transparent acrylic gesso, approx. 16 x 12 inches (40 x 30 cm)
- 2B pencil
- White gesso
- Gloss medium

Brushes

- Round #0 and #2
- Long flat ⅛ inch (3 mm)
- Flat #8 and #10

Palette

- Apricot (or a blend of Diarylide Yellow and Titanium White)
- Burnt Umber
- Deep Portrait Pink (or a blend of Burnt Sienna, Naphthol Red and Titanium White)
- Raw Sienna
- Red Iron Oxide
- Vandyke Brown
- Vivid Red Orange

FRENCH BRAID
BY LORENA KLOOSTERBOER
16 x 12 inch (40 x 30 cm)
Glazing warm transparent colors over light values produces bright and luminous tones, creating the illusion of realistic hair.

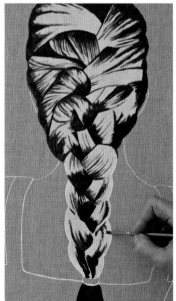
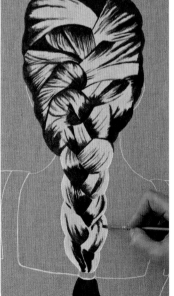

2 Use a long flat ⅛-inch (3-mm) wide brush to paint the darkest areas with pure Vandyke Brown.

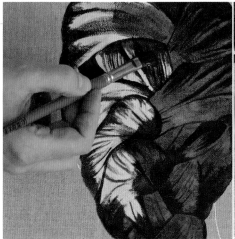 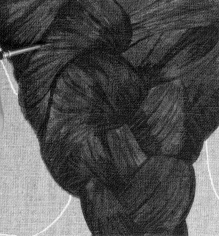 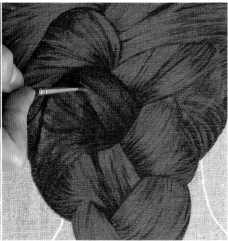

3 Blend a transparent glaze of Burnt Umber with gloss medium and apply it to the entire hair mass with a #8 flat brush.

4 Using a #2 round brush, apply undiluted Red Iron Oxide randomly in the direction of hair growth to liven up the flat browns.

5 Using the same brush, apply undiluted Raw Sienna to areas of mid-tone to light values. Also add a few stray hairs.

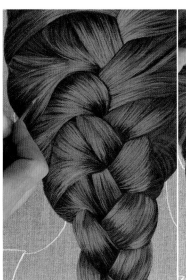 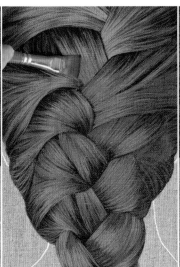 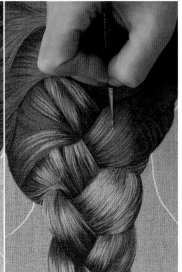 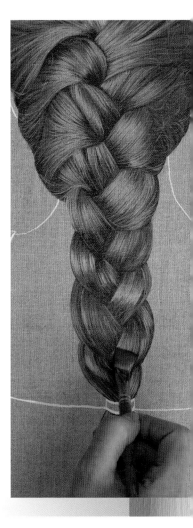

6 Start refining the lighter areas with a #0 round brush using Deep Portrait Pink (or a blend of Burnt Sienna, Naphthol Red and Titanium White). To ease continuous smooth brush strokes, add a bit of gloss medium to the color. Paint the thin lines in the direction of the hair.

7 To warm up the previous layer of mid-tone highlights, blend Vivid Red Orange with gloss medium. Use a #10 flat brush to glaze this transparent color covering all the hair.

8 For the final highlights, use a #0 round brush, applying Apricot (or a blend of Diarylide Yellow and Titanium White) in thin lines on the lightest areas. Do not cover evenly, but add random, short strokes in the direction of the hair. Also add a few stray hairs.

9 Repeat the above glazing process: Blend Vivid Red Orange with gloss medium and glaze the entire head of hair using a #10 flat brush.

The earliest animal paintings are found in prehistoric caves. Today animals continue to be a favorite subject and inspire artists around the world.

ANIMALS

The theme of painting animals has developed over time whereby today several distinct categories exist. Yet many of these artists cannot be labeled into just one category as many render different animals, jumping between breeds and species, or combining several in one painting.

Genres in animal art
Wildlife artists depict a variety of animals in their natural habitats, many advocating environmental conservation by showing the magnificent but fragile beauty of the natural world around us. Equine artists specialize in portraits of horses. Some artists exclusively paint farm animals and livestock; others focus on sea life, reptiles or insects. Pet portrait artists paint cats, dogs or other domestic companions, often on commission. Bird painters specialize in all sorts of feathered species. Paintings of anthropomorphized animals—dressed up and humanized—portray animals as humorous characters. Artists in the fantasy genre often create fantastic beasts or mystical, mythical or folkloric creatures, such as mermaids, dragons or griffins.

Animal painting often goes hand in hand with other genres, as animals are depicted in a variety of different settings. Wildlife artists are usually also accomplished landscape painters. Other artists combine animal painting with still life or human portraiture.

Depicting animals as emotional, conscious beings helps to portray them in a touching and expressive manner and indicates the close relationship between humans and animals. The sheer variety in beauty, appearance, textures and colors make animals an endless source of inspiration.

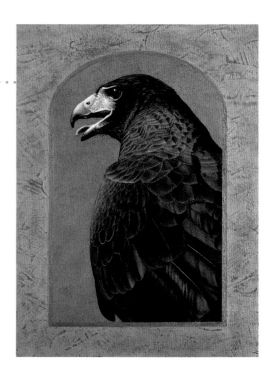

LEADER OF THE PACK
BY SANDRA BLAIR
12 x 9 inch (30 x 23 cm)
A portrait of a Harris's Hawk with exquisite plumage, featuring delicate colors and intricate patterns suggesting subtle iridescent feathers.

Studying your animal subject is key to understanding anatomy and surface textures. Besides examining high-resolution photographs, personal interaction with animals, visits to zoos and aviaries, even taking a safari, allow for close observation. You need to become intimately familiar with the animal in order to paint it successfully, capturing not only its shape and texture, but its essence as well. There are numerous excellent books, DVDs and workshops specializing in painting animals.

The amazing variety of fauna found on earth makes it impossible to cover all aspects of animal painting in the following few pages. The focus will be on painting fur and feathers, inevitably resulting in the exclusion of other beautiful fauna such as fish, sea life, reptiles, amphibians, insects and other invertebrates.

FRANSMAN II
BY JANTINA PEPERKAMP
9½ x 15¾ inch (24 x 40 cm)
*The fur and facial features
of this French bulldog are
exquisitely depicted. The
downward viewing angle gives
this pet portrait a stirring,
contemporary look.*

DANGEROUS GAZE
BY DRU BLAIR
15 x 22 inch (38 x 56 cm)
*The superb portrayal of the light
and shadows cast upon realistic
fur and eyes, skillfully juxtaposed
with a blurry background, bring
this magnificent beast to life.*

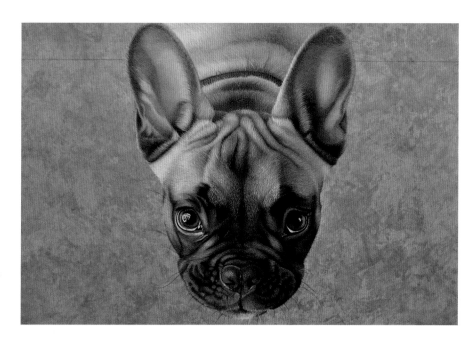

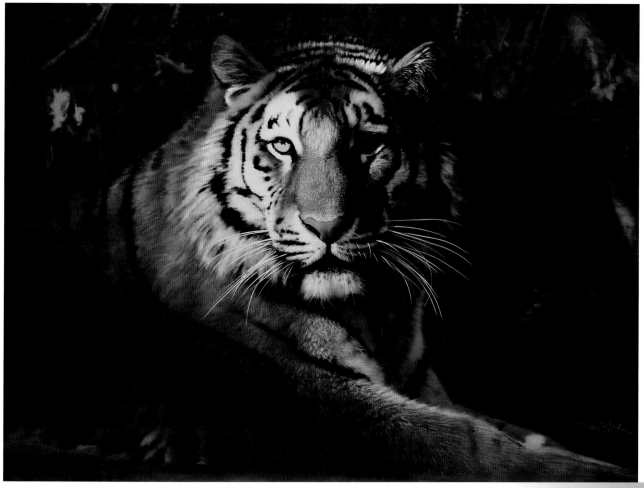

Animals continues over the page →

Fur is one of three characteristic features shared by 5,000 species of mammals. Hair and fur have evolved into many different textures and colors, performing a variety of functions.

ANIMALS: FUR

Functions of fur include appearance (camouflage, social information and warning), insulation and protection (against climatic conditions and dangers) and sensory purposes (whiskers to perceive immediate surroundings).

Many animals have an undercoat of a different (usually darker) color, and some have dark skin that affects the visual nature of their coat. Some animal hairs are dark with light tips, or vice versa, and some furs are spotted or striped. Moreover, most mammals have long wiry whiskers, as well as long hairs sprouting from the "eyebrow" area

Dr PinkNose
BY GWENN SEEMEL
8 x 8 inch (20 x 20 cm)
This creative white cat portrait is composed of many layers of little abstract shapes in vivid colors and intense values, cleverly giving the fur its direction and the animal its shape.

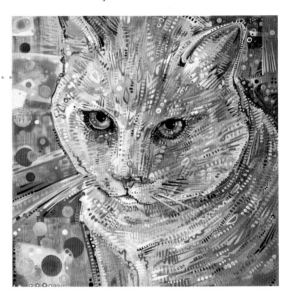

The Night Watch
BY SANDRA BLAIR
8 x 10 inch (20 x 25 cm)
Moonlight shapes the character of cool and warm colors of the wolf's highly realistic fur, while skillfully implemented value changes create the illusion of the fur's direction and length.

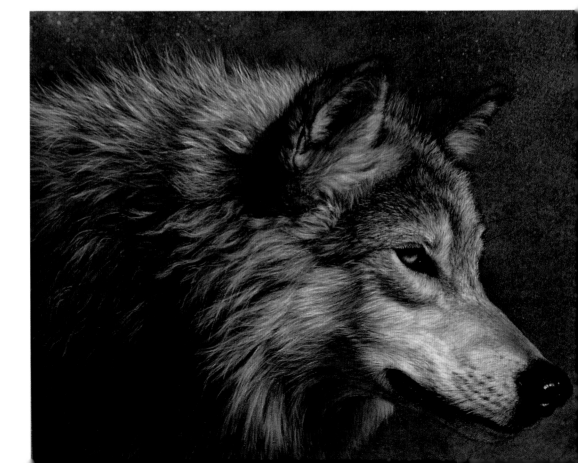

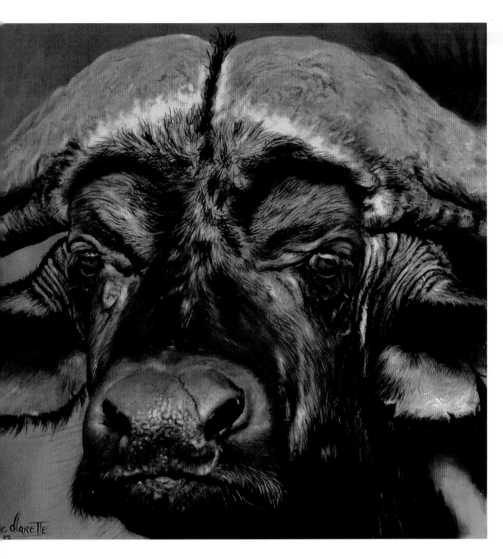

- Look at animal fur as an abstracted arrangement of shapes and values.

- Observe the hair structure and texture: fur can be silky and shiny, thick and opaque, spiky, coarse or curly, uniform or clumped together.

- With short hair, pay attention to the direction of hair growth. With long hair, pay attention to the shape and volume in which hair flows and falls. Adapt the length of your brush strokes to the length of the hair.

- Fur is layered—paint it bottom up, overlapping the lower fur.

- Facial fur fans up and outward from the nose, deviating around the eyes and ears.

- Adding shadows to fur will help define the skeletal structure underneath.

- Avoid using pure white for highlights—blend pale pastels instead.

- A studio-mixed black looks more natural. For example, blend Burnt Umber and Ultramarine Blue. Add more Burnt Umber for a warm black; add more Ultramarine Blue for a cool black.

- Use worn-out brushes, especially battered stiff bristles, to paint fluffy or tangled hair.

- Fur grows in specific directions on different parts of the animal. Note changes in values where fur parts or clumps together.

above the eyes and tufts of hair sticking out of the ears.

Due to the amazing variety in textures, we can easily distinguish between the short uniform hair of a cow hide, the medium-length fur of a mouse, the curly coat of a lamb, the silky coat of a Yorkshire terrier and the long mane of a lion.

The anatomy of an animal dictates how the coat wraps around its body. Observation is key to determine the patterns and directions in which hairs grow, especially in facial areas. It is imperative to gain a good understanding of how all these features interact to form the visual appearance of the animal.

Painting the background first will make it easier to assess color and values, and helps integrate the animal into its environment. Many artists then paint the eyes and nose of the animal first to help establish an emotional connection.

Painting fur, much like human hair, is best accomplished by painting it in layers to create

depth. Block in shapes in the darkest values to establish the undertones. All pelts have a dark base (even in white animals, such as polar bears, arctic foxes and white cats). Next, paint the forms that suggest the direction and flow of the fur using mid-tone values. Brush strokes should follow the direction of hair, maintaining a certain randomness to avoid a contrived look. Finally, paint the highlights and reflections in the lightest values following the direction of hair flow. Add whiskers and stray hairs, when applicable.

It is not necessary to paint each individual hair. Avoid heavy definition unless it's a detailed close-up. Leaving certain areas undefined sometimes enhances a sense of realism.

Glazing an underpainting can drastically simplify painting realistic fur. Glazing can also adjust existing colors and values. (See pages 166–169 for glazing.)

BUFFALO
BY ERIC MARETTE
20 x 20 inch (50 x 50 cm)
Exquisite cool blues and purples enrich the illusion of short fur, delicately contrasting the warmer colors found in the animal's eyes, ears and mouth.

Animals: Fur continues over the page ⟶

PAINTING FUR: MOUSE

When painting fur, highlights and shadows not only indicate the direction of the light source, but also help suggest the animal's three-dimensional body shape underneath the fur. Springy hair and whiskers are always painted last.

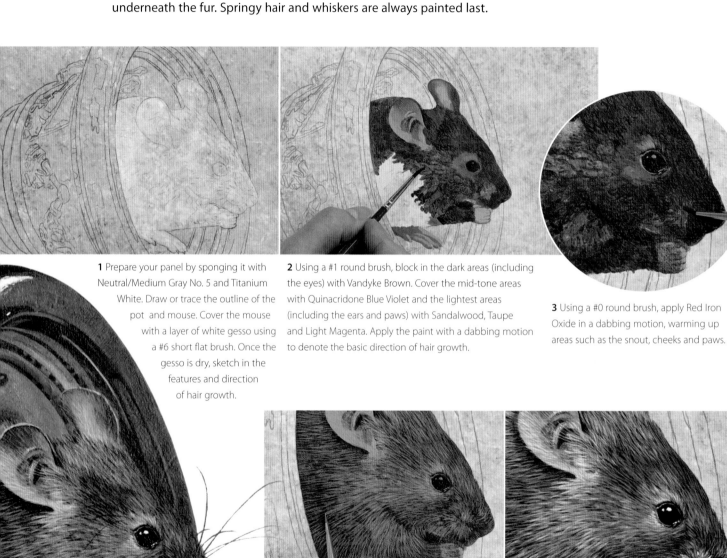

1 Prepare your panel by sponging it with Neutral/Medium Gray No. 5 and Titanium White. Draw or trace the outline of the pot and mouse. Cover the mouse with a layer of white gesso using a #6 short flat brush. Once the gesso is dry, sketch in the features and direction of hair growth.

2 Using a #1 round brush, block in the dark areas (including the eyes) with Vandyke Brown. Cover the mid-tone areas with Quinacridone Blue Violet and the lightest areas (including the ears and paws) with Sandalwood, Taupe and Light Magenta. Apply the paint with a dabbing motion to denote the basic direction of hair growth.

3 Using a #0 round brush, apply Red Iron Oxide in a dabbing motion, warming up areas such as the snout, cheeks and paws.

4 With the same thin brush, cover the furry parts with short strokes of Naples Yellow. Add a little bit of gloss medium to extend brush strokes. Follow the natural direction and pattern of the animal's hair growth—and don't forget the ears.

5 Repeat the previous hair layering process, applying Titanium White to areas where the fur is highlighted. Add white to highlights in the eyes and paws. The Titanium White looks too bright while wet, but once it dries it will sink into the previous paint layer and tone down.

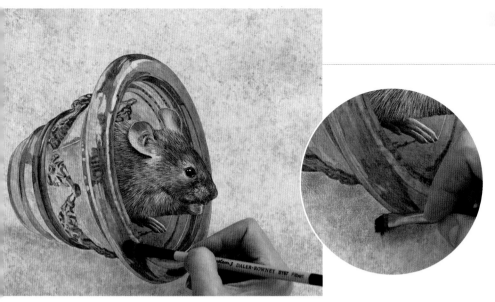

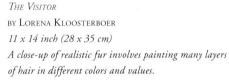

6 The mouse is now finished, but its contours have a harsh, unnatural delineation. Paint the surrounding background to be able to later integrate the mouse. Paint the blue pot in glazes of Ultramarine Blue blended with gloss medium, using a #3 filbert. Add the dark values, using Payne's Gray and a #2 round brush.

7 Use a #6 short flat to dry-brush the translucent shadows underneath the receptacle with Payne's Gray and Ultramarine Blue. Layer a glaze of Cerulean Blue diluted with gloss medium over the pot to intensify the blues, and scumble the same color into the shadow area below the pot.

THE VISITOR
BY LORENA KLOOSTERBOER
11 x 14 inch (28 x 35 cm)
A close-up of realistic fur involves painting many layers of hair in different colors and values.

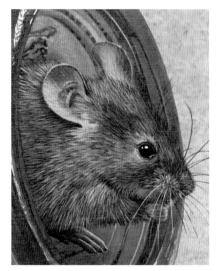

8 Using a #1 round brush and Titanium White, add highlights in the glass. With the smallest round brush and the colors previously used for the fur, add hairs around the silhouette of the mouse, so that they overlap the background. Finally add the whiskers and brow hairs, using Vandyke Brown for hairs overlapping the light background and Titanium White tinged with Naples Yellow for the hairs overlapping the dark background.

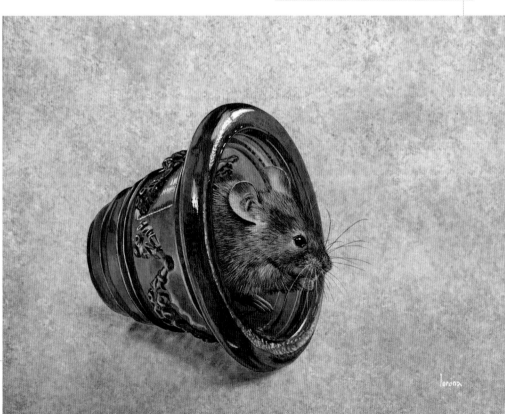

Throughout history birds have been valued by humans for their beautiful plumage. Birds and feathers, whether exotic or ordinary, are an exciting subject to portray.

ANIMALS: FEATHERS

Bird and wildlife artists share an interest in painting birds and feathers with portrait, landscape and still life artists. Feathers can be decorative (an ostrich plume fan), utilitarian (a writing quill) or symbolic (the dove of peace). Portrait artists paint pet songbirds and parrots alongside their subjects, while landscape artists include poultry and waterfowl in landscapes.

The plumage of tropical birds, such as parrots and hummingbirds, is incredibly colorful, but even seemingly plain birds, such as crows, exhibit beautiful iridescent highlights. Likewise, intricate feather patterns can be found on common birds such as house sparrows, ducks and pheasants.

Paint the background first to make it easier to assess color and values, and to help integrate the plumage into its environment. Fill the outline of the bird with relevant shapes suggesting the direction and flow of feathers. Feathers are best painted from dark to light. Start with dark value areas, then build up more detail in mid values, and finish with highlights in the lightest colors. Instead of painting each individual feather in meticulous detail, try to suggest it with shadows. Avoid heavy definition, unless it's a detailed close-up.

Sonny Boy
by Barbara Banthien
18 x 12½ inch (46 x 32 cm)
The intricate portrayal of this rooster's plumage is exquisitely rendered in bright colors and bold patterns. The contrasting colors of the grass cleverly echo the shapes of the feathers.

Make your brush strokes follow the direction of the feathers, maintaining a certain randomness to avoid a contrived "scaly" look. Avoid repetitive-looking scalloped rows of overlapping feathers. Variation is key.

Pigeon Frenzy
by Marie Antoniou
16 x 39 inch (40 x 99 cm)
The frenzied nature and energetic movement of the feeding pigeons is rendered by bold, expressive strokes of harmonious colors, perfectly capturing the birds' shapes and plumage.

Painting iridescent feathers

Iridescence is an optical phenomenon that alters the appearance of color. It is seen on certain plumage, insects, sea shells and soap bubbles. Iridescent colors seem metallic, shimmery and reflective, and often have a rainbow quality.

There are several ways to paint iridescent textures:

• Pastel blends: Understated iridescence can be achieved by painting certain details in a pale pastel color. For example, painting a light pastel blue over the black feathers of a crow will suggest subtle iridescence.

• Glazes: Glazing is ideal for mimicking iridescence, because pure transparent colors are glazed over a lighter underground, creating jewel tones. Like highlights, iridescence is added as a final touch. Paint the iridescent area in pure white or a compatible pale pastel shade and let it dry. Blend a glaze using a transparent pigment color and carefully brush it over the light underground. You may need to glaze several layers to achieve the color depth you seek.

• Metallic and interference paint: Iridescence can also be accomplished by using metallic or interference acrylics, especially when applied over a darker underground. Use them sparingly to avoid a garish, artificial look. Metallic and interference colors can be applied undiluted, as glazes or can be blended with regular acrylics, toning down their sparkling quality.

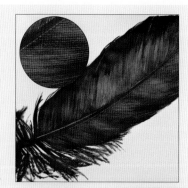

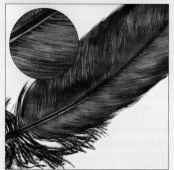

Characteristics of plumage

• Feathers can be seen as an accumulation of graphic shapes defined by colors and values.

• The two basic types of feathers are vaned feathers (defined, rigid) and down feathers (undefined, fluffy).

• Vaned feathers are formed by a stiff central shaft with vanes branching out on either side in a slanted outward direction.

• The wing, breast and tail feathers are organized and directional in structure, defining the shape of the bird.

• Color and patterns often vary between the upper and lower body, as well as between the sexes.

• Understanding the overall construction of a wing is essential to painting birds.

• Understanding the function of feathers (knowing whether they're for flight, insulation or courtship) will help you interpret their structure.

• Glazing an underpainting is an excellent method to paint realistic feathers.

HARVEST RAVEN
BY SHAWN GOULD
8 x 24 inch (46 x 61 cm)
In this superb portrayal of a raven, the cool blues, violets and greens perfectly convey the iridescence of the black plumage, beautifully contrasting the fresh greens and warm oranges of its surroundings.

→

TECHNIQUE FILE 57

PAINTING FEATHERS: PARROT

An easy way to paint realistic-looking feathers is to use a brush that is equal in size to the feathers you will be painting. Each stroke will represent a single feather—you simply need to mix the color for each set of feathers and apply the strokes.

You will need
- Primed canvas or panel, approx. 12 x 16 inch (30 x 40 cm)
- #2 graphite pencil (optional)
- Water or acrylic painting medium

Brushes
- Round #4 and #8
- Filbert #4

Palette
- Cadmium Red Medium
- Cadmium Yellow Light
- Cerulean Blue
- Mars Black
- Titanium White
- Unbleached Titanium
- Ultramarine Blue

3 Use a #4 round brush and a mixture of Cadmium Yellow Light and Cerulean Blue for the green feathers, and Cadmium Red Medium for the red feathers.

4 Indicate the features on the parrot's face and beak with Mars Black. Next, add a small amount of Titanium White to some Cerulean Blue and apply this color to the feathers just behind the green feathers.

5 Mix a little Cadmium Yellow Light with Cadmium Red Medium to paint lighter feathers over the red feathers, using a #4 round brush.

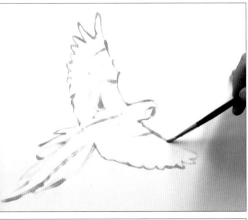

1 Using a #4 round brush, begin by sketching the outline of the bird with a thin mixture of Ultramarine Blue and Unbleached Titanium. You may find it helpful to draw your sketch with a pencil first.

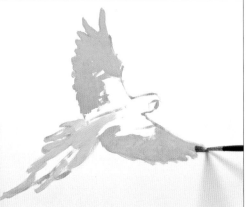

2 Fill in the light blue feathers with a mixture of Cerulean Blue and Titanium White, using a #4 round brush.

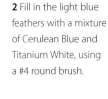

6 Darken the blue feathers at the base of the wing with a deeper blue mix of Ultramarine Blue, Unbleached Titanium and Cadmium Red Medium, varying the amount of red in the mix to create both cool and warm blues, so that you begin to create some depth in these large wing feathers by alternating between warm and cool colors. Apply these mixes with a #4 round brush.

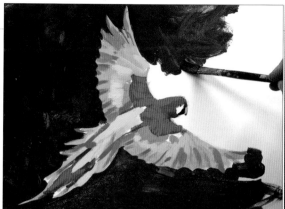
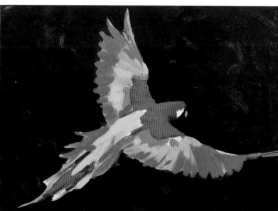

7 To make the dark green background color, mix Mars Black and Cadmium Yellow Light. Using a #4 filbert brush, outline the parrot and fill in the remaining background.

8 To complete the parrot's feathers, use a #8 round brush and a mixture of Ultramarine Blue and Titanium White. Paint any remaining feathers that need to cover the green background using a lighter touch. This will "feather" the strokes and add to the illusion.

Parrot
BY MARK DANIEL NELSON
*12 x 16 inch (30 x 40 cm)
Applying layers of individual feather-shaped brush strokes creates a believable illusion of plumage.*

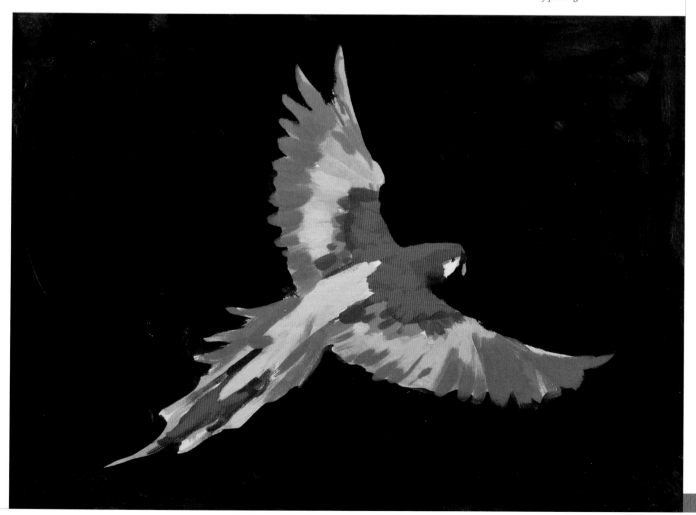

Landscape paintings express our creative desire to capture the world around us, showing natural and urban scenery in a variety of settings, styles and expressions.

LANDSCAPES

A landscape is a painting showing a view of any kind of scenery. Landscape paintings typically evoke images of natural settings, such as panoramic views of mountains, canyons, fields and forests. While landscape painting is an important genre in itself, it is also frequently used as a background setting in other genres, such as portraiture and wildlife painting.

Landscape genres
Over time landscape painting has diversified into many different subcategories.

Seascapes present views of oceans, seas and coastlines. Waterscapes and riverscapes depict scenes with fresh water, such as waterfalls, lakes, fishponds, swimming pools and rivers.

Cityscapes and townscapes show urban settings, such as high-rise buildings, villages and street views. Topographical views depict recognizable (usually urban) locations showing notable buildings such as palaces and cathedrals.

Cloudscapes and skyscapes focus on climatic elements in the skies, such as cloud formations and storms.

Aerial landscapes and cityscapes show panoramas from above, as observed from an airplane.

Hardscapes portray factories, warehouses and other industrial settings.

Inscapes present interiors (of buildings) as indoor landscapes, such as escalators inside a train station. Inscapes can also be abstract or surrealist representations of the artist's psyche, a view of the mind as a tangible space.

Moonscapes depict lunar scenes, including fantasy and science-fiction landscapes.

Expressions in landscape painting
Landscape paintings can be of real or imaginary places or a combination of the two. All acrylic painting techniques—from the watercolor method to alla prima, and from painting knife and impasto to spattering—lend themselves to landscape painting. Landscapes can be executed in numerous different styles, from detailed photorealism to conceptualized abstraction—and every approach in between.

Landscape painting lends itself particularly well to plein-air painting. Plein-air painting takes place outdoors, on location. Leaving the studio to paint outdoors appeals to many artists seeking a connection with nature or who enjoy the interaction with onlookers. Sometimes plein-air artists finish their painting in the studio, either from memory or guided by photographs taken on location.

HIGHPOINT GLARE
BY HANK BUFFINGTON
12 x 16 inch (30 x 40 cm)
This plein-air landscape captures
the atmospheric haze and the
sun's reflection in the water, and
skillfully creates perspective using
warm colors in the foreground
and cool colors for distance.

FULL ORANGE 5AM
BY JASON SACRAN
24 x 24 inch (61 x 61 cm)
This nocturnal landscape is
bathed in warm moonlight
glistening on the water. The
sprinkle of shimmering city lights
masterfully conveys perspective
receding into the distant horizon.

Guidelines for landscape painting

• Always consider multiple viewpoints and angles of a landscape—standing, sitting and squatting present three completely different looks of just one vista. Use a viewfinder to pinpoint a composition and decide on format.

• Changing seasons and climate conditions transform any setting, so the same landscape can be painted in different colors and expressions multiple times.

• Don't be a slave to accuracy. Sometimes repositioning, adding or subtracting certain elements makes a composition stronger.

• Incorporate a limited number of distinguishing elements to characterize your landscape. Including too many elements (i.e., everything you see) will look chaotic.

• Respect atmospheric distance and emphasize focal points. Avoid painting everything in similar detail; include out-of-focus areas.

• Respect the direction of light across all features in a landscape painting. Avoid inconsistencies in direction of cast shadows and highlights.

DUNES FENCE
BY CINDY WENTZELL
8 x 8 inch (20 x 20 cm)
This wonderful landscape was loosely painted
in vivid colors using dynamic brush strokes that
skillfully convey the breeze and sunny weather.

Landscapes continues over the page ⟶

Landscapes frequently include scenery with calm water, such as fishponds, swimming pools, canals, lakes and peaceful rivers. Still water is both reflective and translucent, often making it a daunting subject to paint.

LANDSCAPES: STILL WATER

We can differentiate between two kinds of calm water scenes: those that depict water as a reflective mirror of its surroundings, and those that portray transparent water that allows a view of what's beneath the surface. Sometimes a calm body of water, such as a pond, shows both qualities, in that one area is reflective (showing sky or trees) and another area transparent (showing the riverbed or fish).

Observing the water's surface to analyze abstract shapes and patterns is key, but is quite hard to do, because the eye tends to follow the changing movement. Photographs offer a static view and are ideal to study your subject. Turn reference photos upside down to examine shapes, colors and values. This will help you to paint what you see instead of what you know.

Ripples in water
Water is rarely completely motionless. Even when calm, its surface shows subtle ripples and undulations. Expressing this slight movement is fundamental to capturing the essence of water on a static canvas.

Ripples in water generate irregular abstract patterns that can be jagged, zigzagged, circular or curved. Identify and isolate these shapes and patterns before focusing on color. Water patterns are irregular. Resist the temptation to repeat them; break the rhythm.

Remember that perspective affects the size of these patterns—nearby shapes are bigger, distant shapes get smaller.

Start with a mid-tone value, and add lighter and darker colors to form shapes and outlines.

Resist overblending adjacent colors and values into each other. Water patterns are most often sharply delineated.

ROCKFISH AND WATER SKIPPER
BY GREGORY SIMMONS
24 x 30 inch (61 x 76 cm)
This fascinating perspective of looking straight down into the water without actually seeing the water's surface is masterfully created by the light and shadows of ripples, bubbles and a water skipper cast onto the river rocks.

ROCKS
BY ELIZABETH TYLER
59 x 43½ inch (150 x 110 cm)
The warm colors and rough, spattered texture of the rocks contrast with the smooth gradations of the cool blue water surface, deftly creating an illusion of transparency and movement.

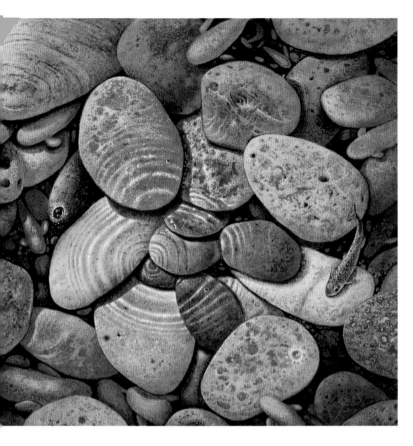

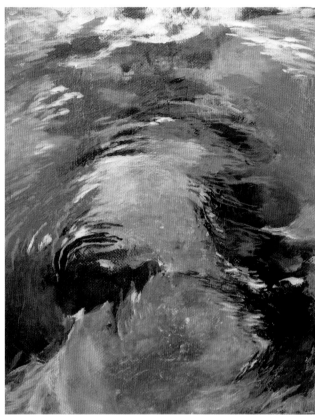

Reflective water

Depending on the viewing angle the water surface can become like a mirror. Water can reflect sky and boats, as well as trees and buildings on the water's edge.

The reflections and shadows of floating objects such as water lilies, ducks or boats, reinforce the credibility of painted water. The same applies to objects sticking out of the water, such as reeds or mooring poles.

Mirror images are always inverted. Due to changed angles in perspective, however, reflections of objects near the water's edge are never exact reversed replicas.

The water's movement distorts reflections into bizarre shapes. Use these peculiar silhouettes to paint realistic water.

Transparent water

Certain angles allow us to see objects underneath the water surface, such as the bottom of a swimming pool, the fish in a koi pond or the pebbles on a riverbed. To depict submerged objects and the water surface simultaneously can be quite daunting, so deconstruction of shapes, values and colors is key.

Start by painting the submerged subject first, such as fish or pebbles. Focus on potential distortions in their form. Concentrate on values and forms. Pay particular attention to refraction: the water surface changes the direction of the contours of emerging objects.

Sky is often reflected in water, even when part of it is visually transparent. Paint this lighter area as a transparent veil, using a white or pastel glaze. This reflective area is often a gradual transition from clear to milky.

Use liquid frisket to protect surrounding areas—it facilitates glazing without having to worry about edges.

Transparent liquids always take on surrounding colors. Layer glazes in those colors over the water area in your painting.

Once the painted water surface is dry, adjust dark areas (such as shadows on the riverbed or reflections of trees).

RIPPLES #9

BY MELODY CLEARY

10 x 8 inch (25 x 20 cm)
Ethereal reflections of
the sky and the landscape
surrounding the water
are expertly portrayed in
graceful abstracted patterns
and shapes, suggesting
the rhythm of the flowing
water's surface.

Landscapes: Still Water continues over the page \longrightarrow

PAINTING STILL WATER: LEAVES

To depict realistic water the artist must sometimes look beyond the water's surface and paint reflections and floating objects such as leaves, boats or ducks instead.

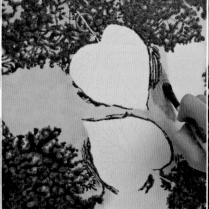

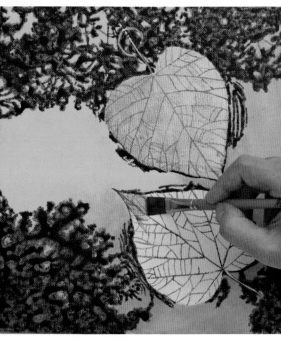

1 Using a 2B pencil, lightly sketch two leaves on a primed canvas. Using a #2 round brush, paint the imaginary reflections of tree silhouettes with Payne's Gray. Add darker spots here and there.

2 Prepare a transparent glaze by mixing Phthalo Blue and gloss medium. Using a #4 filbert, cover the entire surface. Avoiding the leaves, add a second layer and third layer of this blue glaze to intensify the color.

3 Using a #0 round brush and Burnt Umber, paint the veins of the leaves. Glaze the leaves with Burnt Umber mixed with gloss medium.

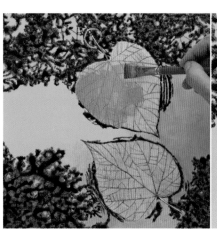

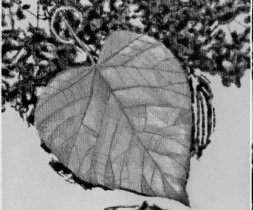

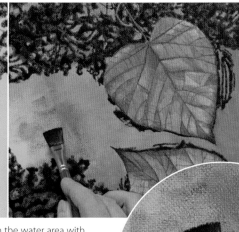

4 Cover the leaves in a thick glaze of Oxide Yellow and a bit of gloss medium, using a #10 short flat brush.

5 Using Quinacridone Rose and a #2 round brush, add details and shades to the leaf structure.

6 Darken the water area with a glaze of gloss medium and Payne's Gray, using the #10 short flat brush. Add several thin layers to dim the bright blue, feathering subtle value transitions. Nuances in value suggest the changing skies reflected in the water.

You will need
- Primed canvas, approx. 10 x 10 inches (25 x 25 cm)
- 2B pencil
- Gloss medium

Brushes
- Filbert #4
- Flat short #2 and #10
- Round #0 and #2

Palette
- Burnt Umber
- Hibiscus (or a blend of Naphthol Crimson, Arylide Yellow and Titanium White)
- Oxide Yellow
- Payne's Gray
- Phthalo Blue
- Quinacridone Rose
- Sap Green
- Titanium White
- Vivid Lime Green

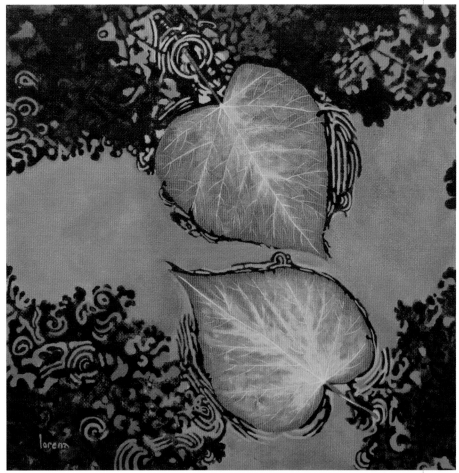

FALLEN LEAVES
BY LORENA KLOOSTERBOER
10 x 10 inch (25 x 25 cm)
Two floating leaves and the reflections of trees silhouetted against a dark sky create a convincing visual impression of still water.

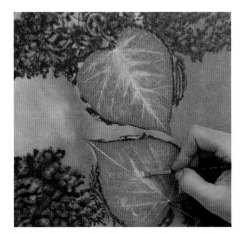

7 Changing your mind about color is not a problem when using acrylics. Here, different colors are layered over the previously painted earth-colored leaves, using Quinacridone Rose, Hibiscus, Sap Green and Vivid Lime Green.

8 Intensify the dark and light reflections of the trees and sky using a #2 round brush. Create graphic ripples using Payne's Gray and Phthalo Blue. A blend of Phthalo Blue with Titanium White brightens the water in areas surrounding the floating leaves.

Landscapes: Still Water continues over the page ⟶

PAINTING STILL WATER: BOAT

Masking the objects in the water (here, a boat) enables you to paint smooth gradations, representing the level surface of still water.

You will need
- Primed panel, approx. 8 x 10 inches (20 x 25 cm)
- 2B mechanical pencil
- Glazing medium
- Masking tape
- Toothbrush
- Gloss medium

Brushes
- Filbert #3 and #10
- Pointed round #0 and #2

Palette
- Lamp Black
- Cadmium Yellow
- Dioxazine Violet
- Naples Yellow
- Nickel Yellow Azo
- Permanent Light Blue
- Titanium White
- Transparent Red Oxide
- Turquoise Light Blue

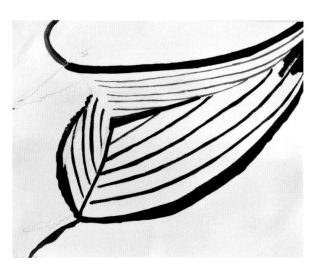

1 Using a mechanical pencil, lightly sketch in the boat and reflection. Your composition should be somewhat centered, but not static: the slight curves of the boat and reflection should meet a little off-center on the canvas. Add a dark outline with Lamp Black acrylic paint and let it dry.

2 Paint in the reflection with a mix of Turquoise Light Blue, Cadmium Yellow and Titanium White, darkening the value of the green toward the edge of the boat. Paint the darker shadow in upper left of the canvas with a mix of Turquoise Light Blue and Dioxazine Violet. After the underpainting is dry, paint the boat in a light wash of Nickel Yellow Azo. While it is drying, spritz with a water bottle and let it drip.

3 Be sure that everything is dry before proceeding. Add glazing medium to a wash of Transparent Red Oxide. Using horizontal brush strokes, paint loosely over the boat and its reflection. While the wash is drying, spritz it with clear water from a water bottle, allowing the water to drip down and create texture. At the top of boat, soften the edges with a filbert #3 brush to flatten the texture on the boat's interior. Leave to dry.

4 Cover the reflection with masking tape, then seal the edges of the tape and the contour of the boat with gloss medium so that no water can seep underneath.

5 Using a filbert #10 brush and varying mixes of Titanium White, Naples Yellow and Permanent Light Blue, paint the water, gradating from white to yellow, to green, to blue. The transition of the color should be soft and atmospheric. The water will be light in value at the top, gradating down to deep blue at the bottom.

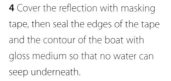

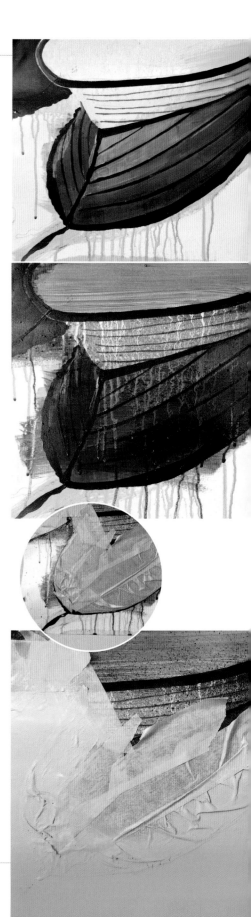

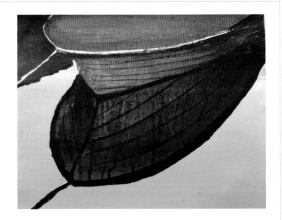

6 When the paint is completely dry, remove the masking tape. Now paint in the rim of the boat and the mooring rope over the shadow, using Titanium White. Using a toothbrush and Transparent Red Oxide, spatter paint over the boat to create a darker tone and add texture and visual interest.

Moored Boat
by Carol Carter
8 x 10 inch (20 x 25 cm)

A dark shadow is cast on the light, still water, creating a bright and striking composition.

Anchored
by Elizabeth Tyler
38 x 13 inch (97 x 33 cm)
The change in the water's depth is beautifully suggested by the illusion of transparency at the bottom of this waterscape, which gradually changes into an opaque surface reflecting sky toward the top of the painting. The dark translucent shadows underneath the boat also skillfully illustrate the water's depth and volume by the stones depicted underneath. The anchor protruding from the water's edge adds to the dramatic sense of perspective.

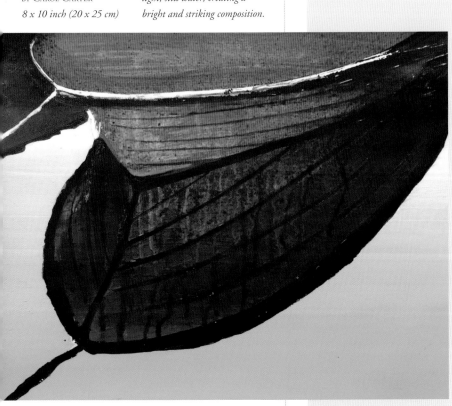

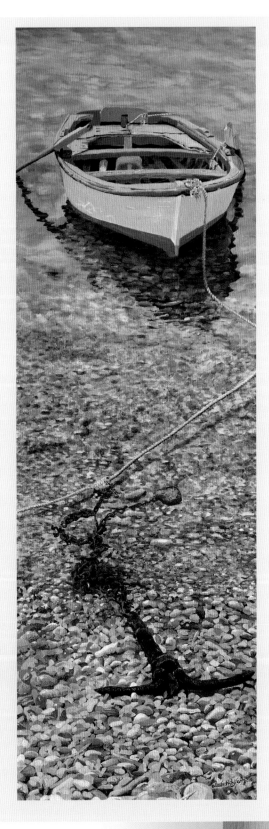

Landscapes continues over the page →

Moving water constantly changes form and color, yet curiously its movement is somewhat predictable—it has a certain rhythmic essence that can be captured and expressed in paint.

VITAMIN WATER
BY ASHTON HOWARD
30 x 30 inch (76 x 76 cm)
This impressive rolling wave has been expertly painted using primary colors forming marbleized patterns and elegant, energetic shapes.

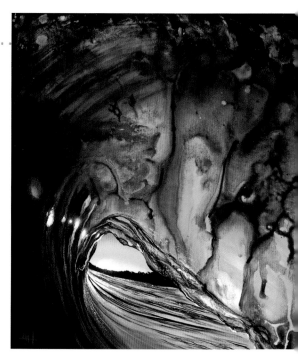

LANDSCAPES: TURBULENT WATER

Moving water comes in many forms, from manmade constructions such as fountains to natural phenomena such as the crashing waves of the sea. Each presents its own artistic challenges.

Waterfalls and fountains
Paintings of waterfalls and fountains often look contrived because they're painted as an unvarying cascade of water. Identifying the most important visual elements, such as splashing droplets, color patterns or variations in texture, helps to conceive and plan the painting process.

The constant torrent looks both continuous as well as fragmented. Close observation shows that water looks homogenous at the origin, and then becomes increasingly fragmented during its freefall, disintegrating into a multitude of droplets. This gradual transition is composed

OUTPOURING, HORSESHOE FALLS
BY RICK DELANTY
36 x 48 inch (91 x 122 cm)
The fluid motion, savage beauty and humid atmosphere of this waterfall were masterfully depicted using oil painting techniques reminiscent of the great plein-air painters.

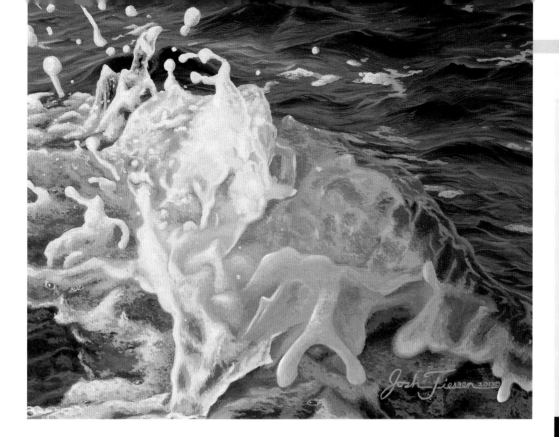

Photographing water

Few artists know moving water so intimately that they can paint it realistically from memory. The rest of us need to paint on location or use reference photos. There are several ways to photograph moving water. Take lots of photos at different shutter speeds to build a personal reference library.

• Digital cameras on automatic settings will snap an image with fast shutter speed (about 1/250 of a second), instantly freezing action. This results in a highly detailed image (see below). While this (over)abundance of visual information is ideal for the hyperrealist artist, it can be daunting for artists painting in looser styles.

• Adjusting the camera to a slower shutter speed (try ⅟₃₀, ⅟₁₅ and ⅛ of a second) will give a longer exposure, considerably blurring the water movement and reducing visual information (see above). This is helpful to conceptualize and paint an impressionistic appearance of motion. Slower shutter speeds need stability. Use a tripod or place the camera on a fence or ledge. Use the self-timer for added stability.

of repeating shapes and patterns, more easily observed in photographs than by the naked eye.

To achieve a credible portrayal, set aside your preconceptions of what falling water looks like—focus on forms and configurations and paint what you see!

Seascapes

The beauty of the ocean lies in its ever-changing appearance and temperament. It can be eerily calm or wildly tempestuous. Depending on weather and location, colors vary from intense turquoises and vivid greens to misty grays and darkest blues.

Sea foam is created by breaking waves aerating the water. It has an irregular, open, interconnected web-like pattern that enhances the impression of movement and volume in a painting. It also indicates the direction of waves or currents, and adds perspective and distance.

Studying the flow of surging water provides an understanding of how shapes, patterns and values create its surface. Print your photo reference and draw lines with arrows, showing the direction of flowing water. Note that waves have multiple curved lines traveling in different directions. These lines also suggest the direction your brush strokes should follow.

Ocean's Emotion
By Josh Tiessen
6½ x 8 inch (16 x 20 cm)
This choppy water, depicted in a monochromatic palette, has an almost pliable quality that hints at volume through shapes and values.

Waves

We are all familiar with views of the recurring, perpetual motion of waves rolling or crashing into the shore. Yet to be able to paint them realistically, keen observation of their abstracted shapes is key.

The volume of a wave is expressed in values—lights and darks. A wave has a three-dimensional form that casts a shadow. Light values are found in sea foam, spray and reflections. Start with mid-tone values, then paint the shadows in dark tones and highlights in light tones. Brush strokes should follow the movement of water for an organic result. Once you have the basic look of waves, add saturated colors to emphasize the translucency of water where the waves lift and stretch, and darker hues where the water is deep. Misty sprays can be spattered or stippled by brush. Create perspective and depth by foreshortening the abstract patterns of foam, shadows and reflections.

PAINTING TURBULENT WATER: WATERFALL

The key to painting moving water is not to overpaint.
Think simple, simple, simple!

1 Tone the whole canvas with Burnt Sienna. Using a mixture of Ivory Black, Cadmium Red, Viridian Green and Ultramarine Blue and a small flat brush, sketch out the lines of the composition, looking for the largest and most important shapes.

2 Begin blocking in the colors, establishing the general hue and temperature but not worrying too much about the exact tone or trying to make the shapes look three-dimensional. Use mixtures of Alizarin Crimson, Ivory Black, Viridian Green and Burnt Sienna for the darker sections and Burnt Sienna, Cadmium Orange, Cadmium Yellow and Ultramarine Blue in the lighter sections; apply with a medium flat brush.

3 Now start refining the form of the shapes by building up light and dark tones. In order to maintain a visual unity, use varying mixtures of the following colors across the canvas: Viridian Green, Ultramarine Blue, Ivory Black and Titanium White with a gray mix made from Cadmium Orange, Cadmium Yellow, Cadmium Red, Alizarin Crimson, Cerulean Blue, Viridian Green, Ivory Black and Titanium White.

4 To create the blues of the water in the mid-ground, the splash of the waterfall and the top of the waterfall, use a mix of Cerulean Blue, Viridian Green, Ultramarine Blue and Titanium White.

5 Continue to refine the shapes and masses. Begin to establish a more accurate sense of light and shade in the painting, using lighter and darker tones of the mixes you have already created. Roughly block in the shapes of the overhanging leaves with a light green mix of Ultramarine Blue and Cadmium Yellow.

6 Paint the water using a small brush and a neutralized light color mix of Cadmium Orange, Cerulean Blue and Titanium White. Mimic the direction of the flow of the water with your brush. For example, use vertical strokes for the waterfall; flicks and dabs for the spray; and horizontal and diagonal strokes for the pool in the center.

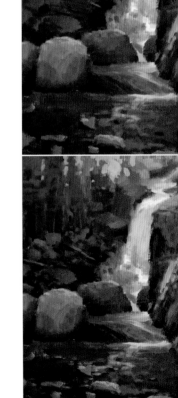

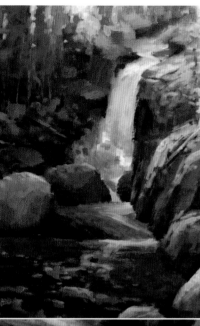

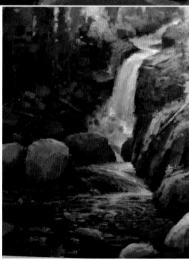

You will need
- Primed canvas, approx. 16 x 20 inches (40 x 50 cm)
- Paper towels

Brushes
- A selection of flats

Knives
- A selection of painting knives

Palette
- Alizarin Crimson
- Burnt Sienna
- Cadmium Orange
- Cadmium Red
- Cadmium Yellow
- Cerulean Blue
- Ivory Black
- Titanium White
- Ultramarine Blue
- Viridian Green

7 Add touches of saturated color to areas such as the cascade and the foreground water, and refine the color and shapes of the larger masses. Start to establish more contrast by adding lighter and darker applications of value/color. Add a blue mix to the foreground water consisting of Viridian Green and Cerulean Blue lightened with appropriate amounts of Ivory Black and Titanium White. Add spots of color to areas such as the tops of the trees, and rocks where the sun is breaking through.

8 Use small, dry brush strokes to create the little ripples and eddies in the stream below the fall, using the same basic colors as before but varying the values— the ripples are lighter on the surface where they catch the light, and darker on the underside where they turn away from the light. Make your brush strokes follow the flow of the water.

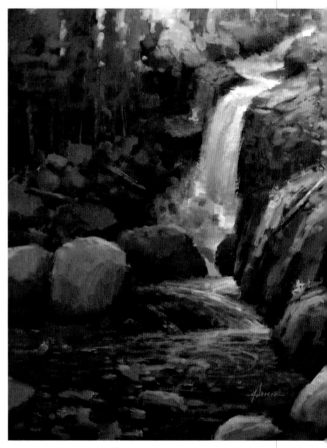

ALBERTA FALLS
BY JASON SACRAN
16 x 20 inch (40 x 50 cm)
When painting water, pay attention to edges. Soft edges create the illusion of movement, splash and spray (for example, at the top of the painting), whereas hard edges convey depth (for example, around the rocks at the bottom of the waterfall).

Landscapes continues over the page ⟶

Clouds appear in an amazing variety of shapes and colors, encouraging all kinds of artistic expressions within different painting genres.

LANDSCAPES: CLOUDS

Cloud formations habitually appear in paintings containing landscape elements and as main features in cloudscapes and skyscapes. In addition to setting a mood, clouds add visual interest, color and beauty.

Painting fantasy clouds works well for certain genres, but realistically painted clouds should be recognizable. Careful observation is key to understanding their structure and personalities.

Cloud painting tips

• White paint becomes optically brighter by blending in a minute amount of color, shifting it to the faintest pastel.

• Apply thin color glazes to enhance or change colors.

• Practice shapes doing quick cloud painting studies. Try out what works best for you—paint only dark values on a white underground or paint only the light areas on a dark underground.

• To avoid blending greens between yellow clouds and blue skies, wait until one color dries to brush the other next to it.

• Take photographs of interesting cloud formations to add to your reference library.

• Study cloud shapes—in the sky, from photographs and on the Internet.

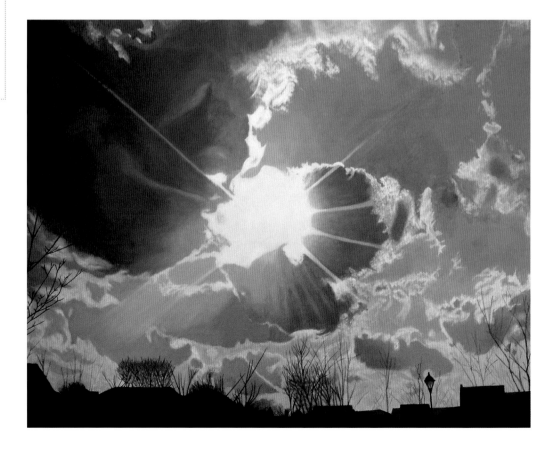

Twilight in Solon
by Livia Ayal
24 x 30 inch (61 x 76 cm)
A sunburst breaking through clouds produces a breathtaking backlit scene masterly painted in juxtaposing oranges, violets and blues. The dark silhouettes of the roofs and trees add a wonderful perspective to this cloudscape.

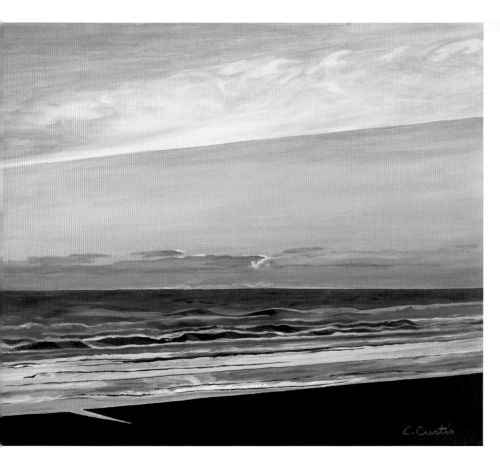

• Just as the sky isn't "just" blue, clouds aren't "just" white—they reflect the colors of light, especially during dusk and dawn when their hues are unbelievable.

• Concentrate on patterns and outlines, and then establish these elements with values and colors.

• Most clouds are a fusion of both soft and hard edges.

• Smooth color gradations and sharp color contrast sometimes occur in the same cloud.

• Shadows in clouds need not be dark gray—as long as the value is dark, you can use any color.

• Shadows within and underneath clouds create three-dimensionality, adding contrast and drama.

• Large clouds cast shadows on the surface beneath, seen as dark bands across a landscape. Rippling shadows convey changing heights of a terrain.

• The direction of the light source (sun or moon) creates highlights and colors, modulating the cloud shape.

• To add perspective to a sky, paint increasingly smaller, less defined clouds as they recede into the distance.

Painting realistic clouds

Among numerous cloud structures classified into a dizzying number of categories, the three most basic types are the cirrus, cumulus and stratus clouds. Each type has specific characteristics that you need to understand in order to depict them convincingly.

Cirrus Clouds Cirrus clouds are thin and wispy, hair-like strands that sometimes produce optical rainbow effects, such as halos and sun dogs. They usually signal the arrival of rain.
• How to paint: Lightly brush and feather white veils across the sky. Alternatively, quickly lift off sky color (while still wet) to reveal the white underground, using a damp brush, sponge or paper towel.

Cumulus Clouds Cumulus clouds are upright, bulbous, cotton-ball clouds with clearly defined edges. They usually indicate fair weather, but can quickly turn into storms.
• How to paint: Focus on shapes and values. Contours are usually sharply delineated, but

DIMENSIONS

BY LINDA CURTIS

24 x 30 inch (61 x 76 cm)
These deceptively simple-looking, unpretentious clouds seem to drift across the ocean during a serene sunset, masterly painted in a restricted palette with an economy of skilled brush strokes.

alternate between hard and soft edges within the cloud formation. Pronounced shadows help define volume. The base of these clouds is usually flat and shadowed. Colors and highlights suggest the angle of the light source.

Stratus Clouds Stratus clouds are flat clouds that appear as hazy horizontal layers. They usually herald light drizzle or snow.
• How to paint: Loosely apply extended horizontal brush strokes, in either straight or undulating motions. These lines are usually parallel, and foreshortening their size will indicate perspective.

Landscapes: Clouds continues over the page ⟶

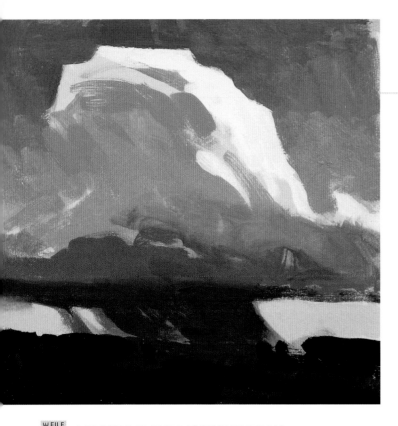

PAINTING CLOUDS: THUNDERSTORM

To paint the clouds in a distant thunderstorm, you will need to use both hard and soft edges. Clouds are one of the very few subjects that have soft edges when seen close up and hard edges when viewed from a distance.

You will need
- Primed canvas, approx. 12 x 12 inches (30 x 30 cm)
- Water or acrylic painting medium

Brushes
- Synthetic round #10

Palette
- Cadmium Yellow Light
- Cobalt Blue
- Dioxazine Purple
- Mars Black
- Titanium White
- Unbleached Titanium
- Yellow Ocher

THUNDERSTORM
BY MARK DANIEL NELSON
*12 x 12 inch (30 x 30 cm)
Working quickly wet-in-wet will make it easier to achieve both soft and hard edges.*

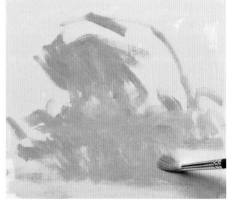

1 Create a base color for the clouds by toning your canvas with Unbleached Titanium. Add a small amount of Dioxazine Purple and Yellow Ocher to this mix and sketch the basic shape of the thunderhead.

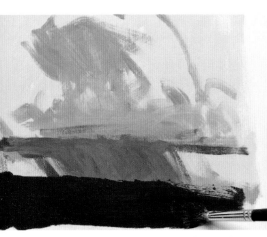

2 Add a little more Dioxazine Purple and Yellow Ocher to your mixture and use this color to paint the curtain of rain beneath the clouds. Add more Dioxazine Purple and Yellow Ocher to your mixture and use this color to create a dark base color for the foreground shape.

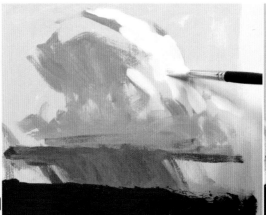

3 Use pure Titanium White to paint the brightest part of the cloud. Allow some of the base color to show through to represent those parts of the cloud that are not in direct sunlight.

4 Paint the initial layer of the sky behind the cloud with Titanium White and Cobalt Blue. Once you have filled in the sky, proceed immediately to the next step before the paint has dried.

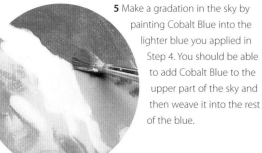

5 Make a gradation in the sky by painting Cobalt Blue into the lighter blue you applied in Step 4. You should be able to add Cobalt Blue to the upper part of the sky and then weave it into the rest of the blue.

6 Paint the lighter gray interior of the cloud with Unbleached Titanium mixed with a small amount of Mars Black.

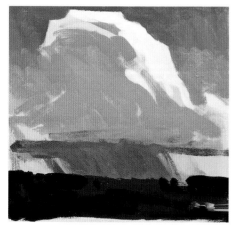

7 Paint the bushes and shrubs in the foreground with a mixture of Mars Black and Cadmium Yellow Light. Having darks colors in the foreground will help to make the cloud recede into the distance.

8 Mix Dioxazine Purple and Yellow Ocher and darken the curtain of rain once more. Add Yellow Ocher and Unbleached Titanium to this mixture to paint the shadow at the base of the cloud.

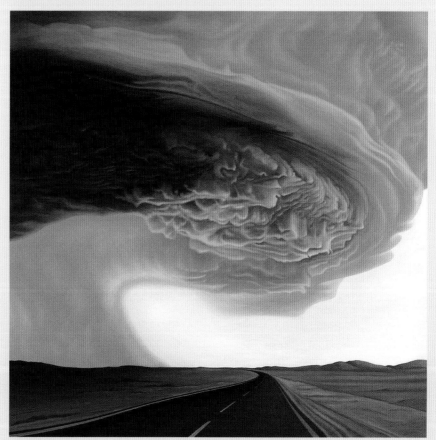

HEIGHTENED ALERT 4
BY MICHELLE MANLEY
30 x 30 inch (76 x 76 cm)

This fabulous menacing cloudscape was painted in a limited palette from dark to light over a near-black underground. Hard and soft edges define the clouds' movement and volume.

Landscapes continues over the page ⟶

Many painting genres, but especially landscape and wildlife, depict vegetation—from solitary trees to dense forests, and from wetland grasses to agricultural fields.

LANDSCAPES: FOLIAGE

FOREST OF BLUE
BY CINDY WENTZELL
8 x 8 inch (20 x 20 cm)
This impressionistic landscape, built up with deceptively simple-looking brush strokes, evokes a sun-dappled forest without needing intricate details.

Painting foliage—whether trees, grasses or plants—challenges the artist to portray a recognizable biological structure with a certain organic randomness.

Vegetation observed from a distance has a recognizable structure and appearance. We can immediately tell the difference between a tropical tree, a fir and a majestic oak—even when images are very abstracted. Except for fictional painting genres, the depiction of believable vegetation considerably enhances any landscape.

While each botanic species has a recognizable shape and appearance, there's also a certain organic randomness—Mother Nature dictates basic characteristics, but allows considerable freedom for personal interpretation as well.

The overabundance of visual elements within a natural setting is so overwhelmingly complex that it needs to be simplified. You must choose which impressions to translate into paint.

Painting trees

Studying the basic shapes, textures and colors of trees will help you recognize the most important features. This will enable you to simplify the translation from visual content into art, whether you paint foliage in high detail or abstracted impasto. Plein-air painting is ideal, but for practical reasons most of us paint trees from memory or use reference photos.

Get familiar with different tree species. Study their silhouette—each species has a specific overall outline and shape.

Trunks aren't just straight poles. Note the contours of the trunk, the texture of the bark and the way the roots anchor the tree into the ground. Trunks have different textures and colors. Bark can be grooved, scalloped, smooth, papery, shiny and even shaggy.

Note the slant and typical character of branches. Branches are never straight; their width varies and they extend asymmetrically out of their

trunk, intersecting and overlapping in a tangle of shapes. Paint branches in different directions and lengths for an organic look. Contrast values to suggest shadows and create depth.

Note, too, the shape of individual leaves, and how they look as a mass in the canopy. Look for patterns and edges. Capturing the main characteristics of foliage is key within any painting style

Greenery isn't "just" green. The variety of greens and other colors is spectacular, even within one single plant or tree. Colors and shapes not only suggest season, weather, time of day and geographical location, but also set a mood.

The light source influences highlights. Scattered, dappled light filtering through foliage forms patterns of light and shadows, filtering through leaves to form speckled bright patches.

ROUNDING THE BEND
BY JEANETTE CHUPACK
20 x 30 inch (51 x 76 cm)
The detailed true-to-life depiction of disordered foliage and roots is reinforced by their reflections in the water surface, which are wonderfully contrasted against the deep blue of the water.

Tree painting tips

• To mimic nature, always paint slight variations between trees of the same species.

• Avoid using greens straight out of the tube. Blend them with other colors, especially blues, reds, yellows and grays.

• Blend a little black into different yellows to obtain a range of subdued khaki greens.

• Add other colors (greens, yellows, blues or reds) to earth browns to enliven trunks and branches.

• Colors and values become lighter and hazier as trees recede into the distance. Also foreshorten their size to suggest perspective.

• Paint negative spaces (such as sky) between gaps in branches and leaf canopy.

• Take photographs to add to your reference library.

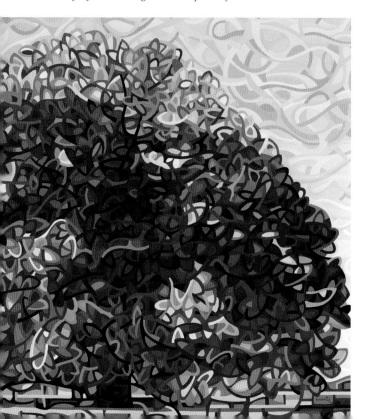

THE BUDDHA TREE
BY MANDY BUDAN
30 x 30 inch (76 x 76 cm)
Distinctive, vividly colored shapes are ingeniously placed to converge into a highly recognizable tree. The placement of darker values creates visual gaps in the foliage and gives the tree volume.

Landscapes: Foliage continues over the page ⟶

PAINTING FOLIAGE: TREES

One of the keys to painting foliage successfully is to think of it as a mass, rather than attempting to put in individual leaves and branches. In this demonstration, subtle color changes make the foliage look suitably three-dimensional, while interesting textures are created on the foreground trunks.

You will need
- Primed canvas, approx. 16 x 20 inches (40 x 50 cm)
- Paper towels

Brushes
- A selection of flats and filberts

Palette
- Alizarin Crimson
- Burnt Sienna
- Cadmium Orange
- Cadmium Red
- Cadmium Yellow
- Cerulean Blue
- Ivory Black
- Titanium White
- Ultramarine Blue
- Viridian Green

1 Tone the whole canvas with Burnt Sienna. Using a large flat brush and a mix of Burnt Sienna with some Ivory Black and Viridian Green, roughly map out the composition, looking at the negative shapes (the spaces in between the tree trunks) as well as at the positive shapes (the tree trunks themselves). You are essentially drawing the "skeleton" shapes of the trees.

2 Begin to block in the painting in color masses—the dark foliage (mixed from Viridian Green, Alizarin Crimson and Ivory Black with a touch of Cadmium Yellow), the lighter trunks (a mixture of the darker mixture with a little more Ultramarine Blue and Titanium White), the alternating bands of mid- and dark green on the ground and the sky (using Ultramarine Blue, Viridian Green and Titanium White with a touch of Cadmium Orange)—establishing the overall hues and temperature.

3 Refine the shapes of the foliage masses, and begin to give the trunks a sense of form, using a darker gray color mixed from Alizarin Crimson, Ultramarine Blue, Ivory Black and taking the value down with a touch of Titanium White, Cadmium Orange and Cadmium Yellow for the shaded sides of the trunks and adding touches of Viridian Green and Alizarin Crimson as appropriate.

4 Begin to create a more realistic sense of light and shade. Block in the lighter bands of grass with saturated mixes of Viridian Green, Cadmium Orange, Cadmium Yellow and Cerulean Blue. Add highlights to the right-hand side of the trees with a mix of Titanium White, Cadmium Yellow, Cadmium Orange and Viridian Green. Add the dark rings on the bark by mixing Ivory Black, Ultramarine Blue, Alizarin Crimson and Cadmium Yellow.

5 Add touches of lighter color mixes of Viridian Green and Cadmium Orange, adding Cadmium Yellow with Titanium White liberally to areas where the sun is breaking through, such as the grass.

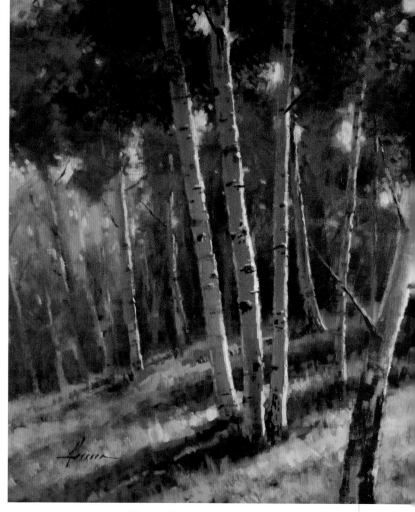

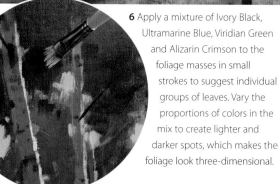

6 Apply a mixture of Ivory Black, Ultramarine Blue, Viridian Green and Alizarin Crimson to the foliage masses in small strokes to suggest individual groups of leaves. Vary the proportions of colors in the mix to create lighter and darker spots, which makes the foliage look three-dimensional.

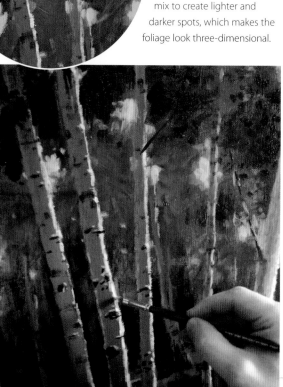

7 Add texture and tonal variation where necessary, using a small brush and the same mixes as before.

MORNING LIGHT
BY JASON SACRAN
16 x 20 inch (40 x 50 cm)
The key to making a convincing cohesive image of this type is simplification—be careful not to overwork the small details such as in the leaves and grass. Texture, both tactile and visual, is important; some areas of thick paint and a variety of brush marks will result in a more naturalistic picture of foliage.

Landscapes continues over the page ⟶

Throughout history paintings have featured stone or brick-built houses, farms, castles, cathedrals and all kinds of buildings. Today the urban equivalents of the landscape are the cityscape and the townscape.

LANDSCAPES: STONE AND BRICK

Manmade constructions can be painted in virtually any style and technique, but whether we paint a modest farmhouse, a towering high-rise, a church ruin or a deserted factory, we have to apply the universal rules of perspective if we intend to create the illusion of realistic depth and space. This applies to all realist paintings, but it is especially important for right-angled subjects such as buildings.

Perspective

The method of depicting three-dimensional objects on a flat surface in order to create a visual illusion of accurate height, width and depth is known as perspective. The mathematical rules of perspective (from Latin *perspicere*, meaning "to see through") were conceived during the Renaissance. Before that time, dimensions in paintings were stylized and symbolic and far from realistic.

Of course, you can directly trace, copy or project photographs onto the canvas to ensure the perspective is accurate. Nonetheless, knowing the rules of perspective is invaluable when it comes to working out why something in a painting looks off-kilter, and how to fix it. There are many books and websites that explain the essentials in a straightforward manner.

Drawing accurate perspective is accomplished by combining two concepts, namely the horizon

Cool Shade and Weathered Stone
by Alix Baker
16 x 16 inch (40 x 40 cm)
Rugged shapes in cool grays, sunny yellows and earth reds convey a sun-drenched street and stone houses without the need for lots of detail.

Exit #8
by Hisaya Taira
21 x 29 inch (53 x 73 cm)
In this hyperrealistic painting of a subway platform, the fluorescent light reflected on the floor has been meticulously painted to convey the stone surface, while the grout lines reinforce the illusion of perspective.

Painting stone and brick

Stone and brickwork are painted after the overall edges and borders of the larger shapes of buildings, walls or roads have been established. Methods vary, but here are some tips that may prove helpful.

• Paint large shapes first, using the base color of mortar.

• Mask mortar lines to protect their base color, and then apply the brick or stone color.

• Bricks and stones are often multi-hued. Spatter, sponge or streak paint in different tones.

• Add shadow lines (opposite from the light source) on edges to create three-dimensionality.

• Crisp lines and edges enhance focal points.

• Create depth by fading colors into the distance.

• Always paint small details last.

• Avoid painting stone and brick in too detailed a fashion when other content in the painting is less defined.

• Enhance old stone with moss, lichens or cracks.

line and the vanishing point(s). The horizon line is the term used to describe eye level—it is an imaginary horizontal line that indicates the height of your eyes' viewpoint. All other lines converge toward this imaginary horizon line. We always see the world at eye level, so the horizon line changes the angle of our view when we change position. The same setting looks different seen standing upright, squatting

down or from a hot-air balloon. Vanishing points establish the spot(s) where lines converge. Except for edges and lines parallel to the horizon, all other lines aim toward the vanishing point(s). The three most basic and commonly used types of perspectives feature one, two or three vanishing points.

KLOOSTERKERK (CHURCH)
BY JOHAN ABELING
21½ x 31½ inch (55 x 80 cm)
The precision of the aged stones of this church were rendered by multiple thin layers, while applications of thicker paint to the mortar lines emphasize three-dimensionality.

TECHNIQUE FILE 63

PAINTING STONE AND BRICK: COTTAGE

To represent a surface that is made up of many small parts (a wall made of stones in this case), you can give the impression of details without rendering each part. Suggest a pattern of stones stacked on top of one another using short, horizontal brush strokes.

You will need
- Primed canvas, approx. 12 x 16 inches (30 x 40 cm)
- Water or acrylic painting medium

Brushes
- Round #10

Palette
- Burnt Sienna
- Cadmium Yellow Light
- Cadmium Red Medium
- Mars Black
- Titanium White
- Unbleached Titanium
- Ultramarine Blue
- Yellow Ocher

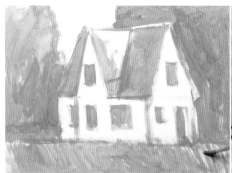

1 Using a #10 round brush and Yellow Ocher, sketch the cottage and surrounding trees.

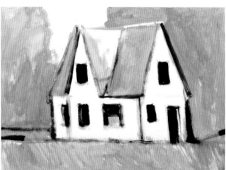

2 Outline the shaded undersides of the eaves and block in the darkest parts of the windows and door with Mars Black.

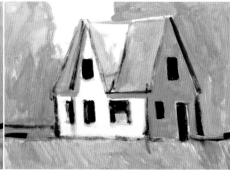

3 Combine Unbleached Titanium with a small amount of Mars Black and fill in the shaded gable end of the cottage.

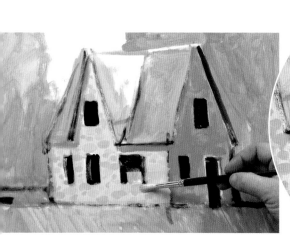

4 To paint the stonework on the light side of the house, mix Unbleached Titanium with a small amount of Yellow Ocher. Depict the stones using short, horizontal strokes that echo the pattern of the stonework. Mix a very small amount of Mars Black with Unbleached Titanium to get a gray stone color and apply it in the same manner.

5 For the stones on the shaded side of the cottage, mix Unbleached Titanium with Burnt Sienna and Mars Black. More Burnt Sienna will make the stones brown; more Mars Black will make the stones gray. Paint this side of the cottage, using short, random strokes as before.

6 Mix Mars Black with Cadmium Yellow Light to create a green color for the trees and the grass. More black will make a darker green, more yellow will make a lighter green. Use rough brush strokes to create texture in these areas, allowing some of the underlying colors to show through. Combine Cadmium Red Medium, Mars Black and Unbleached Titanium for the shadow color on the roof of the cottage.

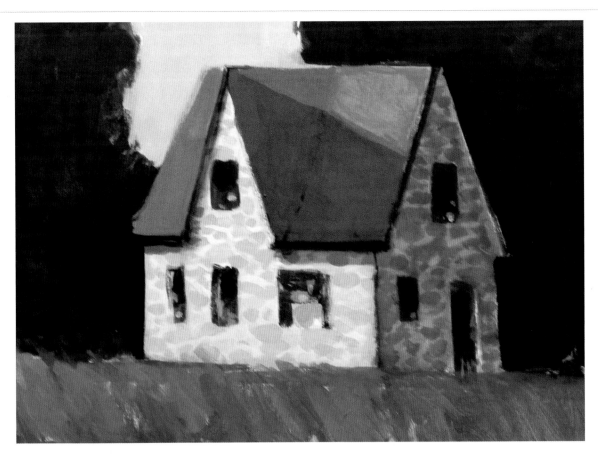

STONE COTTAGE
BY MARK DANIEL NELSON
12 x 16 inch (30 x 40 cm)
*Rather than render every
stone and every blade of grass,
you can achieve the illusion of
detail by employing a series of
well-placed brush strokes.*

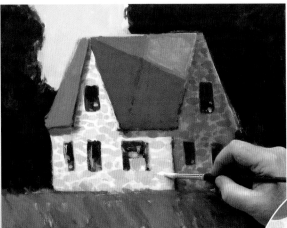

7 When the painting has dried, apply a semi-transparent glaze of Unbleached Titanium to the entire roof. Paint the blue sky with a combination of Ultramarine Blue and Unbleached Titanium.

8 Use Unbleached Titanium mixed with Titanium White to fill in the spaces between the stones on the light side of the cottage. The stones on the light side of the cottage will be lighter as a group, the stones on the shadow side of the cottage will be darker as a group.

BE A PRO

Although the act of painting is the driving force behind all acrylic artists, there are a number of theoretical and practical issues that affect and shape our creative work and life. It doesn't matter whether you are a professional, a student or a hobbyist; we all have to deal with issues such as how to present ourselves as credible and serious artists, where to find opportunities to exhibit our artwork and gather a following, how to best deal with comments and criticism, and how to connect with like-minded peers. This chapter focuses on these and other non-creative issues that are part and parcel of being an artist.

Main picture
IZABELA LECKA
BY MICHAL LUKASIEWICZ
31½ x 23½ inch (80 x 60 cm)
Being an artist propels you on a journey of self-discovery, experimentation and continuous learning. This wonderful portrait is the result of a confluence of skills, notably in its superb use of color, application of organic texture and composition.

Above from left to right
WRAP 01 (detail)
BY RODERICK E. STEVENS II
see page 223

PINE SPRITES (detail)
BY MANDY BUDAN
see page 282

HALCYON BLUES (detail)
BY LORENA KLOOSTERBOER
see page 211

VITAMIN WATER (detail)
BY ASHTON HOWARD
see page 264

Although some artists are reluctant to give their paintings a title, preferring the artwork to speak for itself, the majority believe that a title is just as important for a painting as it is for a book, song or theater play. Finding a title for a painting is a creative task, yet many artists struggle with it.

GIVING YOUR PAINTING A TITLE

Considerable time and energy go into creating a painting, so the search for a title deserves some thought. A title can complement the painting by being memorable or making a certain impression. Even the title "Untitled" signals a message.

The title usually emerges during the painting process or right after the painting is finished. Sometimes the title suggests a theme or content for the artist to interpret and develop into a painting. Consider what you would like the title to convey. A well-chosen, memorable title not only gives clues about the subject matter or the artist's intentions, it also can evoke emotions in the viewer. A title can be intriguing, thought-provoking, illuminating, informative, profound or lighthearted—it says something about the creator of the artwork, as well as the artwork itself. Avoid vulgarity, unless a crude title fits your painting's meaning. But be aware this may repel potential collectors as well as art galleries.

PINE SPRITES
BY MANDY BUDAN
30 x 30 inch (76 x 76 cm)
When out walking, the artist was struck by the way the sun lit up a pine tree, giving the impression of tiny lights dancing, reminding her of sprites that are bound to their trees.

CHURCH AND STATE
BY KEITH J. HAMPTON
24 x 48 inch (61 x 122 cm)
The artist chose this title to highlight the church-like architecture of the courthouse, with newer additions typical of modern governmental architecture. The piece explores the recent political impacts of the separation of church and state.

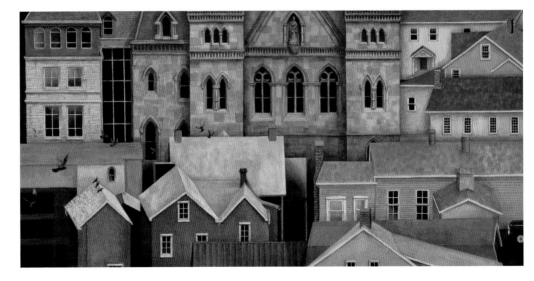

The quest for a title

Sometimes, writing down a list of associated words will spark ideas, and a thesaurus can help suggest synonyms. Say the title out loud to verify that it flows and is easy to pronounce. Make sure that your title is spelled correctly, as grammatical errors reflect sloppiness. Consider the following ideas to find a fitting title for your artwork:

• Color or composition—when a color dominates the painting, it can be used in the title. The title may also allude to the artwork's structure, design or style.

• Emotion—the title can convey a particular sentiment presented by the subject matter, such as a feeling, weather, season, time, celebration, tribute and so on.

• Meaning—the allusion to symbolic, poetic or literary language within a title can be a powerful message about emotions or thoughts.

• Message—the idea and intention behind a painting with ideological, sociopolitical or religious content can be explained or reinforced through the title.

• Subject—when the painting is of a person, animal, object, building or geographic location, the artist can use its name or description in the title.

• Alliteration—the repetition of a particular sound, word or phrase—reinforces meaning.

 Allusion—an implied reference or figure of speech—can be used when the title reflects the less-than-obvious.

• Metaphors—words with dual meanings—make a thought-provoking title.

• Oxymoron—a combination of contradictory or incongruous words makes an intriguing title.

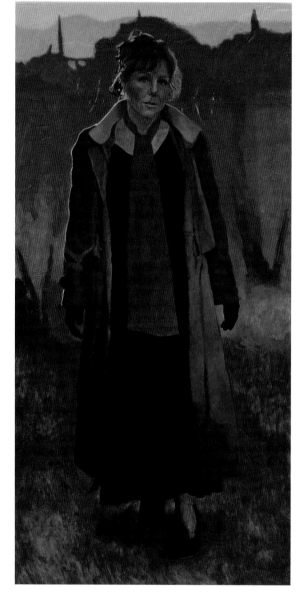

RED SCARF
BY ROBERT BISSETT
48 x 24 inch (122 x 61 cm)
The artist spotted this woman on her way to a concert. The light inspired Bissett to envison this painting. Bissett likes to give each painting a unique name, focusing on something that distinguishes it.

SECLUDED REFLECTIONS
BY BRIAN LASAGA
14 x 10 inch (36 x 25 cm)
The artist was photographing an abandoned house when he was inspired to paint the doorknob on the weather-beaten front door. Naming the painting was an organic process: Titles usually come to LaSaga as he paints. That title may change as the painting evolves and sometimes comes to him only upon completion of the work.

Giving abstract art a title can be a challenge—often the title is the only key to understanding the art, other than the piece itself. The title may indicate the formal values of the piece, such as color or design, but a visionary title can inspire the viewer to look for deeper meaning. However, you do not need to reveal the full meaning of the painting in the title: a bit of mystery allows room for the viewer's personal interpretation.

A signature on a painting not only identifies the artist, it also acts as the artist's seal of approval after completion—an indication the painting is considered ready for display.

SIGNING YOUR PAINTING

Although some artists do not sign their paintings, either because of misplaced modesty or because they are confident that their work is so recognizable that it needs no signed identification, there are several very good reasons to sign your paintings. Placing your name on your artwork is a sign of authorship and of pride in your work. An unsigned painting loses its identity over time, and the lack of signature will make it seem less valuable. It's difficult to discover the provenance of an unsigned painting. And an unsigned painting also gives the appearance of being a work in progress—unfinished.

Choosing your signature
Put some thought into what best represents your personality and painting style. You don't have to sign your full name—you might decide to use your initials or a monogram, or just your first or last name. Or perhaps you could use a symbol or a pseudonym.

Play around with ideas and doodles. Look at different signatures in galleries and museums to see which ones appeal to you and what kind of visual impression they convey. Above all, make sure your signature is legible and recognizable.

Location, color and value
Traditionally signatures are placed on the bottom right- or left-hand corners, although a painting can be signed anywhere as long as it doesn't detract from the subject matter. Never place the signature too close to the edge, where it may be hidden by the lip of a frame. Always sign the painting before varnishing it! Signatures on top of varnish give a falsified impression, and will vanish when the varnish is removed.

Also consider color and value. Using a color and value already present in the painting makes the signature blend in. Alternatively, you can use a contrasting color and/or value to give it more definition. Remember that, just like painting

mistakes, a botched signature can be quickly wiped off if still wet or changed by glazing it in a different color or value.

Name changes
If your name changes as a result of a change in marital status, should you change your signature? Going from a maiden name to a married name, and sometimes back again after a divorce, can be detrimental: consistency is important and it makes sense for artists to continue using the name they've had since birth or since they started painting, regardless of marital status. This also makes it easier for others to identify an individual's artwork as time passes.

Additional identification
It is good practice to write your full name on the back of your painting, especially if your artist signature is shortened to initials or a symbol. In addition to your signature, consider adding a personal touch, such as a fingerprint or genetic material such as an eyelash.

Dating your painting
While great art is timeless, many believe a painting should be dated, if not next to the signature then at least on the back. Although most collectors and galleries are keen to know the year of creation, a date next to a signature can look obtrusive and distract from the subject matter. The date on an older painting also suggests it hasn't been sold yet, losing some of its appeal for those who equate sales to creative achievement.

Consider not dating your artwork at all—not on the front nor the back. If you keep good records, you will always be able to answer the questions of those interested in knowing the details, including the date of creation.

The artist's signature

1 Marie Antoniou signs her paintings with her initials. This graphic visual contrasts well against the loose, expressive brushwork of her painting.

2 Brian Simons signs his paintings with his last name. Here, the signature is in the shadow of the plate of oranges, so as not to be too conspicuous, and is written in a color used in the composition.

3 Josh Tiessen signs his paintings with his full name. Here, he has chosen a value a couple of shades lighter than the selected area in a color that echoes the predominant color scheme.

4 Rick Delanty signs his paintings with a signature and hand-carved seal or "chop mark"—similar to those used in Oriental paintings to identify the artist.

5, 6, 7 Flora Doehler uses initials, first name and full name.

8, 9 Consider the placement of your signature. In both of these paintings, Shawn Gould has signed in the corner that draws the least attention.

1

2

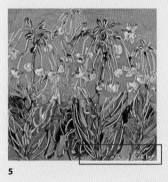
3

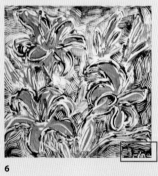
4

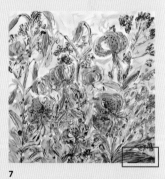
5

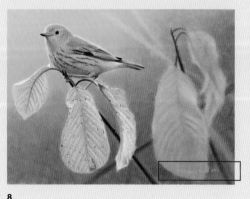
6

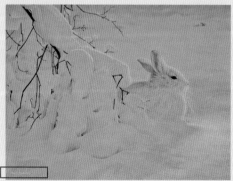
7

8

9

Once you finish a painting it needs to be photographed for the record, to add it to your portfolio, enter exhibitions and for printed and virtual publication.

PHOTOGRAPHING YOUR ARTWORK

Having your paintings professionally scanned or photographed is a recurring expense that most of us are unable or unwilling to make. Fortunately, digital photography makes taking good-quality photographs easier and more affordable than ever before. Free of the restrictions of the film roll, you can happily click away and review each shot immediately, while computer editing software allows you to adjust the digital image to match the original painting.

You don't need a professional photo studio set-up or an expensive camera to create good-quality digital images. A compact digital camera, access to a photo-editing program on a computer and a few additional gadgets will allow you to take surprisingly good photos. Here are some guidelines that will help you get started.

Setting up your painting

Take photos of your finished painting after signing it but before varnishing or framing it. For upright shooting, hang the painting on a wall, position it on an easel or set it on the floor leaning against a wall. For downward shooting, place the painting flat on the floor—this position only works for small paintings. It's important that the camera is at a 90° angle to the painting surface, otherwise the image will be distorted. Place or tape a color guide card close to the edge of your painting, without overlapping it. This color guide will help to color correct the digital image afterward.

Setting up your camera

First, turn off the automatic flash and the date stamp functions, as well as the image stabilization (IS) if you are using a tripod.

Set your camera to the largest image size it can

What you need

Essentials
- A (compact) digital camera: 10 megapixels or more, with a large LCD (liquid crystal display) preview screen. Buy the best within your budget, preferably from a trusted camera manufacturer that offers high-quality lenses for better optics. Keep the manual handy for quick referral.

- Memory card: Preferably 64 GB or larger.

- Rechargeable batteries and charger: Reusable and longer lasting than alkaline batteries. Get a second battery set as a quick replacement spare, and keep it charged.

- Tripod: One that's easy to adjust. A good-quality tripod will last a lifetime.

- Photo-editing software such as Adobe Photoshop or Corel PaintShop Pro.

- Computer access.

Recommended extras
- A cable release: This inexpensive gadget plugs into the camera and allows you to trigger the shutter release without finger pressure that causes the camera to shake. A remote release is also available and functions without cable attachment.

- Two (flood) lights: Either a two-lamp photography kit or two lamps with full-spectrum lighting. Unless you live in a region with wonderful weather, it is worth the investment.

- A color guide or color checker: The colored squares on this card will assist in digital color correction.

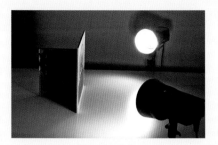

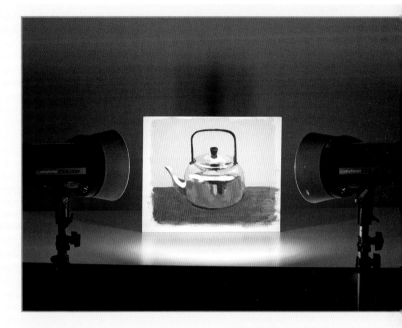

Position of the camera and lights

If you have a small painting, position it on a tabletop easel or sit it upright supported by a heavy object. A large painting can be elevated on an easel or propped up against a wall, as in the diagrams below. Aim the camera straight at the painting. Make sure you can see the entire painting inside the viewfinder display. Position the camera so that it is perfectly perpendicular to the painting surface—compare the edges of the viewfinder to the edges of your painting. Place the lights on either side of the camera to achieve evenly distributed indirect lighting.

Tilt the camera so that it is at a 90° angle to the painting surface.

Place the lights on either side of the camera at a 45° angle to the painting surface.

produce and to automatic (consult your manual) for point-and-shoot simplicity.

Connect the cable release. Place the camera on the tripod and adjust its position to squarely face your painting, pointing straight at the center of your artwork.

Use the LCD live preview screen as a viewfinder. Move the tripod with the camera until the painting fits within the screen without being cropped.

Make sure the sides of the painting are perfectly parallel to the sides of the LCD screen. Some preview screens have a grid overlay setting that helps as a visual guide.

Setting up lighting

For constant, unchanging lighting conditions it is best to use artificial light. Place two lights at 45° angles on either side of the painting, out of the field of view of the camera lens. Alternatively, place both lights on one side to create shadows that emphasize brush strokes or impasto textures.

Turn on the lights and look at the camera display—if glare occurs, slightly decrease the lights' angles to 35°.

Shoot!

Once you have the camera and lights positioned, you can start shooting photos. Take many

Photographing Your Artwork continues over the page ⟶

Shooting in natural light

If you live in a good-weather region, you can set up your painting outside and shoot it on an overcast day or in the shade using natural indirect light. Diffuse or cloudy morning light is ideal.

If you shoot indoors without artificial lights, a room with large windows can offer indirect daylight, but be especially mindful of glare and cast shadows.

Tips

• Get to know your digital camera and your photo-editing program. It really pays off to read manuals and watch video tutorials online.

• Never be too embarrassed to ask for help when it comes to digital photography and computer programs. Everybody needs to learn, nobody starts out as an expert! Ask an experienced friend to guide you through the basics and take notes for future reference.

• If you do not have a cable release, use your camera's delayed timer setting to avoid camera shake when pushing the shutter button.

• Learn how to resize digital images by changing the resolution (dpi or dots per inch) and the print size (in pixels, inches or centimeters) to adjust for various uses.

• Several free photo-editing software programs are available for download on the Internet, offering a solution for those on a tight budget. Do your research and read reviews to find the best one for you!

photographs with different light angles and distances, and play around with your camera settings, reviewing the shots for instant feedback. Have some fun experimenting!

Computer photo editing

Download your photos onto the computer to review them and choose the best one. Rename it and open the photo-editing program to adjust this digital image until it looks exactly or as close to your original painting as possible. Do not be tempted to make it sharper, add more contrast or intensify colors—you want the digital image to be a faithful representation of your artwork. Note that colors can vary among computer monitors, so make sure your monitor is properly calibrated.

The list of photo-editing software features is too comprehensive to discuss within these pages. Here are some key basics to look up on your software's help system or manual:
• Straighten up the image using the distort tool, if necessary.
• Adjust brightness, contrast and color, if necessary.
• Resize the image at different resolutions, saving all versions.
• Crop the image to only show the painting, eliminating the background and color guide.

The good, the bad, and the ugly

The first example shows the right way to photograph your artwork. However, many times small details get overlooked, resulting in a distorted image that doesn't do your artwork any justice.

Fragile by Lorena Kloosterboer
11¾ x 11¾ inch (30 x 30 cm)

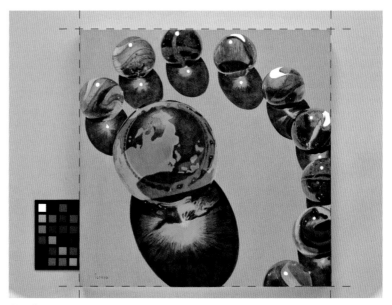

Good
The color guide next to the painting is used to color correct the image.
The dotted lines indicate where you should crop your digital image to only show the painting.

Flare

Light reflecting on a glossy surface creates bright areas, washing out colors and veiling details.

Color bias

Illumination by light other than full-spectrum daylight will influence and alter colors. Here, the photograph is too blue.

Cast shadow

Anything placed between the light and the painting will cast a shadow. Here, the top right-hand corner is too dark.

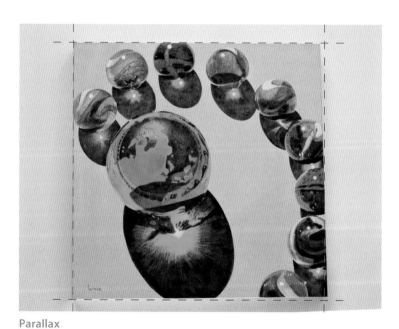

Parallax

When not photographed at a perfectly perpendicular angle to the flat surface, the edges will appear slanted and tilt out of context. This image is impossible to crop correctly.

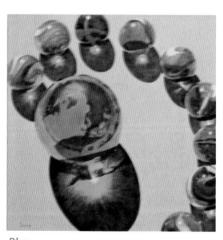

Blur

When the camera shakes or is out of focus the image blurs, losing precision and detail.

A frame is a decorative molding encasing a painting. It is meant to enhance and protect the artwork, and facilitate its display.

THE ART OF FRAMING

A frame can enhance a painting in an unobtrusive, low-key manner or in a striking, ornamental fashion, depending entirely on style, subject matter and personal taste. Ideally the frame plays a supporting role, drawing attention to the painting and giving it a finished appearance. The wrong frame overwhelms the artwork, competes for attention and/or makes the painting look gaudy.

Classical paintings in museums are usually displayed in ornate gilded frames, yet the frames enhance the paintings even though they are often works of art in their own right. Contemporary paintings in museums and art galleries usually have more subdued, inconspicuous frames. Plein-air frames are broad, flat frames that significantly increase the overall dimensions of the artwork, giving it a sophisticated "matted" look. Despite the name, plein-air frames can be used on any painting subject and style.

Types of frames

Unless the painting is on a staple-free edge canvas or cradled panel, it needs to be framed. Paintings on paper should be matted and framed behind glass or Plexiglas. Frames come in a wide variety of materials, textures, colors and profiles.

There are basically two types of frames:
• Regular frames have molding with a lip and rabbet. The rabbet allocates space to hold the artwork. The lip typically extends about ¼ inch (5 mm) past the edge of the rabbet, covering the edges of the painting surface. The artist needs to be aware of this slight "loss" in circumference when signing the painting.
• Floater frames have no lips to cover edges and are designed to go around the canvas or panel, leaving the entire painting visible (including the sides). Floater frames create the illusion that the painting "floats" inside the frame because there's a space between artwork and frame. They protect the painting's edges, giving it

Frame profiles
Knowing the vocabulary of frame profiles will make it easier to discuss your options with a framer.

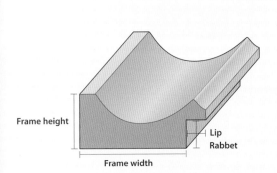

Wood frame

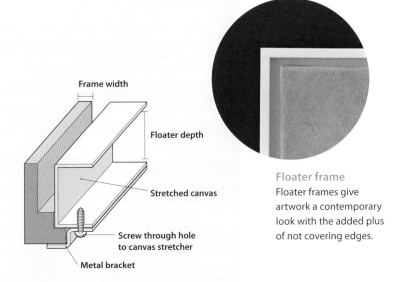

Canvas floater frame

Floater frame
Floater frames give artwork a contemporary look with the added plus of not covering edges.

Glass versus Plexiglas

When framing behind glass you have a choice between using glass or Plexiglas.

• The clearest glass is museum-grade glass with UV-protectant coating. It is virtually scratch resistant, but heavy in weight and quite fragile, which makes it challenging to ship or transport.

• Plexiglas comes in many grades and qualities; the best offers a UV-protectant and anti-static coating, and is almost glare free. Regular Plexiglas scratches more easily than glass, but is virtually unbreakable. It is also lightweight and therefore easier to ship or transport.

• The best Plexiglas for framing is Acrylite OP-3. It is clearer and stronger than glass, and available with a scratch-resistant coat on one side.

• Many art galleries demand framing behind Plexiglas to eliminate the costs and hassles caused by breaking glass.

Taking measurements

Frame measurements indicate the size of the opening, not the outside borders of the molding. To determine the size of your frame, measure the outside edge of your painting; this is the size of the frame you need.

Color mats

Take care when choosing the mat color because the wrong choice can easily spoil your work.

Top left: Off-white. This is possibly too light and does not really enhance the picture, rather it washes it out.

Top right: A warmer and darker tone of cream works a little better because the specific tone is present in the painting.

Bottom left: Green complements some of the colors in the background of the picture. This choice lets the image speak for itself, simply providing a neutral border.

Bottom right: Here, a red mat is used to highlight the fall tones. However, red mats can easily dominate a picture and the eye will be drawn to the mat and not the picture.

a finished contemporary look. Floater frames cannot be fitted with a mat or glass.

Choosing a frame

The choices and combinations of frames and mats are virtually limitless. When you frame your work for personal display you are free to choose any color and style. However, if your painting will show at an exhibition, it is best to select a neutral color in a classic or simple frame. Get framing ideas by visiting museums and art galleries.

To visualize framing results, take your painting to a framer to look at corner samples of both frames and mats. Having a professional framer handle the work can be expensive, but many framing and art supply stores offer more affordable ready-made frames in standard sizes, with or without glass, and ready-cut mats. You can also order frames online, in both standard and custom sizes. Ordering a frame online has an additional benefit: the box it is shipped in can be reused to ship your framed artwork.

Mat or passe-partout

Paintings executed on paper and framed behind glass or Plexiglas should be mounted with an archival, pH-neutral mat (also called a passe-partout). A mat is a cardboard sheet 1/16–5/64 inch (1.5–2 mm) thick, with an excised, beveled window. The mat has a dual purpose: it visually

The Art of Framing continues over the page ⟶

Narrow mats

A narrow mat can be very effective, but bear in mind that a little of the outer edges will be lost in the lip of the frame. In general, large paintings need narrower mats.

Standard mats

It's common practice to make the bottom edge ½ inch (12 mm) wider than the top and sides to correct an optical illusion that occurs when all are the same. This is a fairly standard proportion of mat-to-painting.

Wide mats

A mat as wide as this is most suitable for small paintings—it adds presence and saves the painting from becoming lost on a wall.

Framing tips

• Clean the glass or Plexiglas meticulously to avoid trapping dust or hair inside the framed artwork. If possible, handle with cotton gloves.

• Lay your painting face down on a towel or carpet to avoid damaging the surface during framing.

• Avoid using saw-tooth hangers; they are disliked by a majority of galleries and museums.

• Avoid plastic frames and cheap metal frames with sharp edges.

• Attach D-rings or screw-eyes approximately a quarter of the way down from the top of the frame, making sure they are at equal height. Placing them too low will cause the artwork to tilt forward when hanging on the wall.

• Art supply stores, framers and some hardware stores sell packs that include everything you need to hang a painting. Make sure you buy one recommended for the weight of your painting.

extends the painting and it centers it inside the frame. More importantly, it prevents contact between the painting and the glass, avoiding mold or stains caused by condensation.

A well-chosen mat enhances the artwork and guides the eyes toward it. Mat measurements indicate both the outside edge (the size of the frame) and the inside opening (the size of the artwork). The inside measurements of the mat need to be about ⅛ inch (3 mm) smaller on all four sides than your painting, so that the mat overlaps and covers the edges. To cut your own mat, you'll need a sharp blade or X-Acto knife, a cutting mat and a steel ruler; alternatively, consider buying a mat cutting kit.

Framing hardware

There is a variety of hardware available to fasten (also called fitting or mounting) the painting into the frame. Which system to use depends on the type of frame and the painting support, but using removable hardware enables you to swap the artwork without damaging the frame. Here are a few options:

• Turnbuttons are screwed onto the back of the frame, and as their name suggests, can be turned (flipped) aside to remove the artwork.

• Spring clips attach to the frame with a single screw; their flexible, springy metal arms hold the artwork in place.

Turnbutton

Spring clips

Canvas clips

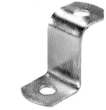

Z- clips

• Canvas stretcher bar clips (also called canvas-clips or clip-its) are simple spring clips that require no screws or tools to fasten stretched canvas into a frame, allowing easy removal and remounting of artwork.

• Offset clips (also called Z-clips) screw onto the back of the frame. When the depth of the rabbet is too shallow for the painting support to be placed flush with the frame, the offset Z-clip holds it in place.

Hanging hardware and picture wire

The best way to attach wire to a painting is by screw-eyes or D-rings. Whenever possible, attach these to the insides (not the backside) of the frame, stretcher bars or cradled sides; this allows hanging the painting flush to the wall, and also prevents the wall from being damaged by protruding metal hardware.

Picture wire is made up of several strands of stainless-steel wire that are twisted together, giving it superior strength. Some have a plastic coating. The weight of the artwork will determine the thickness and strength of the wire that you need to use. Note that most packaging indicates the maximum carrying weight. To calculate the length of wire needed, multiply the width of your painting or frame by one and a half.

You will also need several tools: diagonal pliers or wire cutters to cut wire to the desired length, an awl (a thin, sharp-pointed tool) to make a hole in the frame, stretcher bar or cradled wooden edge to easily insert screws, and screwdrivers in several sizes.

TECHNIQUE FILE 64

HOW TO ATTACH WIRE TO YOUR FRAME

There are two methods to attach the wire to the screw-eyes or D-rings. Leave enough slack in the wire so that when pulled taut upward it is well below the top edge of your painting or frame.

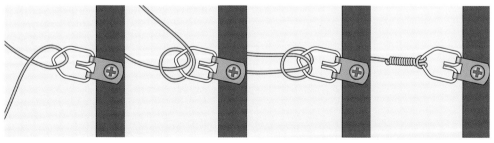

1 Thread the wire through the ring.

2A Double loop the wire and continue to Step 3.

2B Alternatively, feed the wire through the ring to form a knot.

3 Tightly twist the remaining end around the hanging wire.

Large ring and chain

Plate ring and cord

Screw ring and picture wire

Spring clip

Bracket

Turnbutton

Clip

Z-clip

Mirror plate

An exhibition or sale may require you to ship your artwork to a distant location. Knowing how to pack your painting securely is a crucial first step for problem-free shipping.

PACKAGING YOUR PAINTING

Shipping artwork implies placing precious cargo in the hands of strangers. There are no guarantees that artwork will not get damaged during transit, but you can increase the odds for safe delivery by making sure your artwork is meticulously packaged. Neat and careful packaging also underlines your care and respect for your artwork, which makes a positive impression on the recipient.

Packaging options

There are several packaging options to securely ship your painting. The cheapest and easiest is using bubble wrap and a cardboard box. Expensive but highly recommended is the reusable art shipping box lined with convoluted foam that allows removal of the center layer to precisely fit your painting. Most expensive is using a custom-built wooden crate, the method most professional art-shipping companies use.

TECHNIQUE FILE
65

HOW TO PACK YOUR PAINTING

Follow these guidelines to build up several layers of protection to prepare your painting for shipping.

You will need

• A cardboard box measuring about 3 inches (7.5 cm) larger on all sides than your artwork (including frame)
• Acid-free tissue paper
• Bubble wrap
• Cardboard or foam board, two pieces, ¾ inch (2 cm) larger on all sides than your artwork (including frame)
• Four cardboard corner protectors in a suitable snug-fitting size
• Masking tape
• Mover's tape, 2 inches (5 cm) wide
• Scissors
• Sharp box cutter with extra blades
• Waterproof marker

Packing tips

• Never use packing peanuts—they offer limited protection, because they settle during shipping and are a terrible nuisance to unpack.

• Cardboard corners are easy to make yourself; find a template online in the size you need.

1 Only for paintings under glass: Stick a few lengths of masking tape in a crisscross pattern on the glass. In case of breakage, the tape will keep the glass in place.

2 Protect the surface of your acrylic painting by covering it with acid-free tissue paper. Prevent any plastic from coming into contact with the acrylic painting surface, as it may stick and leave unwanted texture.

3 Fit cardboard corner protectors over the four corners.

4 Add two sturdy pieces of cardboard or foam board to the back and front of the painting. Tape them together on the sides at intervals to prevent them from shifting.

5 Write your contact information on the cardboard or foam board, so that the painting can be identified even if it gets separated from its box.

6 Wrap this package in a layer of bubble wrap. Repeat with a second layer. Use masking tape to make it easy to peel the packaging open.

7 When shipping multiple paintings in one box, repeat the above process with all pieces.

8 Place the wrapped painting in the cardboard box. Fill any leftover empty spaces with wads or strips of bubble wrap, or air pillows (make your own by blowing into plastic sandwich bags and tie a knot—they need not be taut). The entire content of the box

has to be fitted closely without leaving any space to jiggle, shift or move—a snug fit is of utmost importance!

9 Seal all the box edges shut, using mover's tape.

10 Mark the box as "fragile" and, if desired, indicate where to open the box.

11 Add a clearly legible shipping address, including phone number, as well as your own name and return address.

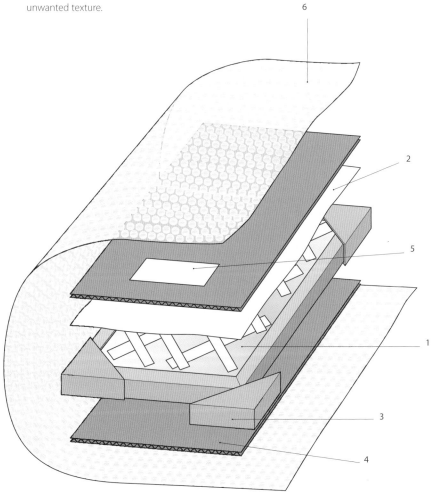

Padded art shipping boxes

There are many kinds and sizes of special reusable art boxes with thick protective inner layers that absorb shocks and safeguard your artwork during shipping.

Although artists are rarely well organized in regards to all the minutiae of deskwork, it pays to keep detailed records of everything related to your artwork and art career.

RECORDS AND RÉSUMÉS

The free artist's spirit in you probably recoils at the idea of doing office tasks, but keeping track of both your artwork and your own achievements is extremely valuable. Over time, these records will also become a personal chronicle.

Records
Luckily most of us can handle "paperwork" on a computer, making it easy to write down and regularly add information, save digital images, and keep track of correspondence, financial data and the whereabouts of your paintings. Make it a routine to save (digital) photos of your finished paintings, tag them with the title, and list the following information in a Word document, spreadsheet or on paper:
- Title of painting
- Size, medium, support (if framed, a description and total size)
- Date of completion
- Price
- A description, if so desired, including inspiration and thoughts
- Location of hard-to-find signature, if applicable
- Information about (copyrighted) reference material, if applicable
- Exhibition venues, locations and dates
- Publications featuring the painting, such as magazines, catalogs, websites and blogs
- Awards or honors received, venue and date
- The sales price and commission, venue and date, and the collector's name (if the piece sells). Also keep track of consignment agreements, juried entries and results, gallery information and any other art documents sent or received. It is also valuable to keep records of rejections—I archive all my rejections in a separate folder to keep me grounded in reality.

It doesn't need to be complicated—simply allocate a folder where you gather everything that relates to your art. This will allow you to easily find and consult information.

Pricing
Pricing your artwork is difficult—you want a realistic price, not so high that it deflects sales, not so low that it devalues your work. There are no rules, no formulas and no easy answers when it comes to setting a price. Some artists set a fixed price per square inch or overall size; others set it according to time and effort. The value of art is subjective; it is worth what others pay for it. Compare your paintings to those similar in style, size and location to get an idea on pricing. Be realistic. Unless you are well connected, it is unlikely you'll become rich quickly.

Galleries in the United States generally ask for 50% commission; galleries in other regions vary between 20% and 50%. It is tempting to ask a higher price when selling through a gallery than when selling direct to a collector, knowing that a large chunk of income is allocated to commission, but it's good practice to maintain equal pricing so that collectors and galleries don't feel cheated. Hopefully a gallery sale will enhance exposure and the status of your art.

The Artist's Résumé
Keep a detailed record of all art-related projects and continue to add over time to build up a comprehensive CV. Out of this information, you can create a shorter résumé customized to suit each situation.

In some situations (such as website listings), you may prefer to remove your mailing address and/or telephone number for personal safety reasons.

B. Kolinsky
Acrylics Avenue 123, Palette City, Dreamland
012-345-6789
b.kolinsky@brush.mail
www.art-by-bk.com

Date of birth and location are optional.

1962, Palette City, Dreamland

EDUCATION

MA	Fine Art (candidate)	Artist College	
BA	Painting	Color Institute	
	Open Atelier	Drawing Studio	

Grand Gesso, Utopia 2014
Grand Gesso, Utopia 2000
Grand Gesso, Utopia 1990–1999

- Do not list non-art-related studies, such as high school.
- Include training courses, workshops, private art tuition and residencies.
- If you studied without earning a degree (which is not unusual) list the time period.
- If currently enrolled, add the word "pending" or "candidate" after the degree, and list the expected graduation date.
- If without formal training, indicate you are self-taught.
- Put dates in reverse chronology, with the most recent date first.

EXHIBITIONS

Selected solo exhibitions
2014 Acrylic paintings *Finding my Voice* Art Gallery Palette City, Dreamland
2009 Acrylic paintings All *Art Blue* Art Museum Flat Brush City, Dreamland

Selected group exhibitions
2014 Juried Exhibition *Acrylics Club* Art Center Palette City, Dreamland
2010 Art Group Show *Love of Art* Art Gallery Flat Brush City, Dreamland

- Use the term "Selected Exhibitions" as a heading when you have a short list.
- List small number of exhibitions under one heading.
- List large number of exhibitions under separate headings: solo exhibitions, two-person exhibitions, group exhibitions.
- Put dates in reverse chronology, with the most recent date first.

AWARDS

2014 Gold Medal Art Center Palette City, Dreamland
2012 Creative Achievement Art Publication Dreamland
2009 Honorable Mention Acrylics Contest Grand Gesso, Dreamland

- Add all special recognitions, art prizes, scholarships, art competitions, fellowships and grants.
- If applicable, add the name of the jury member(s) after the award.
- Put dates in reverse chronology, with the most recent date first.

BIBLIOGRAPHY

How to Paint Art Publication A. Critic 2014
Artistic License Acrylic Book B.A. Writer 2011
Heavy Body Acrylics Impasto Magazine P. Knife 2010

- Include all media where your artwork has been featured: magazines, newspapers, radio, television, catalogs, books, blogs and websites.
- If accumulated to large number, list the most relevant under the heading "Selected Bibliography."
- Put dates in reverse chronology, with the most recent date first.

COLLECTIONS

Art Museum Round Brush City, Utopia
Big Bank Building Flat Brush City, Dreamland
Handsome Actor Hollywood, Dreamland

- List high-profile collections where your artworks reside, including public, corporate, permanent and private collections.
- Do not list private collectors unless you have their permission to use their names.
- Do not list family members or friends.
- List in alphabetical order.

PROFESSIONAL AFFILIATIONS

Acrylic Artist Group Flat Brush City, Dreamland
Fine Art Gallery Round Brush City, Utopia
Modern Art Gallery Quinacridone Town, Dreamland

- List current galleries representing your artwork.
- List artist group memberships.
- List in alphabetical order.

PROFESSIONAL EXPERIENCE

Art Teacher Artist College Grand Gesso, Dreamland
Painting Workshop Color Institute Grand Gesso, Dreamland
Studio Art Tutoring Home Studio Palette City, Dreamland

- List any art-related work, such as teaching workshops, lectures and presentations.
- Do not list non-art-related work.
- List in alphabetical order.

10 résumé tips

- Keep it short, simple and straightforward.

- Exclude any of the above categories that do not apply to you.

- Do not use images, colored paper or unusual and/or colored fonts.

- Have a consistently formatted layout.

- Use 10- or 12-point legible fonts, such as Times New Roman, Garamond or Palatino.

- List all dated entries in reverse chronological order, by placing the most recent date first and the oldest last—except for undated entries, which should be listed in alphabetical order.

- Rearrange the order of categories above by importance and relevance.

- Tailor your résumé to each specific occasion.

- Proofread your résumé before sending it out.

The purpose of the artist statement is to present a basic written introduction of you and your artwork, in order to broaden your audience and enhance the viewing experience of your artwork.

THE ARTIST STATEMENT

Many artists are stumped when asked to provide an artist statement, believing that their artwork should speak for itself. Writing often doesn't come easy, and it's especially hard to translate visual content into a few short paragraphs that represent you and your art, but the process can prove invaluable to gain a deeper understanding of your creative path.

Thoughts on substance

First, you have to think about content. Ponder on the following and jot down any thoughts that come to mind without bothering with spelling or language. These notes will be the foundation for your artist statement, to be rewritten, edited and polished afterward.
- Introduce yourself: Who are you?
- What motivates you to paint?
- What inspires you? How do you choose your subject matter?
- What is unique about your artwork? What does it mean to you?
- What do you want to express? Does your art convey a message or an emotion?
- What connects your art expression to your medium—painting in acrylics? Are there any special tools or techniques you use?

How to write an artist statement

Distill your previously written notes into a text of between one and five paragraphs. Each paragraph should be between three and five sentences. Your artist statement should fit on one letter-size page. It need not include all your thoughts; just select the most important and interesting ones.

Once you finish compiling the text, put it aside before re-reading it. Try to evaluate your statement from an objective and detached viewpoint. Continue revising and perfecting the text without losing sight of the points you want to make.

Before publishing your artist statement, ask friends, family and/or fellow artists for honest feedback on content, spelling and punctuation. If your text isn't satisfactory, consider hiring a professional writer or editor to handle it for you. Over time, continue to revise and update your artist statement to reflect the changes in your creative life.

10 tips to write your artist statement

- Write for those who do not know you or your art.

- Be personal—write in the first person.

- Use understandable everyday language. Avoid using technical jargon or references to erudite or obscure topics.

- Use a conversational tone. Avoid appearing arrogant or pretentious.

- Avoid information overload. Leave readers wanting to know more.

- Address common questions. Be specific and avoid vagueness.

- Write from your personal perspective. Do not tell readers what to think or feel—allow them room to form their own opinion.

- Do not compare yourself to other artists. Avoid name-dropping.

- Use a thesaurus.

- Keep it short and to the point. Avoid verbosity.

Pitfalls to avoid

These three artist's statements make some common errors—make sure yours doesn't fall into the same trap.

"I have been an artist since I was five years old. My mother was also an artist as well as my great aunt, so I come from a long history of artists. I grew up in Riverside, California, where there was not a lot of exposure to art or museums when I was young. I started making paintings and drawings more seriously in high school, and then went on to get a college degree. I graduated from art school with an MFA and began my professional career."

Do not talk about your childhood or family unless it is crucial to your work. Most artists have been drawing since they were toddlers so this does not really address who you are as an artist or what kind of work you make.

"I often use found objects in my work and use them to relay what I hope is a compelling investigation into ideas of ecology. With the current debates about global warming, I want to address those ideas to a wide audience. I make collages out of found trash that I want to convey to people that they should recycle."

If possible, avoid using terms like "I hope" or "I want" as they do not sound confident. Your artist statement should be clear as to your ideas and goals. Using abstract or superficial wording like "ecology" is too broad of a topic. Be concise and direct about the meaning in your work.

"I am a conceptually based artist who is interested in the sublime elements of a contemporary response to sensualize the unmitigated relationship among the dimensions often seen in the current matrix of society. My work is a means to capture subjectifying elements produced in a culture of transformation. Using acrylic as a way to approach the cutting edge void of the complex historical strategies of history, I often depict the imaginations of historical contexts."

Using a lot of jargon or art speak doesn't really say anything specific, giving us no idea of what the work is truly about. When your statement sounds too complicated and snooty most people will lose interest.

Once you have found your artistic voice and feel confident about the quality of your artwork, you may consider seeking gallery representation.

SEEKING GALLERY REPRESENTATION

The first thing to know is that there are no magic formulas that guarantee your work will get accepted into a gallery. All you can do is follow some basic steps to initiate contact and take it from there.

Before approaching a gallery, research whether the quality, style and subject matter of your artwork will fit in; although it may well be that the gallery is looking for completely different artwork. If possible, visit the gallery, attend some openings and talk to the staff.

Establish initial contact by email—never walk into a gallery with a portfolio unless you're invited to do so. Be polite but direct; tell them you are seeking representation. Add your contact information, including a website link (if you have one) showing current artwork. Do not send images yet. Galleries receive numerous submissions, so it's best to first ask whether they currently accept portfolio submissions, and if so, whether they have submission guidelines. Avoid annoying the gallery by overloading them with unrequested images and information.

If, after a portfolio review, your work is declined, politely thank the gallery for their time and let them know you may submit new work in the future—then move on. Never request a critique or feedback—this is not the gallery's

Dos and don'ts seeking gallery representation

Do	Don't
• Research your target gallery to assess whether your artwork fits.	• Present your artwork unless it is ready. Make the first impression count.
• Find out the name of the gallery owner, director or curator in order to address them by name.	• Show irrelevant or outdated work, this could lose you an opportunity.
• Follow the gallery's submission guidelines to the letter.	• Slack off in communication or neglect to follow through on promises.
• Send in a short bio, but have a long version at the ready if requested.	• Take rejection personally.
• Make sure all your contact information (name, address, phone number, email and web address) is easy to find.	• Ever be rude or disrespectful.

function. Try not to take rejection personally; there can be a multitude of different unknowable reasons why the gallery declined your work. The reality is that galleries have no magic formula for choosing successful artwork either, which explains why so many of them end up closing their doors.

While a gallery can potentially increase your sales and exposure, it doesn't guarantee them. Nor does it mean you can solely concentrate on painting and leave all the marketing up to the gallery. When you become part of a "stable," it is wise to build a personal relationship with your gallery, keep communication channels open, supply the gallery with enough (but not too much) inventory, and arrange your participation in group exhibitions. Make sure you sign a consignment agreement that clearly delineates financial and practical matters.

Although most artists link prestige and status to gallery representation, it is no guarantee for artistic success or sales.

Vanity galleries and vanity publications

In recent years a large number of so-called "vanity" galleries have appeared, offering artists exhibition space for a fee. Likewise, artists are invited to buy pages in "vanity" art books.

While many beginning artists are attracted to the idea of adding exhibitions and/or publications to their résumé, it seldom leads to sales or recognition. Most vanity galleries are located inside secluded office buildings, which makes it unlikely that many people will visit the venue.

The same applies to vanity art books, which are mostly bought by the artists who appear in them. Promises of wide distribution and large mailing lists should be taken with a grain of salt.

These are profitable business models that make a living by tapping into the artist's need for recognition. It is important to be aware of this art world phenomenon—the decision to invest is entirely up to you.

Art galleries
Art galleries can be found in every city and in most towns across the world, from really impressive spaces with high ceilings, to small, cozy, living-room-like settings. Look for representation in a gallery that fits your art in genre, size and quality.

Artists can participate in juried competitions to compete for a chance to exhibit or publish their paintings, build up their résumé and win awards, money and other prizes.

ENTERING JURIED EVENTS

A juried exhibition is a regional, national or international competition in which artists' work is evaluated by one or more judges on skill, style, theme, use of medium and/or some other classification. For a minor entry fee, artists compete for participation in an exhibition (physical or virtual), art publication, gallery representation, a monetary prize or sponsored art supplies. Jury members, often artists, gallerists, publishers or curators, are invited by the organizing body to select the finalists.

Juried competitions are announced in art magazines, online art forums and by art groups. First read the prospectus to find out whether your artwork fits the premise of a juried event. Assess the rules, entry guidelines (by mail or online), entry fee payment (check or credit card), deadline and other practical information. If the competition is for participation in a physical exhibition, be prepared to deliver or ship your painting both ways if selected.

The odds
Sometimes restrictions apply on age, geographical location, residency, medium, style, size or subject matter. Sometimes there are hardly any restrictions and a juried event accepts all media (including photography and multimedia), which increases the amount of participants, considerably lowering your chances. Obviously the odds of winning a small local group event are higher than for winning a renowned international event that attracts thousands of entries.

Participating in a juried event
There are no surefire formulas for winning competitions; the only thing you can do is follow the competition guidelines meticulously to avoid being disqualified and give your artwork a running chance.
• Make sure both you and your artwork are eligible.
• Enter good-quality images only.
• Make sure your images meet all size and format specifications.
• Pay your entry fee.
• Respect the deadline.
• Fill out the entry form legibly and truthfully.
• Keep a copy of all paperwork for future reference, including entry form.

Acceptance and rejection
After you have entered a competition, all you can do is hope the judge or jury panel will notice your artwork and like it enough to select it. While ideally the process of selection happens on a large screen, with the jury taking ample time to study each individual entry, this doesn't always happen in reality. Sometimes the jury preselects entries by viewing thumbnail images, which can result in them overlooking pale, uniform or subtle artworks that do not catch their eye in small-sized formats. Sometimes the high number of entries demands so much time that the jury ends up rushing through the process, viewing each image for just a few seconds.

When dealing with acceptance or rejection, it is wise to take these possible factors into account. Assessing art is highly subjective and realizing this makes rejection less personal and slightly easier to accept. Bearing this in

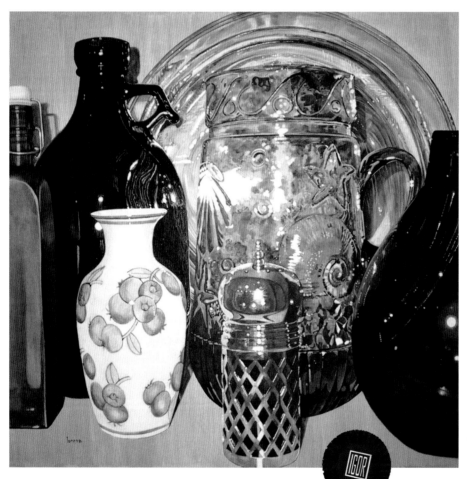

Red dot

At exhibitions you often see little red dot stickers that serve to indicate that the artwork has been sold. Half dots indicate artwork is reserved or "on hold." The purpose of red dots is to maintain the integrity of a show, so that both unsold and sold artworks remain on display until the exhibition closes. The red dot also has a cognitive impact on the status of an exhibition—the higher the number of red dots, the more work has sold, which in turn is linked to perceptions of value, importance and success.

GRANO SALIS
BY LORENA KLOOSTERBOER
24 x 24 inch (61 x 61 cm)
This painting was honored with a Creative Achievement Award at an international juried exhibition. The judges considered the close-cropped angle and detailed textures worthy of an accolade.

mind places acceptance and winning in its proper perspective.

Artists are always hopeful that their artwork will get noticed and earn accolades, yet being centered and realistic will help you weather the highs and lows of juried events. Over time, as you continue to enter juried events, you will realize that both rejection and acceptance are an integral part of your artistic path.

Prizes
Juried events often offer monetary prizes, sponsored art supplies, ribbons, certificates or other appealing rewards and honors.

Most artists welcome solitude and enjoy spending long hours by themselves, toiling in the studio. Yet artists also need creative feedback, support, encouragement and a sense of belonging. Where can you find this sense of community?

ART COMMUNITY

Every artist needs to spend time painting to develop techniques, increase skills and grow artistically. Nevertheless, it is just as important to be part of something larger and to connect with other creatives. Although there may be competition, interacting with other artists gives us energy, inspiration, motivation and the kind of support that only peers can give.

There are a myriad of ways to reach out to fellow artists. Geographic location isn't a factor any more—thanks to the Internet, we can connect with individual artists and artist groups halfway across the globe without even leaving our studio!

Learning and teaching
Some artists attend art schools for a formal education; others are self-taught, acquiring skills through their own efforts without formal training. Because the creative learning process never ends, attending workshops, classes, lectures and other art instruction can prove incredibly enlightening. Learning new skills and interacting with peers in a classroom setting can prove fruitful, especially when you find yourself in a creative rut. Many artists become art instructors and enjoy the give and take of teaching, which in turn can enhance their own creativity.

Artist groups
Local, national and international artist groups accept members either through open membership for anyone who paints or juried membership based on skill level, style and/or medium. For an annual fee, members can participate in physical and/or online exhibitions, workshops, lectures and other art-related activities. Artist groups also offer exposure through their websites and promote their raison-d'être and agenda, which may be based on a style (e.g., realism), a technique (e.g., plein-air painting) or a medium (e.g., acrylics). Based on the premise that there is strength in numbers, these groups give artists a sense of community and belonging, and offer the opportunity to compete and connect with fellow artists.

Artist websites
The Internet has made it incredibly easy to look at art from around the globe, to discover new artists and techniques and become inspired. Compared to art books it has the great advantage of allowing us to easily communicate with an artist if we feel the need to comment or ask a question. Many artists' websites link to other artists and/or artist groups. Artists' blogs offer interesting content, touching on topics such as thought processes, techniques, product reviews and art theories.

Social media
Social media offer a highly accessible virtual meeting place where people can share information, images and videos. Social networking sites such as Facebook, microblogs like Twitter and content communities such as YouTube all fall under the label of "social media." This relatively new phenomenon has spawned a globally interconnected society of artists of all levels, who share their artwork (in progress and/or finished) and talk to each other about life and art. These are wonderful systems to get inspired, give and receive support and advice and find friendship among peers.

Art attracts unsolicited opinions from virtually everybody. While nobody is likely to scrutinize, let alone criticize, the handiwork of a plumber, doctor, postal worker or store clerk, artwork is judged openly and freely all of the time.

CRITIQUE VERSUS CRITICISM

Juried exhibitions
Entries for juried exhibitions are usually requested in digital form, but sometimes artists are asked to present the artwork in person. Be prepared to stand in line!

Artists continue to create, even though well-intentioned opinions and harsh criticism can be painful and devastating. It's important to distinguish legitimate evaluation from thoughtless remark. All artists need feedback, so it is up to us to place others' opinions in the right context. Consider the difference between criticism and critique:

• Criticism is an expression of disapproval on the basis of perceived faults or mistakes. Criticism is negative, destructive and mostly futile.
• A critique is a detailed evaluation of artwork in the context of aesthetics, skill and technique. Critique is positive, constructive and often useful.

It is just as hard to give a critique as it is to receive one. Consider the following strategies:

Receiving a critique
• Only request a critique from knowledgeable people whose opinion you trust. The most valuable critique comes from fellow artists or art teachers who understand your methods and techniques.
• Only request a critique to improve yourself—never as a substitute for attention.
• Seriously consider the critique—it can prove highly enlightening.
• It is your choice whether or not to implement the advice.
• Never take a critique personally—it is about the artwork.

Giving a critique
• Only give a critique on request, in a safe environment or privately.
• A critique never involves cruelty or ridicule—it is based on support and understanding.

• Emphasize both the strengths and weaknesses, and clarify them.
• Avoid speaking in absolutes—say "I think it is …" instead of "It is …"
• Limit your advice to three or four concrete points for improvement.
• Give practical, specific suggestions.
• Your advice need not be taken and that's okay.

Dealing with criticism
Most unsolicited comments are not based on an understanding of the creative process or technique, but are given from a subjective viewpoint that reflects more on the commentator than the artwork. Although words can wound and dishearten, you should always try not to feel offended. Ask yourself the following questions:
• Does this person have the authority and expertise to evaluate my artwork?
• Is it constructive criticism intended to help, or is it meaningless criticism intended to hurt?
• Does the remark offer me any useful information?

Artists want their artwork to be seen and enjoyed by as many people as possible. To stimulate interest, why not create fine-art reproductions and printed products?

GETTING YOUR ARTWORK NOTICED

Artists are frequently tempted to give away their paintings to those who express admiration and interest, whether out of sheer generosity, hoping to create goodwill or for promotional purposes. Giving your art away for free has several disadvantages: it doesn't generate income, it depletes inventory and it deprives you of the chance to exhibit that piece. It devalues your artwork, because free things are usually considered irrelevant. Giving away art also disturbs the art market and invalidates the efforts of fellow artists and galleries.

Still, you want your artwork to reach a wide audience, gain a following and get people talking—not only at exhibitions but everywhere.

Consider having your paintings reproduced as giclées (see below), postcards or in little booklets, or printed on a variety of functional objects, such as office supplies or clothing. These are all excellent options of getting your artwork noticed without giving away the original painting. You can create these items as gifts for family and friends, or use them as promotional handouts. You can charge enough to cover your costs or sell for profit to people who can't afford to buy the original artwork.

Giclées

A giclée is a high-quality fine-art print that is an exact visual replica of the original artwork. It is fairly easy to have a giclée made by a specialized printer. You can order one or multiple giclées, on paper or on canvas, and in different sizes. Many artists supplement their income by selling fine-art giclées at exhibitions or through their website. Selling giclées is a great solution when a painting has sold but continues to generate interest.

Art books

Self-publishing has become extremely popular in recent years. Create your own fine-art book with an on-demand web-based printing service. Consider having a fellow artist or art teacher write the introduction.

Internet printing services

Online suppliers of printed-on-demand products offer a relatively inexpensive way to get your work out to a wider market. It is fairly easy to upload a high-resolution photo of your painting, use a template and add a caption to produce a custom-made art object.

Desk and wall calendars, which showcase 12 paintings make original and practical gifts, especially during the holiday season.

Having postcards and greetings cards printed with your images is a great way to show your artwork, so get (back) into the habit of mailing paper greetings cards for birthdays, holidays and other occasions. Many artists sell their fine-art postcards and greeting cards at exhibitions and on their website. Business cards with your website address are convenient and look much better than a scribbled URL on a paper napkin.

Stylish brochures and mini photobooks are a quick and easy introduction to your artwork. Easy to carry, they are a clever way to instantly show your paintings without the need for long explanations.

And don't restrict yourself to images printed on paper: mugs, tote bags, T-shirts, baseball caps, pens, note pads and magnets—there's almost no end to the list of things on which images can be printed. Add your name and website address whenever possible.

As artists, we are judged by our behavior as well as by the work we create, so it is vital to behave ethically, and within the confines of the law.

ETHICS AND COPYRIGHT

Promotional material
Print-on-demand leaflets and postcards of your work are a relatively inexpensive way to produce promotional material for yourself as an artist.

In this age of social media, falsehoods and misconduct surface faster than ever before. Words and actions that used to be private have become public. Photographs and paintings are easily compared, uncovering copycats and artists lying about the provenance of reference material.

Of course, everybody makes mistakes and everyone has the right to a personal opinion—but it is important to be aware of how your actions reflect on you as an artist. A lapse of judgment or a few tactless words may ruin your reputation, future sales and opportunities.

Do everything you can to build up a good reputation:
• Be truthful—on your résumé, on entry forms and everywhere else. When you commit to doing something, follow through.
• Be fair and respectful of others: do not use insulting, belittling or abusive language. Eschew any form of prejudice, racism and sexism.
• Avoid criticizing fellow artists, especially young and/or beginning artists. Be supportive—if you don't have anything positive to say, don't say anything. Only critique work when requested to do so—and keep the critique private.
• If you do make a mistake, apologize—and rectify your oversight immediately.

Understanding Copyright
Copyright is a legal concept giving the creator of an original artwork exclusive ownership rights for its use, display, distribution, sale and the option to create derivative work (that is, new artwork adapted from the original). Ideas are not protected, but must first be expressed in material form to fall under copyright laws.

Copyright laws and agreements between countries differ slightly, but most conventions are similar to US copyright law. When you create artwork, the copyright is automatically yours for free, for the duration of your lifetime and for up to 70 years after your death. Numerous artists' trusts extend copyright beyond those years, so be careful when using vintage artwork in your painting. For a fee, your national Copyright Office will research whether copyright applies.

Copyright is shown by the © symbol. You can choose to write it on the back of your painting, next to your name and the year. But even without this symbol, the copyright is yours.

To allow others the use of your creative work (including photographs), you must give them written permission. Likewise, you need written permission to use someone else's creative work. The sale of a painting does not automatically include the sale of its copyright, so even when artwork is sold, the artist retains the right to make reproductions and derivative works. You can choose to sell the copyright to the buyer of the artwork, which needs to be stated in a contract. This sometimes occurs when artwork is purchased for commercial use.

Copyright infringement is punishable by law. It is wise to keep records of your reference material, such as photos and sketches, as proof of your creative process.

Once the statutory term of a copyright expires, the artwork enters the public domain and becomes free for use by anyone. Note that the fact that artwork appears in public (for example, on the Internet) does not automatically mean it is in the public domain.

GLOSSARY OF ART TERMS

The vocabulary of artists contains many technically specific words, some of which have ambiguous or contradictory meanings. Sometimes the gist of such words can only be deduced from the context they appear in. Here are some of the most used words in regards to painting in acrylics; many other terms are explained within the text.

Achromatic Having no color or hue. Blacks, whites, grays and most browns are achromatic. Obtained by mixing complementary colors.

Acid free A painting surface with neutral pH that will yellow or darken less with age.

ACMI Art and Creative Materials Institute, an international organization promoting safety in art products through certification.

Acrylic A type of water-soluble paint with pigments suspended in an acrylic polymer resin binder that dries to a hard, durable, waterproof plastic film.

Acrylic gesso Preparation of acrylic polymer binder, chalk and pigment.

Additive Ingredient added to acrylic paint or medium to support a painting technique. It evaporates during the drying process and does not influence the final look of the paint.

Airbrush A handheld air-operated spraying tool that nebulizes paint by way of a compressed (fast-moving) airstream.

Alla prima Italian term meaning "first attempt" or "at once." 1. It describes a painting that is finished in one sitting. 2. It describes said technique.

Analogous colors Colors adjacent or next to one another on the color wheel.

Artistic license To apply your own artistic vision, regardless of rules, theories or what reality looks like.

ASTM The international quality standard granted by the American Society for Testing and Materials.

Atelier French word meaning "workshop." Used to describe an artist's studio.

Bias *See* Color bias.

Binder A paint ingredient that holds (binds) pigments together. Also called vehicle.

Bleeding Occurs when one wet color unintentionally flows or migrates into another wet color.

Blending Painting technique that achieves a gentle, gradual transition from one color or value to the next.

Blocking in A first painting stage when areas of color are put down.

Bloom Irregular shapes occurring when one wet color floods into another. Also called backrun, backwash, blossom, oozle or runback.

Body Refers to the relative fluidity or thickness of the paint. *See* Viscosity.

Body of work A term that describes the collection of paintings an artist has made in a certain style, approach or technique.

Brilliance The purity of a color or absence of a muddy tone in a color.

Brunaille A grisaille using brown tones. *Also see* Grisaille.

Canvas 1. A textile, such as cotton, linen, hemp, sacking, muslin or sailcloth, that is stretched over a frame to make a surface to paint on. 2. Any surface to which paint is applied: textile, wood, board. 3. The painting as a work in progress.

Chiaroscuro From Italian *chiaro* meaning "light" and *oscuro* "dark." A painting style using a range of values in sharp contrast to create the illusion of space and depth. Examples are paintings by Caravaggio and Rembrandt.

Chroma The intensity (purity) and saturation of a hue. Also called chromaticity.

Chromatic black A mix of colors forming a near-black not containing any black pigments.

Chromaticity *See* Chroma.

C.I. *See* Color index.

Color The most basic element of paint. Every color has three characteristics: hue (name), value (tone) and chroma (saturation).

Color bias Color influenced by a neighboring hue on the color wheel. For example, a red can tend toward orange (warm) or toward violet (cool). Also called undertone.

Color Index (C.I.) A code and number that identify the chemical composition of a pigment.

Color index name Precise way of defining the pigment used in paint as assigned by an internationally accepted standard.

Color shift A slight darkening of color after the acrylic polymer clarifies during the drying process.

Color temperature The warmness or coolness of a color. *See* Color bias.

Complementary colors Two colors

on opposite sides of the color wheel. When placed next to each other they make each other appear brighter. When mixed together, they cancel each other out. Also called complementaries.

Composition The arrangement of all the structural elements within a painting, such as color, patterns, shapes, lines, highlights and shadows.

Cool colors The blue/green/violet side of the color wheel. The colors appear to recede toward the back of the picture plane. *Also see* Warm colors.

Crazing Small, interlacing cracks on the surface of paint or varnish.

Critique Detailed evaluation of artwork in the context of aesthetics, skill and technique. Verb: critiquing.

Crosshatching Shading technique built up through a series of thin parallel strokes at right angles or varying directions that create a mesh-like pattern. *Also see* Hatching.

Deckle edge Ragged irregular edge formed during the handmade papermaking process found on some watercolor papers.

Desaturated color Color that is toned down by adding white, gray or black, or by mixing it with its complementary color.

Dry-brush Painting technique using a small amount of paint on a dry brush, producing a broken, scratchy effect.

Dyad Color scheme built from two colors equally spaced around the color wheel.

Earth colors Neutral colors (not found on the color wheel) such as browns, beiges, grays and ochers, or colors made by mixing complementary hues.

Etcetera effect A series of repetitive abstracted marks or a pictorial impression suggesting the flow and continuation of a precisely painted realistic subject in the foreground. Sometimes used to paint lettering, foliage, grass and other complex repetitive subject matter.

Ferrule Part of the paint brush that holds the hairs onto the handle.

Filler Relatively cheap substance mixed with pigment to extend paint volume, used in student-quality and cheaper paints.

Flat wash Area of one even color and value.

Focal point The main subject or element in a painting that attracts the viewer's attention first.

Foreshortening A technique used in perspective to create the illusion of an object receding into the distance.

Format The shape or dimensions of a painting surface. Format or size is always indicated in height x width. *Also see* Landscape format, Portrait format.

Fugitive colors Colors that are neither lightfast nor permanent, which will eventually fade.

Gesso (acrylic) Preparation of acrylic polymer binder, chalk and pigment, used as a ground.

Glaze 1. Thin transparent layer of color applied to the surface of a painting to modify colors and/or values. 2. An acrylic mixing medium that adds transparency and spreading ability to paints.

Gradation A painting technique that creates a gradual change from a color or value into another color or value in order to create forms that appear three-dimensional.

Graduated wash One color area progressing in value from dark to light.

Granulation Mottled or speckled effect when pigments settle into a coarse surface as the paint dries.

Gray scale Progression of tones from the lightest light to the darkest dark. *Also see* Value scale.

Grisaille From the French word *gris*, meaning "gray." An (under)painting in gray tones that establishes the structure and values of a painting.

Ground Coating applied on a surface before paint is applied.

Hatching Shading technique built up through a series of thin parallel strokes that can be short or long, close together or farther apart. *Also see* Crosshatching.

Highlights Areas that have the lightest value.

Hue 1. A specific color. 2. The name of a color. 3. Another word for the word "color." 4. On a paint label it indicates that other pigments were used for the referenced color.

Impasto From Italian meaning "dough" or "paste." The technique of heavily applying paint with a brush or a painting knife.

Imprimatura Italian term meaning "first paint layer." The first thin layer of paint to color the white ground. Also called underpainting.

Interference Paint that changes color depending on viewing angle.

Intermediate colors *See* Tertiary colors.

Iridescence Luminous colors that appear to change when viewed from different angles. In nature, as seen on some bird feathers, soap bubbles, oil slicks and sea shells.

Iridescent Paint that reflects light and appears to change color and sheen depending on viewing angle.

Knock back To mix tiny amounts of the complementary into a color to tone it down.

Kolinsky sable A natural animal hair used in top-quality artist's brushes. The hair is dark red along its length, turning black at the tip.

Landscape format A horizontal rectangle that is wider than it is tall. This format can be used for any subject matter, not just for painting landscapes. *Also see* Portrait format.

Lifting out A technique that removes paint from a painting to create highlights, usually done by brush or sponge.

Lightfastness The measurement of a pigment's resistance to fading under prolonged exposure to light.

Local color The actual hues on the surface of an object, usually reflected off other objects nearby.

Low Countries The region of what today are Belgium (Flanders) and the Netherlands.

Mark making A term that describes the different lines, textures, patterns or brush strokes created in a painting.

Medium 1. (plural: mediums) A binder or vehicle for pigment; a polymer emulsion that modifies the handling properties or appearance of acrylic paint, which can also be used on its own. 2. (plural: media) A broad term for drawing or painting material, such as oils or acrylics.

Monochrome (monochromatic) A range of tones or variations of a single color.

Negative space Areas in a painting between, around or beyond the objects that form part of the composition.

Neutral color Neither a warm nor cool color. Sometimes referring to colors not included on the color wheel and not associated with a hue, such as browns, grays, whites and blacks. Neutrals result from combining two complementary colors.

Neutral colors Colors toned down by adding white, gray or black, or by mixing them with a complementary color.

Opaque (opacity) The covering ability of paint in that it does not allow light to pass through. It is the opposite of transparent.

Open time The interval of time that acrylic paint stays wet and workable.

Overspray Miniscule airborne paint droplets produced by an airbrush.

Painterly Term used to describe a painting style that embraces, shows and honors the medium it's created in rather than hiding it.

Palette 1. Receptacles made of wood, metal, plastic or glass used by the artist for mixing paint. 2. Figuratively, the range of colors used by the artist.

Permanence The length of time a pigment retains its original color.

Pigment The color element in paint. Dry, ground and powdered color that is mixed into a medium such as acrylic polymer resin to make a chromatic paint. There are thousands of natural and synthetic pigments available, which all behave differently.

Plein air Painting done outside instead of inside the studio. From French *en plein air* meaning "in the open air."

Portrait format A vertical rectangle that is taller than it is wide. This format can be used for any subject matter, not just for portraits. *Also see* Landscape format.

Primary colors Yellow, red and blue—the colors that can't be made by mixing others. Also called primaries.

Properties Another word to describe characteristics, qualities, traits, attributes.

Retarder An additive added to acrylic paint to extend its open time, formulated to slow (retard) drying.

Rheology The kind of flow and elasticity of acrylic paint and mediums. Short rheology refers to a semi-solid consistency; long rheology refers to a "syrupy" consistency.

Saturation The purity and strength of a color. Paint as it comes from the tube is at maximum saturation; once other hues are added, saturation decreases.

Scumbling A technique where a thin or broken layer of color is brushed over another so that patches of the color beneath show through.

Secondary colors Green, orange and violet—made by mixing two primaries.

Sgraffito From the Italian word *sgraffire* meaning "to scratch." A technique in which a top layer of color is scratched to reveal the color beneath.

Shade A color with black or other dark color mixed into it, creating a darker version.

SID *See* Support induced discoloration.

Spattering A technique that creates random droplets of paint.

Staining power A pigment's ability to transfer color.

Still life (plural: still lifes) A painting of primarily inanimate objects.

Stippling A technique that applies small dots of color with the tip of a brush.

Stretcher bar The wooden frame that canvas is stretched and attached onto.

Studio The artist's workroom or workshop. *Also see* Atelier.

Study A practice painting made in order to capture the essence of a subject or scene, or to evaluate a composition.

Support induced discoloration (SID) Discoloration occurring when impurities leach out from a porous substrate and react with the ground or acrylic paint.

Temperature Refers to the warmness or coolness of a color. *Also see* Color bias.

Tertiary colors 1. The six colors between primaries and secondaries on the color wheel: red-orange, yellow-orange, yellow-green, blue-green, blue-violet and red-violet. 2. Brown tones (russet, citrine and olive) made by mixing all three primaries in different proportions. Also called intermediate colors.

Tetrad Color scheme built up from four colors equally spaced around the color wheel.

Thumbnail Small, rough sketch delineating the elements of a future painting to further develop an idea or try out different compositions.

Tint A lighter value of a color made by adding white.

Tinting strength The degree of intensity in which a particular color or pigment affects another one when mixed with it.

Tip dry Dried paint build-up on the needle of an airbrush, causing erratic spray patterns due to clogging.

Tone The lightness or darkness of a color, rather than actual hue. Also called value.

Tooth The surface texture (smooth to rough) of a painting surface to which the paint will cling.

Toxicity The level of poison of a pigment.

Triad Color scheme built up from three colors equally spaced around the color wheel.

Trompe l'oeil French term meaning to "fool the eye." Paintings that create a powerful illusion of depth and three-dimensionality.

Underpainting The first layers of paint established in a painting, before any details are painted.

Ultraviolet light stabilizers (UVLS) Ingredient that slows the effects of ultraviolet light on color lightfastness.

Undertone The color seen when a paint color is spread very thinly. *Also see* Color bias.

Value The lightness or darkness of a color, rather than actual hue.

Value scale Progression of tones from the lightest light to the darkest dark. *Also see* Gray scale.

Variegated wash Area where colors bleed into each other.

Varnish A transparent, protective coating added to a finished, dry painting.

Veil A thin transparent layer of paint that produces a veil or fog. Useful to lighten areas or tone down colors.

Velatura Italian for "veil."

Verdaille A grisaille using muted green tones (a base traditionally used for the underpainting of skin tones). Called *verdicchio* in Italian. *Also see* Grisaille.

Viscosity Refers to the relative fluidity or thickness of the paint. Low viscosity is fluid or liquid, high viscosity is buttery or thick. Also called body.

Warm colors The red/orange/yellow side of the color wheel. These colors appear to advance toward the foreground. *Also see* Cool colors.

Wash Thin, fluid, usually translucent coat of paint, usually over large areas. *Also see:* Flat wash, Graduated wash, Variegated wash.

Wet-in-wet Painting technique where wet paint is applied to a wet surface, so that colors can blend and mix together on the painting surface.

Wet-on-dry Painting with fresh wet paint applied onto a layer of dry paint.

Wet-to-dry color shift Slight darkening of color when the acrylic polymer clarifies during the drying process.

C.I. PIGMENT CHART

Pigments—both natural and synthetic—fall into two categories: organic (modern) and inorganic (mineral).

• Organic pigments can be recognized by their modern-sounding names, such as Quinacridone and Phthalo. Organic pigments are usually transparent (ideal for clean vivid glazes), and offer high chroma and high tinting strength.

• Inorganic pigments can be recognized by their natural-sounding names that reflect their origins, such as Cadmium, Oxide, Umber, Ocher and Sienna. Inorganic pigments are usually opaque, and offer relatively low chroma and low tinting.

C.I. PIGMENT CODE	PIGMENT NAME	COLOR EXAMPLE	OPACITY
PB = Pigment Blue			
PB 15	Copper Phthalocyanine	Phthalo Blue, Phthalo Turquoise	Transparent
PB 28	Oxides of Cobalt and Aluminum	Cobalt Blue	Semi-opaque PB 29
PB 29	Complex Silicate of Sodium and Aluminum with Sulfur	Ultramarine Blue (Green Shade)	Semi-opaque, Opaque
PB 35	Coeruleum	Cerulean Blue	Opaque
PB 36	Oxides of Cobalt and Chromium	Cobalt Turquoise, Cerulean Blue	Opaque
PB 60	Anthraquinone/Indanthrone/Indanthrene Blue	Indanthrene Blue	Semi-opaque, Transparent
PB 73	Cobalt Silicate	Cobalt Blue	Semi-opaque
PBk = Pigment Black			
PBk 6	Carbon Black	Lamp Black	Opaque
PBk 7	Amorphous Carbon	Carbon Black	Opaque
PBk 9	Amorphous Carbon (charred animal bones)	Ivory Black, Bone Black	Semi-opaque
PBk 10	Crystallized Carbon/Graphite	Graphite Gray	Semi-opaque
PBk 11	Synthetic Black Iron Oxide	Mars Black	Opaque
PBk 19	Hydrated Aluminum Silicate	Gray	Transparent
PBk 31	Perylene	Perylene Green	Transparent

As of June 2014, the European Union is considering the restriction or ban of cadmium pigments.

C.I. pigment code

Each C.I. code starts with one set of letters, indicating the color family it belongs to. The number behind the letters identifies the chemical pigment.

PB = Pigment Blue
PBk = Pigment Black
PBr = Pigment Brown
PG = Pigment Green
PO = Pigment Orange

PR = Pigment Red
PW = Pigment White
PV = Pigment Violet
PY = Pigment Yellow

PBr = Pigment Brown			
PBr 6	Mixture of Synthetic Iron Oxides	Mars Yellow	Opaque, Semi-opaque
PBr 7	Natural Iron Oxide	Raw Sienna, Burnt Sienna	Opaque
PBr 7	Natural Iron Oxide with Manganese	Raw Umber, Burnt Umber	Opaque
PBr 24	Chrome Titanium/Chrome Antimony Titanate	Naples Yellow, Golden Yellow	Opaque
PBr 25	Benzimidazolone	Van Dyke Red	Semi-opaque
PG = Pigment Green			
PG 7	Chlorinated Copper Phthalocyanine	Phthalo Green, Turquoise, Viridian Hue	Transparent
PG 17	Anhydrous Chromium Sesquioxide	Chrome Oxide Green	Opaque
PG 26	Cobalt Chromium Oxide/Cobalt Chromite Green Spinel	Cobalt Green	Semi-opaque
PG 36	Chlorinated and Brominated Copper Phthalocyanine	Phthalo Green (Yellow Shade)	Transparent
PG 50	Cobalt Titanate	Green, Teal, Turquoise, Cobalt Green	Opaque
PO = Pigment Orange			
PO 20	Cadmium Sulphoselenide	Cadmium Orange	Opaque
PO 36	Benzimidazolone	Orange	Semi-opaque
PO 43	Perinone Orange	Perinone Orange	Opaque
PO 48	Quinacridone	Quinacridone Orange	Transparent
PO 71	Diketopyrrole-pyrrole	Transparent Pyrrole Orange	Transparent
PO 73	Diketopyrrole-pyrrole	Pyrrole Orange	Opaque

PR = Pigment Red			
PR 5	Naphthol ITR	Naphthol Crimson	Transparent
PR 9	Naphthol	Naphthol Red, Vermillion Hue	Semi-opaque
PR 101	Synthetic Iron Oxide Red	Burnt Sienna, Red Iron Oxide	Opaque
PR 101	Transparent Iron Oxide Red	Red Ocher, Red Iron Oxide	Transparent
PR 102	Natural Iron Oxide	Light Red	Semi-opaque
PR 108	Cadmium Sulphoselenide	Cadmium Red, Cadmium Scarlet	Opaque
PR 112	Naphthol As-D	Naphthol Red Light	Opaque
PR 122	Quinacridone Magenta	Magenta, Deep Purple	Transparent
PR 149	Perylene	Perylene Red	Semi-opaque
PR 170	Naphthol Carbamide	Naphthol Crimson	Transparent
PR 175	Benzimidazolone Red	Brown Madder	Semi-opaque
PR 177	Anthraquinone	Quinacridone Red	Transparent
PR 179	Perylene	Perylene Maroon	Semi-opaque
PR 188	Naphthol As	Naphthol Scarlet Lake	Semi-opaque
PR 202	Quinacridone	Quinacridone Red	Transparent
PR 206	Quinacridone	Quinacridone Burnt Orange	Semi-opaque
PR 207	Quinacridone	Quinacridone Red	Transparent
PR 209	Quinacridone Red Gamma	Quinacridone Red, Crimson	Transparent
PR 233	Calcium, Tin, Silica, Chromium Oxide	Pink	Semi-opaque
PR 254	Diketopyrrole-pyrrole	Pyrrole Red, Pyrrole Scarlet	Opaque
PR 255	Diketopyrrole-pyrrole	Pyrrole Red	Opaque
PR 264	Diketopyrrole-pyrrole	Crimson	Opaque
PR 270	Diketopyrrole-pyrrole Transparent	Red	Transparent

PW = Pigment White			
PW 4	Zinc Oxide	Zinc White, Mixing White	Semi-opaque
PW 5	Lithopone	Zinc White	Semi-opaque
PW 6	Titanium Dioxide Rutile	Titanium White	Opaque

PV = Pigment Violet			
PV 15	Polysulfide of Sodium-alumino-silicate	Ultramarine Violet, Purple	Transparent
PV 19	Quinacridone Violet	Quinacridone Violet	Transparent
PV 23	Carbazole Dioxazine	Violet, Dioxazine Purple	Semi-opaque
PV 29	Perylene	Perylene Violet	Transparent
PY = Pigment Yellow			
PY 1	Arylide Yellow/Micaceous Iron Oxide	Arylide Yellow, Hansa Yellow	Semi-opaque
PY 3	Arylide Yellow 10g/Micaceous Iron Oxide	Hansa, Arylide, Azo Yellow	Transparent, Semi-opaque
PY 35	Cadmium Zinc Sulphide	Cadmium Yellow	Opaque
PY 37	Cadmium Sulphide	Cadmium Yellow	Opaque
PY 42	Synthetic Iron Oxide	Earth Yellows, Yellow Oxide	Opaque
PY 42	Transparent Iron Oxide Yellow	Yellow Ocher, Transparent Raw Sienna	Transparent, Semi-opaque
PY 43	Natural Hydrated Iron Oxide	Raw Sienna	Opaque
PY 53	Oxides of Nickel/Antimony and Titanium	Yellow	Opaque
PY 65	Arylide Yellow/Micaceous Iron Oxide	Yellow	Semi-opaque
PY 73	Arylide Yellow	Hansa Yellow	Semi-opaque
PY 74	Arylide Yellow 5gx/Micaceous Iron Oxide	Arylide Yellow, Azo Yellow	Opaque, Transparent
PY 83	Diarylide Yellow Hr-70	Azo Yellow Orange	Opaque, Transparent
PY 84	Bismuth Vanadate	Bismuth Yellow	Opaque
PY 97	Arylide/Diarylide Yellow	Hansa Yellow	Semi-opaque
PY 101	Iron Oxide	Greenish Yellow, Yellow Ocher	Opaque
PY 110	Isoindolinone	Deep Yellow, Indian Yellow	Transparent
PY 129	Azomethine Copper Complex	Golden Green	Semi-opaque
PY 139	Isoindolinone	Indian Yellow	Semi-opaque
PY 150	Nickel Azo Pyrimidine/Nickel Complex Azo	Greenish Yellow	Transparent
PY 184	Bismuth Vanadate	Bismuth Yellow, Cadmium Yellow Hue	Opaque

INDEX

Quarto would like to thank the following artists, agencies and manufacturers for supplying images for inclusion in this book:

ARTISTS
Abeling, Johan, www.johanabeling.nl, pp.147t, 277b; Agee, Bill, http://billyacrylic.com, p.182t; Akib, Hashim, www.hashimakib.com, pp.150, 153b; Anderson, Freda, www.fredaanderson.co.uk, pp.111, 112, 113; Antoniou, Marie, www.marieantoniou. com, pp.252b, 285; Ayal, Livia, http://liviaayal.com, p.268c; Baker, Alix, www.alixbaker.com, p.277t; Bandurka, Angela, ©2013 www.AngelaBandurka. com, p.209l; Banthien, Barbara, www.banthien. com, p.252t; Bening, Becky, pp.17tm, 30t, 134, 135, 174bl/br; Bennett, Stephen, www.theportraitpainter. com, www.facesoftheworld.net, pp.232t, 234; Bissett, Robert, www.robertbissett.com, p.283t; Blair, Dru, www.drublair.com, pp.72l, 109c/bl, 195, 196, 197, 247b; Blair, Sandra, ©2014 www.sandrablair.com, pp.246, 248b; Boutet, Claude, p.94b; Bowley, Flora, www.florabowley.com, p.12br; Budan, Mandy, www. abstractlandscapepainting.com, pp.273b, 281tcl, 282tr; Buffington, Hank, www.hankbuffington.com, pp.132, 257t; Burridge, Robert, www.robertburridge. com, p.13b; Caldwell, Steve, www.stevecaldwell. co.uk, p.243; Carter, Carol, www.carol-carter.com, pp.228–229t/b, 262–263l; Cassells, Laara, www. laaracassells.com, pp.199c, 243l; Castellanos, Andrés, www.andrescastellanos.com, p.233; Castelli, Adriano, Shutterstock.com, p.301b; Chadwick, Mark, www. markchadwick.co.uk, pp.131tc, 156tr; Chupack, Jeanette, www.jchupackart.us, p.273t; Cleary, Melody, www.melodycleary.com, p.259tr; Colclough Thomas, William, www.williamthomasart.com, p.227t; Crisp, Jane, www.janecrisp.co.nz, p.124tr; Curtis, Linda, http://paintingsbylindacurtis.us, p.269; Delanty, Rick J, www.delantyfineart.com, pp.264b, 285; Denman, Andrew, www.andrewdenman.com, pp.89br, 123b, 158b, 160t; Doehler, Flora, http:// floradoehler.ca, pp.58b, 70r, 90tl/tr, 131tr, 177, 229br, 285; Douglas, Neil, www.neildouglas.com, pp.11l, 127, 175tl; Eddy, Don, www.doneddyart.com, pp.93tcr, 106–107, 193b; Fenelon, Dan, © copyright 2007, www.danfenelon.com, p.9t; von Goethe, Johann Wolfgang, p.95tl; Gould, Shawn, www.shawngould. com, pp.166t, 253b, 285; Grégoire, Kenne, www. kennegregoire.com, p.201t; Groves, John, www. johngrovesart.co.uk, p.12tr; Haghighi, Raoof, www. raoofhaghighi.com, pp.34b, 162; Hampton, Keith J., www.itsallart.com, p.282b; Howard, Ashton, www.ashtonhoward.com, pp.264t, 281tr; Jeong, Joongwon, http://blog.naver.com/carandini, p.235b; Karpinsky, Lena, www.ARTbyLENA.com, pp.43tl, 69b; Kennedy, Reenie, www.reeniekennedy.com, p.12tl; Kowch, Andrea, www.andreakowch.com, p.92; LaSaga, Brian, www.brianlasagarealism.com, pp.199tl, 202b, 283b; Lukasiewicz, Michal, www.lukasiewicz. exto.be, p.280; Lynn, Linzi, © copyright 2008, www. linzilynn.com, p.10br; MacEvoy, Bruce, © copyright 2009, www.handprint.com, p.96; Manley, Michelle, © Copyright 2008, www.michellemanley.com, p.271br; Marette, Eric, www.facebook.com/eric.marette.5, pp.154, 249t; McArdle, Thaneeya, www.thaneeya. com, p.28b; McCord, Linda, www.lindamccord. com, p.137t, 213b, 232b; Meredith, Raette, www. artbyraette.com, p.175tr; Mewborn, Michael, michaelmewbornart.com, p.42; Murray, Linda, www. artbytheriver.com, p.190b; Naylor, David, http:// davidnaylorpainter.com, pp.93tcl, 101; Nelson, Mark Daniel, www.markdanielnelson.com, pp.206–207l,

214–215, 218b–219, 240–241, 254–255, 270–271, 278–279; Northrup, Tammy, www.myflowerjournal. com, p.182b; Oakley, Paula, www.paulaoakley.co.uk, p.216b; Ohnemus, Pamela, www.pamohnemus. com, p.12bl; Okai Davis, Jeremy, http://work. jeremyokaidavis.com, p.130; Pence, Barbara Louise, www.bpenceart.com, p.149b; Peperkamp, Jantina, www.jantina-peperkamp.nl, pp.11r, 235t, 247t; Pérez, Luis, www.luis-perez.com, p.123t; Persson, Hazel, www.fineartamerica.com/art/all/hazel+persson/ all, p.100; Purcell, Debra, http://debradenisepurcell. fineartstudioonline.com, p.10bl; Quiller, Stephen, www.quillergallery.com, pp.17tl, 21t; Rippington, Stephen, www.stephenrippington.co.uk, pp.93tl, 111, 112, 113; Runge, Philipp Otto, pp.93tr, 95tr; Russell, Andy, www.andyrussell.com, p.13t; Sacran, Jason, www.jasonsacran.com, pp.257b, 266–26/, 274–275; Santander, Cesar, © copyright 2014 www. cesarsantander.com, pp.131tl, 194t, 212b, 223tr; Saunders, Raechel, www.raechelsaunders.com, p.187b; Saura, Carlos, www.carlos-saura.net, p.217t; Scaglia, Ken, © 2009–2011 www.kenscagliastudios. com, pp.126t, 129, 213t; Schonzeit, Ben, www. benschonzeit.com, p.198; Schrijver, Michiel, www. michielschrijver.nl, p.8r; Scotti Franchini, Beatriz, www.beatrizscottifranchini.com, p.142; Seemel, Gwenn, www.gwennseemel.com, pp.10tr, 242, 248t; Sidaway, Ian, http://iansidaway.co.uk, pp.111, 112, 113; Simmons, Gregory, www.gregsimmonsart. com, pp.43c, 167t, 259tl; Simons, Brian, www. briansimons.com, pp.201tb, 285; Sims, Carol, www. carolsimsartist.com, p.227b; Solberg, Morten E., www.mortenesolberg.com, pp.43tr, 226; Stevens II, Roderick E, IGOR, www.yesitsapainting.com, pp.218t, 223tl, 281tl; Sundell, Lexi, www.lexisundell. com, p.10tl; Taira, Hisaya, www.ne.jp/asahi/tir/art/, pp.203, 276b; Tajik, Mojtaba, www.assarartgallery. com/main/artists/mojtaba_tajik, ©Assar Art Gallery, pp.200, 207r; Tauchid, Rhéni, www.rhenitauchid.com, p.30bl; Tiessen, Josh, www.joshtiessen.com, pp.91tl, 265t, 285; Tyler, Elizabeth, www.elizabethtyler. com, pp.258, 263tr; Wallace Jacobs, Louisa, www. louisawallacejacobs.com, p.159t; Wentzell, Cindy, www.cindywentzell.com, pp.256, 272; Wessmark, Johannes, www.johanneswessmark.se, p.75t; White, Ralph, www.ralphwhite.com, p.9b; Willard, Peter, http://pjwart.tumblr.com/, p.178b; Yaki, Nancy, www.nancyaki.com, p.8l; Zamora, James, www. jameszamora.com, pp.91tr, 209r, 222;

All other gallery art by **Lorena Kloosterboer**, www.art-lorena.com

AGENCIES AND MANUFACTURERS
Courtesy of **BLICK art materials**, www.dickblick. com, pp.53t, 54l, 2nd from left and far right, 55r, 70tc/ tr, 77cl/cr, 121tl, 180b 2nd and 4th from left, 292cb; Calvio, Martina, p.115tr; © 2014 **Christie Digital Systems**, www.christiedigital.co.uk, p.121tr; © 2014 **Daler Rowney**, www.daler-rowney.com, p.18bl; Donegan, www.doneganoptical.com, p.61c; **Getty Images**, pp.304–305t; © **Golden Artist Colors, Inc.**, www.goldenpaints.com, p.18bm; Courtesy of **Jerry's Artarama** © 1989–2014 JerrysArtarama. com, pp.77tl and both images far right, 295br; © Copyright 2010 **Kodak**, www.kodak.com, p.121tc; Courtesy of **LION Picture Framing Supplies Ltd**, www.lionpic.co.uk, p.292t/ct/b; © 2014 **Liquitex Artist Materials**, www.liquitex.com, pp.18br, 26t, 27r, 28t, 39l, 45l/t, 4/t, 48l/t, 49r; **Lambrechts, Hans**, www. hanslambrechtsfotograaf.be, p.7; **Munsell Colour System**, p.95b; © 2014 **Winsor & Newton**, www. winsornewton.com, pp.26c, 27l

We would also like to thank: **L.Cornelissen & Son**, www.cornelissen.com, for supplying art materials shown on pp.28t, 39cl, 45t, 46–47, 51, 69t, 80b, 82t, 83tr; **Piet van Nassau** at **ColArt**, www.colart.com, for supplying label images shown on pp.26, 27; **Karen Atkinson** (www.gyst-ink.com) for the text on p.299

All step-by-step and other images are the copyright of Quarto Publishing plc. While every effort has been made to credit contributors, Quarto would like to apologize should there have been any omissions or errors—and would be pleased to make the appropriate correction for future editions of the book.

BLICK art materials **JERRY'S ARTARAMA®**

www.JerrysArtarama.com

A big thank you to my team at Quarto: Kate Kirby, Victoria Lyle, Moira Clinch, Caroline Guest, Sarah Bell and Julia Shone, it was a true pleasure to work with you. As a first-time author I couldn't have wished for better guidance and support.

A big thank you to all the talented artists from around the world who allowed me the privilege of displaying their superb artwork in my book. You truly are an inspiration and you make the world a more beautiful place.

A big thank you to Becky Bening, for your love and friendship, hands-on support, artwork and our daily long-distance pep talks. I couldn't have done it without you.

And last but always first, thank you to Kurt Jonckheer, for always believing in me, for your unwavering encouragement, wise guidance and unconditional love. I'm forever grateful for the path we walk together.

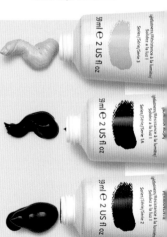